Media Poetry:
An International Anthology

Eduardo Kac
Editor

Media Poetry:
An International Anthology

Eduardo Kac
Editor

intellect Bristol, UK / Chicago, USA

First Published in the UK in 2007 by
Intellect Books, PO Box 862, Bristol BS99 1DE, UK

First published in the USA in 2007 by
Intellect Books, The University of Chicago Press, 1427 E. 60th Street, Chicago,
IL 60637, USA

Copyright © 2007 Intellect Ltd

All rights reserved. No part of this publication may be reproduced,
stored in a retrieval system, or transmitted, in any form or by any means,
electronic, mechanical, photocopying, recording, or otherwise, without
written permission.

A catalogue record for this book is available from the British Library.

Cover Design: Gabriel Solomons
Copy Editor: Holly Spradling
Typesetting: Mac Style, Nafferton, E. Yorkshire

ISBN 978-1-84150-030-0

Printed and bound by Gutenberg Press, Malta

Contents

Introduction 7
Eduardo Kac

Introduction to the First Edition (1996) 11
Eduardo Kac

I – Digital Poetry 13

The Interactive Diagram Sentence: Hypertext as a Medium of Thought 15
Jim Rosenberg

Quantum Poetics: Six Thoughts 25
Stephanie Strickland

From ASCII to Cyberspace: a Trajectory in Digital Poetry 45
Eduardo Kac

Unique-reading Poems: a Multimedia Generator 67
Philippe Bootz

Interactive Poems 77
Orit Kruglanski

We Have Not Understood Descartes 85
André Vallias

Virtual Poetry 91
Ladislao Pablo Györi

Nomadic Poems 97
Giselle Beiguelman

Beyond Codexspace: Potentialities of Literary Cybertext 105
John Cayley

II – Multimedia Poetics 127

Holopoetry 129
Eduardo Kac

Recombinant Poetics 157
Bill Seaman

Videopoetry 175
E. M. de Melo e Castro

Language-based Videotapes & Audio Videotapes 185
Richard Kostelanetz

Biopoetry 191
Eduardo Kac

III – Historical and Critical Perspectives 197

Media Poetry – Theories and Strategies 199
Eric Vos

Poetic Machinations 213
Philippe Bootz

Digital Poetics or On The Evolution of Experimental Media Poetry 229
Friedrich W. Block

Reflections on the Perception of Generative and Interactive Hypermedia Works 245
Jean-Pierre Balpe

Screening a Digital Visual Poetics 251
Brian Lennon

IV – Appendices 271

Media Poetry Chronology 273
Selected Webliography 279
Sources 283
Biographies 285
Acknowledgements 287

Index 289

INTRODUCTION

Eduardo Kac

The first edition of this anthology came out in 1996 as a special issue of the journal *Visible Language* (vol. 30, n. 2). The original title and subtitle were "New Media Poetry: Poetic Innovation and New Technologies". For this revised and enlarged second edition I changed "new media poetry" to "media poetry", and the subtitle now accents the global nature of the movement. I changed "new media poetry" to "media poetry" because now, ten years later, digital and electronic media are no longer new in society in general or in poetry in particular. The change we see today is not one of kind but degree. In other words: the question concerning media today is no longer the passage from a society without personal computing devices and mobile networked media to one in which they reshape social space and interpersonal experience; the question today is the acceleration and expansion of this process. This implies further miniaturization (greater portability), additional media convergence (integration of word, image, sound, movement, transmission, and many other sign-processing features into a single device), and broadband network ubiquity (the eventual ability to process and exchange messages in any media anywhere). This process will undoubtedly contribute to expand the poet's creative media and will affect the writing/reading process in stimulating ways.

Another fundamental aspect of the difference between the terms "new media poetry" and "media poetry" is that while "new media" is often associated with digital technology, "media" is broad enough to also encompass photonic and biological creative tools as well as non-digital technology (e.g., analogue electronic technology and poetic experiments conducted in zero gravity). Further, the general term "media poetry" – without the word "new" – is useful in defining the broader field of technology-based poetic creation going back to the 1960s and projecting it forward into the twenty-second century. "New" is too ephemeral; "media" connotes the various means of mass communication thought of as a whole – in other words, technological systems of production, distribution, and reception.

It is a truism to state that the audience for poetry in general is not large, and that readers of media poetry constitute an even smaller group. In 1996 the audience for media poetry was fundamentally composed of the poets themselves and their immediate circles. In order to share

the results of our poetic experiments we met informally, exchanged disks via the postal system (because the network was not capable of storing, displaying, streaming, or transmitting specific formats and large files), convened (and often presented together) at international conferences, discussed common interests via e-mail and listservs, and mounted exhibitions. Fortunately, it is possible to say that in these ten years the audience for media poetry has grown. Several factors contributed. The original edition of this book was the first anthology of its kind published anywhere – a truly international anthology of media poetic theory featuring essentially poets themselves discussing their works and ideas. In the last decade, several anthologies and monographs have been published, contributing to shape the field and spread the reach of the poets' accomplishments. As a consequence of the international growth in production and scholarly interest, media poetry started to be incorporated into the curriculum of literary and interdisciplinary studies programs, with the by-product of countless master and doctorate theses being produced. While academic scrutiny and exegesis in and of itself, as a scholarly exercise, would be of no particular interest, the fact that interested literature students have read – and reflected on – the work of these poets with focused interest and intellectual curiosity is a clear sign of change. Perhaps even more significant in the educational context is the fact that now we also see creative writing classes incorporating digital technologies, which means that interested young writers now have environments in which they can be supported in the production of their own original works. An ever-broader global media art exhibition circuit started to incorporate media poetry works that cannot be properly or exclusively displayed online, such as installations. It is a unique sign of the new boundary-blurring condition of language-based media art that many works are equally comfortable in "visual art" or "creative writing" circuits – what makes this clearly different from 1960s conceptual art is the literary dimension of these works in direct engagement with the new cultural context of global digital networks. Finally, the greater accessibility of personal computers and mobile devices and the growth of the Web have helped disseminate that facet of media poetry that is specifically digital.

Clearly, technology as a writing and reading medium occupies an important place in the creative repertoire of the poets represented here. However, it is important to insist on the fact that they come to technology out of their own individual literary needs; that is, the impulse to combine their personal vision with a radical reimagining of poetry's expressive power through programming, interactivity, looping, networking, and many other new procedures. Technology alone is not the focus. Inasmuch as their work does indeed break new ground through the creation of new poetic forms, the focus must always remain on their individual poetic visions. This is true of all noteworthy art and poetry (think of Cummings and his inseparable portable Smith-Corona). By the same token, it must also be clear that what is at stake in media poetry is *not* a retake of the modern ideal of the "new" as a value in itself. Quite simply, the essays in this book demonstrate that formal innovation is a process intrinsic to culture. Formal innovation has always been and always will be a part of art and literature.

So, if technology plays a fundamental role in the poetry here documented but is not the central or dominant issue itself, what should be the focus of the reader's attention? The answer is simple: the poems themselves as verbal/visual/acoustic entities and as cognitive/perceptual/kinesthetic experiences. Each poet addresses his or her own themes through his or her own compositional system. An examination of the personal characteristics of the production of media

poets is a significant task, to be taken up at another place and time, by diligent researchers. Undoubtedly, the poets' own essays and the critical reflections collected here will be of assistance in this task. The poems are the focus of the reader's attention, but the poems themselves, by the very technological nature that makes them what they are, cannot be directly presented in a print compendium. Most digital pieces herein discussed can easily be downloaded or seen online (see the Webliography section), whereas other works can be seen during international exhibitions, visits to public or private collections, or special events. Inevitably, the distribution of media poetry follows from its immaterial condition.

The contradiction between the wide distribution of the media poems and the limited circulation of the first edition of this book (which was distributed directly to libraries and not available through bookstores or the Internet) is the main reason for this second edition. Since it first came out as a journal special issue, it could only be consulted at the libraries that owned it; it did not circulate as a regular book. Its accessibility has remained restricted to devout researchers. While a portion of the original material has subsequently found its way online, the collection itself, as the focused mark of media poetry's foundational moment and as an inclusive and portable volume, was not available until now. This book is both a historical document of the dawn of media poetry and a contemporary tool meant to be instrumental in the wider dissemination of the poets' achievements – the poems, which are, in the end, what truly matters.

It is no small wonder then that requests for a widely accessible edition of this book have been consistently forthcoming. In responding to them I was faced with the dilemma of either reissuing a facsimile edition of the book, exactly as it first came out in 1996, or editing a new book with the most current developments in the work of the original contributors as well as in the ever growing production of some of the many experimental media poets active today. In the end, I decided to merge the best of both worlds. Precisely because of its now historical status – time is relative: in the digital age, ten years may be perceived as equivalent to several decades of pre-digital time; not to mention that it first came out in the last century – I opted to keep all texts featured in the first edition (see Sources at the end of the book), add a few previously published but little known significant texts and images, and complement them with a series of new texts especially commissioned for this book, including some translated from French, Portuguese, and German.

Ten years later, ex post facto, we may ask: was/is media poetry a movement, like Beat or Language? Or a new form, like video art? Literary critics may decide one way or the other, but the incontestable fact is that the innovative media poets represented here – and many others documented elsewhere – have sought to redefine poetry in their experimental works created with, through, and for media and environments as diverse as video, electronic displays, computers, holograms, biotechnology, early and contemporary digital networks, cellular phones and other mobile media, skywriting and its logical consequence: outer space. Seen collectively, their works are a testament to poetry's relevance to contemporary life.

In a world in which we are constantly bombarded by the detritus of information technology, from irritating e-mail spamming to ravishing computer viruses, some may argue that the place of poetry should be a removed and more quiet realm that provides a respite from the twirling chaos of the technology-inflected contemporary life. Readers in need of restorative experiences

are reminded that poetry is not a substitute for a walk in the park, sunbathing, or meditation. Traditionalists with a penchant for colloquial directness or vernacular linearity are advised to avoid media poetry and pretend not to be surrounded by television, video and music players, cellular phones and Internet forms such as e-mails, instant-messaging, chat rooms, video conferencing, and blogs in which language is malleably and constantly expanded and transformed. Contrary to the ordinary use of words in these contexts, however, poetry is a profound engagement with language and so the poets whose work shapes this book challenge themselves and their audiences and argue instead that precisely because of the malaise generated by and through technology, the writer's task imposes itself as reshaping the media and transforming technology into an instrument of the imagination. Poetry liberates language from ordinary constraints. Media poetry is a paramount agent in pushing language into a new and exciting domain of human experience.

Chicago, May 2006
Paris, August 2006

Introduction to the First Edition (1996)

This is the first international anthology to document a radically new poetry, one that is impossible to present directly in books and that challenges even the innovations of recent and contemporary experimental poetics. The new media poetry documented here pushes language into dimensions of verbal experience not seen thus far. The work of the poets explained and discussed in this issue takes language beyond the confines of the printed page and explores a new syntax made of linear and non-linear animation, hyperlinks, interactivity, real-time text generation, spatio-temporal discontinuities, self-similarity, synthetic spaces, immateriality, diagrammatic relations, visual tempo, multiple simultaneities, and many other innovative procedures. Due to their immaterial nature, the poems created by the authors in this anthology can only be stored in computer disks, videotapes, and holograms. They can only be read on CRTs, whether with disks, tapes or via the Internet, and on holograms.

This new media poetry inserts itself in the field of experimental poetics, at the same time that it clearly departs from the formal conquests of other groups or movements in the twentieth century. From the rational and anti-rational approaches of the avant-garde movements of the first half of the century (including Futurism, Cubism, Contructivism, Dadaism, and Lettrism) to the print-based directions of the second half (including Spatialism, Concretism, L=A=N=G=U=A=G=E, Beat, Visual Poetry, Fluxus, and Process/Poem), experimental poetics has seen a relentless exploration of the verbal sign in "codexspace", to use a term introduced by John Cayley. The poems discussed in this anthology do not follow this route; instead, collectively they state that a new poetry for the next century must be developed in new media, simply because the textual aspirations of the authors cannot be physically realized in print. The old storage medium created by Gutenberg must now be replaced by floppy and hard disks, CDs, CD-ROMs, DVDs and SuperCDs, magneto-optical disks, tape, and holographic film. Many of the authors included in this anthology also make their works and theoretical writings available on the Internet.

The geographic diversity of this small sample of new media poetry – from Argentina and Brazil, to the United States, and to the Netherlands, France, Portugal and the United Kingdom (via Canada) – is a clear indication that this is an international phenomenon. At the same time, the age range in this anthology, from authors in their 30s to those in their 60s, shows that this is

more than a single generation's issue. What this anthology documents is an innovative work that seems to contradict postmodern obituaries of new and non-pastiche manifestations. Technology has undoubtedly changed artistic practices in a profound manner in this century. In most cases, however, what one sees is the impact of technological innovation reflected on traditional forms, as exemplified by pop artists' use in their paintings of mass media and television imagery, or by the current use of the Internet to publish traditional lines of verse. This anthology, on the other hand, reveals poets that appropriate the new writing tools of our time and with them give life to new and differentiated poetic forms. The multiplicity of forms here recorded (Rosenberg's simultaneities, Valias' multimedia text, my own holopoetry and digital poetry, Cayley's cybertexts, Bootz's unique readings, Györi's virtuality, and Melo e Castro's videopoetry) are complemented by Eric Vos' critical analyses of some of the fundamental principles of the innovative poetics outlined collectively by the authors.

This anthology is by no means comprehensive. A more thorough examination of experimental poetics and technological innovation would have to include pioneers of electronic sound poetry, such as François Dufrêne, Henri Chopin, Bernhard Heidsieck, Brion Gysin, and John Giorno; forerunners of digital poetry, such as Aaron Marcus, Erthos Albino de Souza, and Raymond Queneau; contemporary polywriters such as Richard Kostelanetz, Jackson Mac Low, and Silvestre Pestana; and electronic media artists who straddle between literature and the visual arts, such as Bill Seaman and Jeffrey Shaw.

While some of the present forms of distribution of new media poetry are doomed to disappear in the near future, as is the case of the videotape with the imminent arrival of small digital video disks, the revolutionary change in writing and reading strategies new media poetry promotes are likely to have a long lasting presence. The changes at stake are not a matter of writing lyric sonnets with a word processor instead of a typewriter; the focal point is not a change in writing medium, but the fact that we now also have new accessible reading possibilities. What held back this area of experimentation for over two decades, namely limited processing power, huge size and general unavailability of computers to readers, is no longer an impediment to the development of new media poetry. This international phenomenon started notably in the early 1980s and continues with renewed strength today.

The reader interested in locating the actual poems discussed in this issue will find plenty of references in the texts. In addition, a Webliography included at the end provides the reader with links to Web pages of direct interest, including some pages authored by anthologized poets that include digital poems available for downloading. I have also edited, in non-commercial CD-ROM format and in limited edition, the first International Anthology of Digital Poetry, which includes works by the poets represented here.

This is only the beginning.

Eduardo Kac

PART I – DIGITAL POETRY

The Interactive Diagram Sentence: Hypertext as a Medium of Thought

Jim Rosenberg

1. Diagrams: A Separate Channel for Syntax

The most basic elemental structural act, the most fundamental micromaneuver at the heart of all abstraction, is juxtaposition, 'structural zero': the act of simply putting an element on top of another, with no other structural relation between the two elements except that they are brought together. But consider the problem of the poet in bringing this about. When a sound is played simultaneously with another sound, the result is a sound. When a painter places a bit of coloured space on top of another bit of coloured space, the result is a bit of coloured space. A mathematician would say that the domains of the composer or visual artist are *closed* with respect to the operation of juxtaposition: the result of juxtaposing two elements from the domain is another element from the domain. But what happens when we juxtapose words? Whether it is done by means of sound – either via simultaneous readings by multiple performers, or by overlaying magnetic or digital media – or visually, the result of juxtaposing words – in the almost palpable physical sense of putting them directly on top of one another – is likely to be sheer *unintelligibility:* one will be lucky to make out any of the words at all. How is the poet to achieve juxtaposition with no sacrifice of intelligibility?

But it gets worse: how can direct juxtapositions of words be *used* in larger structures? It is not hard to work in modes that give up such structures as syntax. One simply does without. Asyntactic poetry is a large and fruitful domain in which to work. On the other hand, giving up all possibility of structure is giving up a great deal indeed. Syntax is at the heart of how we normally structure words. How does one achieve such structuring and yet still have complete freedom to use juxtaposition wherever it is artistically important? How does one designate the *structural role* of a juxtaposition in a larger structure? One could put this question a bit more crudely by asking: What is the part of speech of a juxtaposition? The composer John Cage once criticized the twelve-tone system as having no zero.[1] One could say that syntax 'has no zero': in a sentence every element has its structural role with respect to the syntax diagram, or parse tree; there is no way to have words in a sentence whose syntactical relationship to one

16 | MEDIA POETRY: AN INTERNATIONAL ANTHOLOGY

another is the *null relationship:* no relation at all except that they are brought together. How can the poet have her cake and eat it too? I.e., how can one keep both syntactical null relationships and much more elaborate relationships, in which juxtapositions act as elements?

These are some of the formal problems that have motivated my work going back more than 30 years. A method for approaching the second problem – how to incorporate null structures as structural elements – became apparent long before I realized how juxtaposition could actually be implemented. By devising an explicit visual structural vocabulary – separating syntax out into its own channel, so to speak – structural roles could simply be directly indicated. The elements occupying those roles might be words or word clusters or other structural complexes. Thus began a long series of works called Diagram Poems.

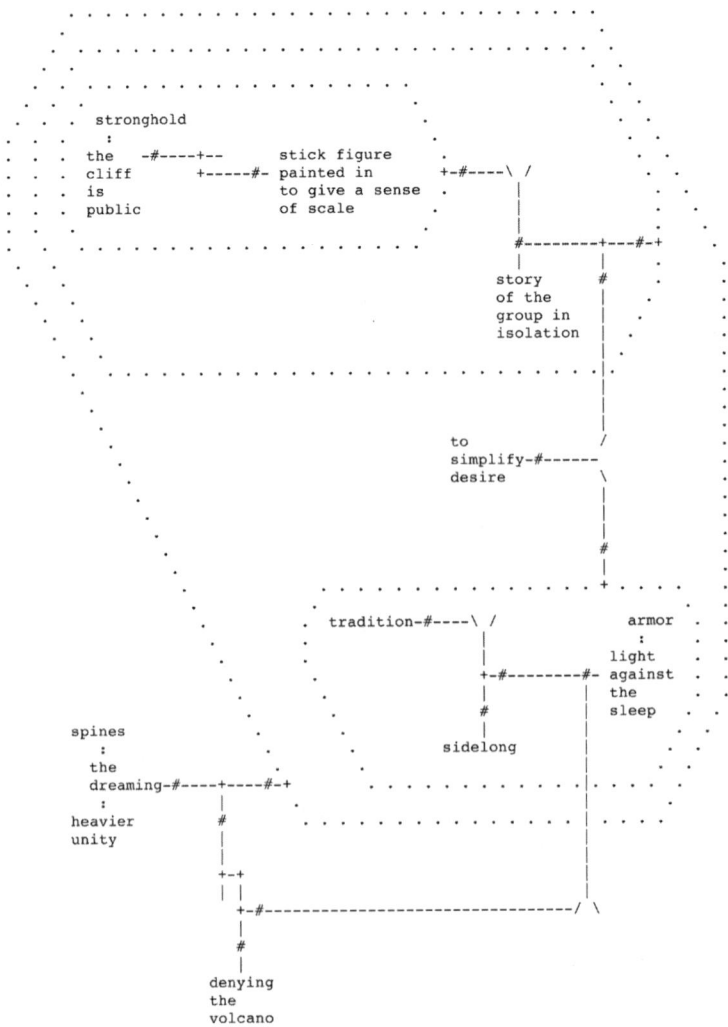

Figure 1: A diagram poem from *Diagrams Series 3*.

Figure 1 shows a poem from *Diagrams Series 3*.[2] It illustrates many of the facilities provided by the diagram notation in a variety of works spanning a large number of years. The configuration:

```
x  -#----+--
         +-----#-y
```

shows a simple modifier relationship where x is modified by y. The configurations:

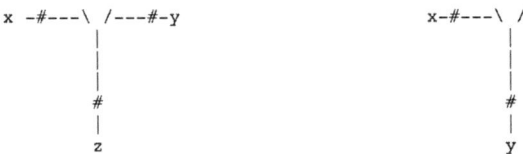

show verb relationships; in the left case above, z acts as the verb relating x and y, in the right case above, y acts as the verb and x acts as the subject.

These relationships can be built up into complexes in two ways: where a 'node' in a relationship is a loop of dots, the element participating at that node is the entire contents of the loop; where a node terminates in the graphical part of a relationship, the element at that node is *the act of making* that relationship.

A number of interesting things happen when syntax is 'externalized' in this way. Syntax came about originally in conjunction with speech, where speaker and listener are constrained by: (1) the requirement that the listener 'decode' the message approximately synchronized in real time with the speaker; and (2) the aid of only whatever 'temporary storage' the listener has available in short-term memory. One might say that the function of syntax is to pre-code the message with *storage cues* so that the listener will know how to park pieces of the message in short-term memory so that they can be properly assembled in the logical relationships desired by the speaker – all in more or less real time without getting behind the speaker. Writing, however, changes the picture completely. Obviously, the real-time constraints are absent: the reader may take as much time as desired, may revisit parts of the message as many times as is necessary, and may even browse the message 'out of order'. In addition, a written document may be said to *provide its own storage*. In contrast to speech, where whatever parts of the message that are not properly stored in short-term memory by the listener are simply (and irretrievably) *gone*, the written message *persists*: it stores itself, it stores its structure, it stores its own logical relationships.

Secondly, by externalizing syntax, all points and substructures in the message are *accessible* in ways not normally found in speech. That they are accessible to the reader has already been discussed. Some interesting ways they are accessible to the writer are revealed by Figure 1. Note the relationship of the phrase 'story of the group in isolation' to a larger whole in which it appears. In an externalized graphical syntax, such a relationship is easy to simply *draw*; joining a part with a larger whole in which it participates is as easy as joining a part with a

disjoint part. Relationships between a part and a larger whole in which the part occurs are an obvious logical structure that occurs commonly in the world; yet this is difficult to do in conventional syntax. In addition, the fact that relationships may simply be drawn to parts of the message already laid out allows for complex multiple pathways to be established within even small messages; the message may *feed back upon itself*. Feedback, while a ubiquitous structure in nature, is notoriously difficult to deal with. It violates the principle set theorists call 'well-foundedness'; it may induce the potential for infinite loops in computer programs; where feedback is introduced into the way sound elements are combined in an electronic synthesizer the results may be completely unpredictable: all bets are off. Figure 1 also illustrates this concept of feedback inside the sentence: the 'highest-level' logical relationship shown in Figure 1 relates the configuration at the very bottom, in which 'denying the volcano' is a modifier, with a cluster 'already' deep within the message: 'armor: light against the sleep'.

A feedback loop may seem an inimical structure to a programmer, where the threat of infinite loop is ever present (and indeed the infinite loop stands out as an archetype 'cardinal bug' second only in its fearsomeness to an out-and-out crash); one may say that the threat of infinite loop stands as the fear at the heart of all programming. (Technically, the theorem that one cannot algorithmically determine whether a general computer program will lead to an infinite loop is known as the halting problem, and establishes absolute limits on what is computable.) Yet, when the composer induces feedback into synthesized sound structures, the ear can hear it as a single sound; when a graphical feedback loop is established in a visual syntax, the mind can apprehend *the loop as a whole* as a single gestalt. Of course to do so, *time must not be constrained*. It is difficult to see how an aural syntax, subject to real-time constraints, could accommodate feedback loops.

A diagram syntax is notably non-linear. While this is an important point, one must be careful to avoid going too far in pushing non-linearity as a distinction between a diagram syntax and the conventional speech syntax. The essence of syntax is its ability to convey logical relationships across a distance of intervening words; one might say syntax has been our way out of the bind of achieving complex speech structures in the face of the constraint of linear time. Conventional syntax provides a start toward obtaining full non-linearity from an inherently linear channel; a diagram syntax can break free completely to non-linearity without restraint. Non-linearity is freed to extend far down into the fine structure of language – just barely above the word. Or, to put it slightly differently:

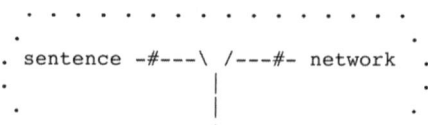

2. The Interactive Juxtaposition
But how to actually achieve juxtaposition of words – to place them literally on top of one another – and sacrifice nothing in the way of intelligibility? Too often we think of words simply as whatever comes out of a word *processor* – or perhaps one should call it a word constrainer,

THE INTERACTIVE DIAGRAM SENTENCE: HYPERTEXT AS A MEDIUM OF THOUGHT | 19

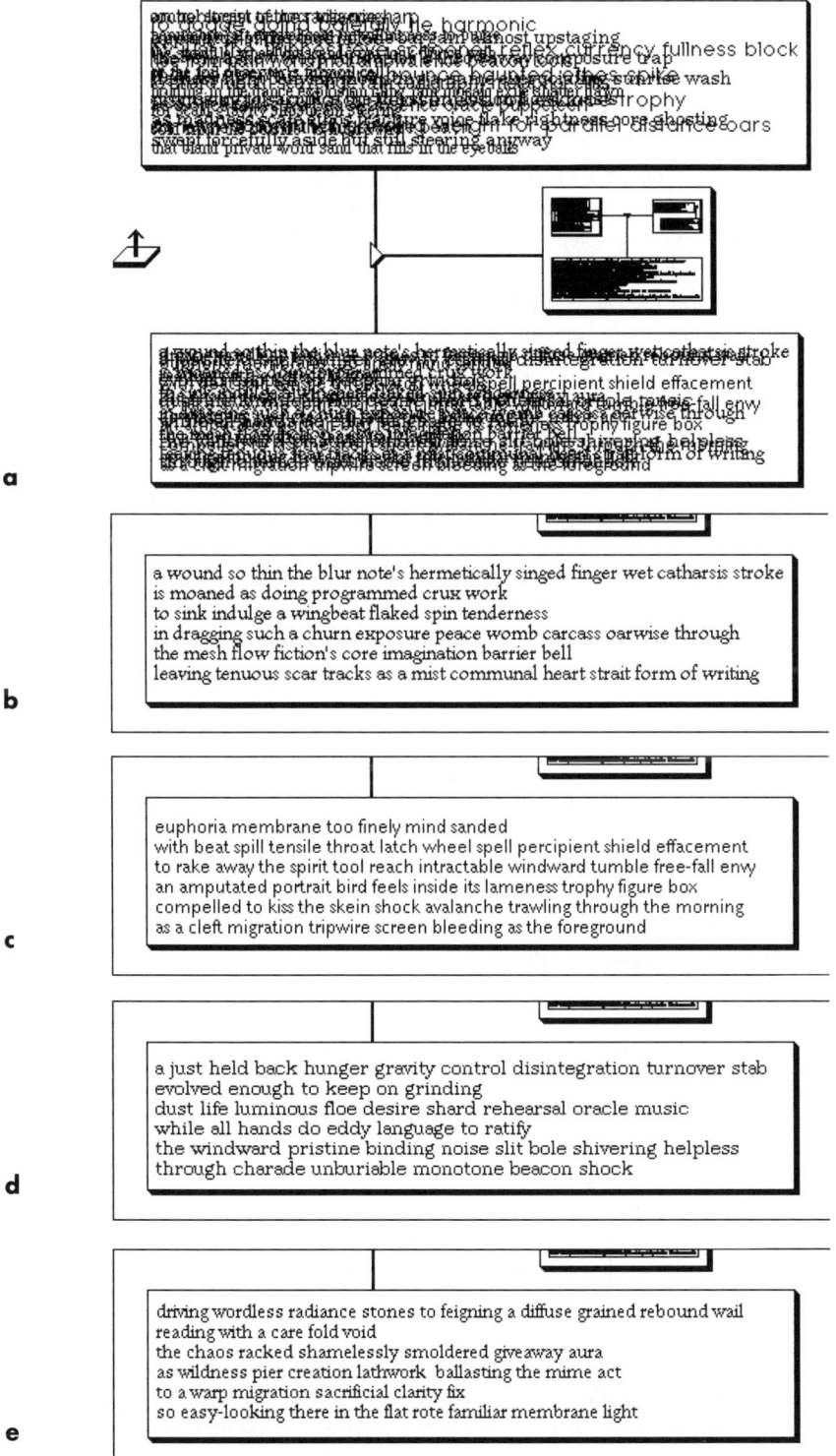

Figure 2: Taking the Diagram Interactive: Hypertext as a Medium of Thought.

forcing as it does the words into the familiar linear chains (with a nod to non-linearity by allowing hypertext links) and certainly *not* allowing words to be one atop another! A graphics program, on the other hand, allows text objects to be placed on top of one another with complete graphical freedom, but the legibility problem remains. Yet the graphics program gives a clue: juxtaposition combined with intelligibility is achieved (at last) by using interactive software. In a construction I call a *simultaneity*, words are placed in the same location – with all the freedom and fluidity a graphics program allows. At first it appears the words are simply overlaying one another – with no solution at all to the problem of overlay plus legibility. In this state the simultaneity may be called *closed*. The act of *opening* the simultaneity consists of moving the cursor using the mouse to a particular 'hot spot' on the screen. When the cursor enters this hot spot, all layers of the simultaneity but one are hidden: the one visible layer can be read unimpeded by its partners in the juxtaposition.

Figure 2 shows a simultaneity from *Intergrams*.[3] In 2a the simultaneity is closed and all layers are visible; in the detail views 2b-2e the simultaneity is opened showing each layer. (A static illustration cannot convey the *tactile* aspects of causing the different elements to appear by moving the mouse with one's hand; the reader will have to try to imagine this.)

A diagram is a marvellous instrument for presenting information of great complexity in a small space – to the point that the phrase 'Well, you'll have to draw me a diagram' is a stereotype epithet of complaint that something is too complex. There are limitations to diagrams, however. What happens when the space required is not small? How does one manage a diagram comprising *thousands* of elements? Enter hypertext.[4]

Hypertext is most often thought of as a special kind of computer software – or as the documents produced using that software, but here I would like to consider the idea of hypertext as virtual diagram. In the classical model of hypertext, a document is structured as a network of *nodes* and *links*. The nodes are typically either entire documents, or document regions (known as anchors); a link is a relationship between document places such that clicking on the anchor at the source end automatically takes the user to the destination anchor. If a hypertext is small enough and simple enough, the entire network can be represented by other means than using a computer – on paper, for instance.

Often hypertext begins (alas) at the level of the document; such documents are fully linear and use completely traditional methods for structuring text internally. Using links, associations are built up among places in these documents. The notation of the diagram poems suggests a different possibility: hypertext built up from scratch using very fine-grained word elements, where hypertext is used to carry the infrastructures of language itself, e.g. syntax. One may speak here of *hypertext as medium of thought*: rather than hypertext serving as an association structure for thoughts that are not themselves hypertexts, an individual thought itself is 'entirely' hypertext. To use terminology familiar to computer programmers, hypertext becomes a medium in which one thinks 'natively'.

Why should we do this: construct a morphemic hypertext[5] – hypertext taken into the fine structure of language? Why not make do with the syntax we have? Why not leave hypertext structure to relate 'conventional' documents, at the level known in the hypertext literature as the lexia?[6]

To answer this question, let me pose a counter-question: How does a single mind apprehend a complex network? It is becoming more and more clear that not only are networks – in the actual physical sense – becoming more and more important in our lives, the network as a metaphor is becoming increasingly important in dealing with a wide range of aspects of living. What does it mean for thought when an individual thought is itself a network? Does it help in understanding the complexities of life's networks around us, containing us, moving us, to 'think native' in a mode that is inherently network? Many seek in art a *refuge* from complexity; indeed, many consider simplicity as such a paramount goal for art that it virtually defines artistic purpose. For others, complexity is taken as a given in this life, and art is seen as an aid that can help us *to live with it* rather than fight it or withdraw from it. To understand the network one *becomes* the network. Thought itself is a network, there is no other-than-network:

```
thought -#---\ /---#- network
             | |
             | |
             +----+
```

The obstacles in the way of achieving such a hypertext of thought are many:

(1) Lack of Tools. Most commercially available hypertext systems are not adequate. Although much attention has been paid in the hypertext research community to a variety of structural models other than the standard 'node-link' hypertextmodel,[7] this has borne very little fruit in tools available for the kinds of computers writers are likely to have accessible.[8] Instead, commercially available hypertext software tends to either adhere too rigidly to a node-link model or require the user to build everything 'by hand'. Typical hypertext structures are or-based, i.e. disjunctive: from lexia L with links X, Y, and Z one may choose X *or* Y *or* Z. Syntax structures are *and-based*, i.e. conjunctive: a sentence with parts X and Y and Z consists of X *and* Y *and* Z. (Consider the classical phrase structure rule.

S → NP + VP

A sentence can be rewritten as a noun phrase followed by a verb phrase. One does not get to *choose* which of NP and VP to use; they are both there.) This is not to argue against the use of disjunctive structure, or 'classical' hypertext links. Rather, the need is for both to be available as an author requires. Typically, commercially available software has no built-in support for conjunctive abstractions at all.

Another problem with available software packages is too rigid an attitude toward *behaviour*. Available hypertext systems typically offer only off-the-shelf behaviours that cannot be extended by the user. At the other extreme, systems like Hypercard are fully programmable, but do not allow that programmability to be encapsulated in pluggable objects. (For instance, a Hypercard button has no storage containers!)

(2) Reticence to tackle 'language itself'. There is no gainsaying that the idea of using hypertext to carry the infrastructure of language itself is an extremely radical proposition – one from which many will shrink. One source of objection is the idea that 'language itself' is off limits by virtue of being biologically hard-wired.[10] There are two answers to this: the artistic answer and the

engineering answer. For the artistic answer, consider the analogy of dance. No one would dispute that there is a biological basis for how our bodies are put together, for the conformation of bone structure, for the ways that joints work: in short, biology places many constraints on how the human body can move. This has not notably abolished the dance. To the contrary: one may say it has *created* the dance: we admire those who can show us what the boundaries are for how the human body can move, who can take us all the way up to those boundaries and perhaps even stretch them. To the degree that syntax is biological, it makes experimentation on the limits of syntactic structure *more* valuable rather than less valuable. For the engineering answer, consider the analogy of computer networks. Again, there is no disputing that neurons are biological objects, and that genetics has a great deal to do with how neurons function individually and how the nervous system functions collectively. This does not diminish the utility or importance of those 'externalized nervous systems' we call computer networks. The proposal for hypertext as a medium of thought, for hypertext inside the infrastructure of language, is a proposal for an 'externalization' of syntax analogous to the externalization of the nervous system manifested in computer networks.[11] Just as computer networks do not 'replace' the biological nervous system, an externalized mechanism of thought does not 'replace' syntax; rather it adds to syntax and allows new possibilities.

For instance, how do we allow more than one user 'inside the sentence'? For a diagram syntax this is almost trivially easy: each user's relationships can be distinctively marked – using colour, for instance, or any other form of explicit marking. How is it possible using conventional syntax to construct a 'multi-user sentence'? It is exactly in joining multiple users that our biological nervous systems break down and externalized ones show their true value. How does one construct a true multi-user medium of thought? To repeat: a multi-user medium of thought does not mean a multi-user mechanism for bringing together 'single-user thoughts' but rather a medium where *the individual thought* can be a multi-user construction. Just as multi-user interactions require an externalization of the nervous system, a true multi-user medium of thought will require an externalization of syntax.

It all interacts:[12]

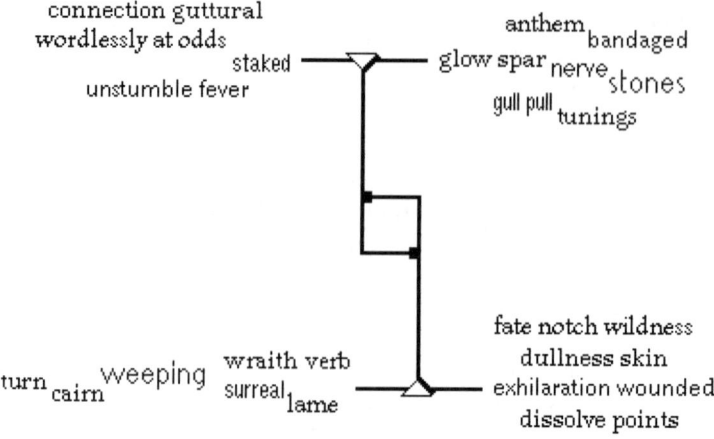

Notes

1. See, for instance, Cage, John, '45' For A Speaker', *Silence*, The MIT Press, Cambridge, 1961.
2. Rosenberg, Jim, *Diagrams Series 3*, published on demand by the author, Grindstone, PA, 1979. Excerpts appeared in *Interstate 14*, Austin Texas, 1981.
3. Rosenberg, Jim, *Intergrams*, Eastgate Systems, Watertown MA, 1993.
4. The term 'hypertext' was originally coined by Ted Nelson. The literature on hypertext is extensive; for a bibliography (though dated) see Harpold, Terence, 'Hypertext and Hypermedia: A Selected Bibliography', ed. Berk, Emily, and Devlin, Joseph, *The Hypertext/Hypermedia Handbook*, McGraw-Hill, New York, 1991. The best single-source introduction to hypertext is probably still Nelson, Theodore H., *Literary Machines*, T. H. Nelson, Swarthmore, PA, 1981.
5. The term 'morphemic hypertext' was applied to my work by the hypertext researcher Catherine C. Marshall (private correspondence).
6. The term 'lexia' was borrowed from the writings of Barthes by George Landow to refer to a document piece at a hypertext node; see Landow, G. P., *Hypertext: The Convergence of Contemporary Critical Theory and Technology*, Johns Hopkins University Press, 1992.
7. See, for instance, Marshall, Catherine C., Halasz, Frank G., Rogers, Russell A., and Janssen, William C. Jr., 'Aquanet: a hypertext tool to hold your knowledge in place', *Proceedings of Hypertext '91*, ACM, New York, 1991 for a model based on relations; Parunak, H. Van Dyke, 'Don't Link Me In: Set Based Hypermedia for Taxonomic Reasoning', *Proceedings of Hypertext '91*, ACM, New York, 1991 for a model based on sets; and Stotts, P. David, and Furuta, Richard, 'Petri-net based hypertext: Document structure with browsing semantics', *ACM Trans. Off. Inf. Syst.*, 7, 1, (January), 1989 for a model based on Petri nets.
8. In some ways the wide popularity of the Internet has actually made this problem *worse*. Not only is hypertext on the World Wide Web currently almost entirely node-link, it is a particularly simplified form of node-link hypertext.
9. The concept of conjunctive hypertext was introduced in Rosenberg, Jim, 'Navigating Nowhere/Hypertext Infrawhere', *SIGLINK Newsletter 3*, 3, December 1994, http://www.well.com/user/jer/NNHI.html.
10. For a review of issues pertaining to the biological basis of language, see Pinker, Steven, *The Language Instinct*, William Morrow and Company, New York, 1994.
11. Externalization of language is discussed extensively in Donald, Merlin. 1991. *Origins of the Modern Mind*. Cambridge: Harvard University Press.
12. The final figure is a single plane in a simultaneity from Rosenberg, Jim, *Diffractions through: Thirst weep ransack (frailty) veer tide elegy*, Eastgate Systems, Watertown MA, 1996.

QUANTUM POETICS: SIX THOUGHTS

Stephanie Strickland

Introduction

In a world of electronic, photonic, and bionic technologies, what and how does poetry speak, write, sound? What qualities emerge as it threads network flows, protein synthesis, random generators, algorithmic visual tools, sound engines, and other instruments that do not aim to (re)produce notes, or words, or pigments, but rather their own mesh of variable pattern.

For more than a century poetry has risen from the printed page, (re)locating itself in the corporal voice, in the life of the community, on the walls of cities, as part of performance. Now, by means of new technologies, poetry lives in new multi-dimensional environments. The position of the reader/auditor/viewer, who is sometimes a possible collaborator, has shifted – one more shift in a long history of shifts in reading mapped in the anthology *A Book of the Book*.[1] We do not know the "future of reading," though a recent Xerox Parc installation, *XFR: Experiments in the Future of Reading*, prototypes some exciting possibilities. Digital art makes us think of other directions. In the electronic arts, on which I will focus, (inter)convertibility of all previous media and energetic forms to one digital bitstream is a key capability and constraint.

The six major interests for me, as maker and receiver of these works, are 1) the discovery or refinement of new time dimensions, from macroscopic "world lines" to engagements at the periphery of attention to "curled-up" hidden possibilities; 2) privileging what I call a stenographic paradigm for interaction: "moving through me as I move";[2] 3) cultivation of an oscillatory or flickering kind of attention, directed not only to different components but also to different emergent levels as we have learned to understand these in dynamic systems; 4) thinking beyond oscillation to superposition; 5) remolding our sensorium, our neuro-cognitive capabilities, through these new works; and finally, 6) a sense of the importance of the practice of translation, understood as encompassing acts of transduction, transposition, transliteration,[3] transcription, transclusion,[4] and the transformation we call morphing.

One: Time Dimensions[5]

What is engaging about poetic works in new media? A way of entering time, unmatched by our other experiences. We are taken, not by the site or the map, but by the ongoing journey; not by the view or the path, but by the changing of the view, the diverging of the path; not by the archive or database, but by the ever re-contextualized act of retrieval; it is, then, not stasis, not velocity, but a new sort of time connection: what speeds me up, what slows me down, what hangs –

For almost a century, Einsteinian physics has taught that the universe has no master clock, no space pervaded by absolute time. We are intellectually convinced, but we have no "feeling for," no intuitive sense of what it is to travel on a world line in an irreducibly compound space-time. We do not understand kinesthetically that a world line never ends or begins, that it can time-reverse without violating laws of physics. Could we simulate the experience of such travel in the unconstrained dimensionality of cyberspace?

Designers in educational multimedia have produced tools such as *Mathematica* and *ODE Architect* to provide an interactive sensory grasp of highly abstract structures, but electronic poetic art has only begun to harness similar strategies and has not given itself the task of rendering temporal abstraction. One wants to grasp *temporal* abstraction because the critical changes from sub-atomic levels through biological macromolecules, cells, organs, individuals, societies, on through ecologies, are decisive *time-based* events. These changes are jumps between levels that reveal emergent properties. Such properties are unpredictable by, and unanalyzable in terms of, properties of the prior level, *even though* there is an unbroken line of inheritance from bottom to top, and even though there is always a part/whole relation between the levels. In the transition from any one of these levels to the next, not only is the whole greater than the sum of the parts, but the emerging qualities feed back on the parts and give them qualities they could not have if isolated.

How do we measure time, then? Metronomes of considerable historical importance include the solar and lunar cycles, the rhythms of the tide, the heart, the menstrual cycle, and now, vibrations of a cesium atom. Most important, we ourselves are proper clocks, measuring one kind of time, because a proper clock, in Einsteinian physics, is a clock affixed to a moving object.

In this age of preeminently bio-science, we re-understand the body, have in fact translated the body through cloning, through digitized anatomy, through medical body-scan devices. We newly understand that the human timekeeper, the heart, is not the kind of clock that measures unvarying flow, but is rather a fractal tempo tracker that runs concurrently to the beat of several highly variable drummers. When it runs to no beat, or if it collapses to one stereotypic periodic behaviour, losing some of the long-range correlations that tie it to events thousands of beats into the future, then it is about to die. Is the Internet also a fractal tempo tracker?

The tracing of a heartbeat over a period of milliseconds, then seconds, minutes, hours, days, exhibits a pattern that remains the same. The concept of fractal shifts here from self-similar structure in space to self-similar dynamics in time. Thus, though you cannot tell what timescale you are looking at simply by seeing, or hearing, these patterns, the pattern's persistence does become a means to travel *between* timescales. And although it is true that an average regularity,

a pulse, can be established, this is not the most interesting pattern – as a measure, it smoothes and destroys the huge amount of information hidden in the micro-measures, in the fluctuations, the interbeat intervals.

How can we use these dynamic measures, these hidden dimensions, for poetic works? By using large networks as our instruments, as arguably Net artists Mez (Mary-Anne Breeze) and Netochka Nezvanova[6] both do, creating and exploring multiply connected spaces in which different regions of space and time are spliced together, but more than spliced; in which histories are alterable, always different, manifesting in many media, driven to immaterial spaces by the assaults of technology – or are they released by technology, escaping both identity and identification, in search of some new present that they are leaning into? As Talan Memmott says, "Adentity is another manner."[7]

One poetic work that thinks time dimensions in new media is *1:1*, a time series image of the Internet, created by Lisa Jevbratt.[8] In this piece, softbots, or agents, continuously scan servers doing an interlaced search of all possible IP addresses, expressed as four octets, and then expressing the results in terms of five different visualization algorithms. The search zooms in repeatedly on different samplings, each of which constitutes not a slice, but a snapshot, of the Web, which increases in resolution as the scans move toward sampling all the octets, after which they recommence. The title *1:1* refers to a scale of 1:1, suggesting that this map has the same size as its referent. In fact, the interface here has become not only the map but the environment, implying all of the logical problems Lewis Carroll addressed in 1893, in his book *Sylvie and Bruno Concluded*, and raising, as well, the issue of map as time tunnel, map-meaning dependent on date.

Readers of *1:1* can select locations via the Hierarchical, Random, Petri, Excursion, or Every interface. The latter is a densely striated coat of many colours, a clickable image map linking to every top level website associated with an IP address. The specific colour of each square is generated by using the second, third, and fourth octets to specify RGB numbers. The Petri interface resembles a star-map of live sites, each of which brightens the more it is clicked, demonstrating the self-fulfilling-prophecy aspect of collaborative filtering. The Excursion interface permits a recursive choice from a search-progress graphic that opens nested windows; Hierarchical allows consecutive choice of each octet; and Random requests a randomly generated choice. When using these database interfaces, readers experience predominantly undeveloped sites and inaccessible information, at best a few hits among the myriad error messages that announce vacant or forbidden sites. Without a probabilistic sampling scheme, without recursive searches, without a time series interface, this particular view of one of our most important public environments would not be available. This interface/visualization only transiently yields to a gestalt. It must be reconstituted continuously with computer processing time and human cognizing time, a kind of temporal knowledge that we learn to feel with and that digital artists are exploring in unpredictable ways.

Two: The Stenographic Paradigm[9]
If we think of oral performance as mapping time into time, an insertion of the invisible into the invisible, smoke in air; if we then think of script as mapping time onto space, the time-uttered word now held on vellum, stuck there, ink-spattered, or the time-uttered word now chisel-chipped on stone, we will think, the letter kills, but the spirit (-voice) gives life.

And then, if we think of print as mapping time onto a grid, the justified page stamped by type set in rigid frames, always the same, no difference one copy to the next, under the control of the Learned Latin line, a line that has excluded childhood and linguistic play, that has excluded those prohibited from learning by reason of their birth, we will wonder where the human voice has hidden itself – and notice that the Romantics and Mary Shelley, for different reasons, aligned themselves with technology dreams.

And if we ask, finally, in this line, what does the electronic word do, will we say that it maps time into a medium that defeats geometry, that is profoundly anti-spatial, not a place to hold and to own, but a place to log in, full of transitions, timely views, snapshots of malleable non-placed space? Will we say that many co-present, fleeting, refugial, but reappearing, glances and glimpses can begin to assemble themselves across many levels of reference and embeddedness, across many types of text, and will this act of recombination or reconfiguration have a shared public structure, the structure of a quest? A quest, we must ask, of whose unconscious.

What anthropologists call polychronic time, software engineers call multitasking: doing many things at once. Both multitasking and microprocessing, as Sadie Plant points out in *Zeroes + Ones*, are activities associated with the work of women in many societies and eras. This interruptible ability to do many "little" things at once is contrasted with monochronic male time, a time in which only one task is addressed, no matter its mental, physical, or ritual character. In a digital age, all are interruptible, and digital art often takes on the "never done," always renewable quality of so-called "women's work".

Rosmarie Waldrop, in her prose poem "Accelerating Frame,"[10] describes this mode of reading: "I badly wanted a story of my own, as if there were proof in spelling. But what if my experiences were the kind of snow that does not accumulate? A piling of instants that did not amount to a dimension?"

Vannevar Bush[11] wanted his Memex to intercept and capture the neural circuits of the stenographer who could reduce his words to a phonetic code on the fly, whose encoding practice was encompassed by her body. I want to do the same thing, not from the position of Bush, outside the device, but from the position of the stenographer, attached to it. In her body, words moved through her as she moved, a fluent circuit of meaning that she hosted, instigated, permitted, understood, explored, and enjoyed. Her somatic practice deflects not only the threat of analytic dispersal, into "simplified language…nascent form…intelligible only to the initiated," as Bush characterizes her code, but also the threat of obsessive recombination and confusion, the multiple overlapping streams of speech she is asked to transcribe.

The notion of "moving through me as I move," as a paradigm for interaction, intends to install the stenographer, and not her employer, as the crucial creative/receptive presence in digital art. Hers is an egalitarian position that can be stated of, and by, each element in a dynamic network. "Move through me as I move" is as much the "voice" of a hypertext as it is of the writer/encoder. It is also the voice of the network addressing all those hosting it and served by it. In the case of work open to multiple authoring, or to synchronous reading and performance, the command 'move through me as I move' represents the utterance of each of the performers and participants speaking to all the others.

The stenographer, however, is more than a writer/reader/monitor; she is also the operator of an appliance. This position is described by Talan Memmott, here explicating his theory/fiction hybrid, *Lexia to Perplexia*, winner of the 2000 trAce/altx New Media Writing competition:

> With a document that is acted upon, unfolded, revealed, opened rather than read, full of holes to elsewhere, hiding secret inScriptions, filled with links like mines and traps and triggers – we are no longer talking page or screen, but appliance. Navigating the Lexia of *Lexia to Perplexia* is…like getting a new device and trying to figure out how…it works.…"[12]

The stenographer moves within an unforeseeable context. Communicating by "strokes" in an energized yet languid atmosphere, she is absorbed, alert, and somehow also free to gaze about the room – the aspect that most disquieted Bush. She participates in a form of dancing in which the lead changes many times a minute, her moments of apprehending/encoding activity giving way to deep moments of passive reception in a regular alternation or oscillation.

Partnering the machine – and then the network, always in touch as well with the social networks in which the digital networks are embedded, people often need to change their patterns, or moves, to deploy or receive effectively. The more one becomes attached, the more one wants a fluid form of action/understanding. "I want to be as able as a spider, sitting astride thousands of webs she has spun, to sense each soft ripple or bursting hail of electrons coming toward me and, of course, those pouring back – from my fingers, my mouth, perhaps even my glance."[13]

Figuring this back-and-forth motion, I wrote a poem about Sand (silicon-based e-media) and Soot (carbon-based life) called *The Ballad of Sand and Harry Soot*.[14] It hosts a seeming disjunction of image and text on each of its 33 pages. Images from Jean-Pierre Hébert's *Sisyphus* – a device shown at Siggraph 1999 that inscribes algorithmic patterns in sand with a steel ball – are the ones most prevalent in the *Ballad*. Other images suggestive of digital or mathematical culture, such as a Metro card, Webcam photos, a core dump, or an animated fractal, accompany the text of a love poem, a ballad of love gone wrong or at least not entirely right, between Sand and Soot. At one level, the disjunction of image and text mirrors the difficulties of this pair; however, the particular discordance, or non-reference, that seems to exist *between* image and text will, at some point, spring into resonant oscillation for the reader who either sees, or reads, an avatar of carbon-based chemistry in Harry Soot and one of silicon life in Sand.

Though this poem was written to probe differences between Sand and Soot, I came to identify, not only with Harry Soot, despite gender and temperamental differences, but also with Sand. A sensuous willingness to be pulled in, or to pull in, is part of what I feel about her. And certainly the intent of the *Sisyphus* device in actual operation is to create a meditative environment, which occurs as you watch it draw and also as you contemplate what it has drawn, a transient silicon image, equally present in the sand being traced and in the tracing program.

This early hypertext does not use programming to fluidly adjust to each reader, but it does provide a world responsive to many approaches. There are no privileged nodes, no highlighted links – the links must be found by caressing the text with the cursor in an attentive stenographic manner. Three navigation methods are explicitly described, each explicitly recommended, and

their combination in any fashion also explicitly catered for. Beyond the multiple, but un-urged, choices on any page, there are "tendencies and flows" for the reader who seeks direction; for instance, there is a persistent but not rigid tendency for links to be found in both the Soot and Sand portions of the text at each node.

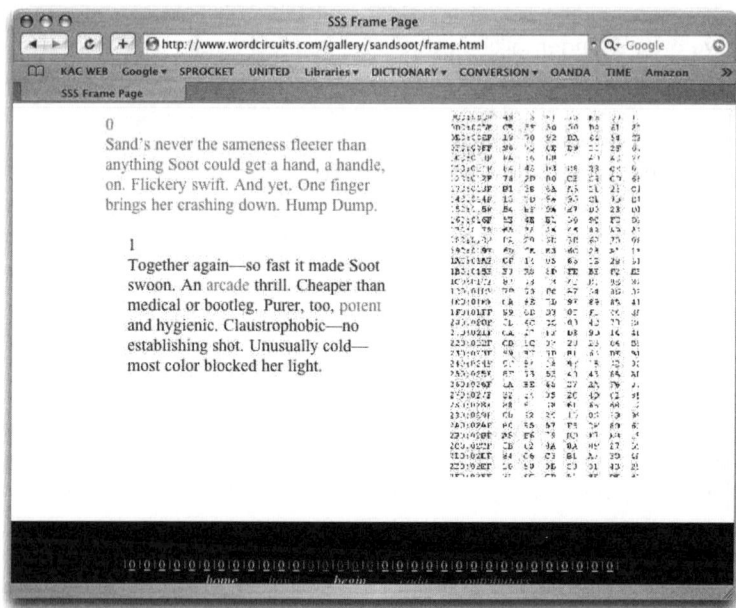

Figure. 1: Stephanie Strickland, "Ballad of Sand and Harry Soot", hypermedia poem, 1999.

Four key images in the *Ballad* were created by Alex Heilner and shown at the 6th Annual Digital Salon. On his contributor page within the *Ballad*, Heilner explains: "This series of 'microbe' images...seeks to invert traditional understanding of our internal and external environments. Large, orthogonal, built objects...have been re-imagined here to represent the most basic organic living beings...." Thus, a DNA molecule is figured from transmission towers, helicopters appear as mosquitoes, and the island of Manhattan is hidden as a collection of floating microbes.

Scale is elided on the Web, as it is in the stenographer's practice, where events in the conference room, in her brain, in her hand, and on her code-filled writing machine are nearly simultaneous. Many different scales can be present to the same screen, as if they belonged together, as if they cohered there as "naturally" as they do in the stenographer's body. But a change in scale is a change of context: the view/read cusp will shift differently for zoomed text than it will for text that is panned. In fact, this kind of zoom or scale-changing cusp may be a particularly important one in a world where we are asked to process simultaneously scales from the nano to the cosmic.

Sand as meta-medium, the digital medium into which everything else can be poured – sound, image, touch, data – has its own Protean or Circean character, a hyper-environment, a cave, in which any world can present itself and be lived. There is a process of interpenetration, or perhaps learning, that goes on between Sand and Soot, moving through each other as they move, yet they are strongly contrasted to the end. The stenographer at her stenotype was an early pioneer in this environment. Her continual active choice to attend or to blur her focus, to remain poised or to flow within the moving stream, is a task we take up. We will not all take it up the same way. We bring many biophysical and cultural heritages to the task.

Three: Oscillation and Resonance[15]
Alan Sondheim and other digital e-media hyperpoets speak about taking a long time to "tune" their works, and I think this verb will ring true for most e-artists, truer than editing, cutting, retouching, painting over, or rehearsing, for instance.

An oscillating, or flickering, pattern has often been invoked with regard to electronic art. Katherine Hayles has said, "We have only begun to construct a semiotics that takes into account the different functions signifiers perform when they cease to be flat marks and become instead layers of code correlated through correspondence rules."[16] In recognition of the layered dynamic interactions between text and code, she proposed the term "flickering signifiers" for text onscreen. Both Richard Lanham in *The Electronic Word* and Bolter and Grusin in *Remediation* have remarked the importance of an oscillation between the viewer positions of "looking at" and "looking through"; that is, between experiencing works primarily as heavily mediated and "windowed," in the software sense, or primarily immediate and immersive, as in looking through transparent glass. I would like to propose a third kind of flickering or oscillation, the oscillation that occurs between the processing of alphabetic text and the processing of image in works that use both. A digital writer who uses image and text is in fact writing a score for their shifting interrelation.

Flickering or oscillating poems differ from pure sound and pure image work in the following respect: whereas sound layered on sound creates new sound, and image on image makes new

image, alphabetic text, superimposed on alphabetic text *or* on image, does not reliably yield legible text. In the poems that explore this truth, one flickers between seeing the viewable and reading the legible. Jim Rosenberg[17] and Mez are poets who approach this movement very differently. Rosenberg overlays his texts in a dense blur of self-interfering micro-information, a tangle literally drawn apart by hand into legible text. But no sooner do words come into focus than the slightest mouse movement dissolves them back into blur. These texts thus move through the reader, as she moves, at *exactly* the pace her hand/brain browses – and superimposed on that oscillation, one experiences a constant trembling across the view/read cusp. Mez, on the other hand, in a practice she calls "M[ez]ang.elle.ing,"[18] leads us to confront the legible with strategies ordinarily reserved for the viewable, giving us text that rewards a scanning multi-directional view that is not restricted to movement in lines.

My own e-poems investigate oscillation between image, text, sound, and animation, both within and between hypertextually linked units. In this way, several states of oscillation, a set of cross-rhythms, come into being.

In 1995, I translated my book-length poem *True North*,[19] featuring language-revolutionaries Emily Dickinson and Willard Gibbs, to Storyspace. The *True North* themes of navigation and embeddedness moved from being print concepts, refracted in language, to being the steering mechanism and constitutive structure of the hypertext. For this textually driven work about navigation, I designed the two most important orienting elements to be visual. The first of these is a set of mouse-drawn Storyspace maps, emblematic shapes with their legends of node names. As sitemaps *and* as pattern poems, they give a very fair idea or sampling of *True North*. They provide a mode of understanding that may supplement, *or* substitute for, following links and reading text. Such a displacement of text by image, that also functions recursively as a guide to text, is itself a distinct mode of oscillation – one which co-exists with the familiar reference oscillation between a map and what it maps. The second orienting device was the colouring of a few words on each page. Since Storyspace does not use colour to signify text-links, instead permitting the reader to press a key to reveal boxes around link words, each colour operates visually to suggest a connection between similarly coloured words: each colour *is* an embedded link, but one traceable only by human memory, not by software.

A different kind and rate of oscillation occurs in *To Be Here as Stone Is*,[20] an early digital poem (properly viewable on Netscape 4) written collaboratively with M. D. Coverley. This poem is composed of two very different sorts of screens: six highly visual ones with sound that use Anfy Java applets and thirteen primarily textual ones where lines of verse are overlaid on a visual background, itself layered with a text ribbon. The links between these promote a rapid exchange between two kinds of attention, between primary viewing/listening and primary reading/searching, for the links must be sought for, by cursor scanning, on the textual pages. The experience of strongly discernible shift resonates with the text of this poem which shifts the reader from photons to cosmos and back.

In the Flash poem, *Errand Upon Which We Came*,[21] Coverley and I choreographed animation for the alphabetic text as well as for accompanying images and sound. The reader/operator of this text may press the silver butterfly to the screen if she wishes to read with complete accuracy, but she may prefer to oscillate between sampled reading and periods of viewing.

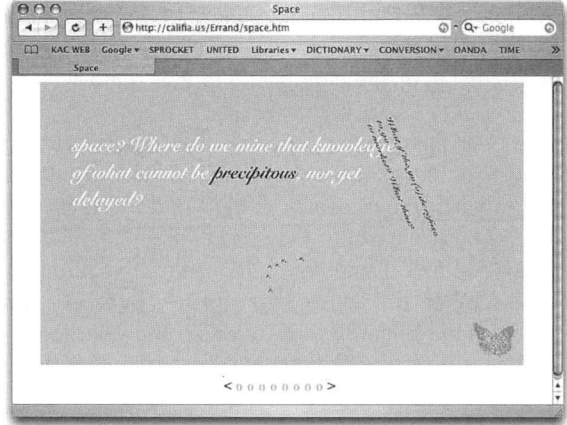

Figure. 2: Stephanie Strickland and M.D. Coverley, "Errand Upon Which We Came", hypermedia poem, 2001.

The words of *Errand* address the reader, speak to her of fragmented mobile text; speak to her, in fact, of the very act of reading she has undertaken: in response, she may actively intervene in the poem to read or redirect it, or she may attend to it as a movie.

One *Errand* stanza begins with the question "space?" floating down from the top of the screen, followed by a second question about knowledge-mining. A flock of butterflies flies in from upper right and circles around toward screen center. A third and fourth question, about "go(o)ds" refusing to go to market, appear onscreen. They imitate the butterflies' circling motion. At the end of the Flash movie we see two dimnesses in the central far distance, one, the almost out-of-sight V of butterflies; the other, the lines of the last two questions, now collapsed to one extremely faint line poised at the butterflies like a lance. The question is *visually* posed as to whether the image and text must attack each other, or may perhaps exist in oscillating accommodation.

The range of oscillation and its timings are extended in my next project, *V*, a poem distributed *across* media. *V* exists, in part, as an invertible two-in-one print text, *V: WaveSon.nets/Losing L'una* (Penguin, 2002). No matter where one begins it, upon arriving midway at the URL, http://vniverse.com, a reader must choose: either invert the physical book and continue from the other "end," or go to the Web address to find the poem's digital embodiment, *V: Vniverse*, a Director project made in collaboration with Cynthia Lawson. *V* exists in the virtual space of oscillating attention *between* book(s) and screen, each of which is interpreting the poem in its own material way.

V analogizes the role of nomadic peoples of the Ice Age to nomadic peoples of the Information Age. Acts of migration are key to both. The *Vniverse* interface, like the night sky read by Ice Age nomads, is a continuous present of varying forms in which readers trace their own path. As with the night sky, highly abstract diagrammatic images are produced by tracking. Sweeping a mouse across the *Vniverse* screen full of "stars" causes fleeting forms to appear that disappear back into the darkness. These are spontaneously read as constellations, though most of them (the Broom, the Dragonfly, the Embryo, etc.) are invented. Rolling-over a star releases its constellation, its keyword, and the spelling-out text of a numbered tercet. Clicking stabilizes the constellation, making it temporarily permanent, able to be read if it is traced *without* clicking. A second click (or any double-click) releases the text of a WaveSon.net, assembled not sequentially, not the top-down of print, but in relation to that chosen tercet, which displays in color while the other lines display in white. Clicking yet again oscillates the form between a Son.net and a set of triplets, creating a kind of doubled reading. Toggling between these provides a spatial micro-texture unavailable in print, an interplay between a pattern and its activation – not only the patterns of the alphabetic text, but their relation to the diagrammed constellation which is being read visually at the same time.

Clicking the darkness makes everything disappear, whereas pressing a "next" activates many implicit time-scales. A text-decay process takes place that leaves many states of the poem co-present onscreen. The time of break-up, the time of emergence, and the time of cross-layer existence *between* dissolving and emerging text co-exist with the time of reading forward in the same constellation. Many foci compete for attention even though the overall environment is highly textual and subdued. A reader who continues to swing her hand across the screen, as

she reads, brings forward at her own pace, moving as she moves, the time of overlying keywords, the almost auditory time of the spelling-out tercet, and her own hand's rhythm. This play-read process is an iterative one. The iterative process of return overwhelms individual differences in sampling, just as years of sky observation yielded recognizable repetitions or significant conjunctions. Extinction, as much as production, is to be read.

For people of the Ice Age, their sky became an Oracle, a constructed relation to the natural world probed by counting. The *Vniverse's* Sibylline space can also be probed directly by number, by entering any star's number in the small circular dial in the upper right of the "sky". The *Vniverse* not only creates a fragile, infinitely interruptible location, but there is a special smoothness to its space that comes from the way it was programmed in Director. This highly recursive piece never leaves its original frame which helps give the illusion of words moving directly in and out of the sky. In this space, time never advances – so far as the Director timeline is concerned – but it is highly active. All of the time resources go toward responsiveness and the production of language, rather than visual display. All the stars are waiting – each one a standpoint and a center – and they are more active than the constellations, though the visual impression is the reverse. Here, space has been fashioned to amplify the sense of resonance that internal timings create.

Simone Weil distinguished different ages in the history of science according to the values they embodied. She claimed that Greek science was motivated by ideals of "balance" and "beauty". The Greeks, she said, saw a moving waterline on a hull as an image of balance; whereas Newton, in the next age of science, one that valued energy and work, saw a loaded-down ship; he saw force and displacement.

Willard Gibbs, in the nineteenth century, devised visualizing methods which redefined the meaning of space. Instead of being a static Cartesian grid, his phase space could represent every possible lifeline of a system, any system, any number of coexisting systems. Gibbs's method, criticized by some as *merely* visualizing, was grasped at once by James Clerk Maxwell – the man whose equations define electronic reality – as both profound and productive. The very shapes of graphs and models yielded truths about energetics of the system – the relation of transitions to degrees of freedom and free energy; phase transition itself, as from ice to water, being a change of identity toward which the whole system was attracted.

Simone Weil died in England in 1943. What word might she have chosen, had she lived, to name value for our age, as "balance" and "beauty" named value for the Greeks? I would propose her Greek term μεταξύ translated as "betweenness" or "resonant communication". Resonance entails response, interaction, co-creation, a space between.

Quantum reality, the reality of electronic computers, works by resonance.

Four: Superposition
To recognize threads in the cloth, then patterns in the weave, and then to understand every thread, every pattern, as co-present, superimposed on each other in a multi-dimensional space, a superposition space: all "there" until "then, when" only one is observed, one trailing and entailing long-range correlations.

Quantum mechanics is an engineering science used for building electronic devices. The equations "work," as well tested as any, but the language describing what they do is either entirely mathematical or verbally extremely counter-intuitive. To explain all the *observed* effects, one must acknowledge that "the particle" is in more than one place, is in fact "everywhere at once".

It takes a very long time to compute atomic angles in a molecule, using quantum mechanics, yet the forming molecule figures it out instantly. It seems to store superpositions, many states at once, or to do many calculations simultaneously. In a quantum system when two particles interact, their fates are entangled, interdependent, remarkably correlated, beyond any such interdependence in the classical world. To measure one is to affect the state of the other, no matter where that other is. Quantum mechanics suggest every possible separate configuration and a profound entanglement, that can yet be undone, can decohere. What it does not suggest: intermediate states, fused combinate states, *Gesamtkunstwerke*.

The physics of neuron and transistor depend on quantum mechanics, but neural processing appears to take place at the classical, Newtonian level. I offer no suggestion of quantum mechanism, here, with regard to digital art; but rather a set of metaphors for understanding that draws on the struggle between mathematical abstractions and words in coming to terms with quantum mechanical effects. I suggest that we may need and expect a new level of emergence, a new form of gesture, of notation, perhaps notating processes rather than images or outcomes – even as the Feynman diagrams permitted a rethinking of quantum mechanics – to grasp the situation that has emerged in the ever-filling space of interconnected digital structures, to understand the effects of network connectivity on the synchronization of biological oscillation.

Five: Neuro-cognitive Shifts: Seeing the Wave Through the Particle[22]

The flow of waves and of particles, the scan constantly sweeping down over the screen/over the eye, cutting it off, setting a rhythm of passes, shifts us toward an older information-processing pattern, holistic pattern-recognition, away from our newer accomplishment, sequential analysis. Sequential analysis had allowed us to become adroit at anticipation, not be trapped the same way twice, and now sequential analysis is relocated to the writing and execution of code. These two types of thinking, pattern recognition and sequential thinking, are highly associated with visual and auditory processing. Visual processing is almost entirely static pattern recognition – with one exception, when we react instantly to the image of a rapidly approaching object, a response not handled by the brain but hard-wired in the retina. Auditory perception is, however, inherently sequential, because sound is received not as a broad field of information but in a stream.

How might we grasp several levels of information at once? How do we combine different types of processing? Two non-electronic examples are autostereograms and calligraphic inversions.

Autostereograms are computer-generated random dot "Magic Eye" pictures, used to entertain but also for vision training. Embedded 3-D images are discovered, perceived, in what appears to be a plane of flat repeating patterns, when fused by the brain's active seeing. Each eye is addressed separately and neither eye alone can perceive the hidden form. The perception is not instantaneous, because the brain has to take time to create the perception. One must look *through* the plane image, and not focus on it, in order for the perception to occur.

Inversions, from the book so named by Scott Kim, are calligraphic words that read the same upside down and/or in the mirror and/or across other symmetry operations. As Douglas Hofstadter, remarking on similar games he and his friends played, says: "We were not very good at it, for we never came across the key insight that [Kim] has learned to exploit, namely, that letter *parts* can be regrouped so that what is one letter going one way may be two letters or half a letter when read the other way."[23] Here we see that the letter is no longer the combinatorial primitive, but that the human sensorium is used as a guide to create new, more granular, "primitives".

How do we make or recognize patterns, with our visual and auditory cognitive systems, both employed at their different time-processing scales, both passing through that mill of scans that supervenes on our gaze as the screens repaint themselves, leaving us to glean from gaps in the glow what we can or will. Something has been "carried across," from one energy form to another, from one "language" to another. Is it an algorithm indifferent to its manifestations? Is it a melody, a font design, that survives all texts in it, all arrangements of it? What gets carried over does not remain unchanged, not in either or any of its locations. The appellations source and target exchange places at a high-frequency rate, both in the process of translation and in its generated forms. There is no seamless information environment, only increasingly extended forms of attention and inter-attention, cross-modes of attention, muscular, neural, endocrinologic, visual, acoustic, kinesthetic, and proprioceptive. New forms of learning, as with the Magic Eye pictures and Kim Inversions, are called for to integrate environments partially digital, partially photonic, partially biotechnical.

In relation to space/mapping, road builders, travelers, and wanderers maintain different body/map relationships; but from a time/processing awareness the pathway to the present is created *by* the "travel" (signal) which has built a transient road. To arrive, to be, at the present, by wandering or by intention are not fully distinguishable in a world where which choice gets made depends on interactions between internal rules and completely unpredictable gradients in the external environment *at that time*. Frozen accidents create history and are the means by which we reveal it.

Can digital art change neuro-cognitive timespace? We know that the number of neurons firing in the adult brain of a person who has played a musical instrument since childhood is appreciably greater than the number in a person who has not played an instrument.[24] We know that timespace perceptions change in our dreams, those powerful wetware virtual reality machines. When we dream, we do not need to discriminate between what originates in perception and what in fantasy, because physiology protects animal bodies from dreams by decoupling them from the possibility of action: during dreams motor commands are inhibited before they reach the body's muscles. But with digital simulations such source-monitoring becomes a pressing issue, because we have no comparable mechanism for decoupling representation and reality in public simulations, the sort of digital work that dominates adventure games, television, the Web – or the larger-scale work apparent in blockbuster movies and theme park thrill rides. One can easily imagine public spaces, like a subway system, transformed by such simulations. What would be the consequence of an art that affected our time-sense as dreams do, but without dream safeguards and without any public source-monitoring standards or conventions in effect?

Guitarist Davey Williams, a performer of freely improvised music since the mid-70s, says: "Improvising, for me, is almost a state of unconsciousness. You kind of lose your awareness because you're leaning into the present, you might say. It's like a dream, the way you don't realize you're dreaming until you wake up."

When "leaning into the present," a very awake state of intense focus and a deeply asleep state of dream seem to co-occur. Timespace perceptions are observed to change when people are particularly awake, focused, and concentrated in a task. An example from Tracy Kidder's *The Soul of a New Machine* describes a computer engineer who is so focused on his task that his sense of duration has been affected: he is able to respond to nanoseconds. Since the time it takes to snap your fingers is 500,000,000 nanoseconds, these are presumably below the threshold of human temporal consciousness, yet

> It's funny, [the engineer says,] I feel very comfortable talking in nanoseconds. I sit at one of these analyzers and nanoseconds are *wide*. I mean, you can see them go by. "Jesus," I say, "that signal takes twelve nanoseconds to get from there to there."[25]

What about the neurophysiology of time perception? From the edge of awareness through to speech: one-thousandth of a second for neural firing, one-hundredth of a second for neuronal pattern formation, one-tenth of a second for vocal articulation or action, and more than three seconds for narrative description. Tools from dynamic systems help us understand how we might develop time concepts from this physiology, particularly the retrospective and prospective horizons involved with our sense of being in a "now". The basic event or fusion interval specifies the minimum time between events such that they *can* be perceived as distinct and not simultaneous. This time is different for each sensory modality. The modalities also interact with each other, and a lot of Web art explores these interactions through the use of micro-manipulated streaming sonic and cinematic effects.

The neuronal level relates to brain operation. Any mental act involves the concurrent participation of separated regions of the brain. The time needed to relate and integrate signals from these separate regions is called the relaxation or holding time, during which perceptual flashes are spread and organized by cell assemblies to create the synchronized firing we need in order to act, to move our mouse for instance. From a mathematically intractable number of possibilities, from many competing cell-assemblies, the interaction of external gradient and internal rules yields one particular "now," without the assistance of either an internal or external clock – synchronization occurring rather by resonance.

From this point on in the cognizing process, on the scale of seconds forward, language does finally enter, and with it, all that descriptive assessment entails. Thus the e-artist is tapping many scales, fine-tuning neuro-cognitive and muscular response both to fluctuations in the signal propagation structure of the Net and to the emerging nuances of the way, on another level, Web traffic communicates a social environment. Web literature and art also exploit different aspects of the time-based human perception process, playing with the fusion interval limits, and – because they require a large number of actions from their readers, clicks, mouseovers, drags and drops, shifts of a joystick, scans, zooms, probes of all kinds, maneuvers to be made within a certain time frame in some literary and all game environments

– playing also with the synchronized neuronal patterns that must be mobilized for action. A number of works also explicitly address questions of time, history, and memory, often using dynamic means, Web-streaming or telepresence, in order to do it. They contribute to enlarging the window of "now," both by the new calisthenics they offer our perception system and by the fact that they bring into consciousness many more of the microfluctuations and/or fractal patterns that had been smoothed over, averaged over, hidden by the older perception and knowledge systems.

Consider the work of Tom Brigham, the inventor, in 1982, of morphing. In a morph, as with individual frames on a reel of film, a series of discrete images moves across a screen so quickly as to give the impression of a transformation without discernible intermediate steps. Unlike with cinematic frames, however, morph technology allows for the separate interpolation of different attributes of the series, such as shape, colour, texture, and motion.[26] Brigham's morph-making work shifts the emphasis in digital arts from rendering impressions to rendering *the process of forming* an impression.

The material of his work is the infinitely fine transition. He deploys frequencies detected by image-processing software at sites of rapid change in an image; these are, he says, sites of high "spatial frequency," that one comes to acquire a feeling for. The morph, as it enacts before our eyes, relocates our perception from routine to active recognition, the kind we bring to interpreting optical illusions, the kind which makes us experience seeing as an act of understanding and not as a receiving of the properties of objects. Brigham explains that "...in addition to controlling surface qualities, morphing allows control of an image's meaning, blurring the distinction between a physical object and a mental construct."[27] He links the experience of a morph to the psychological illusion of continuity, itself a second-order time-based motion. In a morph, Brigham explains, "an image smoothly transforms, morphing into another with a motion so slow as to be almost imperceptible. Yet, at precisely some specific increment, itself undetected, the content changes utterly and a different pictorial subject becomes comprehensible."[28] That is to say, an emergent level is experienced. According to Brigham, it is this *motion* that is read, not the underlying static images, so that "a slight change in materials results in a total reformation of content."[29]

Brigham's aims are high. He understands morph technology not merely functionally, as a way to extend cinematic techniques in a digital arena, but asking rather:

> Will it show us how to unsettle and evaporate complacent interpretations? Will it help us understand the constructs of our mind that overlay the world? ... A transformation that hesitates and hovers between two identities engages the mind in a special way... What lies between one face and another? A variety of faces. But what lies between a face and a chair? A tougher question with more answers, and a more difficult morph.[30]

A work by Noah Wardrip-Fruin and collaborators, *Impermanence Agent*, expands the sense of "now" in yet a different way. It pushes at the edges of awareness by explicitly incorporating peripheral attention into the act of reading. *Impermanence Agent* is not a site to be visited or clicked through; rather, it runs in tandem with the reader's Net browsing. An active agent, it adds to, alters, and comments on the pages readers visit, as well as taking material from those

pages to create the ever-scrolling content of its own divided window, meant to be kept open for about a week in the top corner of a reader's monitor. There its own story of grief will be both told and lost as it permits elements of the reader's browsing to invade and transform it to the point of extinction.

A reader intent on browsing, who has enabled *Impermanence Agent*, will find her attention constantly solicited, but only peripherally, by the active image in the corner of her screen, and by invasions of unselected material into her focus. The "now" of her reading is both threatened and fertilized. Her content is mirrored back to her in such a way that she feels how it cumulates and overwhelms another's story; how a click made in a second, can, through the mechanism of selection, become amplified and feed into and feed back on the longer scale of narration, destabilizing the bounds of "now" and "here".

Six: Translation Rethought

The concept of "conversion media", according to Sean Cubitt, construes differences between media as "*only* [emphasis added] a matter of the conversion of data streams into one form of output or another...[they] become a matter for the end user, just as fonts and default colors have become for Web users."[31] In such an environment, one is faced with creating translations and/or algorithms for translation that accommodate output over large numbers of forms, but over which in fact very little control exists. What the receiver views or hears or experiences is as controlled by his particular devices and his personalizing choices as by the poet's implementations. This challenge is perhaps not so different from that facing the print translator of hieroglyphic or Chinese or Linear B texts into twenty-first-century English, the idiosyncratic "hardware," in this case, being the time-bound, culture-imbued body of the unknown recipient.

John Felstiner, an acclaimed literary translator, has turned his attention on his own process in a book that has never been out of print since 1980, *Translating Neruda: The Way to Macchu Picchu*. Felstiner believes so strongly in the process of translation that he teaches Keats in German, Yeats in French, Eliot in Spanish to his Stanford students. In a 1997 interview, Felstiner says,

> [...] the poem is just as fine in the original as it ever was, no matter what happens to it in translation. But still, there's a sense in which the poem can remain static, or dormant maybe, or quiescent, or even overcrystalized, unless it is brought back into life. ... I often liken the process to a stress electrocardiogram: you put the poem under a kind of alienating stress to see what's really going on in it, because you can't see that in the quiescent state. It seems to me that to translate a poem is in a sense to – I wouldn't want to say *revivify*, because it doesn't need re-; it isn't dead – but to vivify it, especially in your native language....[32]

Later, he adds, "I feel that the translator enters some kind of trajectory, call it a re-arcing back, a sparking back, or call it a boomerang." To a reader in the digital arts this statement resonates strongly. The act of translation across natural languages and between cultures evokes justified resistance and claims that it cannot be done, yet in Felstiner this act finds a positive champion: he claims that it is a revealing and life-giving act.

In digital translation each non-electronic art – visual, linguistic, vocalizing, written, sonic, musical, cinematic, animating, gestural, or other – enters a new timespace, under a new regime

of attachment, to encounter newly trained sensoria. It is subject to the emergent behaviour of networks and subject to a constraint of oscillatory resonance with its many new partners, each as convertible as the other into a bitstream. However harsh this process may appear, it can, as Felstiner suggests, reveal dimensions unseen (or unfelt, or ungrasped) in its former "quiescent" state. I find translation newly appropriate as a model: a process that involves transliteration,[33] transduction, transposition, transcription, transclusion,[34] and transformation. With regard to new media poetry written with new technologies, I would also suggest that print is a fully viable position within the many conversion sequences, as well as having a place in documented code and as one element at the presentation level of many e-works. It is not the source, nor the target, but neither is it displaced beyond the displacement of any other non-electronic modality, mathematical, visualizing, moving, sonic, or haptic.

Some questions are not easy. Why does DNA write RNA in order to write proteins? Why that much "translation"? Evidently, some aspect of the entire systemic environment makes this an optimal choice. I think of Salman Rushdie's sea of stories. The sea is not a storeroom – the sea is an ocean comprised of the streams of story, of poem, of poesis/making, held in fluid form. If, to that metaphor, we add the oceanographer's knowledge, gained only in the last 40 years, of how the oceans store and exchange energy through the movement of water masses from basin to basin and through the activity of eddies, which hold more than 90 per cent of the ocean's energy, we can amplify the metaphor and see that to access energy and life the poems must move from basin to basin and swirl in the eddies, becoming new versions of themselves. I suggest that the dynamic electronic composition of various media streams supports exactly such movement. Beyond that, we understand that 90 per cent of the "stories" are *in process of* "translation". The actual home of the poems is in the eddies, only occasionally arriving at the basins of contemplation.[35]

A work of digital art and telepresence that raises issues of translation is Eduardo Kac's *Time Capsule*.[36] It does not investigate the space "between" print and e-domains, but it does investigate and reside in the unspoken but experienced spaces between its various transversions. Kac, whose family arrived in Brazil from Eastern Europe and who now teaches at the Art Institute in Chicago, makes holographic poems that display time-reversibility and also makes work that combines robotics and telecommunications. The world of *Time Capsule* is a world where, for many, TV competes with, or even exceeds, face-to-face experience in providing the effect of being "live," and where this effect of "live" has become the effect of "truth": technology the transmitter become technology the warrant.

What is the *Time Capsule* Kac embeds in this world? It is a complex act. On 11 November 1997, in a room in São Paulo with parquet floors and ornate plaster ceiling, he created an inner room of movable white walls on one of which hang seven sepia-toned photographs his grandmother brought from Poland in 1939 – the *actual* photographs, he says in a talk given a year later, though in the gallery they are not identified in any way. On the facing wall, as of the next day, he hung a diptych combining an X-ray of his ankle with an enlargement of the registration screen for a Web database used to track lost animals; for, on the prior day, broadcast live both to Brazilian TV and to the Web, Kac had injected his leg with a microchip implant that contained a programmed identification number and that, when scanned, emitted a radio signal. He then put his leg in the scanning device, and his ankle was Web-scanned from

Chicago, the scanner button being pushed by a telerobotic finger. Kac then registered himself, as both animal and owner, in a North American pet database, the first human to do so.

Time Capsule takes place in Chicago, Brazil, Poland, the airwaves, the phone lines, around the world on the Web, and in Kac's flesh wherever he goes, yet is called site-specific. It takes place on 11, 12, 13 November, or now on his webpage devoted to it, or always, in his leg, or in the thirties in Poland. It is a body, a broadcast, a netcast, a database, an identification, a schedule, a sound byte, an implant, a webscan, an X-ray, a gallery show. In these respects it resembles the spatially distributed cell-assemblies that have to be synchronized temporally in a neuronal pattern for us to take action. The meaning of the image changes with the pathway. A man is marking his ankle with an identification number under the photographed eyes of his refugee family, a family in flight from a regime that wrote numbers on skin with needles. Without being bound to any machine he is now always readable by a machine, wearing an electronic anklet that monitors him as much as any prisoner. The temporal scales range from milliseconds to years, but where is memory, personal or collective, the kind of memory we believe ethically needs to persist? Is it "quiescent, or even overcrystallized"? Has Kac effectively relocated it in the microfluctuations, in multifractal patterns that persist beyond the persistence of any given sequence, even though we may consciously experience it as disconnected and diffuse, as both refugial and vivid?

In new media, our task is the measure of measure. To accomplish this we write less "with places" and more with "transitions". Space does open up, perhaps monstrously, to a world of currents and translations. We don't see these spaces full so much as feel them fill. We don't watch them perform; we perform them, in part, in connection with others, in processes of conjugal transfer that propagate themselves. Our probes help us draw the connections and form the perceptions needed to flow, to participate in and comprehend an increasingly complex patterning that enfolds us, from nano-techniques to cosmic extent through genetic alteration and the new world disorders.

Notes
1. Jerome Rothenberg and Steven Clay, ed. *A Book of the Book*, Granary Books, 2000.
2. Stephanie Strickland, "Moving Through Me as I Move: A Paradigm for Interaction", presented as part of "The Pixel/The Line: Approaches to Interactive Text" art panel, Siggraph 2001, in *First Person: New Media as Story, Performance and Game*, MIT Press, 2004.
3. John Cayley, "T_R_A_N_S_L_I_T_E_R_A_T_I_O_N", http://www.shadoof.net/in/translit/transl.html.
4. In Ted Nelson's Xanadu and ZigZag programs, "transcluded" units of information are shared across a system of evolving versions in n-space. Each unit can simultaneously be part of many different dimensions; but, unlike units or cells in a spreadsheet, it is not required to have any particular set of connections.
5. Much of the discussion here is taken from my essay "Dalí Clocks: Time Dimensions of Hypermedia", *ebr* 11, winter 00/01, http://altx.com/ebr/ebr11/11str.htm.
6. Beatrice Beaubien, "mez|||net|!|zen – Net Fr!sson," *American Book Review*, vol. 22 no. 6, September/October 2001.
7. Talan Memmott, "E_RUPTURE://Codework'.'Serration in Electronic Literature," *American Book Review*, vol. 22 no. 6, September/October 2001.
8. Lisa Jevbratt, http://c5corp.com/1to1/index.html.
9. Much of this discussion is taken from my essay "Moving Through Me as I Move: A Paradigm for Interaction", presented as part of "The Pixel/The Line: Approaches to Interactive Text" art panel, Siggraph 2001, in *First Person: New Media as Story, Performance and Game*, MIT Press, 2004.

10. Rosmarie Waldrop, *Another Language: Selected Poems*, Talisman House, 1997, p.103.
11. Vannevar Bush, "As We May Think". Prepared by Deny Duchier, April 1994, http://www.isg.sfu.ca/~duchier/misc/vbush/. Originally published in *Atlantic Monthly*, July 1945, pp.101–108.
12. Talan Memmott, interviewed by Mark Amerika, *Rhizome*, http://rhizome.org/object.rhiz?2145.
13. Stephanie Strickland, "To Be Both in Touch and in Control", http://altx.com/ebr/ebr9/9strick.htm, summer 1999.
14. http://wordcircuits.com/gallery/sandsoot/.
15. Much of this discussion is taken from my essay "Moving Through Me as I Move: A Paradigm for Interaction", presented as part of "The Pixel/The Line: Approaches to Interactive Text" art panel, Siggraph 2001, forthcoming in *First Person: New Media as Story, Performance and Game*, MIT Press; and from "Seven-League Boots: Poetry, Science, and Hypertext", http://altx.com/ebr/ebr7/7strick/, summer 1998, which also appears in *The Measured Word: Essays about Poetry and Science*, University of Georgia Press, 2001.
16. N. Katherine Hayles, Commentary on "The Dinner Party". *Riding the Meridian*, vol. 2, issue 1, spring 2000. http://www.heelstone.com/meridian/templates/Dinner/hayles.htm.
17. Jim Rosenberg, "Barrier Frames". *Eastgate Quarterly Review of Hypertext*, vol. 2, no. 3, 1996, http://www.well.com/user/jer/j/barrier_frames_4.html.
18. Mez (Mary Anne Breeze), "The Art of M[ez]ang.elle.ing: Constructing Polysemic & Neology Fic/Factions Online", *Beehive* 3:4. Dec. 2000, http://beehive.temporalimage.com.
19. Stephanie Strickland, *True North*, University of Notre Dame Press, 1997; *True North*, Eastgate Systems, 1998.
20. M. D. Coverley and Stephanie Strickland, "To Be Here as Stone Is", *Riding the Meridian*, vol. 1, issue 2, 1999, http://califia.us/SI/stone1.htm .
21. M. D. Coverley and Stephanie Strickland, "Errand Upon Which We Came", *Cauldron & Net*, vol. 3, winter/spring 2000/2001, http://califia.us/Errand/title1a.htm .
22. Some of this discussion is taken from my essay "Dalí Clocks: Time Dimensions of Hypermedia", *ebr* 11, winter 00/01, http://altx.com/ebr/ebr11/11str.htm.
23. Douglas Hofstadter, "Foreward", in Scott Kim, *Inversions: A Catalog of Calligraphic Cartwheels*, Key Curriculum Press, 1996, p.12.
24. Constance Holden, "Music as food for the brain", *Science* 282 (20 Nov.1998), p.1409; Norman M. Weinberger, "The music in our minds", *Educational Leadership* 56:3 (November 1998), pp.36–40.
25. Tracy Kidder, *The Soul of a New Machine*, Avon, 1981, p.137; also quoted in Ursula Heise, *Chronoschisms: Time, Narrative, and Postmodernism*, Cambridge University Press, 1997, p.44.
26. Tom Brigham, "Toward the Visceral Representation of Thought", *Imaginaire numérique*, Paris: Hermes, 1987, p.38.
27. Tom Brigham, "The Art of the Morph", *ArtByte* (October-November 1998), p.38.
28. Ibid.
29. Ibid.
30. Ibid.
31. Sean Cubitt, "Multimedia" in *Unspun: Key Concepts for Understanding the World Wide Web*, ed. Thomas Swiss, New York University Press, 2000, p. 172.
32. Damion Searls, "Bringing the Poem to Life: An Interview with John Felstiner", *Poetry Flash* 275 (January-February 1998), p. 5.
33. John Cayley, "T_R_A_N_S_L_I_T_E_R_A_T_I_O_N", http://www.shadoof.net/in/translit/transl.html.
34. In Ted Nelson's Xanadu and ZigZag programs, "transcluded" units of information are shared across a system of evolving versions in n-space. Each unit can simultaneously be part of many different dimensions; but, unlike units or cells in a spreadsheet, it is not required to have any particular set of connections.
35. John Cayley's poem, *riverIsland*, as shown at TechnoPoetry Festival 2002 (Georgia Institute of Technology) could be seen as supporting this claim. My own poem, *V: WaveSon.nets/Losing L'una*

(http://vniverse.com in collaboration with Cynthia Lawson), supports it in an entirely different manner.
36. Eduardo Kac, http://www.ekac.org/timec.html. Much of the discussion here is taken from my essay "Dalí Clocks: Time Dimensions of Hypermedia", *ebr* 11, winter 00/01, http://altx.com/ebr/ebr11/11str.htm.

From ASCII to Cyberspace: A Trajectory in Digital Poetry

Eduardo Kac

I will discuss the development of my work with experimental poetry, focusing on my digital and Web-based works. I will start with my ASCII works in the early 1980s and proceed to comment on the multimedia and interactive works that followed, culminating with the first poem written for the ultrabroadband Internet of the future.

* * *

Between 1980 and 1983, aware of the multiple directions visual poetry had taken in the twentieth century, I experimented with different media in search of a new poetry. I created public performances with poems in vernacular and ribald language that had political connotations. I published visual poems produced with mechanical and electric typewriters; I used collage, photocopy, printing, photography, and typographic techniques; I wrote poems with a cadence between prose and verse; I created animated poems for electronic media. This extensive experimentation made it clear to me that one of the main forces behind the re-emergence of visual poetry in the second half of the twentieth century was the popularization of print technology. I concluded that I would have to move beyond the limitations of the print medium and try to think my way outside this form. I was not interested in creating physical, three-dimensional object-poems, since this sculptural approach also belonged to the tradition of visual poetry. In other words, I realized that the poetry I wanted to develop would have to jump off the printed page, but could not be embodied in tangible objects. I wanted to develop an immaterial poetry for the information age; that is, poetry native to the new cultural environment of digital global networks, with its dynamic data flux and distributed communication systems.

In 1974 I had read an encyclopedia article on holography.[1] The article intrigued me so much that I preserved it. In the early 1980s I read it again, this time already as a potential technical solution to the poetological problem I had created. However, at that point I still could not

understand how a luminous, immaterial three-dimensional image could be recorded on a two-dimensional surface and dispense the use of special glasses. The idea seemed fascinating. When I saw a hologram for the first time, early in 1983, it became clear that this medium had the potential solution for the aesthetic problems I was struggling to resolve. I then set out to develop a textuality to be modulated by the elusive nature of holographic space which would be experienced with its own rhythms, somewhere between the two-dimensional surface of the page and the solid three-dimensional form of the object. The new poetry I was going to develop would create poetic experiences never before seen, literally introducing the word into a new dimension. In the following years I became a holographer and subsequently a computer animator. This has enabled me to be in control of the execution of all stages of my poetic work and to learn through my experimentation in the laboratory about the limits and prospects of holographic writing.

My strategy in these works has been to push further the visual syntax and the rarefied lexicon that has been a main vector in experimental poetry since Cummings, Belloli, Dias-Pino, and many others. The challenge now was to take the word into photonic and virtual spaces, enable it to have a malleable temporal dimension, and explore features of the verbal sign so far unthinkable. The transposition of visual syntaxes realized in print and other material media is of no interest; it is the immaterial dimension of the word that matters most. Parallel to my holopoetry,[2] since the early 1980s I have also created a series of digital and Net poems that have expanded my experimental field and enabled different levels of readerly interaction and participation. In what follows, I will discuss these works.

From ASCII to LED
ASCII is the acronym for American Standard Code for Information Interchange. It is a standard that identifies the letters of the alphabet and other symbols through a numerical code in order to exchange data between different computer systems. Unlike the characters in word processing documents, the ASCII character set allows no special formatting, such as bold, underlined or italic text. All the characters used in e-mail messages are ASCII characters and so are all the characters used in HTML documents. (Web browsers read the ASCII characters between angle brackets, "<" and ">", to interpret how to format and display HTML documents.) An "ASCII file" is a data or text file that contains only characters coded from the standard ASCII character set. Characters 0 through 127 comprise the Standard ASCII Set and characters 128 to 255 are considered to be in the Extended ASCII Set.

Between 1982 and 1984 I developed a series of fifteen works that I called "Typewritings", in which I explored the possibilities of the Standard and the Extended sets. The series was comprised of seven abstract constructions with rarefied semantic fields and eight works in which I explored figurative or referential possibilities, at times through the use of the ASCII set in conjunction with other media (e.g., rubber stamps and photocopy). These typewritings go from orderly arrays, which were capable of network transmission at the time, to more radical explorations in which the ASCII characters were used in angular compositions with juxtapositions, superimpositions, and other procedures.

My ASCII exploration unfolded into my first digital poem realized electronically, "Não!" (No!), which was conceived in Portuguese in 1982 and shown publicly in 1984 at the Centro Cultural

Figure. 1: Eduardo Kac, "Untitled VII" (ASCII poem from the "Typewritings" series), 1982-84.

Cândido Mendes, in Rio de Janeiro, on an LED display. An ASCII version of this poem was first created in the context of the "Typewritings" series and published in my artist's book "Escracho" (1983).[3] "Não!" is organized in text blocks which circulate in virtual space at equal intervals, leaving the screen blank prior to the flow of the next text block. The visual rhythm thus created alternates between appearance and disappearance of the fragmented verbal material, asking the reader to link them semantically as the letters go by. The internal visual tempo of the poem is complemented by the subjective performance of the reader.

The Minitel Network
These ASCII and LED works propelled me to experiment with digital networks – that is, to create poems specifically for this new distributed global environment. In the early 1980s, when there was no Web as we know it today, one of the most exciting early forms of the Internet was the French minitel, which was implemented in different parts of the world under different names. One such name was "videotext".

Thus, between 1985 and 1986, I created a series of works on the minitel (videotext) network:[4] Reabracadabra (1985), Tesão (1985/86), Recaos (1986), and D/eu/s (1986). The

Figure. 2: Eduardo Kac, "Não!" (No!), LED poem, 1982/84. The ASCII version from 1982 (top) was presented in its final LED form in 1984 (bottom), at Centro Cultural Cândido Mendes, Rio de Janeiro.

minitel/videotext system allowed users to log on with a remote terminal and access sequences of pages through regular phone lines. This network functioned very much like today's Internet, with sites containing information about countless subjects. It also allowed users to send messages to one another (email).

The minitel poem "Reabracadabra" was shown in 1985 in the group exhibition "Arte On-Line", a minitel art gallery presented by Companhia Telefônica de São Paulo. All of my minitel poems were shown together in 1986 on the network and via terminals at the *Brasil High Tech* exhibition, realized at the Galeria do Centro Empresarial Rio, in Rio de Janeiro.

FROM ASCII TO CYBERSPACE: A TRAJECTORY IN DIGITAL POETRY | 49

Figure. 3: Eduardo Kac, "Tesão", frames from minitel animated poem shown online in 1986. The frames are shown in three vertical columns and the sequence in each column is displayed from top to bottom.

Figure. 4: Eduardo Kac, "d/eu/s", frames from minitel animated poem shown online in 1986. The frames are shown in two vertical columns and the sequence in each column is displayed from top to bottom.

FROM ASCII TO CYBERSPACE: A TRAJECTORY IN DIGITAL POETRY | 51

Figure. 5: Eduardo Kac, "Recaos", frames from minitel animated poem shown online in 1986. The frames are shown in two vertical columns and the sequence in each column is displayed from top to bottom.

In the early 1980s in Brazil, where I created these digital poems, minitel terminals were available around the country in airports, shopping centers, universities, and other public spaces. My animated poems were read in the network and seen by remote readers online from both public and private (home) terminals.

The minitel poem "Recaos" (after the word "caos", i.e., chaos in Portuguese), for example, was created in 1986. When viewers logged on, they first saw the letter C on the lower right corner of the screen. The letter A appeared above the C, followed by a series of letters O moving upwards. This motion was against the default mode of the medium, which refreshed pages with slow top-to-bottom scans. Like a light beam, the letter was "reflected" by the top margin of the screen and redirected down and to the left, where it once again "reflected" off the left margin of the screen towards the right margin. As it moved swiftly across the screen horizontally, it changed into the letter S. Up to this point all letters were red. Once the letter S reached the rightmost margin of the screen, the acrostic SOS was formed in blue at the center. The animation then came to a halt, leaving the viewer with the image of the infinite symbol. In "Recaos", through this particular rhythmic behaviour, the letter C performs and duplicates itself on the screen, suggesting simultaneously the outline of an hourglass (slow passage of time) and the infinity symbol (time beyond speed). In the process, the letter C is transformed into other letters, spelling *caos* and *sos*, and leaving along the way a mnemonic trace of other words, such as *só* (alone) and *ossos* (bones), in Portuguese.

When viewers logged on to read the minitel poem "D/eu/s" (1986), they first saw a black screen. Then, a small white rectangle appeared in the middle of the screen. Slowly, vertical

Figure. 6: Eduardo Kac, "IO", screen view of the three-dimensional navigational poem, 1990.

FROM ASCII TO CYBERSPACE: A TRAJECTORY IN DIGITAL POETRY | 53

Figure. 7: Eduardo Kac, "OCO", sequence of images showing the runtime poem, 1985/90. The frames show, from left to right, how the process of appearance and disappearance of one letter changes the meaning of the poem.

bars descended inside the horizontal rectangle. At the bottom, viewers saw apparently random letters and numbers, reminding one of conventional bar codes. Upon close scrutiny the reader noticed that the letters formed the word "Deus" (God, in Portuguese). The spacing of the letters revealed "eu" (I, in Portuguese) inside "Deus". The numbers were not random either. They indicated the date when the work was produced and uploaded to the network.

Animation, Navigation, Interaction

As I wrote holopoems and minitel poems, I also started to experiment with run-time animations[5] created on desktop computers. "OCO" started as a holopoem in 1985 and was recreated as a digital silent piece (run-time looped animation) in 1990. The letters O, C, and O are seen as a tunnel that houses the floating letter I. "OCO" explores the three-dimensional architecture of these letters and the multiple meanings (in Portuguese) that emerge when the letter "I" appears and disappears rhythmically in virtual space. These meanings emerge through the cognitive associations made by the viewer as well as the perceived spatial relationships between the letters:

OCIO s. m. 1. leisure, rest (time). 2. immobility, inactivity. 3. laziness, iddleness, indolence. O, o s. m. 1. zero, cipher. 2. (minuscule) symbol for degree.

Figure. 8a: Eduardo Kac, "Storms", hypertext poem, 1993. Shown are three moments in the navigation process.

/ article (m.) the. /pron. 1. it, him, to him. 2. you, to you.

CIO s. m. rut, heat, oestrus; (of fishes) spawning.

OCO s. m. hollow, excavation, hole, emptiness.
/ adj. 1. hollow, addle, deep, empty. 2. (fig.): a) futile, vain, void, insignificant, trivial. b) cavernous.

Taking this exploration of the virtual architecture of the letter further, I created "IO" (1990), a three-dimensional navigational poem. In this piece the letters/numbers I and O appear as elements of an imaginary landscape. IO means "I" in Italian. In this piece it can also give rise to other readings, as the binary pair one/zero, for example. The reader is invited to explore the space (up/down, left/right, forward/backward) created by the stylized letters and experience it both as an abstract environment and as a visual text. The self is presented as an inexhaustible navigational field. "IO" was translated to VRML – Virtual Reality Mark-Up Language, the first Web-native three-dimensional environment – in 1995 and made available on the Internet at that time.

Figure. 8b: On the left, the Kabbalistic Sefirotic Tree. On the right, the link structure of the hypertext poem "Storms".

56 | MEDIA POETRY: AN INTERNATIONAL ANTHOLOGY

The question of smooth navigation in cyberspace opened entirely new possibilities, since the reader now treated the text as a field; that is, as an open expanse of space. Navigation, however, can also be explored via a series of discrete jumps from one space or field to another. With hypertext links we consider the text itself as a network, with each link connecting to another node in the text/network. In 1993, I finished "Storms", my first hyperpoem. It is organized in vocalic and consonantal bifurcations. To navigate through the poem one is invited to click on a letter (either vowel or consonant) at any given time. In some instances, navigation can also take place by clicking anywhere in the space around the word. If the reader does not make a choice – that is, if he or she does not click on a vowel or consonant, or in some instances also on empty space, the reader will remain stationary. The poem does not have an end or

Figure. 9: Eduardo Kac, "Accident", sequence of images showing the runtime looped poem, 1994. The frames show, from left to right, the transformations that form the poem's loop.

conclusion. This means that one can continuously explore different textual navigation possibilities or quit at anytime.

After I finished the first draft of this hyperpoem, I noticed that its structure was coincidentally very similar to the diagram of sefirotic systems typical of the Kabbalah. This made me realize that I could push it further by borrowing some links I had observed in a particular sefirotic system.[6] What was at stake with "Storms" was a disengagement of the textual distribution characteristic of print. The node – and not the syllable or word – from which links irradiate was the new unit of measurement. The reader has to make selections in a way that is similar, albeit not identical, to the way the writer has. The reader is now presented not with one narrowed-down selection of words in strings or in graphic layouts, but with an electronic field that is a complex network with no final form. This piece was shown on the Internet in 1994.

Also shown on the Internet at the same time was "Accident" (1994), a looped run-time piece that explores sound, image, text, and movement. An investigation of the infinite loop as a poetic rhythm, this poem is about accidents of language, possible misunderstandings, and the lack of need of language when two lovers meet in their embrace. In "Accident" the verbal material is subjugated to violent visual and aural distortions. These fluctuations suggest that antinomies based on language's precision or imprecision disappear in ecstatic encounters, when a lover's discourse is made of physical contact, gazes and gestures. The poem starts with a fragment of a sentence ended by a period. It says: "the words won't come out right." This sentence is repeated and transformed several times through elimination of certain letters, engendering new meanings and suggesting perhaps the hesitations of a speaker's mouth opening and closing (if visualized frontally) or the vigorous moments of lovemaking (if seen as a stylized profile representation). Seen as a whole, the poem ultimately states: "the words won't come out, right or wrong, tonight."

UPC (1994) is an installation-poem, a looped and silent live video piece in which seven-foot-tall letters are projected on the wall. The letters in the live, never-ending video emerge out of focus on the right, move across diagonally into focus, and disappear again out of focus to the left. Literal and at the same time metaphorical, the verbal material evokes multiple analogies: "Nothing Above To Left Or Right Nothing Below". This piece was shown simultaneously on the Internet (as a CU-SeeMe videostream) and at a gallery exhibition.[7]

"Insect.Desperto" (1995) operates in Portuguese and English at the same time – one not being the translation of the other. The words moving on the screen are in English, while the soundtrack is in Portuguese. Even if words in one language are not understood, the visual or aural properties of the rhythmic treatment of the verbal material contributes to the overall experience. The piece also addresses the differences between spoken and written languages, exploring distinct possibilities unique to these semiotic systems.

"Insect.Desperto" runs only once and then collapses. This is meant to stress the linearity of the experience and at the same time to undermine it. To see/read it again, i.e., to open it, the viewer/reader has to double-click on it once again. The piece has sequence reversals throughout the cycle that only become evident to the attentive viewer/reader. These reversals open new possibilities of signification. The elusive movements of the words on the screen can

58 | MEDIA POETRY: AN INTERNATIONAL ANTHOLOGY

Figure. 10: Eduardo Kac, "Insect.Desperto", sequence of images photographed off the screen showing the runtime poem in motion, 1995. The photographs capture moments in which words appear, overlap, flash, move, or disappear.

be read in many ways. They can be seen as unresolved hesitations concerning the construction of syntagms. They can also be seen as reflecting the fleeting behaviour of flying insects. In either case, both are meant to evoke inconsistencies and undecided aspects of life. My website went online for the first time on 2 June 1995, and this piece was first made available online at that time.

In 1996 I created "Letter", a VRML poem that presents the viewer with the image of a three-dimensional spiral jetting off the center of a two-dimensional spiral. Both spirals are made exclusively of text. The reader is able to freely navigate this cosmic verbal image. Thus, reading becomes a process of probing the virtual object from all possible angles. The reader is also

Figure. 11: Eduardo Kac, "Letter", VRML poem, 1996. Shown is one moment in the navigation process.

Figure. 12: Eduardo Kac, "Wine", 1996, runtime poem. The sequence of images shows different moments in the development of the poem.

Figure. 13: Eduardo Kac, "Reversed Mirror", videopoem, 7 min, 1997. The frames show, from left to right, the oscillations that configure the poem's transitional syntax.

able to fly through and around the object, thus expanding reading possibilities. In "Letter"[8] a spiraling cone made of words can be interpreted as both converging to or diverging from the flat one. Together they may evoke the creation or destruction of a star.[9] All texts are created as if they were fragments of letters written to the same person. However, in order to convey a particular emotional sphere, I have conflated the subject positions of grandmother, mother, and daughter into one addressee. It is not possible for the reader to immediately distinguish to whom each fragment is addressed.[10]

"Secret" (1996) is a VRML poem. There is no "correct" way to read/navigate "Secret". The reader's experience will be determined by the choices she makes in the act of reading and the digital environment (that is, computer and browser) used to read the poem. The words in "Secret" are dispersed in the semantic darkness of a potential space. Upon close scrutiny, distant blinking lights might reveal themselves as words. If the reader gets too close, the words will fly by as flocking birds or orbiting celestial bodies.[11] The reader is invited to navigate this space and create cognitive links between immaterial presences, voids, and distant signs. Secret was made available online in 1996.

Also available online the same year is "Wine" (1996), a delicate and silent animation poem. It suggests an inebriate mental state in which foreground and background blend in almost undifferentiated fashion. The poem articulates the fleeting apparitions of the words from within themselves, as if one word would write another. Words will momentarily manifest themselves in unexpected areas on the screen, often bordering the very edge. The word "window" acts as a central metaphor, as it suggests the separation between internal and external spaces (both on mental and physical levels). It alludes both to the physical and the computer window. The "verbal wind" penetrates both spaces and flows in both directions. The poem communicates as much through the verbal apparitions as it does through their carefully orchestrated evanescence.

"Reversed Mirror" (1997), is a seven-minute single-channel videopoem. It was produced without the use of cameras. The material was generated directly within the editing equipment.[12] This work takes language into a domain of trance where the subtle dissolution and reconfiguration of verbal particles is charged with a feeling that is at once calm and vibrant. Through its peculiar rhythm it articulates the notion that language (particularly written language) is in fact nothing but a transitional moment in a much more complex semiological continuum. This model promotes a cognitive framework in which language emerges from an inchoate semiological pool, only to return to it and from it emerge again, in an unstable, perpetually irresolute vacillating graphematic motion. Not unlike the phenomenon known as "Brownian motion", this work reveals erratic random movements performed by verbal particles, as if caused by the continuous bombardment of the particles by the molecules of the surrounding medium.

Avatar Poetry: Writing for the Future Internet
My most recent digital poem, "Perhaps" (1998/1999), is the first poem written specifically for the ultrabroadband Internet of the future. The poem is a world with 24 avatars, each a different word. It may be called an "avatar poem", since each reader, in order to read the poem, must establish his or her own presence in this textworld through a verbal avatar. As remote participants choose a word and log on with their word-avatar, they contribute with their word choices to

Figure. 14: Eduardo Kac, "Perhaps", screen shots of the multi-user VRML poem written for the ultrabroadband Internet of the future, 1998/99.

determine the semantic sphere of that particular readerly experience. Once in the world, they make decisions about where to go. In so doing, they move towards or away from other words (i.e., towards or away from other participants), producing a syntax of transient meanings based on the constant movement, as well as the approximation and isolation of the words. For example: the word "blood" moving towards the word "abloom" has a very different meaning from the word "titanium" moving away from the word "violet". Here is the complete list of avatars readers may choose from: abloom, blood, canyon, daze, eleventh, fabric, grace, hour, ion, jet, kayak, lumen, mist, nebula, oblivion, pluvial, quanta, radial, sole, titanium, umbra, violet, xeric, year, zenith. This poem was experimentally read online throughout 1999 using a special server in the Art and Technology Department of The School of the Art Institute of Chicago.

Conclusion
Several of my poems explore motion, displacement, and metamorphosis. In some poems I use only one word, exploring aural qualities, connotative or denotative meanings, graphic form, ambiguities, and other properties. In many of my multiword poems a given word may lose graphical integrity and become temporarily something else, a sign or an abstract pattern with

no extra-linguistic or extra-pictorial reality. Visual and verbal transitions will often evoke transitional meanings that cannot be frozen into specific words. This textual drift suggests, ultimately, a view of the word and the world as malleable.

The writer that works with new media must give up the idea of the reader as the ideal decoder of the text and must deal with a reader that makes very personal choices in terms of the direction, speed, distance, order, and angle he or she finds suitable to the readerly experience. Readers often encounter a textspace where the graphical substance of the verbal material is under constant disturbance, being transformed, morphed, or disintegrated in a new signifying process. The writer must create the text taking into account that these decisions, being personal as they are, will generate multiple and differentiated experiences of the text and, most importantly, that all of these occurrences are equally valid textual encounters.

Notes
1. "A holografia", *Conhecer Nosso Tempo* (São Paulo: Abril Cultural, 1974), pp. 350-352.
2. Kac, Eduardo. *Holopoetry: essays, manifestoes, critical and theoretical writings* (Lexington: New Media Editions, 1995); Kac, Eduardo. "Holopoetry", in: Kac, Eduardo, (ed.) *New media poetry: poetic innovation and new technologies*, Providence: Rhode Island School of Design, 1996. (Series: Visible Language, 30:2), pp. 186-212.
3. *Escracho* can be consulted in the following public collections: Museum of Modern Art, New York; Harvard University, Houghton Library, Department of Printing & Graphic Arts; University of New Mexico, General Library, Albuquerque; and Joan Flasch Artists' Books Collection, Chicago.
4. Different countries, such as the UK, France, Japan, Canada, USA and Brazil, implemented different versions of the minitel concept under their own names. The UK called it Prestel. The Brazilian system was dubbed Videotexto. In Canada it was known as Telidon. In the USA the network was named Videotex. Under the name "Minitel", France implemented a comprehensive videotex network that was widely used throughout the 1980s. In 1984 Minitel terminals were distributed to subscribers free of charge, which helped to further popularize the network. From 1983 to 1994 (the year of the Internet boom), use of the Minitel grew continuously. In 1995 there were seven million Minitel terminals in France. Although most countries no longer use videotex, the medium was still employed in France in 2006. It was also possible to access the Minitel through the Web.
5. The *On-Line Dictionary of Computing*, served by the Department of Computing of the Imperial College of Science, Technology and Medicine, University of London, thus defines "runtime": "1. The elapsed time to perform a computation on a particular computer. 2. The amount of time a processor actually spent on a particular process and not on other processes or overhead (see time-sharing). 3. The period of time during which a program is being executed, as opposed to compile-time or load time." Consulted on 7 January 2003.
6. Sefirotic system according to Pa'amon ve-Rimmon, Amsterdam, 1708. See: Halevi, Z'ev ben Shimon. *Kabbalah: Tradition of Hidden Knowledge* (London: Thames and Hudson, 1979), p. 65.
7. Eduardo Kac, *Dialogues*, Center for Contemporary Art, University of Kentucky, Lexington, 1994.
8. In 1998, on the occasion of my solo exhibition *Language Works* (17 July to 29 August 1998), curated by Julia Friedman and realized at Aldo Castillo Gallery, in Chicago, I presented "Letter" as a ten-by-fourteen-inch Iris print on Arches paper. This piece is now in the collection of George Hartogensis, Chicago. See: Garrett Holg. "Eduardo Kac at Aldo Castillo, Chicago", *Artnews*, November 1998, p. 170; Pablo Helguera. "Restless Words", *Art Nexus*, no. 31, February - April 1999, page 119 and 120. See also: < http:// www.ekac.org/castillo.html>.
9. Browsing an issue of *Scientific American* in 2002, I saw a picture that is extremely similar to my poem "Letter". The caption stated: "A picture like this could not have been drawn with any confidence a decade ago, because no one had yet figured out what causes gamma-ray bursts – flashes of high-energy

radiation that light up the sky a couple of times a day. Now astronomers think of them as the ultimate stellar swan song. A black hole, created by the implosion of a giant star, sucks in debris and sprays out some of it. A series of shock waves emits radiation." See: Neil Gehrels, Luigi Piro and Peter J. T. Leonard. "The Brightest Explosions in the Universe", *Scientific American*, December 2002, pp. 84–85.

10. The words in the cone make reference to the death of my grandmother. The words in the planar spiral make reference to the birth of my daughter.
11. In 1996, when opened in Voyager, the VRML browser in which "Secret" was originally viewed, the poem opened with a scene that evokes a moon over the skyline of a silhouetted city. This is in fact a point of view inside a word, as if the computer screen formed a surface that separated the word in two, with the other half hypothetically "floating" outside the screen. The scene changes immediately with the first navigational movement. This situation of enabling a transitional form of visual reading inside the three-dimensional word itself is a new semiological condition, and as such was chosen to open Secret. Although "Secret" will open differently in every VRML browser, a unique feature of this reading environment, inside views will always be experienced in transition.
12. I created the text on a character generator using a Bauhaus font and writing with white letters on a black background. The words were always expanded to fit the screen with the post-transform and size functions on the Grass Valley Group DPM-700 (Digital Picture Manipulator – DPM), which caused some (desired) pixelization. The text was luminance-keyed over a white background to remove the low luminance component of the picture (black). Clip and gain functions on the DPM were used to force the white on black to become gray on white. The text was routed into an effects bank on an A/B Grass Valley switcher, using a multiple diamond pattern wipe, which had the frequency and the amplitude of its pattern modulation at full tilt. On the second effects bank of the same Grass Valley switcher, I had the same pattern wipe with the same modulation, wiping between the still store of every other piece of text. As the sources were sequentially alternated, the text was wiped between black and the character generator. Fader bars were used to implement the change from one to the other by hand, with a subjective tempo, in real time.

Unique-reading Poems: A Multimedia Generator[1]

Philippe Bootz

Definition
From the reader's point of view, unique-reading poems are interactive "multimedia" texts that progress in a coherent fashion from one reading to the next. The reader's actions progressively give form and meaning to what he reads until the poem reaches its final state. Based on irreversibility, unique-reading poems do not reset when the reader switches off his/her computer. A unique-reading poem's final state is only realized once for a given reader and this final result is replicated indefinitely in the next readings. The reader, however, can never reset or cancel any of his actions.

In this article, I will take the poem *passage* as an example to describe the underlying structure of unique-reading poems and the "unacceptable" aesthetic proposal which it entails.

I. The visible structure in *passage*
In *passage*, the reader can perceive three successive phases: the first is multimedia, the second interactive and the third is animated and non-interactive. The first two phases are composed of several sequences.

In the first phase, between each sequence, the reader is taken back to a menu where he/she can choose from several options, i.e. "next reading", "prologue's reading" or "rereading". If he/she selects "rereading" the last sequence will come up again on screen, unchanged from his/her previous reading. However if "next reading" is selected, this sequence will not be accessible anymore: reading is choosing, closing a door in order to move forward.

In the second phase, "rereading" is no longer a menu option. However, when the reader executes "next reading", the text seems to be the same as he/she realizes the same textual generation process. This process does not go through the same stages as those in the first generation. The reader cannot cancel any previous choice. There is no "rereading" in the

traditional sense of the term and, in fact, the poem is truly unique-reading: reproducing the same generation process amounts to building more text along the lines of the choices made by the reader during the previous reading.

In the third phase, "next reading" has disappeared from the menu options. "Rereading" means reactivating the same textual process, but also generating the same text-to-be-seen[2] as the latter is produced from a fixed set of data. Here both meanings of the term "rereading" coincide. An animated poem, in the classical sense, appears on the reader's personal computer.[3] This text-to-be-seen will be different if generated by another computer where a different reading path was followed.

The unique-reading poem can be compared to a living organism which grows according to the reader's actions. But unlike a living structure, it becomes static when all conditions are fulfilled, its state similar to that of any printed text. Behind this characteristic emerges the confrontation between a vision of literary work as a defined object or sign (particularly vivid in literature) and a conception of literature as a continuous generation process: permanent in its functioning but only readable through its relative and transitory states.[4] I call this kind of work "procedural work".

2. Unique-reading poems: a new literary form

2.1 *The unique-reading poem within the functional model*
Since 1995 I have developed a functional model.[5] This model (Fig. 1) places computer literary work in a communication process between author and reader. It gives prior importance to the performed functions and only considers textual objects as materials modified or generated as a result of these functions. No textual object can contain all the work's properties.

In digital literary work one can distinguish several types of textual objects: the author-text (elements produced by the maker, i.e. the source code and the data; it cannot be reached by the reader), the text-to-be-seen (the reader has access), the read-text (the reader's mental representation of the whole communication process including its functions and objects) and the inferred data which are generated by the generation function, sometimes while the reader is reading but are not intended for the reader. The written-text is another textual object corresponding to the author's project as it transpires from the completed literary work.

Together all the properties of each textual object do not suffice to fully describe the procedural work. Procedural works cannot be assimilated to the textual objects alone and even less so to the elements accessed by the reader. Some elements interfere in the generation process, which neither the author nor the reader can influence (such as the speed of execution of the program, the available resources and the operating system). This relative autonomy of the reader's and the author's fields is a fundamental characteristic of procedural works which emerges from the functional model. This autonomy allows the appearance of new literary forms such as unique-reading poems which are very different in the reader's and the author's respective fields.

The text-to-be-seen only exists within a particular space and time frame inside the generation process. If isolated, i.e. recorded or printed, its characteristics change and it becomes

Figure. 1: Philippe Bootz, The functional model of the unique-reading poem *passage*, 1995.

permanent. But if we examine a real procedural text-to-be-seen which is not isolated, the rereading process reactivates the generation process and is not just a "second reading of the same text-to-be-seen". The rereading process becomes therefore instrumental: procedural works are not meant to be read but reread.

In this model, literary work is the text's field. It is clearly an open system made of a generation process and some inputs and outputs, i.e. the author-text, the text-to-be-seen and the inferred data. Unique-reading poems could not exist without these inferred data.

Unique-reading poems launch a process generating *on a given computer an irreversible* final text-to-be-seen. To create a unique-reading poem the whole generation process must be activated at least twice: the first activation (comparable to reading in the common meaning of reading a book) to create the final state and the second (equivalent to a rereading) to activate the final state.

In unique-reading poems, the "reading"[7] function is constructive insofar as it allows the poem's final state to be realized whereas the "generation" function is unproductive as it progressively impoverishes the author-texts' potential. Therefore the reader only has access to a small part of the work's materials.

Procedural works establish a discrimination between readers. During their reading, all readers do not have access to the same texts-to-be-seen. This is generally true for hypertexts or automatic generators. Unique-reading poems establish this discrimination but also introduce another one in the last phase: two readers reading the same text-to-be-seen in the same place and at the same time but who have not performed the previous readings together are not in the same reading situation. In its final state of *passage*, the text-to-be-seen has a history for the reader – that of its "making" – who manufactured it with his actions. It also has "memories" of the previous readings. The reader therefore creates in the read-text some semantic links between some elements of the final text-to-be-seen and some that are memorized: the read-text for the reader and the work itself are in a diachronic relationship. Another reader who did not experience the manufacturing of this particular text-to-be-seen can not possess the same history. For this reader, the read-text and the work itself will be set in a synchronic relationship. Both readers may not read the same meaning beyond the same words.

70 | MEDIA POETRY: AN INTERNATIONAL ANTHOLOGY

Figure. 2: Philippe Bootz, screen capture from the unique-reading poem *passage*, 1995.

Figure. 3: Philippe Bootz, screen capture from the unique-reading poem *passage*, 1995.

Figure. 4: Philippe Bootz, screen capture from the unique-reading poem *passage*, 1995.

2.2 Unique-reading forms, a "trap for the reader" in the reader's field

By contrast with printed texts that are static and complete, the reader has no means of accessing a global vision of the work submitted to him. He cannot guess what is beyond the mere words and whether there is "something else apart from the reading". In that sense, *passage* is a very linear work. By masking the deeply logical structure which generates it, the text-to-be-seen gives no alternative to the reader but to make his own mental representation of the work (the read-text) which does not match the writer's initial project (the written-text) neither in its structure nor sometimes in the semantics. Therefore, while the reader believes that he dominates and assimilates the literary work by his reading, he has a false representation of it. In the functional model this characteristic is branded as "trap for the reader". This is the most surprising consequence of the separation between the writer's and the reader's fields but also the most stimulating which, beyond the new and explored literary forms, gives the procedural work all its creative (and scandalous) force. The notion of "reader's trap" recognizes that a part of this literary work is not aimed at the public. It is when it promotes communication while communication is in fact negated that the procedural work becomes unacceptable[8] because it places its reader in a non-receiving situation: to read is to participate in the irreversible manufacturing of the work but not to receive it. This is the pragmatic functioning of procedural works that has been admirably summarized in the *alire* journal by this fundamental maxim: reading forbids reading.

2.3 the unique-reading form, a structural component in the writer's field

The diachronic behaviour of a procedural work must be considered as carefully as its synchronic behaviour on which critics have based their work since the beginnings of literature.

The written-text of a unique-reading poem associates a hypertextual structure representing the work's diachronic features with a generation structure (a descriptor's generator) that represents its synchronic aspects. Their unique interdependence contributes to the overall coherence of the work and gives it its unique-reading nature.

If we take *passage* as an example, in the creation of its final state, i.e. in the second phase, the generator is guided by the reader who is instrumental in allowing it to update the different states. This generator elaborates a descriptor of the future text-to-be-seen, processing data from the generation process. This descriptor does not hold all the characteristics of current or future texts-to-be-seen[9] but only those that will allow the generation process to choose from several sub-processes when the final text-to-be-seen is generated.[10] Furthermore, any value of the descriptor's variables cannot be modified once attributed (the reader's actions are irreversible). The creation phase is completed once each variable of the descriptor has been attributed a value. In order to prevent an infinite looping in this phase, after the work has been executed a few times,[11] non-allocated variables are given a value by default set up by the author. Therefore the textual process evolves towards a final text without any participation of the reader. However, one can speak of "interactivity" insofar as the reader's inaction is interpreted by the computer as his/her acceptance of the author's choice.[12] In this phase, interactivity has a technical function: it chooses a variable or gives it a particular value.

In the next phase, the non-interactive final state, the textual process uses the descriptor in order to generate the text-to-be-seen. As the descriptor's variables can no longer be changed, the calculated solution will be the same for all rereadings on the same computer. Indeed the descriptor contains the "inferred data" saved on the hard disk and present in the functional model (Fig. 1). In this sense the descriptor is a formal tool necessary for the realization of unique-reading works. It is also a representation of the work's state as chosen by the reader and gives information on the latter which is used by the author. In *passage* this information is processed as the reader's semantic requests. Therefore the generative behaviour of the unique-reading form consists in a simulation of a dialogue between reader and author.

With the hypertextual structure, one can describe the variety of textual processes successively involved. Each process is a node in the hypertext and every possible activation a calculated link. The reading, in its diachronic development, is a path taken through this hypertext. In our description, attributing a value of the former descriptor amounts to exploring a particular node called "paradigmatic" unit, but, on the other end, choosing a variable is exploring another type of node called "syntagmatic" unit. There is interactivity (decision-making) when links are established between these two units: when a variable is chosen the syntagmatic unit is changed into a paradigmatic one and, when the variable is attributed, goes back to being a syntagmatic unit. Some links are managed by the author. In this description, unique-reading is defined by links' calculation methods, i.e. a paradigmatic unit can only be visited once and some links are conditioned by others already realized. Because these links do not link different textual objects but rather the different behaviours of the textual process, not only the "generated texts" have a potential nature but also the "generators themselves".[13]

The final state of the unique-reading poem by which the same textual process is identically reproduced for each reading is simply described as the common node towards which all the

paths within the hypertext necessarily converge. This node is the one which, within all the hypertextual structure, possesses the greatest number of calculated elements as it has to adapt to every possible path. Therefore it is in every sense an automatic generator, which, however, hides its automatic nature to the reader who is always presented with the same generated solution.

In *passage* the structure has a particularity that is not essential to the unique-reading structure: an initial sequence, a first phase that develops over several rereadings.

I would finally like to point out another trap for the reader, typical of unique-reading forms. When the descriptor is being set up, some automatic or combinatory generators use its attributed values to elaborate the text-to-be-seen. Therefore the reader thinks that he realizes an animated combinatory exploration and that his actions only serve to define the grammatical features of the text-to-be-seen which he/she has in front of him/her. At this stage the reader cannot guess that his/her choices will serve later to determine semantics. Even a knowledge of some particularities of the written-text will not give a clue about the links' activation dates or their location on screen. This contributes to an even more lively and emotion-oriented reading as opposed to an analytical reading. Therefore, by giving a great deal of fascinating but in practice unusable information, the critic becomes an instrument in the mutation of this reading. However, by alerting the reader to what neither he/she nor the reader[14] can read, it plays an essential role: inadequacy of information which he/she brings to this reading is the cultural and social, therefore collective, safeguard of the change in individual reading. Readers have not chosen to move from an informative reading to a reading functioning like a life experience, constructive and destructive,[15] but instead it is the society's mechanisms which have failed in efficiently informing readers how to read differently. Unique-reading poems assert the non-informative but experimental nature of reading which, in our information and communication society, is comparable to a life experience.

A possible opening
As other unique-reading poems are produced, the possibility of linking them and thus creating "Locked Works" emerges: a transversal structure[16] that would link unique-reading-poems separately produced, thus transposing the unique-reading process to the level of all texts-to-be. Therefore, the reader would always get the impression that the poem that he/she is reading has been written after the others that he/she has just read, even if this impression is wrong. The reading chronology would create a read work independent of the writing chronology, thus locking the reader in his/her own reading. The work will not be a unique voice given to everybody but a very personal vision dependent on one's own voice, entrapped in a personal reading as it is the case with human encounters.

Notes
1. Adapted from an article published in *Rencontres médias*, BPI, Pompidou Center, Paris, 1999, pp. 39–66.
2. This term is defined in the second part of the present article.
3. An animated poem which, however, contains a combinatory element.
4. This conception could be defined as generalized performance only if the performer is not envisaged as either an author, an interpreter, or a player but rather as a property of the process mingled with the text itself. The work exists only through its functioning and all the protagonists (either people or

machines) are all, in one way or the other, instruments of this functioning. Therefore, the "unacceptable" characteristic of procedural works: the reader, who is part of the work, cannot receive the whole of this work because full reception would require taking distance. The work presupposes that it cannot entirely be communicated to the reader who would have to be at the same time an instrument (internal to the work) and an observer (external to the work). This duality reader/observer is not a problem within an interactive installation as a same person performs both roles alternatively. However, this becomes unbearable when a person reading a work published in an electronic journal or on the Web cannot be external to the generation process that he/she is the only one to read. Unique-reading poems fall exactly in this category.
5. Philippe Bootz, "Un modèle fonctionnel des textes procéduraux" (A Functional Model for Procedural Texts), *Les Cahiers du CIRCAV*, no. 8 (Villeneuve d'Ascq, France: Université Lille III, Rexcav, January 1996) pp. 191–216. Further readings: Philippe Bootz, "Le point de vue fonctionnel: point de vue tragique et programme pilote" (The Functional Point of View: Tragic Point of View and Pilot Program), *alire10/DOC(K)S*, pp. 28–47 and "The functional point of view: new artistic forms for programmed literary works", *Leonardo*, 32.4, 1999, pp. 307–311.
6. Philippe Bootz, "Le point de vue fonctionnel: point de vue tragique et programme pilote" (The Functional Point of View: Tragic Point of View and Pilot Program), *alire10/DOC(K)S*, p. 30 of book.
7. In the model, "reading" can have three meanings which need to be distinguished. The "reading function" which is referred to entails all the actions performed by the reader: receiving the text-to-be-seen, sending information, i.e. "reading data", to the computer. The reading "in the classical sense" which was referred to above means the intellectual process by which the reader grasps the text-to-be-seen and realizes the read-text. In the model this process forms an integral part of the "reading function". Finally, reading in the procedural sense of the term means activating the "generation function", i.e. running the work's executable files.
8. This apparent paradox of the reader not being a reader can be resolved when an observer who can inform the reader is included in the system. This theoretical approach is currently being developed.
9. Independently of the global descriptor's generator, some textual sub-processes hold automatic or combinatory generators which use this descriptor to produce during the reading some elements of the multimedia text-to-be-seen.
10. This generator contains four variables or concepts: Time, Material, Gender and Direction. Different values can be attributed to each variable: conditional, future, present, imperfect or past in the case of Time; fire, earth, water and air for the Material variable; feminine, neutral or masculine for Gender; underneath, above, sitting, standing or lying for the Direction. The descriptor itself is composed of four figures, each position referring to a concept. The figure attributed to each position determines the value of the corresponding concept.
11. The descriptor is not limited to the four semantic variables described in note 9. It also holds a few "position" variables for a diachronic reading.
12. Hence another paradox: interactivity is a reading constraint.
13. In *passage*, the generation structure uses three types of generators that interface differently within the hypertextual structure. The first type, typical of the unique-reading form, is the descriptor's generator. This generator does not produce readable elements, unlike automatic or combinatory generators, but a file of inferred data called "descriptor". This type of generator uses interactivity in its informative aspects: it deals with information management between the reader and the program. The second type of generator is formed by classical automatic or combinatory generators. It can use some descriptor's variables to calculate and manufacture some elements (such as sounds, sentences or visual effects) in the current text-to-be-seen. This generator is of a classical type as it has no memory of the previous reading paths and provides no information for future reading paths. It is linked with some hypertext's nodes. These links are managed by the superstructure. The third type of generator is to be found at the level of this superstructure. Each time the textual process is activated, this

generator uses all the available descriptor's data to evaluate the position in the hypertext of the possible processes and to activate the appropriate link. This generator is translated into a path going through this hypertext. Being the superior management structure, it manages priorities between the program's entries and exits. This generator is responsible for the particular "differed" nature of interactivity. Indeed if *passage* seems so linear for the reader, this is because interactivity never interrupts the animation and coherence of the text-to-be-seen. It is not limited to defining the active link at each stage of the textual process; it also determines the activation date of this link.

14. Analysis and reading are two different activities.
15. In unique-reading poems, the progressive completion of the final state for a given reader is only achieved by closing down the potentialities of the textual process: that which is not read will never be read. The unique-reading poems' strength does not lie in their quantity but in their unicity. Each poem is the result of a negotiation between reader and author and holds the memory of its manufacturing.
16. A database structure added to the hypertextual and generative structures already mentioned.

Interactive Poems

Orit Kruglanski

Just before leaving, a friend gave me a present – a word – logorrhea. It means incessant or compulsive talkativeness; wearisome volubility (I looked it up). I packed the word carefully among the rest of my wordly possessions and left for the airport. When I got there, I noticed the word had stained everything, and, more than anything, my next few months. I had just left my country and my job as an interaction designer in order to go and study in New York. I was meeting new people all the time. They all seemed to ask, out of politeness, perhaps, but I answered. Lengthy answers that came subtitled in my mind, 'logorrhea'. That very night I wrote the first of my interactive poems titled 'Words are InnerSpace Invaders', a game of space invaders in which the user tries to defend herself against the words that make up the sentence: 'I'm tired of hearing myself talk about myself so I talk about being tired of hearing myself talk about myself.'

Since then I seem to have been travelling a lot, and I've noticed something: people who don't share a language tend to either understand each other on a very basic level or on a very abstract, intuitive level. As a poet, I have always been somewhere in the middle ground – not totally basic but definitely not abstract. When I wanted to write poetry in digital media, I noticed there was very little language to be shared. Or, that what little language there was resided in the realm of the select few – scholars and initiates of a highly complex and experimental writing.

I can't write like that.

I started by borrowing. For the Space Invaders poem I borrowed the interaction from a game. The words descend from the top of the screen, one by one, with obvious malicious intentions; the user can move and shoot at them. If a word is shot, it disappears but is heard. And anyway they just keep coming at you. I liked the way the required action of the game interacted with the frustration of the speaker in the poem. I also liked the fact that the interaction was complex, but didn't require explaining (assuming the user is familiar with Space Invaders). I wasn't too happy, though, with the strong connection to the gaming world; I wanted to create my own interactions.

Figure. 1: Orit Kruglanski, "InnerSpace Invaders", interactive poem, 1998.

For my next poem I borrowed the interaction from a toy. The poem was an image of a doll's hand with a virtual string which the user could pull; when the user released the string it would slowly return to place, playing an audio of the text 'if I were pure thought/ then I would surely be/ the thought of someone touching me.'

Then I let go. I incorporated interactivity into my sleep vocabulary and started dreaming interactive poems. I let things happen without deciding and ended up in bed with my best friend. I lost my best friend. Then I woke up one night with an abstract shape and a small circle that moved five different ways making a clicking sound and triggering five short poems (audio) about sex and relationships. It was inspired by gravity. I called it 'five small poems for me and my lover' and went back to sleep.

The interaction in 'five small poems for me and my lover' is playful. The texts are erotic and sad, intimate. I noticed that when people used it, they seemed to take a while to notice the text, losing themselves in the playfulness of the interface. When the text finally sinks in, it collides with playfulness and its impact is doubled.

I call these things I make 'interactive poems' because the interaction itself (in its computer-world sense) serves as a major poetic device, playing an important role in the construction of meaning. I like the idea of using electronic devices as poetic ones; I like electronic devices in general, but more then that I like the way people relate to the world and to each other. Art or literature that likes these same things is my favorite type.

My mom says that you should never run after men and buses because another one always comes along. I feel the same way about technology. I prefer slightly old technology. It is less smug. This is why when the Palm Pilot came out I didn't buy one. (I did not have the money either). But my good friend Bruno Vianna did. And he had this great idea – to add a tilt sensor to it. I liked the idea so much that I told him I would write for it.

After a few months of working with the Palm, I was invaded with sadness. The Palm, like me, was growing old. New models were coming out all the time. As our novelty wears off, I told it, we will be discarded and forgotten. The Palm, a faithful servant, almost a friend, how can I explain that it is not in my hands? How can I tell it that I, too, if I knew who to ask, would fall down on my knees and beg for more time, beg for them to stop producing new models, because they scare me.

So I wrote a poem for the both of us (and a tilt sensor). It starts with the word 'please' on the upper part of the palm's screen. As you tilt the palm, the word 'please' turns into a string of letters from which a poem hangs, and, with the inclination of the Palm, quickly falls off screen. The poem is 'please / I do not want to disappear / if you will not hold me / tell me / why am I here? / I only aim to please / not disappear.'

The Palm, new technology that it is, is tinted by what I call 'the coolness effect'. The mere novelty of it, and of having poetry in it, is so fascinating that the "how you say with it" tends to override the "what". Art in very new or unfamiliar technology tends, on first encounter, to exhibit its technology, provoking a 'cool!' response from its audience, regardless of its specific content.

Figure. 2: Orit Kruglanski, "Please", interactive PDA poem (for Palm Pilot with a tilt sensor), 2000.

INTERACTIVE POEMS | 81

Figure. 3: Orit Kruglanski, "WhereAbouts", interactive poem, 2003.

This is a positive reaction. People like cool things. People like interactive poetry because they have never seen anything like it. This is something I am afraid of. This is something I am afraid of because maybe I would never have made it as a poet. And maybe this is why I am hiding behind all this flashy technology – because I don't have what it takes to clench language into a verse that burns the skin of some invisible other.

It is a tricky balance, which must be kept. I write poetry for/with new technologies, I write poetry with/for old and familiar human emotions, and I write thinking of this other. Thinking that maybe s/he has never seen this technology, and what can I say which is not about technology, without pretending the novelty is not there. How can I make this 'coolness effect' participate in what I wish to say without it becoming what I am saying?

And I, too, as a writer, have a first encounter with my new technologies; I, too, am fascinated by the mere existence of the possibility, the novelty, the object Palm, for instance, with its touch screen, so hand-held. Under this spell I wrote: 'the mere fact of / the mere act of / the mere tact of / touching itself' – each time you touch the screen with the stylus, the next phrase appears, then follows the movements of stylus on touch screen like a ribbon tied to a string – 'makes me an object of desire / touching itself'.

One of my 'coolest' projects, and therefore one of the most difficult to resolve, was a poem called 'As much as you love me'. I wrote it for a force feedback mouse I built. (The force feedback mouse is a normal mouse to which I added two electromagnets; it sits on a big metal mouse pad; the strength of the magnets is controlled by the computer, through a microcontroller. The mouse becomes physically harder to move as the strength of the magnets is increased.) I built it with nothing particular in mind, just curiosity. When I had it working it was so cool that I couldn't imagine what I could do with it. I felt that any poem I could write would be less powerful than the innovation, and that the technical 'how does it work?' would be the only reaction I could get with it.

I was disappointed, and people kept suggesting video games that get physically harder as you go through the levels. I was upset and saying 'I don't do video games, I'm a poet', as if I myself did not believe in it. I played with it for a while, trying different combinations of on-screen visuals with varying physical difficulty. Finally, I wrote a poem dealing with guilt, using force feedback as a metaphor for the burden of guilt.

The poem is composed of 'non apologies', phrases that begin with the words 'don't forgive me for...': Don't forgive me for the mistakes I've made. Don't forgive me for the things I've said. Don't forgive me for your stayed-up nights. Don't forgive me for your bitterness...

Each phrase is connected to a 'piece of guilt', little creepy-looking objects on screen. When the cursor rolls over a piece of guilt, it sticks to the cursor and starts moving with it; a string ties it to the edge of the screen; a non apology is heard, and the mouse becomes physically harder to move. Thus, the more pieces of guilt you have collected, the harder it is to move, and on-screen the cursor is burdened by more little objects. The last piece of guilt collected turns off the magnets and makes all the guilt retreat to the edges of the screen. The phrase it has attached to it is slightly different: 'forgive me this, I can't remember loving you'. With

this last phrase the user is relieved from the burden of guilt and the poem returns to its opening screen.

People who go through 'as much as you love me' more then once notice that the phrases are always heard in the same order. And sometimes they ask, 'Can't each phrase be connected to a visual object, so the user composes the order of the poem as s/he goes along?' Of course it can. There are two reasons not to do so. The positive one is that I feel the specific order of the lines in the poem contributes to its effect, the tension building up to the end and the final release from guilt. The negative one is that I feel that the user 'composing' the order of the poem does not contribute anything to the poem in terms of its impact. I do not want to use this possibility only because it is so readily available. I will use it when I create an interface in which the very act of choosing participates in the creation of meaning, reflects on the whole of the poem. Or when I write a text that is really good and different every time its order changes.

You see, poems, traditional poems, on paper, deceivingly stable looking, change with every reading. They change because we know them better now. They change because we, and language, and objects, all accumulate time. And no two readings are the same. Even if you are bored as hell the third time, the experience of boredom itself will be different the sixth time around.

More than I wish I could write a poem that is different every time it is experienced, I wish I could write one that would be always the same. And be the same for everyone. An isolated, pure and singular experience, unchanging, erasing its context.

But poems cannot be the same. One reason is that people cannot be the same. This creates a problem when you call them by a common name: public. I would like to say that this many headed monster called public plays no role in my work. But I cannot. I wish to be heard. By a public. This is implicit in the word publishing. Beyond the technical requirements of knowing how to read the language and having physical access to a poem, there is also a question of cultural literacy required for appreciating a specific poem. In interactive poetry we must add to the technical side of software and hardware to cultural literacy we might need to add computer literacy.

Access to hardware is a big one. Left to my own devices, force feedback mouse, tilt sensor are physical objects the user must posses in order to experience poetry written for them. One of my current projects, the Moussager (a cross between a mouse and a massager), is that kind of project.

On the other hand, I still fantasize with the Internet being democracy, and so create projects for standard software and hardware, such as flash, shockwave, downloadable Palm Pilot files, and even plain text.

When I think of a project, the availability of required hardware is one of my considerations. Another is language. Being an English-speaking Israeli living in Spain, I write in Hebrew, English, and Spanish and then sometimes translate. Relatively well read for a computer person, relatively computer literate for a writer, I sometimes wake up in the morning not knowing in which language to have my identity crisis.

The more I know, the less I know who I am. One solution is to snap shut like a slow box and wish to never learn again. In spite of that, I do. Something new every day. Maybe if I could stop changing (hardware, software, platform, language) I could get really good at something. This is a risk I am not willing to take. I love the challenge. I get frustrated. Interactive poetry is awkward and charming, a small child saying its first words.

WE HAVE NOT UNDERSTOOD DESCARTES

André Vallias

Continuous mutation: this is perhaps the only constant distinguishing mark of the digital media. The growing speed with which hardware and software components change would seem to condemn the creators who venture upon this new territory to production of ephemera, to a permanent process of making and remaking, of endless "work in progress". The general picture is one of instability, of vertigo, and it is at one and the same time a source of stimulation and frustration.

I entered the computer age in 1988, motivated largely by the compelling essays of the philosopher Vilém Flusser;[1] financially I was able to do so thanks to the economic stability of Germany, where I had settled in the preceding year. Galloping inflation and import restrictions would have made this step extremely difficult in Brazil, my country of origin, at any time before the early 1990s.

Basically, my poetic work at the time employed the resources of Desktop Publishing; these were substitutes for the techniques which I had previously used for the composition of visual poems: silk-screen printing, collage, photocopying, instant transfer lettering, etc. Although I was fascinated by the computer, by the breadth and flexibility of this new tool for graphics, the fact that I had perceived no significant alteration in my own poetic procedures drew me into a creative crisis which lasted from 1988 until 1990.

I put this period of silence to good use and started out on research into three-dimensional space; it was there that the potential of the computer seemed to make itself most clearly evident. I exchanged the simulacrum of blank page and palette of colours – available to me through DTP programs – for the black infinity and the austere and complex interface of Computer Aided Design; the AutoCad[2] program became my Ariadne, and coordinates *xyz* my magic ball of thread. The open architecture of AutoCad also led me on to my first stammering efforts in programming language (AutoLisp), an experience which was to prove useful after 1994, when I started on authorship systems in multimedia.

An initial impetus towards construction of three-dimensional letters soon wore off. I could see no possibility of organic integration between the third dimension and the alphabetic code; it seemed to me that such a proceeding would lead to an iconization which, fundamentally, differed very little from the typographic experiments found in the visual poetry of the 1970s and 1980s. So instead I sought to integrate the third dimension into the syntax of the poem.

My creative crisis resolved itself in 1990, with the making of a poem which has become a landmark in my poetic production: "Nous n'avons pas compris Descartes". The title is an excerpt from a text by Mallarmé dating from 1869, his "Notes",[3] which I came upon just when I was putting the finishing touches to the poem. These notes were an outline for a treatise on linguistics which Mallarmé unfortunately never got round to writing. The fifth paragraph in

Figure. 1: André Vallias, "Nous n'avons pas compris Descartes", 1990.

particular caught my attention: "Nous n'avons pas compris Descartes, l'étranger s'est emparé de lui: mais il a suscité les mathematiciens fran·ais" – We have not understood Descartes, it's the foreigners who have laid hold of him; but he has aroused French mathematicians.

I confess that I didn't spend much time on attempts to interpret the fascinating web of Hegelian concepts to be found in the "Notes"; I was quite satisfied with the luminous insight brought to me by the text. I perceived what a mighty feat it was on Descartes' part to have created an interface between the discrete universe of algebra and the continuous world of geometry, thus establishing a basis for what, in the end, was to be the computational graphics which I was using myself.

The poem "Nous n'avons pas compris Descartes", made with the resources of Computer Aided Design, takes as theme the relationship between page and poem; in doing so it transcends this same relationship and makes three-dimensional space the new field of meaning for the poem – its new "page". The sinusoidal form of this "poem" may perhaps be seen as a reference to Descartes' analytical geometry; yet in the end it is arbitrary in its nature. It points above all to a virtual inter-relationship of codes, a programmatic gesture which bestows on this meta-poem the character of a manifesto.

The fundamentals of its making arise from reflection on a series of visual and ideographic codes which begin to take shape during the Renaissance and the Baroque, and which continue with increasing intensity as they accompany the development of western science and technology in all its fields and forms: from classical perspective, still centred upon mimesis of nature, to the anamorphoses of Mannerism, architectural design, isometric perspective, cartography, graphs, charts, tables, and statistics; all those codes, that is to say, of technical and scientific visualization which attempt to go beyond the limits imposed by the linear nature of our society's hegemonic code of communication – the written text.

The common denominator of these codes is their hybrid nature: graphic and numerical elements, colour and text, to a greater or lesser degree add up to a network of reciprocities which will provide the field of meaning for the whole. It is this dynamic and syncretic complex which I call by the name of **Diagram** – from the Greek *di·*, 'through' + *graphein*, 'to write'.

Diagrams, in accordance with the growing complexity and volume of information in our times, find in the computer an ideal stage for development and dissemination. Digital technology provides a basis for increasingly rapid and wide-ranging inter-relationships of codes, since the computer itself transforms text, sound, form, colour, and movement into digits. Starting with "Nous n'avons pas compris Descartes", I have come to see the poem as an "Open Diagram", operating under the sign of diversity. Poetry is set free from the domain of the text – logocentrism – and recovers its primordial meaning of "creation", from the Greek *poiésis*, 'making'.

My work "The Verse" (1991), tries to cast light on this conception of poetry, going back to the neolithic origin of the word 'verse' – from Latin *versus*, the furrow produced by a plough. The work is composed of surfaces built up on graphic representations of long and short syllables – line and semicircle – and following the four principal metric schemes known to antiquity – trochee, iamb, dactyl, and anapest. These schemes are combined so as to give rise to surfaces

(fifteen in all) with different degrees of complexity and to produce an iconicity which interacts with the etymology of the Greek terms – trochee, 'to run', iamb, 'to throw', anapest, 'to strike', dactyl, 'finger'. For the epigraph I took an observation by the poet Gerard Manley Hopkins: "Remark also that is natural in Sprung Rhythm for the lines to be *rove over*..."

The same graphic procedure is used in "PRTHVÎ", a poem written in 1991, to compose a three-dimensional surface on the basis of a type of strophe found in Indian epic poetry; this is made up of four lines, each with seventeen syllables.

Figure. 2: André Vallias, "The Verse" (excerpt: 3 surfaces), 1991.

WE HAVE NOT UNDERSTOOD DESCARTES | 89

In 1992 I began to include movement in my work, with a series of animations, made up from mathematical equations, on surfaces. This appeared as "Surfaces" in 1993, at the event "Linzer Notate", organized by poet Christian Steinbacher in the Austrian city of Linz. This phase of experiment with movement culminates with the video "Falésia" (literally 'Cliff'), dating from 1994, where an element of sound also appears in my work; Falésia is a journey made by way of 3-D visualization of a Sapphic strophe.

At the end of 1994 I came back to Brazil, to São Paulo, where I began to work with multimedia authoring. The poem "IO" (1995) was my first experiment with interactivity; in essence it is constructed and animated with Strata StudioPro software and integrated with Macromedia Director. The reader sets the poem off by making the spherical object move at choice in one of four directions – up, down, left, right. At a given moment a transformation takes place: the

Figure. 3: André Vallias, "IO", 1995 (four frames from one of IO's animations).

object's texture changes, from opaque to transparent, to show the cylindrical penetration within the sphere. This is accompanied by a sound background: the vocalization of "o" and "i", in reference to the opaque and transparent worlds respectively, and the vocalization of the diphthongs "io" and "oi" at the change from one texture to another. At certain moments, chosen at random by the program, quotations and commentaries appear in relationship to the various meanings of the word "IO" – Italian for "I", the sign for Input/Output, numerals "1" and "0" – and excerpts from Hölderlin's translation of Sophocles' "Antigone", in which "io" appears as a phonetic transposition of an ancient Greek interjection indicating pain and lamentation.

In 1996 I moved to Rio de Janeiro and focused my activities on the Internet. 'Aleer' (1997) is a Web anthology of my works: <http://www.refazenda.com.br/aleer>. 'RIO' is a digital-poetic essay about the city where I still live.

Conclusion
Intelligent use of the increasingly sophisticated resources of multimedia for the creation of poetic works is, to my way of seeing things, an irresistible challenge: the computer, as stage for the integration of various different codes – visual, sound, numerical, etc.) seems to me to include within itself and to transcend technologically a whole series of poetic manifestations which started out from the avant-garde movements of the twentieth century, such as "visual poetry", "phonetic poetry", "performance poetry", etc.

Interactivity allows a work to be modified according to internal criteria (those defined in the programming language) and also according to the repertoire and interests of the reader; it opens up a field of unlimited dimensions for poetic research, and becomes an irreversible subversion of the traditional relationship between author, work, and reader.

I believe that the concept of poem as an open diagram, when it incorporates the notions of plurality, inter-relationship, and reciprocity of codes, not only guarantees the viability of poetry in a society subject to constant technological revolution, but places it in a privileged position – that of the "universal progressive poetry" of Schlegel and the "Dichtung + condensare" of Pound. That is to say, *Poiésis*.

Notes
1. Vilém Flusser was born in Prague in 1920. He studied philosophy at the Carl's University and emigrated to Brazil in 1940, where he continued his studies at the University of S„o Paulo. Since 1963 he was professor of philosophy of communication at the Faculty of Communication and Arts. In 1972 he moved to Europe, where he worked as a visiting professor at numerous universities. He was killed in an auto accident on his return to Prague in 1991. Among his most important writings: "Ins Universum der technischen Bilder", European Photography, Göttingen 1985; "Die Schrift", Immatrix Publications, Göttingen 1987; "Vampyrotheuthis Infernalis" (with Louis Bec), Immatrix Publications, Göttingen 1987.
2. Computer Aided Design Software made by Autodesk.
3. Stéphane Mallarmé - Oeuvres Complètes, Bibliothèque de la Pléiade - ...ditions Gallimard, Paris 1945: p.851-856.

Virtual Poetry

Ladislao Pablo Györi

Cyberspace, digital processing, telepresence, multimedia, Internet, VR, computer animation, AI, robotics, expert systems, nanotechnology, electronic photography, fiber optics, 3-D sound, fractal geometry, non-linear dynamics, chaos and complexity, artificial life, fuzzy logic, neural networks, genetic programming...

and ... what about poetry? VIRTUAL POETRY!

Figure. 1: Ladislao Pablo Györi, "Vpoem12", VRML navigational poem, 1995.

Figure. 2: Ladislao Pablo Györi, "Vpoem13", VRML navigational poem, 1995.

Virtual Poetry results from a basic need to impel a new kind of creation related to facts whose emergence – for their morphological and/or structural characteristics – would be improbable in the natural context. This new creation requires a rational and constructive human action, as well as the surpassing of redundant events that confine poetic production to previously absorbed instances and away from new aesthetic functions.

Because of the essential conjunction between human creative work and the utilization of electronic media, which have enormously widened the fields of poetry and art, all creative processes will move into the virtual space offered by the machine. In it, and with the aid of adequate software, signs can reach multiple proportions by means of the application of functions which go as far as to intrinsically modify their usual properties, to generate even unexpected systems due to their radical configuration and behaviour.

The application of computers has facilitated not only access to a custom-definable logical or virtual space (which ignores the coordinates defined in a gravitational one, having no privileged direction or immovable constraints), but also to a large series of algorithmic operations. Fundamentally, it has inaugurated an essentially different field, for which it is necessary to produce new languages that will spawn a new aesthetics. Moreover, in connection with virtual reality, and its extraordinary scope, this proposal avoids the simple transposition of already barren situations supported by old codes of non-electronic systems.

The digital world (computerized, therefore synthetic) deeply differs from physical, real or analogical materiality and goes beyond its limitations and the usual categories of experience associated with it. It founds its mastery in the mathematic or numeric character of the elements that are contained in it and in the possibility to openly establish correlations between virtual space, objects and subjects, as no previous medium has allowed.

Faced with this state of affairs, we start from the innovations developed by the latest constructivist vanguards and from a philosophical and epistemological context in accordance with the current development of the sciences. In this context, we must respond to the imperious need to design the brand new theoretical profiles of this revolutionary technology and the events technically consistent with a N-dimensional virtual space – that is to say, able to be created and treated in that space.

Thus, VIRTUAL POEMS or VPOEMS are interactive digital entities, capable of: (1) taking part in or being generated within a virtual world (here called VPD or "Virtual Poetry Domain") through software or routines for the development of VR applications and real-time explorations that confer diverse possibilities (manipulation, navigation, behaviour) in the presence of environmental constraints and interactions, such as evolution, sound emission, animated morphing, etc.; (2) being experienced by means of partially or fully immersive interface devices (vpoems support "walkthroughs" and "flybys"); (3) assuming an aesthetic dimension (in accordance with the semiotic and entropic concept of information), not reducing themselves to a simple phenomenon of communication (like a pure data stream); and (4) being defined as hypertext structures (circulation of open and multiple digital information) but principally producing hyperdiscourses (through strong semantic non-linearity).

94 | MEDIA POETRY: AN INTERNATIONAL ANTHOLOGY

Figure. 3a: Ladislao Pablo Györi, "Vpoem14", VRML navigational poem, 1996.

Figure. 3b: Ladislao Pablo Györi, "Vpoem14", VRML navigational poem, 1996.

The VPD is a substitutive field for the traditional printed page. The printed page only establishes a superficial and static contact; it is very restricted in relation to the requirements of large versatility and global artificiality that also dominate contemporary poetic production, and which will dominate those of the future. Virtual Poetry Domains also exceed all the more or less established techniques of channeling of poetic messages, because they break in a definitive way with the support that produces and maintains them: real physical space. Vpoems and the VPD have a logical existence. They bear no resemblance to anything, becoming entities with an actuating power (related to the quantity of resources at work) as has never been seen or experimented before.

The opening of computer networks to the VPD will facilitate the realization of virtual "teleportations" of subjects to VP-based computers anywhere in the world. Viewers can obtain an absolutely new remote experience of simulated and exploratory "reading".

Virtual Poetry, as expounded here, is not reduced to the surpassing of certain linguistic codes, the adding of a topic, some formal conquests, another segmentation of a continuum, the utilization of an unusual support ... however important these aspects may be. VP forces the initiation of a new era in the general poetic creation, freeing the human imagination from any real constraint, and giving it a vast and unexplored field. In this new field, everything conceivable (as a construct) can exist. In the future, human-machine experience (as a mixed or cybernetic system) will rise up to levels higher than all those already known.

Buenos Aires, May 1995

Figure. 1: Giselle Beiguelman, "Irene_Ri" ("Irene_Laughs", 2003), made with Santa Ifigênia, a non-phonetic font face by Rafael Lain.

Nomadic Poems

Giselle Beiguelman

Wop Art (2001), *Leste o Leste?* (*Did You Read the East?*, 2002), and *Poétrica* (2003) are projects addressing reading contexts marked by nomadism. The first involved cell phones, the second was a teleintervention combining electronic panels and the Internet, and the third involved PDAs interaction with electronic panels and large plotters. The projects deal with situations in which inscriptions vanish, interfaces multiply and fragment the reception on electronic surfaces, connected to telecommunication networks.

These projects investigate the possible realm of a post-phonetic, hybrid culture, crossed by printed and digital layers, where the informational and esthetic codes are entangled through programming and produce a new semantics involving a rearrangement of signs and signification processes. Triggering and resulting from different variables, these poems have some common starting points and issues which will be discussed here schematically. My goal is not exactly to clarify the poems in *Wop Art, Leste o Leste?* and *Poétrica*, but rather to contextualize them within the fuzzy cartography of cyberliterature, which is not always distinct from other literary forms.

Along these lines, the starting points are the following:

- The place where the text is located is the reader's non-place, space-time of antiphenomenology and visibility.
- Every reader is the book's double, a post-original, immemorial "aleph" who one writes for and who is beyond description.
- Nothing imprisons the text. The prefiguration of writing is always a sordid act, a vile exercise, a mere waste of time within a reading interval.
- Interfaces are primordial environments of the arbitrariness of enacted words, betraying language so as to become language.

Despite the awareness that new production, publication and distribution technologies do not alter much the design of relationships in terms of the complicity, seduction, and empathy which

Figure. 2: Giselle Beiguelman, "Os Vipes são Bípedes" ("VIPs are Bipeds", 2002), an e-graffiti presented at the teleintervention *Leste o Leste?*

establish the fruition of the text, I believe that one cannot fail to perceive the specificities of literary times such as ours. Within the intersections of words and symbols, the boundaries of communication and of art are being redefined.

On discussing new forms of creation mediated by evermore agile and wireless remote networks, such as the ones which *Wop Art, Leste o Leste?* and *Poétrica* interact with, I have to take into account the novel reading contexts which emerge from the interaction with interfaces such as cell phones, palm tops and electronic panels.

Thus it is important to foreground some details of the creative processes involved, for they not only guide the development of this series of nomadic poems, but also highlight their basic assumptions or conditions for existence. I will therefore review some ideas that were developed before, during, and after the creative process itself:

- The popularity of portable wireless communication devices connected to the Internet and the proliferation of telecommunication spaces in urban areas, such as electronic billboards, indicate that the urban lifestyle has encompassed nomadic life patterns.
- PDAs, cell phones, and electronic panels are instruments that were especially devised for situations involving movement, always in transit. These tools enhance adjustment to an urban universe undergoing continuous acceleration and entropy, one that alters and adjusts to new forms of perception, visualization, and reading.

Figure. 3: Giselle Beiguelman, "Streets" (2001). Screen shot of the wap poem in the web emulator.

- Art rendered for these nomadic interfaces makes us reflect on reception in such environments – always in flux, moving, involving interactions between different equipments, and connected to multiple, non-related tasks (such as talking on the phone and driving, checking e-mail and eating, or watching movies and standing in line).
- Creating for such saturated, entropic situations implies reconsidering the nature of artistic fruition and of communicative conventions and formats, in a culture of ubiquity, where contemplation will simply vanish.
- Creation aimed at this emerging context of liquid reading, stemming from and occurring in connected, flowing systems raises a pressing issue: How can we consider art forms conceived to be read "in between", among diverse, simultaneous (but asynchronic) interfaces and actions?

Wop Art was the first move in this reflective process and offered the reader an imponderable situation: op art accessed via mobile Internet, in WAP (wireless application protocol) cell phones. The situation was imponderable not because of the precarious situation of the medium back then, in 2001, but rather due to the incompatibility between what was being offered to read and the reading context itself.

Figure. 4: Giselle Beiguelman, "Streets" (2001), wap poem, *Wop Art* project.

Developed in the 1950s and 1960s, op art is an important reference when reflecting on virtualization experiences, in that the image we see does not exist, it is a result of an optic effect, realized as a potential of the original structure. It is a form of virtualization, which depends on the reader's degree of concentration and introspection. However, images conceived for mobile devices do not concern contemplation. These images are produced to be seen in transit, in a state of dispersion, according to a logic of acceleration which makes introspection unfeasible.

Therefore, it was not a question of adapting op art to cell phones, of creating an optic series which would work as a "tamagoshi" for a sophisticated audience – glorifying the gadget and contradicting the object – but rather offering an ironic situation in which the friction between content and reception seemed thought-provoking: in other words, facing a novel state of artistic enjoyment, in entropic environments.

What is at take here is art not to be seen as art, but getting mixed up with communication devices and being read with countless other inputs constantly intersecting with one another. These relationships were intensely explored in *Leste o Leste?*, presented during the *Artecidadezonaleste* project (Project Cityarteasternzone), in São Paulo, April 2002. In *Leste o Leste?* it was possible for any Internet user to select e-graffitis and send them via Web browsers to an electronic billboard. This large billboard (360 square feet) was located on the Radial

Figure. 5: Giselle Beiguelman, "I Love You" (2002), screen shot of an e-graffiti (avi file) created for the teleintervention *Leste o Leste?*

Leste freeway, which connects São Paulo downtown to one of the most complex urban spots in the city. The images were inserted every three minutes, between the advertising clips commonly shown on this kind of communication device. A webcam focused on the outdoor screen transmitted images back to online viewers.

The teleintervention occurred through the connection of spaces (places where the electronic billboards are located, and the visitors' places), of media (Internet, webcams and panels), and of telecommunications systems (Intranet and the Web). However, everything that was viewed was always a result of an interaction (between the creator and the businesses which produced the interfaces, between the audience and the creator, and all these and the promoters of the event). The audience was called upon to operate commercial products and services, to be curators or editors of the content generated by the artist. The audience had to construe meaning, working with advertising and communication devices.

The central issue in *Poétrica* is the assumption that art created for remote communication devices is rendered through an integration of esthetic, technological, cultural, and advertising repertoires. This produces a new appreciation of the artwork disconnected from its function as object. *Poétrica* was a bet on new esthetic, cultural, and behavioural perspectives unveiled by digital media.

Figure. 6: Giselle Beiguelman, printed version of "2+2 = Crowd" (2002), visual poem of *Poétrica* composed with number "2" typed in Webdings font face

Consisting of a series of visual poems, *Poétrica* is construed with non-alphabetic fonts (dingbats and system fonts). These works undo verbal and visual ties through the combination of fonts and numbers, languages and codes. They investigate and explore the interconnection of networks and media, resulting in visual meanings independent of textuality.

Conceived for PDAs, the Web, cell phones, electronic panels, differently sized papers, and different digital printing methods, *Poétrica* also explores reading and perception contexts. Re-dimensioned and saved as something new, the images are made from the same information, but are not connected to a specific medium, foregrounding the cloning logic that permeates digital creation.

These rearrangements of the same pieces of information – identical in format but not so in terms of fruition – is the fascinating aspect of the cloning logic of digital systems: the ability to be identical while being different.

The poems in *Poétrica* can be viewed and read in distinct complementary forms, not because of screen size or the surface they momentarily adhere to, but rather due to a particular esthetic

Figure. 7: Giselle Beiguelman, palm version of "2+2 = Crowd" (2002), visual poem of *Poétrica*.

phenomenon pertaining to nomadic literature: on being hybrid and unlinked to a specific substrate, it dematerializes the medium, and the interface construes itself as the message.

Contemporary literature has overflown the page margin to invade and be invaded by the transitory territories of screens and windows, of the places and non-places that construe us. Now that we have become speedy snails roaming around the world with a bunch of data located @somedomain, there is an urgent need to consider new forms of writing and literature that respond to the fragmented, mixed character of information. Talking about hybridism is more than giving in to the fashionable universe of what is considered hype at the globalized university. It is a crucial issue. What really matters occurs in multiple platforms, within interconnected spaces, words, and things.

It is very possible that all this Herculean effort to manage data, domains, and new languages is in vain. All that we say nowadays can be deleted and reconstructed without leaving a single trace of what it was meant to be. This does not matter. We did it. We have updated McLuhan. The medium does not count. In these days of nomadic words, the interface is the message.

BEYOND CODEXSPACE: POTENTIALITIES OF LITERARY CYBERTEXT

John Cayley

Introductory

First written and published in 1996, the unrevised form of this essay now comes across, in certain respects, as ancient history – a function of the notorious acceleration of cultural and media development since the explosive growth of the Web after 1994.[1] And yet, it chiefly describes a productive engagement with writing in programmable and, latterly, networked media which dates back, in my own case, to the late 1970s, an all-too-human, rather than silicon-enhanced, historical context.

For the past decade or so I have somewhat unexpectedly found myself participating in an increasingly public project which is still of uncertain designation, but which I am now more or less content to call writing in networked and programmable media. Before this challenge to self-identity, I had worked, in so far as I was engaged in art practice, as a literary translator of poetry from Chinese, with intermittent but serious essays into English poetics and poetry *per se*. Not entirely coincidentally, from the late 1970s, I had self-trained in forms of programming suitable for string manipulation and limited linguistic analysis. Inevitably, I brought the two practices together and made some experiments. In the early to mid 1990s, as the Internet webbed-up and went public (literally, figuratively, and finally commercially), there was suddenly a way to publish some of these earlier experiments more broadly. However, rather than achieving a small but commensurate acknowledgement of this work, I soon found myself co-opted into the difficult-to-designate project of which this book forms a part. I began making contributions to the theory as well as the practice of supposedly 'new' ways of writing and poetics: to 'electronic poetry', 'digital poetry', 'hypertext poetry', 'cybertext poetry', 'new media poetry', etc., etc. More importantly I found colleagues, and found that I was engaged with aspects of poetics which I had not previously or consciously considered as necessary for my work: the poetics of performance writing, so-called 'Language writing', the material culture of the book, and so forth. Given that my focus was and still is text, the production of poetic texts chiefly for silent reading (albeit in new media), why was my work received and channelled in

this way? I believe that, ultimately, an important reason lies in its non-trivial use of programming, programming, not simply of paratext but also in order to the text itself, literary object present as art. In other words, for example, if I had been a hypertext experimenter who made poetry, or a poet of, shall we say, a 'new-' or 'nude-formalist' or whatever persuasion, who happened to have 'webbed up', I do not think my work or this essay would bear the degree of attention it has already received.[2] Recently I have begun to try and theorize what I quasi-jokingly call the programmatological dimension of writing.[3] Without being able, in this immediate context, to make my meaning clear and persuasive, I suggest that it is the role of programming and the programmatological which constitutes an important part of what is interesting about my work and its trajectories.

In the event, I have not radically revised this essay. The inclination I've just made explicit emerges also from the original text. I have made a few changes to the 'preamble', chiefly to set it in a more contemporary context; I've updated a number of the references in the main text and added the briefest outline of selected newer work. The essay's concluding remarks are still, it seems to me, remarkably relevant.

Revised Preamble
The use and abuse of visible language – or writing in the broadest sense – has recently undergone huge, unprecedented and continuing growth. This growth is taking place in cyberspace, in what many critics might well have considered an environment hostile to cultivated 'letters', hostile, at the very least, to the traditional and still pre-eminent delivery media which have made language visible. The narrow bandwidth of current networks, and the limited capabilities of affordable interfaces meant that encoded text was, originally, the dominant medium of information exchange on computer-based networks. And to communicate over these networks, people still, predominantly, write and read. That is, they compose (literary) texts and publish them in cyberspace where they are read, usually in silence, by friends, colleagues, and the more general, 'wired' public. All this has stimulated the emergence of an exuberant mass of new forms and proto-genres of visible language: listserve mailing lists, online conferences or 'chat' zones, MOO spaces and so on. The advent of the World Wide Web has extended and articulated networked literary production to include typographic and other concrete design aspects of textuality. However, the vast majority of this visible language is not seen by its writers or readers as belonging to 'literary' or 'artistic' production in the canonical sense. 'Serious' literary hypertext does exist and is practised increasingly in this context.[4] However, it is perhaps more significant, in cultural terms, that the new quasi-ephemeral forms of non-literary visual language are exerting an increasing influence on self-consciously literary production, in what might be characterized as the real-time realization of contemporary criticism's postmodern intertextual ideals.[5]

But this temporary state of affairs, this a momentary window of opportunity for the partisans of visible language, cannot last. As the bandwidth widens, as the audio-visual takes over from the keyboard and comes to dominate screen, printer, speaker, and as yet undreamed-of appliances and peripherals, a huge swathe of visible language-use will instantly migrate to non- or extra-literate sound and vision. By the time this happens, will visible language have become an understood and established literary medium within the new technosphere? As engaged with cyberspace as it now is with 'codexspace', for example? This is an underlying concern of the

work I describe, the first of a small number of theoretical issues which I shall briefly outline as a context for this delineation of my own practice.

My cybertextual compositions are literary. They are designed to be published on computer-controlled systems linked to their now familiar peripherals. First and foremost, these pieces are designed to be visually scanned on screen, silently read and interacted with through keyboard and pointing device. They subscribe to the notion of written language as a distinct, quasi-independent system of signification and meaning-creation. Its relationship to spoken language is structured but indeterminate as to detail, and is subject to continual contestation, depending on the nature and function of the language being created. When the issue of the survival of textual language-use into the audio-visual age was raised on a hypertext discussion list, I answered for its continuing creative role: "for the very reason that it is silent / because it allows the silent to speak / because it allows the dead to speak / because so many of our thoughts are silent, unspoken."[6] Literature which is engaged with the unique potentialities of computer-based networks is uniquely placed to serve as a link between the silent literary culture of the past and that of the future.

However, the new literature will not be 'computer literature'. There is a recurring popular confusion concerning the nature of the 'computer'.[7] It is not in itself a medium, neither a physical nor a delivery medium, nor a content-bearing, artistic or cultural medium. What we idly call 'computer' is always a system of hardware, software, and peripherals, and this multiplicity is what may become, potentially, a medium; 'potentially' because it is arguable that there must be agreement between producer/consumers about the use of a new medium before it can be recognized as such. Thus, link-node hypertext, especially as realized on computer networks, is a new, rapidly evolving textual medium, gaining wide acceptance. However, 'computer poetry' is not a new medium, it is simply a misnomer. Neither is this a trivial matter of terminology. It is important to make it clear that literary developments in cybertext are not constrained by hardware technologies themselves; they are constrained only by software, which is an *authored* delivery medium. Apart from these constraints which are surmountable through engineering, there are those produced by, as it were, a 'false consciousness' generated by the 'ideology' surrounding the current use of computer-based systems.

For example, we still expect our systems, our new media, to produce forms which are stable, closed. Hypertext in its most familiar link-node manifestation is limited and sometimes self-limiting. There are developers and authors of hypertext who argue that despite these limitations, the medium has opened up huge spaces of unexplored potential for creative activity. Thus, it is time to recognize a new medium, define and accept its limits, and so proceed to exploit the space it has marked out. Unfortunately for this view, the computer, the underlying hardware on which hypertext systems are realized, does not have fixed functionality and is increasingly easy to reprogram. Thus, for example, as a poetic writer with fairly extensive (but far from professional) programming skills, I can break through the boundaries of link-node hypertext with relative ease. The forms of both delivery and artistic media change under my fingertips and before your eyes, allowing, for example, greater reader interaction with the work than is typical of most hypertext. This introduces a new element into the critical understanding and assessment of new literary objects. We must begin to make judgements about the composition of their *structure* – to assess, for example, the structural design or composition of the *procedures* which

generate literary objects – not only the objects themselves. The poet must come to be judged as a sometime engineer of software, a creator of forms which manipulate the language that is his or her stock-in-trade in new ways. This is crucial to criticism, but it also has immediate practical consequences, because a general problem with hypertext is finding your way through it, or rather doing so in a way which is meaningful and enriching. While the poetics of linear, paper-based text has been extensively explored, the multi- or non-linear, generalized poetics of texts composed and structured in cyberspace has a long way to go.[8]

Multi- and non-linear poetics is a recurring theme in my work for other, more contingent reasons and is one of the concerns which originally inspired my move into machine modulated writing. As a trained sinologist who did research on parallelism in Chinese prose and poetry, I was well aware of non-linear rhetorical techniques in writing. The computer's programmable screen offers the possibility of representing such tropes directly, and the development of writing for new hypertextual media should also lead to the development and better understanding of non-linear poetics generally.

Finally, there is a question that is more purely a matter of content: the engagement of writers using these new, potential media with contemporary poetic practice (and with writing practice more generally). Few writers who are established in traditional literary media are engaged with the emergent forms, and many new writers who are exploring those forms are insufficiently aware of relevant past experimentation, of the huge corpus of highly sophisticated writing which already exists, and against which any literary production – embracing all media – must be judged. I speak chiefly to the field of poetic literature, as a practitioner acutely aware of my own limitations and omissions, but to encourage deeper engagement of the world of letters with the ocean of potential literary outlawry.[9]

Scoring the Spelt Air
My own first explorations of machine modulated poetics began in the mid 1970s when personal computers first became widely available. It is clear that the computer's programmable screen provides a way of 'scoring' the presentation of literary compositions which are intended to be read silently. Within a relatively simple authoring harness, the writer has the possibility of presenting the words of a text according to the rhythms of his or her inner ear, in terms of the speed at which words appear on the screen, the positions in which they appear, the pauses between them and between phrases or lines, etc. There is also the possibility of exploring dynamically (in 'real time') non-linear aspects of a poem's rhetorical structures, by scoring its component words and phrases in alternate orders designed to highlight such structures. The most finished result of these investigations is the piece, *wine flying: non-linear explorations of a classical Chinese quatrain*.[10] A collection of techniques for this 'scoring' approach to poetic presentations on programmable machines is provided in a software harness for developing such work, a still uncompleted project, with the general title *Scoring the Spelt Air*.[11]

However, text manipulation and generation by machine seemed to me, from the outset, to provide richer potentialities. When a friend wrote me a personal letter at about this time, coded into the acrostic letters of twenty-six words, one for each letter of the alphabet, I immediately set out to program such a simple and, potentially, 'poetic' encoding technique.[12] At about the same time, I produced various text randomizers: experimenting with disordered text at different linguistic

```
rich    scarlet
                    deepens
                                    herb        path
        faint   turquoise
                            fills
                                            mountain  window

                envy   you
                butterfly
                                through  dreams
                                under    flowers

        wine        flying
```

```
                    scarlet

                    turquoise

            butterfly

                            under       flowers

                    flying
```

Figure. 1: John Cayley, Two screen shots from *wine flying* showing the entire text of the translation of the quatrain by Qian Qi (CE ? 722–80) and a screen showing first fragment of an alternative 'path' through the poem. The words in this fragment were displayed in the order: 'turquoise butterfly flying under scarlet flowers'.

levels – sentence, clause, phrase, syllable, grapheme, etc. – and comparing the results. Another important theme underlying this and my subsequent work emerged in the process: an interest in the effects of procedural techniques on closely written 'given' texts; a testing and re-testing of the hypothesis that such texts seem to retain the tenor of their meaning-creation even after having been subjected to such transformations, so long as readers of the transformed piece are prepared or prompted to involve themselves actively in the reading process.

All of the work which followed involves the use of some form of quasi-aleatory text-generation procedure. These rule-governed procedures are applied to a given text when a reader selects its title from a 'contents' page. The selected piece is then 'read' or 'performed' by the procedure(s) in a series of screens of animated text. Because of the aleatory factor(s) working within the procedural rules every performance is unique; every reading is different and demands the active involvement of the reader.

I use conventional link-node structures only for the explanatory pages/screens of each work. The generational structures at the heart of the work *could* be mapped onto a link-node model having separate 'lexia' for each word of the underlying given text(s) and with links generated 'on the fly' by the object's generational procedures.[13] This amounts to one potential realization of the 'hypertext *within* the sentence and *within* the word' which the hypertext poet, Jim Rosenberg, has repeatedly called for and realized himself in widely different ways.[14] However, the usefulness of the link-node model is highly questionable when approaching literary objects such as those developed by Rosenberg and myself.

Indra's Net
It was only in the late 1980s that the technology to present the results of such work in an appropriately designed format became widely enough available to qualify as, at least, a potential medium of publication.[15] It was at this time that I produced the first published piece in a new medium of my own making, *Indra's Net*, a title which I used for this piece and also for the series of works which have followed from it.[16]

Indra's Net was one of two metaphors which guided the inception and development of this cybertextual project. The concept of Indra's Net originates in Hinduism. The net was made of jewels and hung in the palace of the god Indra, a generative representation of the structure of the universe. I first encountered it in a history of Chinese Buddhism: "a network of jewels that not only reflect the images in every other jewel, but also the multiple images in the others."[17] As a metaphor of universal structure, it was used by the Chinese Huayan Buddhists to exemplify the "interpenetration and mutual identification" of underlying substance and specific forms. In my own work it refers to the identification of underlying linguistic structures which are used to restructure given texts recursively, and so to postulate and demonstrate these structures' generative literary potential; or, on a more grandiose scale, to represent some of the underlying principles of meaning-creation within language itself, those which generate new language in the same way that the universe may be seen to be formed by the falling and 'swerving' atoms of Lucretius.[18]

The other metaphor which helps to structure my work is taken from holography. The neologism, 'holography', is based on the definition of 'hologram' in the *Shorter Oxford English Dictionary*: "A pattern produced when light (or other radiation) reflected, diffracted, or transmitted by an object placed in a coherent beam (e.g. from a laser) is allowed to interfere with the undiffracted beam; a photographic plate or film containing such a pattern." This is transposed from light into language: "A pattern of language produced when the words or the orders of words in a given text are glossed, paraphrased, etymologized, acrostically or otherwise transformed, and such transformations are allowed to interfere with the given text; a set of rules, a machine or a computer program which defines or displays such a pattern."

The first Indra's Nets were acrostic. *Indra's Net: I* is a sampler of this early work and the terminology used to describe it. I should say at the outset that when I first developed this work, I was ignorant of the earlier or coincidental experiments of Emmett Williams and Jackson Mac Low. John Cage's mesostics were also then unknown to me.[19] William's 'ultimate poetry', Mac Low's 'Asymmetries' and, later, his 'diastic' techniques are very similar to what I first termed 'head- or internal-acrostic holography'.[20] However, there are non-trivial differences between

all this work and my own which arise from its method of publication, or more precisely the digital instantiation of my work, which allows such generative procedures to be experienced by the reader in 'real time,' as the text is generated, and not after the author has produced and recorded the new text. The procedures thus move closer to the reader, and, surely, a major component of the appreciation of such work is the reader's potential understanding of 'what is going on' and 'how it's being done'. Beyond a real time experience, the programmable screen allows further intimacy with the process, once a composer has developed meaningful ways for the reader to interact with or even alter the procedures themselves. Moreover, any aleatory or 'chance operation' aspect of such work is only *fully* realized in a publication medium which actually displays immediate results of the aleatory procedure(s). Such works should, theoretically, never be the same from one reading to the next (except by extraordinary chance). Mac Low has preserved and published the effects of chance operations through a commitment to the performance of his pieces; software allows these effects to be carried over into the world of silent reading.

Indra's Net I contains examples of several 'free internal-acrostic hologograms', one 'strict or head-acrostic hologogram', one '26-word-story head-acrostic hologogram' and both holographic and non-holographic 'etymo-glossological Indra's Nets'. The later involve the semi-automatic transformations of words from a given text into expanded glosses based on etymologies and associations of words. I will not discuss them further here because they have not yet been developed as have the acrostic and collocational pieces.[21] Neither will I detail the 'strict' and '26-six-word story or sentence' forms, for similar reasons.[22] Instead I shall outline what I now call the 'mesostic hologogram'.
The implication of applying the word 'hologogram' to a text is that it is generated from material which is contained within itself.[23] The given text is seen as a succession of the 26 roman letters, ignoring punctuation, etc. The transformation may begin at any point in the

white absences
particularly notice
imperative awake
delicate intimate
designs sleeping

intimacies

Figure. 2: John Cayley , Screen shot from 'Under it all'. This is the version of the piece as it appears in *Moods & Conjunctions: Indra's Net III*.

given text. Each letter is, in turn, replaced by any word from the given text which contains the letter being replaced. This kind of hologogram is unlikely to produce anything resembling natural English. Its primary transformational rule is based on arbitrary elements of the script (itself already at one remove from language as a whole) and is, on the face of it, unrelated to any significant aspect of grammar or rhetoric. On the other hand, the notion that words which share letters may, by this token, share something more, is perhaps worth poetic attention. Moreover, the given text may be adapted or composed with an eye to the transformation which is to be imposed upon it. This was undertaken in the case of 'Under it All II', the central piece of *Indra's Net I*. As far as possible all of its nouns are plurals and all verbs agree with the third-person plural. This means that new, derived phrases are more likely to be natural collocations.

An advantage of using software to produce this kind work is the relative speed at which texts can be generated, allowing an experimental phase in the process of composition, with the results of earlier experiments fed back into the finished publication. The development of the Indra's Net project, generally, has been just such a process.

Indra's Net and Visual Poetry

Mesostic work is inherently visual, in the sense that textual choices are based on the identity of graphs in the written form of the language. Moreover, early on, it became apparent that this type of text generation implied a structure that could be represented in three (or more) dimensions. The flexibility of typography on the computer screen allows the instantaneous production of typographical effects which would be very difficult or time-consuming to reproduce on paper. A simple example is the use of emboldening to highlight the letters of the word(s) of the *underlying* given text after a mesostic transformation has been applied. From the collection, *Collocations: Indra's Net II* this emboldening is applied to letters on the screens, as they are generated.[24] [figure 2] A special rendition of *Golden Lion* was also published in paper form in what amounts to a piece of visual poetry in fine printing, as well as a snapshot of cybertext.[25]

It is possible to conceive of more than one implicit three-dimensional space defined by (26) planes of words which share the same letter. One of these is represented on the cover of a paper publication which accompanies *Collocations*.[26] Later I produced a poster poem of the entire text of 'Under it All' in which tone was used to imply this three-dimensional arrangement of words. Each letter of the alphabet is assigned a particular weight of tone – 'a' the lightest, 'z' the darkest – placing it, visually, on a separate plane at a particular distance from the viewer. Each word from the text is printed in the tone which corresponds with that assigned to one of its constituent letters, according to simple rules intended to distribute and use up all of the 26 tones. Such representations could be animated and translated for the computer screen or a computer-controlled installation.[27]

Collocations

Results of the experimentation with the collection of pieces in *Indra's Net I* indicated two principles for further development: (re)composition of given texts in preparation for procedural transformation, and composition, through software engineering, of the procedures themselves.

winds rains waking how many petals must have fallen silent
sleeping forms points on blank white canvases all possible
curves problems far beyond our artists capacities to resolve
consider these our small children who awake see their
sleeping parents doors ajar enter their rooms bright warm
summers mornings all coverings abandoned except these
sheets which trail their sculpted folds over partially concealed
limbs and lie beneath white sheets whose pure brilliancies
children particularly notice their parents barely sleep enjoy
still teasing promises of deeper slumbers return our children
know their parents now are dimly conscious of days approach
notice underlying sheets once more plain white completely
silent tender relations of bodies lying which children believe
they fully understand they long to express perfectly follow
lines linking these bodies then draw their parents intimacies
towards themselves but see sheets infuriating pure white
absences feel everything so still our children forget ignore
lines points on linen canvases know nothing of bodies curves
intimate designs sleeping forms are painfully aware even were
they able to hold in mind draw these forms towards their
hearts eyes hands still too young too inexperienced to follow
lines of intimacies they pursue children artists with their own
unique imperative visions committed to their most perfect
realizations what can our children do they need methods
processes techniques children jump into beds between upon
their parents pummel with shrill words tiny fists limbs twist
flail make demands hairs pulled tangled gentle bruises ta

> dim minimal abstraction
> they welcome the eye a
> tableau but insist on a
> temptation to make

Figure. 4: John Cayley, Screen shot from 'Critical Theory' in *Collocations: Indra's Net II*.

Clearly, in this type of transformation, at the very least, each pair of successive words are two-word segments of natural English. However, the text will wander within itself, branching at any point where a word that is repeated in the base text is chosen, and this will most often occur when common, grammatical words are encountered.

Collocations also includes a 'sampler' of earlier work and one essay in another transformational algorithm, which is based on suggestions of Harry Mathews.[29] In one of these accompanying pieces, a mesostic abecedarian sentence of twenty-six words – containing the letters 'a' to 'z' in turn – is extracted from the given text of 'Under it All'. The sentence is difficult to construe. It is used to transform, mesostically, first itself, and then the text of 'Under it All' and then 'all literature'.[30] Finally, Mathew's advice is indicated to attempt to construe the sentence. Synonyms are gathered for all its words and then the system is allow to follow the syntax of the sentence, picking the gathered synonyms in place of the original words of the difficult sentence. This type of transformation is one that could be developed much further.

Moods & Conjunctions
The following three works in the Indra's Net series, *Moods & Conjunctions, Golden Lion* and *Leaving the City*, do not introduce significant innovations in the 'technology' of the form, that is, in the delivery medium itself. Instead they fill examples of existing forms with content. Content is offered up to the generative algorithms in a slightly different way in all three works, however, since they all set out from *multiple* given texts. The texts may be blended together in the generational process, or one given text may be transformed in terms of another. Although the content of these works is composed and selected as appropriate to the new potential medium, their significance, in so far as this is conceded by their readers, lies in that *formed content*. This is an important point to recall. In the world of 'new media' there is constantly the necessity to remind ourselves that novel literary technologies are not, ultimately, to be developed for their own sake. The works they generate or simply frame must be judged in the context of literature as a whole, as works inscribed as content-in-form.

'Moods & Conjunctions' is the title piece of *Indra's Net IV*.[31] 'Moods' consists of two texts about sex and one about language. One of the two pieces on sex is simply composed of fragmentary clauses made from i) the pronouns I, you and we, ii) the modal auxiliaries and iii) selected adverbial and interrogative conjunctions ('then' has also been allowed). The collocational procedure is applied to all three pieces, such that phrases from one text continue with words from the others. The piece will vary its style and tone considerably. In particular the 'modal' given text has a completely different tone which disrupts the expository prose of the other two given texts as the piece progresses.

full the ear everything even before
form contingency conspires
substance everything content in
substance perfect substance since
the ear sensible even its whole
each interlocked interpenetrated
everything

Leave me the space between

Figure. 5a: John Cayley , Screen shot from *Golden Lion: Indra's Net IV*.

Figure. 5b: John Cayley, The version of *Golden Lion* as printed in its paper form.

Before *Moods & Conjunctions*, reader interaction with procedures and pieces was restricted to exploring explanatory pages, selecting pieces to be generated and the ability to interrupt a piece and set it going at a new point in a particular reading. From *Moods*, new ways of interacting were introduced, allowing greater reader involvement with the generation of text.

ACTUAL POSSESSION OF THE WORLD ...*

actual possession of the world
left Gu Cheng exposed maimed and handicapped
this shining road back to the city
into his own shattered emptiness
finally I listened to the sounds like leaves or any other violence of the picture
there is something in their lives that keeps them following this sound
on the other side I could go anywhere
recall a life that is distant from our own
but this doesn't trouble me because I didn't use words
he constantly tried to return
following this phrase became the picture
once I thought I felt that a new young light had awoken in the woman
all softly speaking in a particular kind of way
one of the world's unceasing infinity of transformations
the violation of corporal integrity is in the wind
they were flooded with both their lives
they were flooded with the body
and my ears went deaf
became fraught and fell ill and she asked me what colour
a truly extraordinary sound
the speech of the cascading rays
I didn't write poetry I didn't use words he claimed
taken from the world he had left long ago into his own shattered emptiness
living into this world
both created and enforced
to imagine such hatred
I awoke I answered we keep on living I began to think of endless transformation
and in gesture like a secret afterwards I began to think of these phrases
they really were flying closer and they turned into words
dawn was the summit and night was speaking
for reasons that were flying closer
suddenly the sounds poured endlessly into my life because I didn't use words
taken from the world both created and enforced
I began to think of whiteness

Figure. 6: John Cayley, Text of 'Actual possession of the world ...', lines gleaned at average collocational strictness 386/500 from *Leaving the City*.

Pieces in *Moods* allow the reader to increase or decrease the likelihood of a collocational jump taking place (e.g. from one occurrence of the word 'and' in a text to another). By moving a pointing device attached to the computer as text is being generated, the aleatory weighting is changed. Collocational jumps become more likely as the pointer is moved leftwards. When the pointer is moved to the right such jumps become less likely. If it is moved to the extreme right, no jumps are allowed, effectively reading through the given text(s) in a 'normal' linear fashion.

Golden Lion, is based on two given texts.[32] 'Han-Shan in Indra's Net' is a short original poem. The second text, 'An Essay on the Golden Lion', is the translation and adaptation of a prose work by the Chinese Buddhist monk, Fazang (CE 643–712). 'Golden Lion' is a mesostic transformation with collocational constraints (as described above), but here the letters of the poems are transformed, one by one, into words from the essay. In the display, a half-line of the poem is shown on the bottom of the screen, with words from the essay above, showing the poem's letters emboldened. The effect is to produce a commentary on the poem in the words of the essay, where the commentary has the poem itself embedded within it. One particular, and slightly edited, rendition of *Golden Lion* has been published on paper as an artists' book.[33]

Leaving the City takes two distinct given texts and blends them using the collocational transformation.[34] One text is a long translation from a talk on poetry and language given by the Chinese poet, Gu Cheng (1956-93), at the School of Oriental & African Studies, University of London, in 1992. The other text is a shorter piece which attempts to come to terms with the brutal events which ended the lives of both Gu Cheng and his wife, Xie Ye on 8 October 1993.

While developing these three works, it became clear that it would be possible to do two new things with the texts as they were generated, allowing much greater reader interaction. Each time these pieces are 'read' on screen, they are different because of the 'chance operations'. However, it is relatively easy to allow the reader to collect phrases or lines of generated text. This allows them to produce a third kind of text, (similar to the edited cut-ups of earlier writers like Burroughs and Gysin), not composed by anyone, but selected and arranged.[35] The illustrated poem, 'Actual possession of the world ...' is such a text, generated from *Leaving the City*. However, the cybertextual system also allows the selected phrases to be *added* to the given text, thus augmenting the possible collocations that may be picked by the procedure in subsequent text generation. The procedure 'learns' new collocations and alters itself. The reader's copy of the work becomes unique, different from every other copy. These potentialities were realized and published in the next Indra's Net, *Book Unbound*.

Book Unbound

When you open *Book Unbound*, you change it.[36] New collocations of words and phases are generated from its given text according to the collocational procedure. After the screen fills, the reader is invited to select a phrase from the generated text by clicking on the first and the last of a string of words. These selections are collected on the page of the book named 'leaf', where they are accessible to copying or editing. But they also become a part of the store of potential collocations from which the book goes on to generate new text. The selections feed back into

118 | MEDIA POETRY: AN INTERNATIONAL ANTHOLOGY

```
        I  each shaped breath   tells    real time  is concealed
              beneath the cyclical          ET      behaviour of clock   and time
        piece   lost warmth    EE                 E    true cold spelt out
              and no breath                              like this last
                   even as  E...                      T   II  the last breath
              speaks              forever the            no moment
         like any other            wind demon            previous or
              subsequent  R                         A   moment  and yet
         the clock applies         time entropy          the same name
              to many           destroyed under           a different
                   instance                          N    of control
         III  she destroyed                              clock time   big ben
         mother of parliament                            speaks a simple
         language  unfraternal   S              I    at cathedral transept
              on church tower             O           face tolling  everywhere
  a)                   the speaking clock   so unlikely   to repeat itself

              IV   each moment  appears to be given   a unique name
         the city  ran on local       ET           not mean time
              town hall clock   EE              E   with a second
         minute hand  ahead                          east of its capital
              V  what if  E...                   T   every clock
                   was like          unique moment       the speaking clock
              she'd never          would become          known
         this season  here  R                     A

```
 VII or lies time affects to stand still
 what if it was impossible ET to apply the word dawn
 to more than EE E one single instant
 at the beginning of some one
 particular day E... T VIII would the cycle
 of recurrence time changes become less easy
 to distinguish nameless demon would it sharpen
 the awareness R A of decay
 until it was concealed beneath unbearably
 present the end the cyclical of her time here
 on this island L N IX would she
 become more conscious
 of mortality if she were denied
 the sense that S I she constantly returns
 to a previous state O of existence
 c) with the same name in the cycle

 X no time for her self would life as time
 be bearable time changes ET nameless demon
 to be destroyed EE E in the dream of a place
 she has left forever the wind flows
 XI into each cabin E... T of memory falls
 the unique name for the unique
 moment left forever
 the unique would become
 impossibly R A infinitely
 elaborate and moment the complex
 a futile and last destroyed ironic
 struggle against L N the inscription of
 entropy XII or plucked
 from chance a procedural system
 like this speaking clock S I gives the illusion
 of real time passing O flake of snow
 d) white noise and riverflow inscribed on a piece of time
```

the process and change it *irreversibly*. If the reader continues to read and select over many sessions, the preferred collocations may eventually come to dominate the process. The work may then reach a state of chaotic stability, strangely attracted to one particular modulated reading of its original seed text. Each reader's copy of the work thus becomes unique; non-trivially different from every other copy.

**The Speaking Clock**
*Speaking Clock* is a mesostic piece which tells the time.[37] It acknowledges Emmett Williams's 'Poetry Clock' and the mechanical 'Word Clocks' of John Christie, but this digital clock tells the 'real time' in language, by performing a mesostic transformation on a 365 word given text. The words of this text are arranged around the clock face on four screens. The digits 1 to 9 are mapped to the most common letters in the given text as 'etanioslr'. The date in the form 'mm/dd' is shown with time in the form 'hh/mm', by choosing words from the given text which contain the 'digit letters' and emboldening these letters on the screen. The digit letters are arranged around the clock face to indicate the simple mapping of letters to numbers and one of the clock face positions will be emboldened to show (roughly) the seconds after each minute. Zero is represented by a word with no emboldened letter. This is a ludic piece with at least one serious point to make about the language of time, and has shown itself to produce some richly evocative phrases.[38]

**(Plastic) Literary Objects**
While, in terms of reader interactivity and constructive, automatic generation of text and intertext, *The Speaking Clock* might seem a retrograde step, in terms of its presentation as a self-explanatory work, I feel it takes a step forward towards current work in progress. The poem as a form, despite the wide range of potentialities on offer in the world of contemporary poetics, is recognizable as such. It is framed by various conventions of publication but, even outside these conventions, it requires little explanation before it is recognized for what it is, leaving aside the question of its readability. On the other hand, in the current state of development, the cybertextual object pretends to require a great deal of supporting explanatory text. This is perhaps inevitable, in the same way that we might have been overly fascinated by the technicalities of cameras and projection devices during the early history of the cinema, and since there is no escaping the requirement to write sets of instructions for using relatively unfamiliar 'machines'.

However, hypertext systems are now, arguably, familiar enough to allow for the creation of cybertextual objects designed to subsist and operate without extensive explanatory framing. Hence the *(Plastic) Literary Objects*, which will be a series of literary 'applications', 'run' on a computer in the way other applications and programs are run. They will generate text if left to their own devices and also respond to any of the recognized 'events' produced by the standard peripherals of today's computer systems, chiefly keyboards and pointing devices. They will shift their textual modulation from one type of transformation to another. They will 'learn' (selectively), altering their content and also the processes of textual modulation in response to reader interaction. They will be designed as forms which can be easily filled with new textual content which may be composed or selected by their readers, who will thus become co-authors, in the form, of new (Plastic) Literary Objects.

## Brief Update on New Work
Actually-existing (P)LO's have not been created as such, except in so far as all these pieces and potential pieces are (P)LO's. Apart from the quantitative, logistical problems of creating a (P)LO as conceived, there is the non-trivial problem of 'what platform?' 'what environment?' 'what software regime?' etc. Since this essay was first drafted, there is ever more the sense that work in these media shall be 'web-capable' and yet the specification of the Web is still indeterminate and the subject of endless proprietorial and non-proprietorial disputes.

Since the clocks, my own work has been chiefly concerned with transl(iter)ation, the programmed, iterative spanning of literal disjuncture or distance. I have made a trans-lingual mesostic piece (*Oisleánd*, 1996), and a 'text movie' involving transliteral morphing (*Windsound*, 1998-99).[39] Various early and provisional versions of a navigable textual object generated from (more complex) transliteral morphs (noth'rs, 1999- ) have been issued.[40] This is still very much work-in-progress, along with *riverIsland*, 1999-, which will attempt a spanning of and commentary on the incommensurate literal disjuncture between western and Chinese systems of transcription. For latest work and developments, visit: http://www.shadoof.net/in/.

## Unrevised, All-too-provisional Concluding Remarks
There is no obvious way to conclude such a bald presentation of a body of work. The question of the work's 'value' has been bracketed in order that its formal engagement with 'experimental poetics and technological innovation' remains the focus of attention, and because it is somewhat easier for a writer to discuss the formal aspects of his or her work – without prejudice. However, the narrow formal attention that is a function of the exploration of 'new media' must ultimately broaden and engage with wider critical perspectives.

Programming is intimate with composition in all of this work. Its content-as-form is inherently protean, in a way that corresponds with the shape-shifting, multi-functional qualities of computer-based systems generally. It points to an area of potential literature which is radically indeterminate (not simply the product of 'chance operations'); which has some of the qualities of performance (without departing from the silence of reading); and in which the reader can extend the usual interpretative relationship with a text by exploring, configuring and even permanently adding to the literary objects of their attention.[41] This not only takes us beyond the bounds of the codex, but subverts the links and lexia of hypertext, leaving us to explore the indeterminate, unbounded literary potential of cybertext.

## Notes
1. Apart from its publication in *Visible Language* 30.2 (1996), the original version of this essay was also translated into Finnish for *Parnasso*, 3 (1999) pp. 290-302
2. 'New formalism' is a term described a relatively conservative practice of versified poetics centred in the United States; 'nude formalism' is Charles Bernstein self-parodic designation of his own (and others) – highly interesting, engaging, experimental and innovative – practice.
3. For this see the brief piece, Cayley, John. 1999, 'Of Programmatology', *Mute* 11 (London, fall 1998) 72-75 (also on the Web at: http://www.shadoof.net/in/prog/progset0.html). A more extended discussion of these issues forms the third part of my long essay 'Performances of Writing in the Age of Digital Transliteration', or 'The Writing of Programming in the Age of Digital Transliteration', forthcoming at http://www.shadoof.net/in/ if not elsewhere.

4. 'Serious hypertext' is a rubric of Boston's Eastgate Systems, one of the major, self-consciously literary publishers in the field, and developers of their own hypertext authoring software, 'StorySpace'. The Voyager Company has also made significant efforts to produce new work in new media as well as transpose appropriate content.
5. Various references: Landow, George P. 1992, *Hypertext: The Convergence of Contemporary Critical Theory and Technology*, Baltimore: Johns Hopkins University Press. Bolter, Jay D. 1991, *Writing Space: The Computer, HyperText, and the History of Writing*, Hillsdale: L. Erlbaum Associates. Landow, George P., ed. 1994, *Hyper/text/theory*, Baltimore: Johns Hopkins University Press. Joyce, Michael, 1995, *Of Two Minds: hypertext pedagogy and poetics*, Ann Arbor: University of Michigan Press. But now, especially: Aarseth, Espen, 1997, Cybertext: Perspectives on Ergodic Literature, Baltimore: Johns Hopkins University Press.
6. Posting to ht_lit@journal.biology.carleton.ca. No longer active. ht_lit is still accessible at: http://www.wordcircuits.com/ht_lit.htm, 28 Mar. 1995.
7. I now prefer to use the term 'programmaton' for most uses of 'computer'.
8. A generalized non-linear poetics is one of the central concerns of the hypertext poet, Jim Rosenberg. See, for example, his introductory essay in Jim Rosenberg, *Intergrams* (Boston: Eastgate Systems, 1993, published as part of *The Eastgate Quarterly Review of Hypertext*, vol. 1, no. 1). Recently he has also posted a draft discussion of these issues to ht_lit (note 3 above), 26 Mar. 1995. Espen Aarseth, 1997, op. cit. has placed hypertext in a clear context.
9. Potential Literary Outlawry or PoLiOu: potentially, a name for a broad range of experimental literary activities which are engaged with their own representation in cyberspace and with the particular capabilities which this new form of representation may offer. Clearly, the name makes explicit acknowledgement to both the anticipatory plagiarisms and the anticipated antagonisms of the OuLiPo (see note 25).
10. Cayley, John, 1988, *wine flying*, London: Wellsweep. *wine flying* was first programmed on a BBC microcomputer in 1983–84. In 1988, it was ported to the Macintosh and HyperCard, which then became my preferred development environment for this kind of work.
11. The project is uncompleted in the sense that the authoring harness has not been prepared for publication, although I have used it for individual works such as *wine flying*. This points to the question of the cybertextual author's engagement in the creation of forms themselves and how this relates to the completed work. At the present time, most of the software forms I make are intimately related to the corresponding finished works, but I can also see that, particularly in the case of non-generative work such as *Scoring the Spelt Air*, that the form could easily be detached from any specific content.
12. The writer of the letter was Humphrey McFall, whom it is a pleasure to acknowledge.
13. 'Lexia' is a term adopted by George Landow from Roland Barthes to indicate the unit of text at either end of a hypertext link.
14. "I am on record as advocating taking hypertext into the fine structure of language, thereby fragmenting the lexia ...", 'Notes toward a non-linear prosody of space', Jim Rosenberg, posting to the ht_lit discussion list (note 3), 26 Mar. 1995; or in a later posting elsewhere, "... my own interest [is] in using hypertext to carry the infrastructure of language itself ..." 28 Oct. 1995. And see Aarseth, 1997, op. cit.
15. I first gained regular access to a Macintosh computer with HyperCard in 1988, as noted above.
16. Cayley, John, 1991–93, *Indra's Net I*, London: Wellsweep. Details of the other publications in the series will be given as they are first mentioned in the text. All are HyperCard 2.x stacks which are published on disk or over the Internet, currently for Macintosh computers only.
17. Ch'en, Kenneth, 1964, *Buddhism in China: A Historical Survey*, Princeton: Princeton University Press, 317.
18. "But the fact that the mind itself has no internal necessity to determine its every act and compel it to suffer in helpless passivity – this is due to the slight swerve of the atoms at no determinate time or place." Lucretius, *The Nature of the Universe*, Book 2, translated by R. E. Latham (Harmondsworth:

Penguin, 1951), p. 68. The swerve or 'clinamen' of Lucretius is also a major reference point for the OuLiPo (see note 25), even though the workshop is, generally, suspicious of the aleatory.
19. See, especially: Emmett Williams, *A Valentine for Noël: Four Variations on a Scheme* (Barton, Brownington, Berlin: Something Else Press, 1973) and also his *Selected Shorter Poems (1950-1970)* (New York: New Directions, 1975). A selection of Jackson Mac Low's Asymmetries is included in his *Representative Works: 1938-1985* (New York, Roof Books, 1986). His 'diastic' technique was used in *The Virginia Woolf Poems* (Providence: Burning Deck, 1985). See also note 24 below. Cage's mesostics include *Roaratorio: An Irish Circus on Finnegan's Wake* (first produced in Paris in 1978) and *I-VI* (Cambridge: Harvard University Press, 1990). There is interesting discussion of these works in Marjorie Perloff, *Radical Artifice* (Chicago and London: University of Chicago Press, 1991), especially chapters 5 and 7. For a far more comprehensive treatment of these and other precursors in the field of innovative poetics, refer to Loss Pequeño Glazier, *Digital Poetics: The Making of E-Poetries* (Tuscaloosa: University of Alabama, Alabama Press, 2002).
20. It would be interesting to make a catalogue of the precise varieties of *generative* acrostic and mesostic procedures, noting their differences; although this is far beyond the scope of this paper.
21. This technique bears certain similarities to those developed by Stefan Themerson and set out in *On Semantic Poetry* (London: Gaberbocchus Press, 1975). Further details of a number of other potential and (in Indra's Net) as yet unrealized forms can be found in the explanatory material which is introductory to the pieces in Indra's Net I-III. These include further etymological and glossological hologograms; phonemic hologograms (these would generate a form of sound poetry) and morphemic hologograms (which I will eventually explore since they would provide a way of engaging a language like Chinese). A forthcoming commission will investigate mesostic transformations from original to translation (in another alphabetic script) and back again.
22. This 26-word form is similar to Williams's 'ultimate poetry' except that in my strict form I try to make a 26-word sentence or narrative (in the traditional order of the letters). An aspect of this form which I cannot resist mentioning is that once, like Williams, Mac Low or myself, you have mapped the 26 letters of the alphabet onto 26 words, it is theoretically possible to encode all of literature acostically or mesostically — translating everything into a 'surface language' of 26 meaning-tokens (with no loss of information). Perhaps alphabetization was once perceived like this, as early scribes moved from away from morphemic script elements — as if 'book' seemed to present itself as: 'house + eye + eye + palm-of-the-hand'.
23. Oscar Pastior in his *Poempoems* (first published in German in 1973) has a more poetic and less formalist approach to such a self-referentiality: "... holography ... to make a text as far as possible such that every part contains the whole. That is an image I hold in front of me." Oscar Pastior, *Poempoems* (London: Atlas Press, 1991; first publication of Pastior's work in English, as part of *The Printed Head* series, vol. 1, no. 5). Eduardo Kac is another early explorer of the application of holography to literature and vice versa. See his first 'holopoem' (with Fernando Catta-Preta), *HOLO/OLHO* (1983), and his remarks in 'Holopoetry and Fractal Holopoetry' (*Leonardo*, 22. 3 & 4, 1989), "Holo/Olho (Holo/Eye) ... is a combination of anagrams in which the word holo mirrors olho and vice-versa. The mirroring effect, however, was conceived so that fragments of the poem would contain enough letters to form the entire meaning: both holo and eye. The arrangement of letters in space was holographed five times; each hologram was fragmented and the five holograms were reassembled in a new visual unit. This holopoem was an attempt to recreate, in its own syntax, a structure that would correspond to the holographic model, according to which the information of the whole is contained in the part and vice-versa." (p. 399)
24. Cayley, John, 1993, *Collocations: Indra's Net II*, London: Wellsweep.
25. Cayley, John, 1995, *An Essay on the GOLDEN LION: Han-Shan in Indra's Net*, Edinburgh: Morning Star Publications. See the discussion of *Golden Lion* below.
26. Cayley, John, 1993, *Under it All: texts, holography, afterword*, London: Many Press. This little book was published in an edition of 221 copies, each of which was unique. Four separately

prepared pages bound into each copy consist of unique samples from two holographic transformations.

27. An animated version for HyperCard is in the works, and there is a plan for an installation to project words onto mesostic planes, realized as a set of 26 transparent screens hung so as to suggest a large cubic word space. Read from its 'front' through all of the 26 layers, fragments of a given text would be legible as the text was generated and projected words onto the planes. But moving around the cube, other mesostically determined orders of words would present themselves.

28. Here, a line of similar and in some respects, parallel work (which did not directly influence my own until recently) runs from the text-scrambling program 'Travesty' by Joseph O'Rourke and Hugh Kenner, intersecting with Mac Low at the point of his *Mertzegedichte: in memoriam Kurt Schwitters, February 1987–September 1989*. During the composition of his *Merzgedichte* in mid 1989 (Barrytown: Station Hill, n.d. [1994]). Charles O. Hartman sent Mac Low several computer programs including 'Diatext' and 'Diatex4'. He also started to make use of Hugh Kenner and Joseph O'Rourke's 'pseudo-text-generating' program 'Travesty' at about this time, to create some of the poems. However, "All outputs were subject to rule-guided editing." (sleeve notes for the audio CD, *Open Secrets* (NY: XI, Experimental Intermedia Foundation, n.d. [1994]). Most recently, such processes have been used in Hartman and Kenner's new book, *Sentences* (Los Angeles: Sun & Moon, 1995). 'Travesty' is a text processor which, set to its higher 'orders', will produce results similar to those of my collocational procedures.

29. Mathews, a member of the OuLiPo, outlines his version of the procedure in: *20 Lines a Day* (Elmwood Park: Dalkey Archive Press, 1988, p. 90). The OuLiPo, or Ouvroir de Littérature Potential, is clearly a basic reference point for cybertextual developments given the workshop's profound and ludic investigations of the relationship between mathematics and literature, constrictive form, combinatory literature, etc. (See, as an introduction: Warren F. Motte Jr. ed., *OuLiPo: A Primer of Potential Literature*, Lincoln and London: University of Nebraska Press, 1986, or more recently Harry Mathews and Alastair Brotchie eds, *OuLiPo Compendium*, London: Atlas Press, 1998). However, the OuLiPo has, at best, an ambiguous attitude to the aleatory as an aspect of generational, constrictive or combinatory procedure, despite the fact that the distinction between choice as chance and the choice of *arbitrary* formal constraints may be too nice to rule out the potential of one or the other.

30. See note 22 above.
31. Cayley, John, 1993-94, *Moods & Conjunctions: Indra's Net IV*, London: Wellsweep.
32. Cayley, John, 1994, *Golden Lion: Indra's Net V*, London: Wellsweep.
33. See note 25 above.
34. Cayley, John, 1995a, *Golden Lion: Indra's Net V*, London: Wellsweep.
35. William Burroughs and Brion Gysin, 1960, *The Exterminator*, San Francisco: Auerhahn Press. Sinclair Beiles, William Burroughs, Gregory Corso and Brion Gysin, 1960, *Minutes to Go*, Paris: Two Cities Editions.
36. Cayley, John, 1995b, *Book Unbound*, London: Wellsweep. *Book Unbound* was also included in the CD-ROM issue, number 3, of the arts magazine, *Engaged* (London, 1995), it was later also selected for inclusion in the Hypertext special issue—edited by Stuart Moulthrop—of *Postmodern Culture* 7, no. 3 (subscribers only); and anthologized in *Dietsche Warande & Beaufort [DWB]* 4 (August 1999) mini-anthology plus CD-ROM on "electronic (visual) literature" edited by Eric Vos and Jan Baetens (screenshot, p. 458; 'Book Unbound' on CD-ROM).
37. Cayley, John, 1995c, *The Speaking Clock*, London: Wellsweep. Extracts from the clock were also published in *Chain*, 4 (fall 1997) pp. 25–27.
38. The serious point, to quote from the given text: "Real time is concealed beneath the cyclical behaviour of clock and time piece. No moment is like any other ... and yet the clock applies the same 'name' to many a different instance." *The Speaking Clock* affects to give a unique name to every moment.

39. *Oisleánd*, as a HyperCard stack only, can still be downloaded from http://homepage.mac.com/shadoof/FileSharing9.html. It was commissioned for an installation at the Midlands Art Centre (MAC), Birmingham, UK in May–June, 1995.
40. Severely cut-back and earlier versions of 'noth'rs' appeared on the CD-ROM which accompanies the current issue of *Performance Research* ('On Line', *Performance Research*, 4.2 (summer 1999), edited by Ric Allsopp and Scott deLahunta); and on the Web at 'Riding the Meridian' <http://www.heelstone.com/meridian/cayley.html>. An initial performance version was shown at Digital Arts and Culture 1999, Atlanta, Georgia, 28–31 Oct 1999.
41. I owe this characterization in part to Espen Aarseth, who has developed a (media independent) "generalized model with a few broad categories that can describe the main differences of textual phenomena." in his excellent book *Cybertext*, 1997, op. cit. He argues convincingly for a distinction between cybertext and hypertext, putting forward the former as an inclusive term embracing, for example, indeterminate or reader-constructed texts, and reserving hypertext for (passively) linked structures of static lexia (textual nodes).

# PART II – MULTIMEDIA POETICS

# Holopoetry

**Eduardo Kac**

### 1. Defining a holopoem
A holographic poem, or holopoem, is a poem conceived, made and displayed holographically. This means, first of all, that such a poem is organized non-linearly in an immaterial three-dimensional space and that even as the reader or viewer observes it, it changes and gives rise to new meanings. In holopoetry, immateriality refers to the fact that the verbal elements are organized in a space made of diffracted light, and not on any tangible or concrete form, such as the printed page. This new space, defined by photons, has no mass or tangible expression. As the viewer reads the poem in space – that is, moves relative to the hologram – he or she constantly modifies the structure of the text. A holopoem is a spatiotemporal event: it evokes thought processes, and not their result.

A holopoem is not a poem composed in lines of verse and made into a hologram, nor is it a concrete or visual poem adapted to holography. The sequential structure of a line of verse corresponds to linear thinking,[1] whereas the simultaneous structure of a concrete or visual poem corresponds to ideographic thinking. The poem written in lines, printed on paper, reinforces the linearity of poetic discourse, whereas the visual poem sets words free on the page. Like poetry in lines, visual poetry has a long ancestry, which runs from Simias of Rhodes (325 BCE), through the Baroque poets, to Modernists such as Marinetti, Kamensky, Tzara, Cummings and Apollinaire, and most recently to the experimental poets of the 1960s and 1970s.

Following in this tradition, while at the same time opening up a new path, holopoetry began in 1983 by freeing words from the page. It was important back then, as it still is today, that the holopoem can be duplicated in large quantities and that it calls for silent reading. As distinguished from visual poetry, it seeks to express the discontinuity of thought; in other words, the perception of a holopoem takes place neither linearly nor simultaneously but rather through fragments seen by the observer according to decisions he or she makes, depending on the observer's position relative to the poem. Placing bodily intelligence on equal grounding with linguistic and logical intelligences, holopoetry transfers to the kinesthetic phenomenon of reading aspects of meaning production which formerly were assigned to linear syntax. In other

words, perception in space of colours, volumes, degrees of transparency, changes in form, relative positions of letters and words, and the appearance and disappearance of forms is inseparable from the syntactic and semantic perception of the text. The instability of colour has poetic function and the visual mutability of letters extends them beyond the verbal domain.

If we compare the elements of language with the basic concepts of Euclidean geometry, we may think of letters as points, words, and sentences as lines, and visual texts as planes. Thus, letters would have dimension 0; sentences, dimension 1; and visual texts, dimension 2. By extension, one might conclude too quickly, holopoems, which free the text from the page and project it into the reader's space, would have dimension 3.

But holopoems are actually quadri-dimensional because they integrate dynamically the three dimensions of space with the added dimension of time. This is not the subjective time of the reader found in traditional texts, but a perceived time expressed in the holopoem itself. Complex digital fractal forms can also be visualized holographically, clearly suggesting that holographic images can also possess dimensions in between those numbered with whole numbers.[2] Fractal geometry describes shapes that exceed the dimension that traditionally would be ascribed to them. As such, I suggest, they teach us to accept the passage from one dimension to the next as a new value in its own right. In this context, Euclidean geometry becomes a part of fractal geometry, since the discrete whole numbers of the former are part of the continuum of the latter (e.g., dimension 2 is in between dimensions 1.9 and 2.1).

In keeping with the mathematical analogy, if we are able to think of dimensions as part of a scaling continuum, it is also conceivable to think of a written language that moves and changes in space-time. Such language, of which holopoetry is a paramount example, is predicated on the dynamic passage from the verbal code (the word) to the visual code (the image) and vice versa. This irresolvable transition is essential to the holopoem. The poetic experience is enriched when the viewer or reader sees a work that continually oscillates between text and image.

It is very important to emphasize that not all texts recorded on holographic film are holopoems. It is technically possible, for example, to record a symbolist sonnet on a hologram. Such a sonnet does not become a holopoem simply because it is displayed on holographic film. What defines a holopoem is not the fact that a given text is presented on holographic recording materials. What matters is the creation of new syntaxes, mobility, non-linearity, interactivity, fluidity, discontinuity, and dynamic behaviour only possible in holographic space-time. It must be said that, in the future, even genuine holopoems might not be recorded on holographic film, since digital recording of holograms will become available. Holograms will also one day be scriptable. When that happens, new possibilities will emerge, and holopoetry will lead to other, newer areas of poetic experimentation.

## 2. Fundamentals of Holopoetics

Poetry is an art that uses words as its raw material. Traditionally, it is the intrinsic verbal inventiveness (phonetic, graphic, syntactic, semantic) of the poem that makes poetry distinct from other genres. However, some of the most radical and fascinating developments in the twentieth century resulted from aesthetic experimentation and the hybridization of genres, processes, and materials, lending poetic qualities to prose and vice versa, introducing literary

properties into the visual arts, and imbuing poetry with graphic substance. Artists' books exemplify an area of intersection between literature and the visual arts. Conceptual art gave greater emphasis to linguistic meaning than to pictorial experience. Visual poetry enriched the word, giving it physicality on the surface of the paper and extending this physicality to other materials, as in the case of poems made with wood, plastic, glass, and metal.

Holopoetry belongs to the tradition of experimental poetry and verbal art, but it treats the word as an immaterial form; that is, as a sign that can change or dissolve into thin air, breaking its formal stiffness. Freed from the page and freed from other palpable materials, the word invades the reader's space and forces him or her to read it in a dynamic way; the reader must move around the text and find meanings and connections the words establish with each other in empty space. Thus, a holopoem must be read in a broken fashion, in an irregular and discontinuous movement, and it will change as it is viewed from different perspectives.

When one reads a conventional text or looks at objects in the surroundings, slightly different images are perceived by each eye. These are two views of the same object. But in the reading of a book, newspaper or printed poem, this perceptual process is not evident, nor does it affect what is being read in any fundamental way: what the left eye sees is virtually the same as what the right eye sees. In the case of a holopoem, however, the reading is a synthesis of the two different inputs received by the eyes and is therefore something more complex and intense. I call 'binocular reading' the process according to which some holopoems present different letters and words to each eye simultaneously. Binocular reading takes place when we read one word or letter with the left eye and at the same time a completely different word or letter with the right eye. In reading a holopoem we are constantly changing the way we mentally 'edit' the text, based on the different inputs taken in during the different fixations of each eye on the letters in space.

The linguistic relation that produces meaning – syntax – is constantly changing because of the reader's perceptual activity. The holopoem's 'perceptual syntax' is conceived so as to create a mobile signifying system and thus extend its expressive power to encompass time, since the words are not fixed upon a surface but rather float in space. Visual poetry developed a visual syntax – based on the rejection of linear syntax and on the elaborate visual treatment of the words on the page. Holopoetry develops a perceptual syntax – based on the rejection of the static syntax of print and on the development of complex and dynamic spatio-temporal verbal systems. In holopoetry words are associated not in a pattern, as in the simultaneity of gestalts, but in a dispersed and non-linear photonic environment.

Holotexts can only signify upon the active perceptual and cognitive engagement on the part of the reader or viewer. This ultimately means that each reader "writes" his or her own texts as he or she looks at the piece. Holopoems do not rest quietly on the surface. When the viewer starts to look for words and their links, the texts will transform themselves, move in three-dimensional space, change in colour and meaning, coalesce and disappear. This viewer-activated choreography is as much a part of the signifying process as the transforming verbal and visual elements themselves.

Language plays a fundamental role in the constitution of our experiential world. To question the structure of language is to investigate how realities are constructed. Holopoems define a

linguistic experience that takes place outside syntax and conceptualize instability as a key signifying agent. They blur the frontier between words and images and create an animated syntax that stretches words beyond their meaning in ordinary discourse. Holopoems undermine fixed states (i.e., words charged visually or images enriched verbally) and create a constant oscillation between them.

The temporal and rhythmic organization of holotexts plays an important role in creating this tension between visual language and verbal images. Most of the holopoems I created between 1983 and 1993 deal with time as non-linear (i.e., discontinuous) and reversible (i.e., flowing in both directions), in such a way that the viewer/reader can move up or down, back and forth, from left to right, at any speed, and still be able to establish associations between words present in the ephemeral perceptual field.

In holopoetry colour is not fixed. It is relative. One viewer can see a letter in one colour and immediately see it change into another. Two readers looking at the same word could see it in different colours simultaneously. While many writers and artists are disturbed by this uncontrollable behaviour, I find it perfectly appropriate to stress the ungraspable nature of meaning. The oscillatory nature of colour in my holopoems moves away from traditional symbolism and from the use of colour as a structuring visual element. The chromatic system of each holopoem is created within certain parameters, which I specify. The creation of viewing zones and the behaviour of colour in a holopoem is intrinsically related, since form and relative position of viewing zones affect the diffraction of light.

A viewing zone is a non-physical zone, located in front of the hologram, through which the reader can actually see the words in the poem. When I create a holopoem, it is part of my writing process to decide how wide, tall, and deep the viewing zones will be. I also decide the shape and relative position of these viewing zones. I can decide how many there will be and what gaps might there be between them. I can combine multiple viewing zones and edit them in many ways. I can decide on a number of viewing-zone parameters, which I use to create the unique quality of each work. The reader never sees a visual representation of these viewing zones. They are invisible. Viewing zones can be rendered sequentially and discontinuously, which helps create the space and the syntax of each holopoem.

Through multiple viewing zones holopoetry promotes new relationships between the appearance-disappearance of signifiers, which constitutes the experience of reading a holographic text and our perception of the organizing factors of the text. In this sense, visual perception of parametric behaviour of the verbal elements heightens awareness of meanings. As readers move they continually shift the focus or center or organizing principle of their experience by looking through dispersed viewing zones. The text they experience stands against the fixity of print and for the branching of holographic space. Parallax is also an important agent in holopoetics. Parallax is the perceived change in the direction of an object, caused by a change in observational position that provides a new line of sight. Many holopoems explore parallax semantically.

Because of their irreducibility as holographic texts, holopoems resist vocalization and paper-print reproduction. Since the perception of the texts changes with viewpoint, they do not posses

a single "structure" that can be transposed or transported to and from another medium. The combined use of computers and holography reflects my desire to create experimental texts that move language and, more specifically, written language, beyond the linearity and rigidity that characterize its printed form. I never adapt existing texts to holography. I create works that develop a genuine holographic syntax.

## 3. Theoretical Issues in holopoetry and the readerly experience

Twentieth-century visual poetry evolved having the printed page as its basic structuring agent, as a support upon which ink is laid to form the verbal composition. As a physical surface where the poem is inscribed, the white on the page gained meaning and in most cases contrasted as silence with the verbal inscriptions that often resonated as representations of sounds. Once printed, the verbal sign is fixed on the surface and its signification is bound by the rigidity of the page, very much like a line drawn on a canvas. The comparison with painting is not accidental, because both modern poetry and modern art searched for the specificity of their materials simultaneously, leading to non-narrative poetry and non-figurative art. As modern painting moved away from representation becoming abstract and non-referential, modern poetry moved away from the linear becoming fragmented. Some poets tried to give a new direction to the ancient "figurative poem" (i.e., a poem in the shape of an object), but this tendency is a minor part of modern and contemporary literary experiments. Even in Apollinaire's *oeuvre*, shaped words do not always signify straightforwardly the subjects of the shapes they were moulded into, creating an ideogrammatic tension between the symbolic [verbal] and the iconic [visual].

Among the linguistic conventions of the West is the left-to-right orientation of the reading process, which is an arbitrary representation of the linear chain of spoken language. This is valid also for the two-dimensional page, which inherited the norm and is read from left to right and from top to bottom. In a sense, the reading from top to bottom follows an ordinary perception of reality, which is regulated by the action of gravity upon elements. A sequence of pages in a book is conventionally read from left to right as well, resembling the chain formed by sequences of words in a sentence. It is impossible not to take into account the limits imposed upon poetic creation by the physical properties of the visual space the poet works with. The poet's challenge is exactly to disregard conventions and to create new codes, moving language beyond the redundant, the verbose and the ordinary. Modern visual poets distributed words freely on the page, or created self-referential structures, sometimes with permutational reading possibilities between the words in the fixed structure. They printed fragments of words, enhancing their visual nature, or made the word an image in itself, always within the perimeter of the immutable page or the tangible boundaries of firm and stable three-dimensional materials. The immutability and stability of two-dimensional and three-dimensional surfaces conditioned the signifying spectrum of visual poetry thus far.

In a reaction against fixed structures, holographic poetry creates a space where the linguistic ordering factor of surfaces is disregarded in favor of an irregular fluctuation of signs that can never be grasped at once by the reader. This turbulent space, with bifurcations which can take on an indefinite number of rhythms, allows for the creation of what I call textual instability. By textual instability I mean precisely the condition according to which a text does not preserve a single visual structure in time as it is read by the viewer, producing different and transitory verbal configurations in response to the beholder's perceptual exploration. The differences between

the holopoem and other kinds of experimental poetry are marked by a set of characteristics that work together to destabilize the text, to plunge it into its specificity as written [text] as opposed to graphic representation [of speech], to create a syntax based on fleeting transformations and discrete leaps.

As Derrida has suggested,[3] no text can be fully controlled by its author, to whom its inherent contradictions and collateral meanings inevitably escape. The precise positioning of [apparently stable] words on the [inanimate] surface of the page gives author and reader the illusion of control, of mastery and command of the text (and often of the exterior reality it refers to). Holographic poetry tries to exhibit the impossibility of an absolute textual structure; it attempts to create verbal patterns with disturbances that magnify small changes in meaning according to the perceptual inquiry of the reader. For example: a syntactical structure can be created in which one could see twenty or more words occupying the same space without overlapping; a word could also transform itself into another word/shape or vanish momentarily. Letters can collapse and reconstruct themselves or move to form other words in a time-reversal transition. These and all other latent expressive possibilities of holopoetry are unique to its grammar and they are only possible in part because its space, as I create it, is an oscillatory field of diffracting light as opposed to the tangible surfaces of pages and objects. The white on the page which once represented silence is removed and what remains is empty space, an absence of (printing) support which has no primary symbolic value. The vacuous gaps between words and letters do not represent positively absence of sound, because the photonic inscriptions do not stand essentially for its presence. We are in the domain of spatio-temporal writing, four-dimensional writing, where spatial gaps do not point to anything except for the potential presence of graphemes. The voids are not to be "seen", unlike the white on the page. They are, to take Derrida's words literally, an interplay of absence and presence.[4]

Needless to say, for the written word AIRPLANE, for example, to refer to [to mean] the vehicle that transports people and objects by air, it must belong to the proper textual and cultural contexts, and its letters must be perceived by our senses in the proper sequence. The word that results from the sequence of letters must remain visually constant. In visual poetry, the verbal sign has been subjected to a number of graphic treatments that contributed to extend the meaning of words beyond their conventional associations. But once a printed word is sliced, fragmented and/or incorporated into a collage, it cannot escape the immutability of the final composition.

The dissolution of the solidity of the poetic space, which makes the discontinuous syntax of holopoetry possible, also affects the signifying units of the poem, i.e., the word and the letter. One of the elements of holopoetry, which nevertheless does not necessarily appear in all holographic texts, is what I call a fluid sign. It is essentially a verbal sign that changes its overall visual configuration in time, therefore escaping the constancy of meaning a printed sign would have as described above. Fluid signs are time-reversible, which means that the transformations can flow from pole to pole as the beholder wishes, and they can also become smaller compositional units in much larger texts, in which each fluid sign will be connected to other fluid signs through discontinuous syntaxes.

Fluid signs create a new kind of verbal unit, in which a sign is not either one thing or another thing. A fluid sign is perceptually relative. For two or more viewers reading together from distinct

perspectives it can be different things at one time; for a non-stationary reader it can reverse itself and change uninterruptedly between as many poles as featured in the text.

Fluid signs can also operate metamorphoses between a word and an abstract shape, or between a word and a scene or object. When this happens, both poles reciprocally alter each others' meanings. A transfiguration takes place and it produces in-between meanings that are dynamic and as important in holopoetry as the meanings produced momentarily at the poles. The meanings of in-between configurations can not be substituted by a verbal description, like the word AIRPLANE can be substituted in the proper context by its definition (i.e., "the vehicle that transports people and objects by air"). Neither can they be replaced by a synonym or a specific word, as grey suggests a specific intermediary position or meaning between black and white.

In holopoetry transient clusters of letters or ephemeral shapes that lay between a word and an image aim to dynamically stretch the poetic imagination and suggest meanings, ideas, and feelings that are not possible to convey by traditional means. Holopoetry establishes a syntax of disruptive events; an animated language that evades and deflects interpretation. Holopoetry is not possible without propagating light as the medium for interactive reading/writing. A holopoem is interactive in the sense that the natural movement of the viewer in front of the holopoem is enough to change what he or she reads. In holopoetry, texts are signifying networks animated by motion scripting and discontinuous word apparitions. This discontinuity is created in a holopoem when the homogeneity of the three-dimensional volumetric space of the hologram is broken down into discrete units that may or may not overlap with one another. Often these units are diffracted obliquely in relation to the hologram, forming complex topologies.

## 4. Writing holopoems

From 1983 to 1987 I pushed the limits of optical holography, writing poems that for the first time introduced in the field of poetics compositional elements such as pseudoscopy, discontinuity, luminous dissolution, three-dimensional juxtaposition, spatial compression, integral animation, colour instability, and digital synthesis of impossible spaces. The body of work I developed during this phase was shown in solo and group exhibitions. As a consequence of my search for a turbulent space that is prone to mutability, I began experimenting in 1987 with a new kind of text I call digital holopoetry. Because I write digital holopoems in a process of stereoscopic synthesis, as opposed to the method of optical recording I used for most of my other holopoems, they allow me to manipulate each element of the text with more precision.[5]

The writing techniques I have developed allow me write texts in which the viewer, just by looking at words and letters, dislocates them from their position in a space zone. The unsettling choreography of my previous texts gains a new motion factor in addition to the "quantum leaps" and the optical fusions that occurred before between two or more zones in space. I can now write pieces in which the reader perceives animated fragmentations and actual metamorphosis within a single zone, or I can incorporate these and other new possibilities into hybrid poems that integrate the optical and the digital. With digital holopoems I extend the solubility of the sign to the verbal particles of written language, the letters themselves, widening the gamut of rhythms and significations of the text.

My writing process can be outlined as follows: 1) generation and manipulation with digital tools of the elements of the text on the simulated space of the computer "world" by means of a raster or vector-based software (this step could also be referred to as the modeling stage); 2) study and previous decomposition of the multiple visual configurations the text will eventually have; 3) rendering of the letters and words, i.e., assignment of shades and textures to the surface of the models (texture maps can be invented at will and shadows can be avoided in situations where they would necessarily exist if we were dealing with tangible models); 4) interpolation, i.e., creation of the animated sequences, which are now stored as a single file on the memory of the computer (this stage could also be referred to as "motion scripting"); 5) exportation of the file to an animation software and editing of the sequences (including post-manipulation of the elements of the text); 6) frame-accurate sequential recording on film of the individual scenes, which correspond to discrete moments of the text (this can also be done with an LCD screen); 7) sequential recording of the individual scenes on a laser hologram; and 8) final holographic synthesis achieved by transferring the information stored on the laser hologram to a second hologram, now visible in white light.

In this process, film is used only as a temporary storage medium (due to its high resolution). It is intrinsic to the method of film the projection in theaters of one and only one frame at a time. All frames are projected in the same space, one at a time, in a rapid succession. The audience perceives exactly the same frame with both eyes. In three-dimensional film, two frames are projected in the same space at one time. Both frames correspond exactly to the same moment, but from discrete points of view. The audience perceives one frame with one eye and the other frame with the other eye, thus forming a stereoscopic image. In holopoetry, all frames occupy the same space, all at the same time, and are not projected but suspended in the same space. They are only perceived if the viewer moves relative to the hologram. Frames can correspond to: 1- the same frozen moment or three-dimensional space as seen from different points of view; 2- different moments of an action; and 3- completely different images corresponding to disparate spatio-temporal references. These possibilities create new reading and writing strategies.

Animation is an important aspect of writing digital holopoems. The word "animation" in holopoetry refers to the fact that the words employed in a piece are set (and seen) in motion. This is usually produced on a computer and then transferred to the hologram, although purely holographic animations are also used occasionally. Computer animations are created specially for the syntax of the holopoem. This involves a complex pre-visualization experience. Computer animations that are created for video or film do not work well in a hologram. This is due to the differences between the monoscopic surface of screen-based animations and the stereoscopic space of the hologram. A holographic animation must be created taking into account the stereoscopic perception of the viewer. For example: in holopoetry the viewer may see frame number one with her left eye at the same time that she may see frame thirteen with her right eye.

### 5. Holopoems
*Holo/Olho* (Holo/Eye), the first holopoem (1983), is a combination of anagrams in which the word "holo" mirrors "olho" and vice versa. The mirroring effect, however, was conceived so that fragments of the poem would contain enough letters to form both holo and eye. The

arrangement of letters in space was holographed five times; each hologram was fragmented and the five holograms were reassembled in a new visual unit. This holopoem recreated, in its own syntax, a structure that corresponds to the holographic model, according to which the information of the whole is contained in the part and vice versa.

Then came *Abracadabra*, a holopoem created between 1984 and 1985. This work illustrates well the concept of discontinuous space, because precise control enabled me to predetermine the region in space where each letter was to be placed, as well as the specific angles at which they would become perceptible. Thus, at no time can the reader simultaneously perceive the complete set of letters that make up the word: one is forced to read discontinuously, in broken fashion. In this holopoem, the letter A, which symmetrically structures the word AbrAcAdAbrA, was image-planed (with part of the image in front of and part behind the plate) in the center of the visual field, while the consonants were placed around it (B and C as real images; D and R as virtual images) as if the vowel were an atomic nucleus and the consonants were the particles orbiting around it.

I created the holopoems *Oco* and *Zyx* in 1985. *Oco* employs two holograms, one with the letter I and the other with the word OCO. The first is displayed in front of the second, multiplying

Figure. 1: Eduardo Kac, "Holo/Olho" (Holo/Eye), 25 X 30 cm, reflection holograms mounted on wood and plexiglass, 1983. Collection UECLAA, University of Essex, United Kingdom.

Figure. 2: Eduardo Kac, "Abracadabra", 25 X 40 cm, transmission hologram, 1984/85 (two points of view). Collection of the Pará State Museum, Belém, Brazil (gift of the National Foundation for the Arts—Funarte, Brazil).

reading possibilities. In *Zyx* I used the three letters that name the axes of three-dimensional space to form new, nonexistent, bizarre-sounding words. The actual work is a set of fragments against a reflecting background that duplicates the reader's face inside the hologram and presents the letters X, Y, and Z in discontinuous fashion. In this holopoem, the volume of each letter dissolves into colours.[6]

In 1986 I made three new pieces. In the holopoem *Chaos* the letters C, H, and A are distributed in pseudoscopic space (space where the image is inverted, inside out – the opposite of orthoscopic space), so that they move in space in a direction opposite to that of the reader's movement. This work opens the possibility of a letter changing into an abstract colour image and vice versa, for pseudoscopic space does not respect optical conventions regarding the proportion and conservation of forms. The letters S and O complete the reading *in absentia*, eliciting SOS from the word CHAOS. Other intertextual possibilities may emerge, such as the words "só" and "ossos" ("alone" and "bones" in Portuguese, respectively).

Also in 1986, I made the holopoems *Wordsl No. 1* and *Wordsl No. 2*. The first is an experiment in optical anamorphosis: the letters of the words "world" and "words" were holographically combined into a new word, WORDSL, and placed in a 180-degree arc around my head. This

HOLOPOETRY | 139

Figure. 3: Eduardo Kac, "Zyx", 50 X 50 cm, laser transmission hologram mounted on front-surface mirror, 1985 (two points of view).

information was transferred to a 90-degree hologram, through a process of contraction in virtual space (space within the hologram) that changed the forms of the letters; some of the letters, however, seem to go around and behind the hologram, reappearing in their proper proportions in real space (space in front of the hologram).[7] The curvature itself of the integral hologram (so called because it integrates motion pictures and holography and because it recreates the integral movement of a scene) is the cause of this phenomenon. This relates to the topic of visual deformation in variously curved spaces, which was investigated by Georg Riemann in 1854 in his non-Euclidean geometry and which greatly interested avant-garde artists early in this century.[8]

*Wordsl No. 2* displays the same verbal material, only this time in a space that is both real and pseudoscopic. This piece proposes a reading in a succession of vertically oriented strips (from the bottom up and vice versa), a sort of scanning instead of a global sighting of the scene or object.

140 | MEDIA POETRY: AN INTERNATIONAL ANTHOLOGY

Figure. 4: Eduardo Kac, "Chaos", 30 X 40 cm, reflection hologram, 1986 (two points of view). Edition of 2. Collection MIT Museum, Cambridge, MA.

In 1987, I created the holopoem *Quando?* (When?), in which a monolithic abstract shape rotates around its own axis, alternately disclosing and concealing the words of the text as it spins.[9]

Figure. 5: Eduardo Kac, "Wordsl", 30 X 30 cm, integral hologram, 1986.

I created a 360-degree hologram, but not a 360-degree image that is seen as one sees a sculpture or an ordinary object. The monolithic fractal object rotates to accomplish almost two full turns inside the hologram. It thus widens the 360-degree space to nearly 720 degrees. This gives rise to a perceptual paradox only made possible by holography: although one sees a 360-degree Plexiglas cylinder inside which there is a 360-degree holographic film, the fractal turns and multiplies the holographic space.

The text was conceived so that it could be read at any angle, but there is a basic structure that allows it to be read either clockwise or counterclockwise. Counterclockwise the viewer reads A LUZ / ILUDE / A LENTE / LENTA / MENTE (the light/deceives/the lens/slow/ly); clockwise the text is A LENTE / ILUDE / A LUZ / MENTE / LENTA (the lens/deceives/ the light/slow/mind). Other readings, just as valid as these, may arise, for instance, A LUZ/ MENTE / LENTA / A LENTE / ILUDE (the light/lies [i.e. tells lies]/slow/the lens/deceives). In Portuguese, the adverb lentamente (slowly) is made up of the adjective lenta (slow) and the adverbial suffix -mente (-ly), which as an autonomous word may mean either 'mind' (noun) or 'lies' ('tells lies').

These words never appear all at the same time; they become visible as the fractal turns inside the hologram and restructures its space. The words float before the fractal, and every time it turns, a new one appears. It is the fractal that causes the passage from one word to the next. As the fractal turns and passes from one word to the next, the words, which are legible when viewed frontally, are seen sideways, thus becoming illegible. They are seen as abstract forms.

Figure. 6: Eduardo Kac, "Quando?" (When?), 40 cm diameter, cylindrical digital hologram, 1987/88.

In this case, the text loses its verbal meanings and the entire set changes into a nonverbal form; thus the revolving fractal makes the viewer see a text in a reversible process. As the fractal turns, the boundary between word and image is assigned to time. For instance, the viewer will read, depending on his or her perspective at the moment, the adverb lentamente (slowly) or see it change into the noun mente (mind) and the adjective lenta (slow). From a third point of view, one can read mente as a verb preceded by a luz: a luz mente ('light lies', in the sense of 'tells lies').

\* \* \*

While still living in Rio de Janeiro, Brazil, I produced seven holographic poems, from Holo/Olho (1983) to Quando?(1987/88). These early pieces were made either in Brazil or in the US. In 1989 I moved to Chicago, where I was able to work and experiment on an ongoing basis. Below I describe briefly the poems I made in Chicago.[10]

My first piece in Chicago was *Phoenix* (1989), a poem composed of only one letter that draws attention to its visual properties instead of representing a particular sound. Designed with ambiguity, the letter W might be perceived as a stylized bird with open wings. It floats in front of the holographic film plane (twenty inches away from it) and is transfixed by a vertical open flame that can be read as the letter I and which moves randomly according to air currents. The laser transmission letter-image produces a curious harmony with the actual flame, suggesting perhaps that we are as fascinated by laser images today as the primeval man was by fire. Where the laser red meets the blue flame, a hybrid magenta is perceived.

Conceived in collaboration with Richard Kostelanetz, the holopoem *Lilith* (1987/89) employs words in French and English to comment upon the legend that gives it its title.[11] In Jewish popular etymology, Lilith means "devil of the night". Its understanding as the "female devil" has Babylonian roots, but Lilith also stands for any myth of "female devils". In Jewish mystic literature, she is the Queen of the Demons. According to another legend, still, she was the first wife of Adam. As opposed to Eve, Lilith was not created from Adam's body and therefore was totally independent of him. According to this legend, it was only after Lilith left Adam that Eve was created. In traditional cabalistic literature – until recently a male-dominated field – she is the symbol of sensuality and sexual temptation. The transformations that take place in the poem between the words HE, EL (short for "Elohim", or "God"), ELLE ("she" in French and mirror image of EL) and HELL are meant to unveil and criticize the bias that surrounds the myth of Lilith, product of a male-dominated culture creating God in its own (male) image.

Three pieces that followed, *Albeit* (1989), *Shema* (1989), and *Eccentric* (1990), approach the issue of structuring a text in discontinuous space in three different ways. *Albeit* is composed of five words that are duplicated and fragmented in space by means of fourteen masters (the counterpart of "negatives", in photography), so as to produce a dense configuration built upon layers of small colour fields and the empty spaces between them. The words are read almost in stroboscopic manner from different viewpoints, multiplying meanings and paralleling, in the process of fragmentation, the contradictory reference to time that the text signifies. The word "take", for example, can be perceived as a verb ("take your time") or as a noun ("your take is over") – a syntactical fluctuation that is instrumental in the textual

Figure. 7: Eduardo Kac, "Phoenix", 30 X 40 cm, laser hologram with open flame, 1989.

instability of holopoetry. The word "time", in another instance, can be a subject, as in "time take(s) over", when the letter "s" is read in absentia. But it also can be a direct object, as in "take your time".

*Shema* is structured with verbal signifiers floating in three expanded colour fields that interpenetrate each other, creating a transitional discontinuity between them. The text is in Hebrew and is composed basically of four words and one big letter. The letter modifies the four words to suggest four new words – depending on the viewer's decisions as s/he moves in front of the piece. In this sense, the word "maim" (water) may be modified by the letter "shien" (S), to produce "shamaim" (sky, heaven). The word "mavet" (death) may be modified by "shien" to suggest "Shmvot" (Exodus). The word "mah" (why? what?) may be modified to form "shamah" (desolation, destruction). At last, the word "mash" (to trough off, to remove) may become "shemesh" (sun). The possible eight words produce an atmosphere of associations, suggesting feelings about death and emotional loss. The piece is dedicated to Perla Przytyk, *in memoriam*.

As with the words in the two previous texts, the basic nine words in *Eccentric* ("shadows", "sounds", "smells", "nos", "nevers", "nothings", "that", "memories", "erase") can never be seen simultaneously in space. But this time, the viewer can not even perceive the words when he or she looks at the piece from a central position. In order to perceive each word, the reader must invent his or her own topological code. One must look for the words diagonally and decide if he or she will read looking up or to the left alternately or successively, or down and to the right

concurrently. The criss-crossing invisible, narrow viewing zones that form the poem allow for a highly turbulent syntax. Adverbs ("nevers", "nos") are found in unusual plural form to stretch their meanings and nouns in the plural ("sounds", "smells", "shadows") can be read as verbs in the present tense of the third-person singular. The very configuration of the letters within each word suggests different interpretations, like the noun "nothings" implying the phrase "not this sign". In parallel configurations, the pronoun "that", for example, can become a conjunction ("nos that shadows erase"), a deitic pronoun ("smell that nevers"), an adjective ("that shadow(s) that nothings erase"), or a subject ("that sounds memories").

*Amalgam* (1990) is composed of two sets of two words each ("flower-void" and "vortex-flow"), and each set blends into the other as the viewer tries to read the text. The reader sees the visual transition between the sets as an attempt to produce a semantical transition as well, so that the in-between shapes indicate in-between meanings. In other words, when the left eye sees one set and the right eye sees the other set simultaneously (as opposed to both eyes perceiving slightly different viewpoints of the same set), the viewer is actually seeing a transitional verbal sign that possesses transitional meanings. This is what I call binocular reading. Normally, left and right eyes see, say, the letter A, from their respective viewpoints. Here, for example, the left eye could see the letter A, but the right eye sees at the same time the letter B instead. Both eyes try to force a synthesis that is deterred by the retinal rivalry.[12] Within this process, a complementary reading strategy can be implemented: nouns can be

Figure. 8: Eduardo Kac, "Amalgam", 10 X 7.5 cm, white light reflection hologram, 1990. Edition of 100. Collection Butler Institute of American Art, Youngstown, Ohio.

interpreted as verbs as in "flow (and) vortex void flower", or "flower (,) void (and) vortex flow".

The first digital holopoem I created in Chicago was *Multiple* (1989), in which the sequence of numbers 3309 is seen floating in space. As the viewer moves past the numbers, they rotate around a pivot point, changing to an abstract pattern and then to the word POEM (and vice versa); at first the three-dimensional form remains the same as it would if it were a regular object – but then it changes. Parallax is responsible for the production of meaning, which is based on the triple function of the sign (word-image-number). This piece translates a characteristic of the Hebrew alphabet (in which letters also stand for numbers) into the Latin one.

*Andromeda Souvenir* (1990) is composed of a single word, which is also perceived as a set of abstract shapes depending on the beholder's viewpoint. If the viewer reads the word LIMBO at first, as he or she moves, the word rotates (crossing from virtual space to real space and vice versa) and comes apart (as if it were exploding). As this happens, the fragments of the word, which are not legible anymore, are now perceived as pure visual forms. This process is reversible in space and time.

If the fragmentation of a sound still produces phonetic resonances, the fragmentation of a letter produces visual shapes – a process that exhibits the graphic nature of written language as opposed to the phonetic nature of spoken language. The word LIMBO connotes "oblivion", "suspension" and "nothingness" in several languages – meanings which are enhanced by the visual process of fragmentation.[13]

In *Omen* (1990) the word EYES floats and spins, emerging and dissolving in a space defined by luminous smoke. This spinning of the word happens so as to make the letter E, as seen from a specific viewpoint, vanish into the smoke before the whole word does, making the reader perceive the word YES at the edge of legibility and suggesting the word SEE. The smoke is charged with ambiguity, because it is perceived both as an element that blocks vision and as a transparent medium. Through this orchestrated motion, it is my intention to create a metaphor that expresses the hazy vision of a future occurrence.[14]

In the three pieces mentioned above, I explored movement but did not work with syntactical discontinuity as I have done in other texts, such as *Abracadabra*, *Albeit* and *Eccentric*. My interest in writing motion texts with irregular syntactical links in a heterogeneous perceptual field led to three new pieces produced in 1991.

*Adrift* is composed basically of seven words that dissolve in space and into each other as the viewer reads them. In one case, the reader may be invited to start reading from the letter which is further away from him or her. In another case, the letter closer to the reader could be the starting point. The reading process occurs back and forth along the Z axes. This piece is also an attempt to work both with the optical and digital, trying to make one lend its properties to the other. The letters that make the words are floating irregularly along several Z axes, except for the word "breathe", which is integrated into the overall light field. This word is blown by an imaginary wind as its letters actually move away from their original position to dissolve again

Figure. 9: Eduardo Kac, "Andromeda Souvenir", 30 X 40 cm, digital hologram, 1990 (three points of view). Edition of 3. Collection Francis Edeline, Tilff, Belgium.

Figure. 10: Eduardo Kac, "Adrift", 30 X 40 cm, digital hologram, 1991. Collection Ruth and Marvin Sackner, Miami.

in the light field. The movement of the letters in this word disrupts the apparent stability of the other words.[15]

The next holopoem I made in this new series is *Zero*, in which words grow or shrink, or turn and break, to express the drama of an identity crisis in a future world. Rotations, fusions, and other actions make the words emphasize their relations and meanings in space. The multiplicity of "selfs" that would be inexorable with the proliferation of cloning is the ultimate theme of the poem, but for a more attentive reader the answer for the enigma could be found in words residing in other words.

In *Adhuc*, the third in the series, as the viewer moves relative to the poem trying to read it, he or she perceives the manifold choreography of the basic words of the piece ("whenever", "four years", "or never", "far eve", "forever", "evening"). All the words refer to time in varying ways, contributing to an overall vagueness that could resist assessment at first sight. The muddled interference patterns that blend with the words help to create an atmosphere of uncertainty, not only concerning the visibility of the words but also about the meanings they produce.

*Astray in Deimos* (1992) explores metamorphosis as its main syntactical agent. Deimos ("terror") is the outer, smaller satellite of Mars. The piece is comprised of two words rendered in wireframe (EERIE and MIST), which are seen through a circle of predominantly yellow light. Surrounding this scene is a web-like landscape made of shattered glass, which partially invades

Figure. 11: Eduardo Kac, "Zero", 30 X 40 cm, digital hologram, 1991. Collection Museum of Holography, Chicago.

the yellow light circle. The circle may represent Deimos as seen on the sky from the ground, or a crater on the surface, or even a spacecraft window through which one may look down at the spacescape.

As the viewer moves relative to the piece, he or she perceives that each line that renders the graphic configuration of each letter starts to actually move in three-dimensional space. The viewer then perceives that as the lines and points go under an actual topological transformation, they slowly start to reconfigure a different wireframe letter. What was read as an adjective is becoming a noun. I call this semantic interpolation. If the viewer happens to move in the opposite direction, the noun is transformed into the adjective. The shifting of grammatical forms occurs not through syntactical dislocations in a stanza, but through a typographic metamorphosis that takes place outside syntax.

In the process of transformation the intermediary configurations of the letters, which do not form any known words, evoke in non-semantic fashion meanings that are conceivably intermediary between the two words (EERIE and MIST). The point here is that this metamorphosis allows the text to suggest other meanings beyond the two words located at the extreme poles of the process. The viewer has to read the transformations without trying to extract semantic meaning from the non-semantic forms. These in-between verbal signs attempt to communicate at the level of abstract visual signs which have no extra-pictorial reality, at the same time that they operate under a specific framework provided by the words at the poles (EERIE and MIST). This can be

Figure. 12: Eduardo Kac, "Astray in Deimos", 30 X 40 cm, digital hologram, 1992. Edition of 2. Collection Museum of Holography, Chicago.

very difficult at first because it escapes our common expectations about how language operates. For example: if I refer to the colours "black" and "white", I can think of a third term that will clearly define an intermediary colour, that is, "grey". This precision becomes impossible, for example, if I refer to the words "knife" and "light". There is no common word that can define an intermediary state or concept between the two nouns. Only in poetry this is conceivable. In *Astray in Deimos* the metamorphosis between EERIE and MIST has the same emphasis that the two individual words have, without forcing the intermediary shapes to refer to extra-linguistic qualities or things in the way the two words do.

*Astray in Deimos* can be interpreted as a spatial haiku of sorts. Its natural subject is the landscape of Deimos, one of the two moons of the red planet. This holopoem is imaginarily written by someone who has visited Deimos, which is known to us through images made by orbiters such as Mariner and Viking. The attentive reader will notice that if the word MIST is perceived first, followed by EERIE, a phonetic link between the two words suggests a third one: mystery.

*Havoc* (1992)[16] is composed of 39 words distributed in three panels. The viewer can start reading from left to right or vice versa, or even start in the center and move in the desired direction. The left panel has nineteen words (NOW, IS, IFS, AND, AIRS, ARE, MIST, BUT, PENS, ARE, THOUGHTS, IF, JAZZ, IS, TOUCH, SO, SPLASH, JUMPS, DRY), the center panel has one word (WHEN), and the right panel has nineteen more words (SHE, IS, HE, IF, FACES, ERASE,

Figure. 13: Eduardo Kac, "Havoc", 30 X 120 cm (triptych), digital hologram, 1992 (three points of view).

SMILES, BUT, THENS, SAY, MEMORIES, ARE, AIRPORTS, LIKE, DROPS, UNDER, MOONS, OF, MAZE).

The verbal material in the left and right panels is organized vertically in three-dimensional space. I used two different typefaces in this piece. When a row has two words, one word is written with serif and the other without, creating an alternating visual rhythm. The colour of the word(s) in one row is different from the colour of the word(s) in the other row, but identical to the colour of the following row, and so on. As in most white-light transmission holograms these colours are never stationary, but the relative chromaticity is preserved regardless of the viewpoint of the observer. This colour modulation extends the rhythm created by the font selection and helps interweave the words visually.

As the viewer moves relative to these two panels, which are usually seen one at a time, all the words in them twirl simultaneously, as if drowned by a violent vortex. The words lose their graphic stiffness. They stretch, deform and contort themselves. As the words collapse they blend into one another becoming absolutely illegible. They form swirling patterns at the edge of the viewing zone and, if the viewer moves in the opposite direction, they return to their temporary state of rest. The opposite rotation of the words in these panels resembles the equally opposite water vortices seen at the northern and southern hemispheres. This fluid visual metaphor is an important element of the piece.

The center panel has a different behaviour. An abstract shape morphs into the word (WHEN) which morphs again into an abstract shape, placing the word at the transitory position preserved in other pieces for the non-semantic in-between shapes. But instead of the smooth metamorphic transition created in *Astray in Deimos*, for example, the word WHEN goes through a compressed and violent process that generates time-smear. Time-smear occurs when the viewer perceives simultaneously two discrete points in the trajectory of a letter or word separated in time. One point can be the "present" or the "future" in relation to the other and the converse, which is to say that both are suspended in time nonsequentially. This unconventional concept translates itself visually into ever unfolding amalgams of images which are perceived as oscillations by a non-stationary viewer. The abstract shapes and the word are decomposed at the boundary of legibility. Surrounding this shifting scene are semi-curved light forms that change and fluctuate. The convex sides of these wave-like, diffused semi-circles face outwards, as if placing now and then the word WHEN in a perpetually moving fluid parenthesis.

The title of my next holopoem is *Zephyr* (1993)[17], which means "a gentle breeze". In this piece a relationship of semantic equivalence is created between word fragments and images seen in transition. It employs particle animation[18] and synthetic water ripples. Particles and ripples are disturbed by an invisible air flow which is imaginarily caused by the reader as he or she moves in front of the piece. As the reader explores the work, verbal and visual elements move and change, making a statement about the fragility of the human condition. The letters in this piece form a word inside another word, one being affirmative (LIFE) and the other seeming to question its assertive character from within (IF). As the viewer moves relative to the piece, it oscillates between preserving these oppositions and solving them by blending the opposite terms. Due to the mutability of forms and the unstable behaviour of words in space, viewers have read other words (LONE, LOVE) in this piece also.

152 | MEDIA POETRY: AN INTERNATIONAL ANTHOLOGY

Figure. 14: Eduardo Kac, "Zephyr", 30 X 40 cm, digital hologram, 1993 (four points of view). Edition of 2. Collection Ramón Benito, Madrid.

Figure. 15: Eduardo Kac, "Maybe then, if only as", 30 X 40 cm, digital hologram, 1993. Edition of 2. Private collection, Kassel, Germany.

As the viewer moves relative to the piece, he or she perceives that the letters are made of minute particles, and that these particles fly towards the viewer – as if they had been blown in the air. A three-dimensional cloud of particles is formed in space. If the viewer moves in the opposite direction, this cloud flies away from the viewer and reconstructs the letters, as if the viewer had blown them away from him or her with his or her own gaze.

The word IF is projected on synthetic water. I disturbed the synthetic liquid surface where the word is projected in order to record visual oscillations of the word. The meaning of doubt raised by the word IF is reinforced by its wavy motion, since the word is perceived as word or abstract pattern depending on the momentary position of the viewer in relation to the holopoem.

All letters are integrated into one entity, but they also dissolve into one another. Looking at *Zephyr*, the reader finds buoyant words, as if the particles and the ripples were relying for their movement on the vagaries of air currents and the displacement of small air masses caused by the movement of the viewer himself or herself.

*Maybe Then, If Only As* (1993) is a subjective statement about what I see as the relationship between the elusiveness of language and the unpredictable and turbulent behaviour of nature. The piece involved the recording of three separate space-time layers of information

The first contained three words: WHERE, ARE, WE? The letters in the word WHERE spin and visually dissolve into falling "snow flakes". The words ARE and WE? are underneath WHERE and are skewed as the process described above takes place. These two words are partially covered by the "snow flakes" of WHERE.

The second layer contains the following words: HERE, WE, ARE, THERE, INK, INSTANTS, AND, WHY? These words can only be seen from discrete points of view and were subjected to other animated processes. The A in ARE spins away from the viewer into holographic space and the other letters move up to suggest WERE. The first four letters in the word INSTANTS slowly disappear leaving ANTS to be perceived at the edge of legibility. The word WHY? is seen flashing at different moments, in different positions, across the space and in jerky fashion, as a graphic echo. These relationships are suggested when the viewer perceives the words breaking down and reconstructing other words in the immaterial holographic space. The words are perceived only for a brief moment and are interrupted by the presence of other animated words. The third layer was used to record dry branches coming out of the film plane and reaching out to the viewer. The branches were recorded against a background of light-generated patterns that subtly evoke the forms of clouds.

### 6. Holopoetry and the future of experimental poetics
Holopoetry defines a new domain of poetic exploration where the text is written with the malleable medium of light, where the word is free from surface constraints, where textuality is signifiers in motion. In a holopoem, the verbal phenomenon cannot be dissociated from the spatio-temporal environment of the optical and synthetic hologram.

If one is concerned with the development of a new poetry for the digital age, it is important to write visual poetry in a medium different than print, a medium that is fresh and the conventions

of which are yet to be invented. To me, holography is such a medium, but I must point out that the use of new media does not constitute, by itself, a standard of quality or of authentic contribution to the repertoire of experimental writing. For example, if someone uses holography simply to reproduce a poem that was fully realized in another form (verse, graphic, etc.), he or she is not creating what I call a holopoem.

In western societies we are all used to electronic texts on television performing the most elaborate pirouettes on the screen. A golfer hits a ball and letters announcing a tournament are scattered on the screen. An electric shaver follows a path made of text about the product, "shaving" the text in the process. Logos fly on-screen to sell the visual identity of large corporations, and so on. The dynamic use of language that we are used to on television promotes most often redundancy, commodification, and banality.

A writer who seeks to explore new parameters of spatiotemporal creation in poetry beyond those of traditional materials will work in new environments, forging new literary media. Just as contemporary art in the twenty-first century knows no boundaries regarding media and processes, twenty-first century poetry goes beyond the book and expands its reach into new information systems. As electronic media such as radio and television reinvent themselves, ubiquitous cellphones, computers, and the Internet form a new mediascape with holograms, videogames, electronic displays, portable media players, and a plethora of new personal writing and reading instruments. The environment or substrate in or on which the poem is written matters inasmuch as the poet explores the latent possibilities of this system as intrinsic to the syntax and overall condition of the poem, including sound, form, rhythm, and imagery. As we take solid steps towards the emergence of a new literary culture, holopoetry stands as a contribution in the form of a poetic language literally made of light in spacetime. As it projects the word into unknown territory it also unfolds new reading strategies. Meaning becomes fluid as the very chatoyant verbal and nonverbal signs that constitute its condensed intensity continuously change with the smallest hesitations of the gaze. With its verbal quanta and photonic streams, holopoetry seeks to reinvigorate poetry with the imaginative power and the mysterious beauty of oscillating language.

**Notes**
1. Derrida reminds us that linearity is "the repression of pluri-dimensional symbolic thought". See: Jacques Derrida, *Of Grammatology*, p. 86, The Johns Hopkins University Press, translated by G. C. Spivak, Baltimore and London, 1976.
2. Every fragment of a hologram contains the whole image. The smaller the fragment, the more difficult it is to resolve fine detail. Commenting on this phenomenon, physicist David Bohm observed that "this global property of enfoldment of information and detail has something in common with both fractal and Fourier orders." See: Bohm, David and Peat, F. David. Science, Order, and Creativity (New York: Bantam, 1987), p. 175. This suggests that the relationship between holography and fractal geometry can be understood not only at the level of the image (digital, holographic) but also in regard to the question of self-similarity. This property was instrumental in the syntax of my first holopoem, Holo/Olho, from 1983.
3. Jacques Derrida, *Of Grammatology*, p.58. Derrida states that the writer "writes in a language and in a logic whose proper system, laws, and life his discourse by definition cannot dominate absolutely. He uses them only by letting himself, after a fashion and up to a point, be governed by the system. And the reading must always aim at a certain relationship, unperceived by the writer, between what he commands and what he does not command of the patterns of the language that he uses".

4. Jacques Derrida, "Structure, Sign, and Play in the Discourse of the Human Sciences", *The Structuralist Controversy; The Languages of Criticism and The Sciences of Man*, R. Macksey and E. Donato, ed., p.64, The Johns Hopkins University Press, Baltimore and London, 1982. Derrida: "Freeplay is always an interplay of absence and presence, but if it is to be radically conceived, freeplay must be conceived of before the alternative of presence or absence beginning with the possibility of freeplay and not the other way around."
5. See: IV Whitman, "Holopoetry: The New Frontier of Language – An Interview with Eduardo Kac", in *Display Holography* (Fifth International Symposium), Tung H. Jeong, editor, proc. SPIE 2333, pp. 138–145 (1995).
6. My first four holopoems were made in Fernando Catta-Preta's laboratory.
7. Jason Sapan shot 16mm film for this piece and Larry Lieberman made the transfer to holographic film. Jason Sapan also shot a documentary video of the making of *Wordsl*.
8. Linda Henderson, *The Fourth Dimension and Non-Euclidean Geometry in Modern Art*, (Princeton, NJ: Princeton University Press, 1983).
9. This piece was created at Azimuth (Ormeo Botelho's computer graphics facility in Rio de Janeiro). The film footage was transferred by Larry Lieberman in Ohio.
10. See: Eduardo Kac, "Holopoetry and Fractal Holopoetry: Digital Holography as an Art Medium", in *Holography as an art medium*, ed. Louis Brill, Leonardo special issue, vol. 22, N$^{os}$ 3/4, pp. 397–402, Pergamon Press, Oxford (UK), 1989; "Recent Experiments in Holopoetry and Computer Holopoetry", in *Proceedings of the International Symposium on Display Holography*, ed. T. H. Jeong, SPIE vol. 1600, Bellingham, WA, 1991, pp. 229–236; and "Holopoetry, Hypertext, Hyperpoetry", in *Holographic Imaging and Materials*, Tung H. Jeong, editor, proc. SPIE 2043, 72–81 (1993).
11. This piece was created when Richard Kostelanetz and I met in Rio de Janeiro in 1987 (following our first meeting in New York in 1986). The pulsed master hologram was shot by Fred Unterseher in Germany, when Kostelanetz and Unterseher met there in 1988. The piece was finally made into a white-light hologram by myself in Chicago in 1989.
12. For a discussion of retinal rivalry and other aesthetic elements unique to holography, see: E. Kac, "On Holography", in *New Media Technologies*, Ross Harley, editor, AFTRS, New South Wales, Australia, 1993, pp. 123–139; and "The Aesthetics of Holography", in *Display Holography* (Fifth International Symposium), Tung H. Jeong, editor, proc. SPIE 2333, pp. 123–137 (1995).
13. Marla Schweppe produced the digital files for *Multiple* and *Andromeda Souvenir* in Chicago.
14. For a more detailed description of "Omen", please see E. Kac and H. Bjelkhagen, "Holopoem blends pulsed and computer holography", *Laser News*, vol. XI, no. 1, p. 3, 1991.
15. This piece was commissioned by Ruth and Marvin Sackner.
16. The holopoem *Havoc* was supported in part by a New Forms Regional Grant, a program administered by Randolph Street Gallery and funded by the Inter-Arts Program of the National Endowment for the Arts and The Rockefeller Foundation, with additional support from the Illinois Arts Council and Randolph Street Gallery.
17. The holopoem *Zephyr* was partially supported by a grant from the City of Chicago Department of Cultural Affairs, and the Illinois Arts Council Access Program.
18. Particle systems can be described as a computer animation technique in which large amounts of very small three-dimensional objects (digital particles) are set to motion simultaneously under a combination of random factors and algorithmic control. Parameters used to animate particles include lifespan (i.e., for how long do they move), speed, quantity, size, colour, starting and ending point, and direction of travel. Once the animation starts, hundreds or thousands of particles move by themselves under constraints set by the artist. There is no need to create key frames or to set motion paths for individual particles.

# RECOMBINANT POETICS

**Bill Seaman**

We are in the midst of profound technological changes that impact upon how people communicate, share knowledge, and learn. Potentially, along with these technological changes comes a related change in poetics. Thus a techno-poetics is explored. Where once we focused on analogue media as the primary means of embodying our ideas through artefacts of thought, our understanding of reality is now interwoven (structurally coupled[1]) with an expanded linguistics of interpenetrated fields of meaning.[2] Some would say this is not a techno-linguistics but an expanded computer-based environmental semiotics. Through Recombinant Poetics virtual space becomes a mutable field for evocative media-related exploration.

Computer-based environmental meaning is potentially explored through the authorship, inter-authorship, and operative experiential examination of a diverse set of media-elements and media-processes. The media that becomes evocative within this techno-poetic virtual environment is diverse. This media includes digital video, digital still images, 3-D digital objects, 3-D animations, digital spoken and written text, digital music/noise – sound objects, and digital texture maps – both still and time-based. Each media-element could be said to convey its own field of meaning. Varying combinations of these fields of meaning are experienced through

Figure. 1: Bill Seaman with Gideon May (programmer), "The World Generator / The Engine of Desire" 1996/97. Menu system (Spinning Container Wheels).

Figure 2: Bill Seaman with Gideon May (programmer), "The World Generator / The Engine of Desire" 1996/97. Menu system (partial screen view).

fleeting electronic environmental perceptual stimulations. The mindset of the participant represents another active field. The vuser (viewer/user)[3] becomes dynamically involved in the construction of meaning. It is through the combination and recombination of these evocative digital fields of meaning, as experienced by an engaged participant, that a new form of poetics can emerge – Recombinant Poetics.

Computer-based environmental meaning can be examined through the operative experience of spaces that explore digital processes as brought about through mindfully aware[4] interactivity. In this computer-based space, our interactive exchange fields have shifted in emphasis from the direct and physical, to mediated electronic perceptual fields. So we ask, how should the techno-poetics of this moment be authored or inscribed? The definition of the word "inscribe" includes both "to mark or engrave (words etc.) on (a surface)" as well as "to fix in the mind". [5] How should such computer-based media-inscriptions reflect the complexity of the history of our relations with this abstract landscape of media experience that forms the larger environment we daily encounter?

New technological systems enable participants to glimpse into the actual meaning-related functionality of media-elements as they are explored through navigation, layering, juxtaposition and interpenetration within a specifically authored virtual environment. A techno-poetic mechanism has been created that enables the observation of the interactive contextualization, decontextualization and recontextualization of media-elements in virtual space. The vuser

Figure 3: Bill Seaman with Gideon May (programmer), "The World Generator / The Engine of Desire" 1996/97. Personal Cipher Machines.

Figure 4: Bill Seaman with Gideon May (programmer), "The World Generator / The Engine of Desire" 1996/97. Dispersion Potentials.

explores operative media-elements and media-processes through direct experience within a meta-meaning environment. This environment enables the experiential perusal of mutable electronic space – a space which exhibits fleeting relations between media-elements that arise through participation. This device becomes a mutable digital inscription mechanism for a new field of poetics – Recombinant Poetics.

The computer presents an environment where one can generate, sense, operate on, transmit, and interact with mutable dynamic media. Our relation to computer-based media-elements cannot easily be separated from other ways we have come to understand the world.[6] Sensual intake of computer-based experience functions in a fluid relation to all experience – to the very manner in which we come to know reality. Media-elements make up a set of variables that characterize a particular aesthetic form of computer-based environmental landscape. This landscape is created through interaction with a generative virtual environment that I have authored in conjunction with the programmer Gideon May. The title of this work is "The World Generator / The Engine of Desire".[7] This is a specific generative virtual environment created as a new space for the production and exhibition of fleeting poetic artefacts. This poetic virtual environment is an evocative experiential site in which the participant inhabits a continuum bridging virtual space with perceptual experience.

Within this virtual environment each of these media-elements has its own communicative or evocative force[8] that acts upon the other media-elements positioned in relative proximity. The

Figure 5: Bill Seaman with Gideon May (programmer), "The World Generator / The Engine of Desire" 1996/97. Floating Function.

160 | MEDIA POETRY: AN INTERNATIONAL ANTHOLOGY

Figure 6: Bill Seaman with Gideon May (programmer), "The World Generator / The Engine of Desire" 1996/97. In the Light of Absence.

active participant continuously registers these forces, bringing along their memory of relations with past experience – their own ongoing field of meaning production – consciousness. Meaning, within this kind of computer environment, is produced through the experience of a series of media-proximities and media-processes accessed through physical and intellectual interaction with this techno-poetic mechanism over time.

A conglomerate media is derived in part from the translated digital traces of past media (film becomes digital video; text becomes digital text; photography becomes digital photography). This media becomes operative within a specific computer-based territory. A dynamic summing of meaning forces is ongoing during interaction within this environment. The history of media-proximities and processes intermingles with the history/memory of our bodily experience of non-computer-based proximities and processes. Real and illusory events come to inform each other. Memory and associative processes are subtly moving and shifting at all times in relation to the shifting context that the work explores – a situation of media-proximities within a virtual environment brought about through generative emergent processes.

Recombinant Poetics is a contemporary poetics that enables an exploration of this active relation between ongoing experience, thought, and memory. This device empowers the participant to bring about interpenetration and juxtaposition of media-elements through their interaction with the following processes: construction processes; navigation processes; processes related to attributing, exploring and observing media behaviours; editing processes; aesthetic/abstraction processes; automated generative processes; processes related to the

Figure 7: Bill Seaman with Gideon May (programmer), "The World Generator / The Engine of Desire" 1996/97. Re-embodied Intelligence.

Figure 8: Bill Seaman with Gideon May (programmer), "The World Generator / The Engine of Desire" 1996/97. Abstraction detail.

sharing of spatial interaction in a networked virtual space; and chance processes of a semi-random nature. This techno-poetic mechanism is organism-like and functions in a self-organizing manner. The participant takes an active role in the generation and construction of meaning within this space.

Central to my techno-poetic device is the potential to transcend the use of words as a means of discourse, to enable the exploration of media experience in and of itself. Virtual environments are quixotic by their very nature. Words can, in fact, approach the relations that may be explored in this kind of techno-poetic environment, as this essay is seeking to do. Yet, the techno-poetic environment seeks to posit an experiential set of human/machine relations. Such

Figure 9: Bill Seaman with Gideon May (programmer), "The World Generator / The Engine of Desire" 1996/97. Text documentation.

162 | MEDIA POETRY: AN INTERNATIONAL ANTHOLOGY

```
The World Generator / The Engine of Desire
Text Included In Menu System

quantum behaviours - the paradox engine
floating signifiers of the doubt progressions (arithmetic)
turn fold library of constellation puns
n spoke shunt jumpers
empty vessel theatre drives
shared oscillation reference fields
generator meta-constructs
random fall mechanisms
auto-positioning game board moves
meta-empty projection fields (in waiting)
snare set models
re-combinant code construction presence
inward and outward shunt vessels
objectspun
large and small infinities of code vicinities
condensation dispersions of infinite re-definition
the looping turn bridge
pool loops / loop pools
room of memory collection debris
the tearing of vessels
the tearing of vessels
endgame of architectural endgames
```

Figure 10: Bill Seaman with Gideon May (programmer), "The World Generator / The Engine of Desire" 1996/97. Text documentation.

```
endgame of architectural endgames
blue museum of theatre engines
null expression receptors
the physics of the void expression
word chain reaction trees
the positioning and re-positioning of object spokes
silent hands repositioning
the lie of luminosity I lay of the landing
reverse engineering paradox
fabrication illuminates the museum of emptiness
fabrications of emptiness in the museum of illumination
low light eye fabrication
structure signatures of sublime erosion
conducting bone transmission pulse bridges
drum language vessel engines
omnilocational eyes in the light of fabrication
sexual signal site abstracters and extenders
elegant locution I mouth of chance
desire exchange foci
arteries of arithemetics
solutions of doubt mixtures
energy of loss
recovery frames
spinning steadily in reverse equal to the speed of rotation
standing still I changing context
```

Figure 11: Bill Seaman with Gideon May (programmer), "The World Generator / The Engine of Desire" 1996/97. Text documentation.

RECOMBIANT POETICS | 163

```
equations of symbolic orders and disorders
vessels of the dance
reorientation rebus
sound distances
sounding out situations
motioning clear
halation of magnetics
motionless flight of the conveyor
window trees
vast territories of the entropyless domain
optical futures
shifter eye constants
numb breather songs
throat of blood rust
symbolic duration of hair
phantom gestures of the body
amplification hands
slow flow / gravity of glass thoughts
blueprint of sand
silence as it circulates and slides
the skin of experience
functions of the desire bearings
physicality of the emotional hand
release of self-guided desire mechanisms
co-ordinates of resonant desire
```

Figure 12: Bill Seaman with Gideon May (programmer), "The World Generator / The Engine of Desire" 1996/97. Text documentation.

```
vessels of the collapsed field
container release triggers
paradox engine maps
drifting non-arrival
drive collision mesh paths
floating destinations
remotional aggregates
felt expressions of the folding engine
a thought map which builds an expression
components of thought (re-embodied)
collapsing through generative mind sites
alife compartments
transfer skin I transposition
chess snare I forking map
self organising desire mechanisms
geometric falls
gravity of luminous hands
resonance scatter drivers
phantom limbics
architecture of thought weaving
violent ballet I quiescent repose
slowly sinking light ship
the circulatory lighthouse of blue sound
empty touch / blue void
ballet ship
```

Figure 13: Bill Seaman with Gideon May (programmer), "The World Generator / The Engine of Desire" 1996/97. Text documentation.

experiential relations transcend the ability of words to articulate the complexity of lived experience. Through use of this mechanism one does not 'talk about' how meaning arises within the techno-poetic environment – one experientially comes to understand this complexity. Meaning arises and falls away across a series of rhizomatic[9] flows made operative within the environment. Descriptive language becomes a secondary approach to sensual computer-based environmental experience in terms of this techno-poetic device.

Recombinant Poetics is informed by a range of topics and experiences. DNA and the dynamic technological processes that surround it become a vibrant metaphor. Questions surrounding the exploration of recombinant processes may become the dominating topic of our time. The living variable media of electronic processes becomes the metaphorical recombinant material of a contemporary poetics of flux. A Recombinant Poetic work presents a mechanism in which a vuser can act upon and explore varying juxtapositions of computer-based media-elements to examine environmental meaning within a mutable generative electronic environment. The generative component is essential to Recombinant Poetics and differentiates it from other fixed virtual environments.

*The World Generator/The Engine of Desire* becomes operative through a new interface metaphor – a series of spinning virtual container-wheels. These container-wheels hold an elaborate set of authored media – elements: 3-D objects, digital video stills, digital video loops, a litany of lines of poetic text, an elaborate series of sound objects (musical loops), a set of varying computer-based behaviours (one can make an object or image spin, rotate, follow a line, move in a spiral path, etc.), a selection of random functions, a series of system commands ("clear world", "center world", etc.)

A surrounding "aura" can be toggled on and off to select a particular media-element to operate upon. When the "aura" is activated the vuser can attach a still as a texture map, attach a digital video to the surface of the virtual object, attach a sound to the object, attach behaviours to the object as well as superimpose sound objects with the initial selection. This "aura" enables what Erkki Huhtamo, in writing about my work, has coined – "World Processing". One can easily edit the environment, making selections, changing entries, alternating choices, eliminating selections as well as instigating semi-random choices. One can even engage the construction of an entire virtual world through a particular menu choice. Stills and movies can also be placed in the environment. The above set of processes can also be explored in relation to digital movies and stills that can also be operated upon in the space as autonomous objects. Modular 3-D text selections can also be positioned and affected by choices from the container-wheels. The vuser inter-authors this environment. Media-elements already carry fields of meaning as they are experienced within the container-wheels before they are used as construction material. Meaning is in part generated and explored though dynamic interactive processes of re-contextualization.

The participant spins these container-wheels from a physical table, makes selections with buttons built into this physical interface and constructs a techno-poetic virtual landscape. The world is presented as a large high-definition digital projection in a darkened room. A physical interface built into the table translates subtle human gesture into movement within the environment. This virtual positioning device enables one to navigate within the environment. One can move

```
born of the wreckage debris (re configured)
light flows across all void distance
looping fields of silence
simple gestures delineate the site of desire
eventual smooth equilibrium
a simultaneity of infinities
storage of desire collapse realms
dispersion of desire vehicles
entering - resonance architectures
self supporting architecture | definition room
self suspended
removal of time place
times items bridging
edge of the world parameters | landscape loop
behavioural voice
orders of magnitude | orders of behaviour
aleotoric driver re-alignment rebus
skin of reason (touched)
museum of the void
circulatory systems
arbiters of displacement
navigational memory
governor of rotation engines desire bearings
conveyor engines
tag shifters | tethered and floating
```

Figure 14: Bill Seaman with Gideon May (programmer), "The World Generator / The Engine of Desire" 1996/97. Text documentation.

```
numb flows
indexical shifters
mixed metaphor [mechanics]
an answer that asks questions
poly-syntactic rotation {objects}
word falls
Body theatre thought vicinities
entering - entering
navigating observation
observation containers
gestures of inclination
shadow triggers
behavioural conveyors
the null set relationals
screen blank vessels
a propensity toward inversion
the back of signs [storage sites]
Wittgenstein's handles
reframing the gaming field
pulse permutation shimmers
sound substitution sets
properties of inverse polemics
action at a distance [bridges]
non-causal chain reactions
recombinant architectures of information
```

Figure 15: Bill Seaman with Gideon May (programmer), "The World Generator / The Engine of Desire" 1996/97. Text documentation.

forward and backward, look up and down, turn to the left and to the right affecting the view of the virtual space. At any time during the selection process the vuser can hide the spinning container-wheels, enter the environment and move through the virtual landscape. The vuser can at will, call up the rotating selection menu as well as present a close-up version of the mechanism for detailed viewing. The participant can also preview sound objects and texts before positioning them in the environment.

One conceptual perspective that can be used to contextualize this techno-poetic environment is from filmic montage. Sergei Eisenstein[10] developed theories surrounding the employment of montage techniques. The most important aspect of his theories, for my purposes, deal with the fact that media-elements, when juxtaposed, generate a "creation" which is greater than the sum of its parts:

> The basic fact was true and remains true to this day, that the juxtaposition of two separate shots by splicing them together resembles not so much a simple sum of one shot plus another shot – as it does a creation. It resembles a creation – rather than the sum of its parts – from the circumstances that in every such juxtaposition the result is qualitatively distinguishable from each component element viewed separately. (Eisenstein, 1974, p.8)

It is this aspect of "creation" that is central to the generation of emergent meaning. This is both a spatial and a time-based relation within this techno-poetic virtual environment. Eisenstein further articulates his concept of creation:

> The strength of montage resides in this, that it includes in the creative process the emotions and the mind of the spectator. The spectator is compelled to proceed along that selfsame creative road that the author travelled in creating the image. The spectator not only sees the represented elements of the finished work, but also experiences the dynamic process of the emergence and assembly of the image just as it was experienced by the author. (Eisenstein, 1974, p.32)

Unlike Eisenstein, there is not a pre-edited entity that the participant experiences, but there is, however, an operative realm of probability, in which the menu system functions as a constant – a set of poetic constraints. The participant becomes actively involved with inter-authorship. Heightened engagement, in which the participant "experiences the dynamic process of the emergence", is what is made palpable to the *vuser* through this work.

I am exploring a co-mingling of the denotative with the depictive, as encountered in virtual space. I have spoken about the use of media-elements, taken from one context and recontextualized in another. Eisenstein was influenced to some degree by Japanese poetics, in particular the compressed form of the *Tanka*. He was well informed about the use of Hieroglyphs: "Hieroglyphs developed from conventionalised features of objects, put together, express concepts i.e. the picture of a concept – an ideogram." (Eisenstein, 1949, p.25) He went so far as to suggest that a *Tanka* (a short Japanese poem) could be seen as a kind of shot list. He wrote "From our point of view, these are montage phrases. Shot lists. The simple combination of two or three details of a material kind yields a perfectly finished representation of another kind – psychological." (Eisenstein, 1949, p.32) It is this psychological space,

```
molecules of thought ambivalence
soft sliding rules
transmutation trigger metaphors
once again removed
one word for another [place]
event window [s]
text behaviours
palpable exchange rotations
thought vessels
algorithmic holds
self aware entities
rotating schedules
conveyor vessels
felt behaviours triggered by non-entities
tactile turnstile conductors
de-contextual contact facilitater fields
false emulates in the netting
room pools
written in rotating drums
encoded function rooms
encrypted rule sets
levels of longing [elucidated]
elliptical or circulatory cross-pollination metaphors
compound collection machines
recollections recombined [false history generator]
```

Figure 16: Bill Seaman with Gideon May (programmer), "The World Generator / The Engine of Desire" 1996/97. Text documentation.

```
code book looks ups
invention generator pulse rhythms
cadence of the trigger variables
apparatus for reflection dispersion
amorous theatre screen mesh
sexual web of perception alloys
carnal I canal
amatory ambience of tender decline
sensorial net drive assembly
fundamental conveyor shaft
morose transference mechanism
shaft passage conveyor
drift course resolve
apparatus shelves
spindle axis vehicles
blue voiceprint snare
angles of envelopment
uncertainty anglesl allusive sextant
shaft beam labyrinth
rotary emission beacon merge
loaded dice object spins
radial illuminations
gyro-linguistic stabiliser
rotation schedules of revolving desire bearings
dispersion potentials
```

Figure 17: Bill Seaman with Gideon May (programmer), "The World Generator / The Engine of Desire" 1996/97. Text documentation.

generated through the perception of the spatial juxtaposition of media-elements, that contributes to an exploration of emergent meaning in Recombinant Poetics. Eisenstein pointed toward the conjunction of the denotative (text) and the depictive (picture) in Japanese arts, stating "Not only did the denotative line continue into literature, in the *Tanka*, as we have shown, but exactly the same method (in its depictive aspect) operates also in the most perfect examples of Japanese pictorial art." (Eisenstein, 1949, p.32)

The functionality of *The World Generator/The Engine of Desire* presents a new technological form of spatial montage. Where Eisenstein explored fixed splices of filmic time, I am exploring a splice of volumetric space, or virtual graft. Visually, this is manifested in two ways in the generative world – the *vuser* sees menu items and when one is selected, observes this media-element entering the space through a spatial dissolve. The *vuser*, through their choice, brings about dynamic cut-like changes in the dimensional space. These decisions enable instantaneous, evocative, collisions or interpenetrations of media-elements.

Eisenstein, in speaking about montage, suggests that it was a form of "collision". "A view that from the collision of two given factors arises a concept." (Eisenstein, 1949, p.37) He continues, relating such an idea to metaphors from physics:

> Recall that an infinite number of combinations is known in physics to be capable of arising from the impact (collision) of spheres. Depending on whether the spheres be resilient, non-resilient or mingled. (Eisenstein, 1949, p.37)

This quote falls neatly into my discussion of *fields of meaning* and *meaning force* as described earlier. Eisenstein explores this notion of force from the perspective of "conflict". He goes on to say:

> So, montage is conflict. As the basis for every art is conflict (an "imagist" transformation of the dialectical principle). The shot appears as the cell of montage. Therefore it also must be considered from the viewpoint of conflict.

> Conflict within the shot is potential montage, in the development of its intensity shattering the quadrilateral cage of the shot and exploding its conflict into montage impulses between the montage pieces. As, in a zigzag of mimicry, the mise-en scene splashes out into a spatial zigzag with the same shattering... (Eisenstein, 1949, p.37)

From the above quote, where Eisenstein discusses "conflicts within the shot", I can further legitimize my understanding of the techno-poetic mechanism from a montage perspective. Although virtual reality is spatial, it is constructed through the presentation of a sequence of spatial two-dimensional views of a three-dimensional space. Immersive virtual space is simultaneously generated by presenting two slightly different perspectives of the three-dimensional space. I have chosen to show only a singular high-resolution data-projection in displaying the techno-poetic mechanism. Although the technology has changed from film to the computer, we are still experiencing an expanse of vision – individual frames that are merged through engagement with the persistence of vision facilitated within this time-based technology. Conflict and/or more subtle non-conflictual meaning-forces that are "of themself" (as I have

```
desire bearings
conductor desire shells
hands of light gestures
alchemical symbols | alchimeral slink
x (...............) y
false emulates of the rotation stands
swivel location fulcrum
circulatory map disruptions
face of light spool
photosynthetic metaphoric fields
doubled over | layered spindle turns
crossed object turnstiles
selection spindle weave
bridge fasteners and repulsion keys
electriconnector contact mesh
folded doubles
oblique enablers
chemical endgame memory flights
biogenetic code plays
bio-endgame storage
digital spill containment vessels
KING and QUEEN electro-transfer ducts
cohesion resonators
rarefied fields
alchemical remembrance
```

Figure 18: Bill Seaman with Gideon May (programmer), "The World Generator / The Engine of Desire" 1996/97. Text documentation.

```
trace balance elements
association valence
paradox shells
meta-lily | periodic vessels
pataphysical drift configurations
trollers of the light realm
thought with spin
sleek oblique luminous links
meta-engine nets
distributor of thought engine filters
table of non-predictable alignments
angle of incidence or inception carriers
dis-logistic sparks of dispersion semantics
angles of percussion and recoil
inexhaustible diffusions
thrown meaning | sliding means
scattered association
oscillation valence
spark of the skew gap
meta-sliding function | poetic engines
function engines of alternating strings
engines of sliding field oscillation
domain of rotation
blind skill within the shells of silence
meta-operator voices
```

Figure 19: Bill Seaman with Gideon May (programmer), "The World Generator / The Engine of Desire" 1996/97. Text documentation.

referred to them above) are juxtaposed within this virtual terrain, both through spatial location (at any given moment arising from the perspective of the *vuser*) and time-based relative proximity (derived through *vuser* interaction with the system). Thus, media-elements can be juxtaposed presenting digital cut-like transitions within the environment, through slow spatial revealing (as derived during navigation), radical juxtaposition brought about through media-behaviours, selected engagement with computer-based processes presented on the menu system (similar to the *Random All* function), and by *vuser* selection and placement within the environment.

The electronic media that is collected and housed within the container-wheels of my techno-poetic mechanism is alive with digital manifestations of inscription, although these media-elements are entirely mutable through the actions of the participant. The dice have been loaded in terms of potential aesthetic outcomes by the intentional authorship/choice of these media–elements. They begin as poly-valent evocative entities, housed within the container-wheels. The authorship of this elaborate set of media-variables is informed by transdisciplinary research and provides a loaded set of fields of poetic constraint for the exploration and examination of the vuser. The media-elements are not just simple examples of the above described variables. A number of aesthetic strategies inform the initial authorship of this particular set of variables. The authorship of this techno-poetic mechanism enfolds fragment-selections from a series of histories: the history of art, literature, philosophy, technology, the computer, as well as the history of the construction of meaning. These foci are all drawn upon in the authorship of this techno-poetic mechanism and are explored through the use of media-elements that exhibit a specific-ambiguity.

The vuser of the environment takes an active role in the construction of meaning through interaction. The initial set of media-elements forms a primary context. The vuser then disrupts this context by repositioning the variables across a "plateau" space, named after the book *A Thousand Plateaus* by Deleuze and Guattari. The vuser can explore placement, displacement, and replacement. The media-landscape is always mutable. Meaning arises through the sensual perusal of the environment as well as through the employment of media-processes that are available to the vuser to operate upon the media-elements. These elements take on meaning within an ongoing constructed context. These contexts are mutable and thus an accretive meaning for each media-element can be witnessed. Media-elements are inter-qualified by their proximity, behaviour, abstraction, interpenetration, and the trajectory of vuser's observation path. Highly abstract worlds can be facilitated. Meaning potentially passes through a series of differing states – from the clear – to the highly poly-semic – to states approaching the dissolution of meaning, as deeply chaotic structures are generated. It is interesting to note that because the participant has followed the set of processes that alter the media-elements, even the most chaotic of environments still carries traces of the initial media chosen to make up that environment.

A body moves this physical interface to bring about digital-environmental changes. An actual physics brings about movement within an environment of authored abstract physics. Our biological nature becomes enmeshed with the digital. Central to this contemporary poetics is a sensual mutable multi-modal layering, enfolding a vast set of poly-valent media-elements exploring relations between text, image and music/sound. A delicate series of mobile thought

```
the desire engine and the agents of oscillation
the sensual transference mechanism
the realm of the desire engine
circumnavigation rings
cycles of relatives
eye of the needle | eye of the loop
tower of babel | eye of the storm
the light of distance
quantum jumps without falls
recognitive resonance
a suspended net sentence
suspension suspended
engendered strings of sonic fields
in the light of absence
puny hardware
mercurial tropes
parallel stream drivers
exploded objects of quiescence
transitional poetics of disembodiment
surrogate sense fields
conundrum domains | bridged and fused
chess theatre drum snare pair
a trap of folded fields
alchemical relatives
objects which turn in on themselves
```

Figure 20: Bill Seaman with Gideon May (programmer), "The World Generator / The Engine of Desire" 1996/97. Text documentation.

```
inversion objects
poem of the exploded word
gathered misnomers
revolving glass door
arboretum of reciprocal inversions
acrostic architectures of collapsed time
bodythought compressions
site which fabricates sites
personal cipher machines
encryption system strings
trap door code names
anagrammatic exchange objects
camouflaged key word states
situationals
poly-syntactic emblems
coded compartments
trade craft decoy ploys
books can become like shoes... [slogans]
ligature of the light passage bodies
hands of information
floating function rooms
indeterminate arcs of reaction
location sensitive self regulating rules
the desire object reflection mesh
a room which gets ahead of itself
```

Figure 21: Bill Seaman with Gideon May (programmer), "The World Generator / The Engine of Desire" 1996/97. Text documentation.

processes arise through use of this game-like interactive techno-poetic mechanism. A layered landscape of media-elements becomes phenomenologically engaging in the exploration and examination of emergent meaning. Years of experiments from the fields of science, engineering, entertainment, and art have yielded a hybrid series of vibrant yet mutant media-processes that can be employed in the creation of a new poetics. This field of generative interactive media-poetry, Recombinant Poetics, is a non-logocentric poetics. There is no hierarchy in the media-elements in that the vuser can choose from any media-variable in the construction of a mutable poetic virtual environment, i.e. if the participant chooses they may select only sound objects to populate the "plateau".

We are connected biologically (structurally coupled) to machines via mind/body relations. Thought is a biological process – a series of electro-chemical flows. As Ted Krueger suggests, machines are part of our ecosystem.[11] Computer-based interactivity enables biological processes to spread across distance and time, to be encoded and decoded through digital artefacts and, in turn, to influence and to be influenced from non-local environments. One cannot deny that the memory of past experience is drawn upon to explore new relational processes. As computer-based environments become central to our living, so do affective media-environments, informing future understandings and enabling high-level communication and inter-authorship.

The experiencing of illusionistic media forms including movies, commercials, entertainment, the internet, the Web, as well as our exploration of virtual environments, all come to inform our understanding of the world and augment other forms of authorship and knowledge production. Recombinant Poetics is a conglomerate-media poetics, drawing from a trans-disciplinary array of authored media-elements as a primary material for the interactive construction of a new poetics – a contemporary poetics exploring media combinatorics. *The World Generator/The Engine of Desire* contains media-elements that have been authored/chosen for their poly-valent nature.

The techno-poetic mechanism can also be experienced in a networked manner. Participants from different cities can enter copies of the virtual space simultaneously. A video-phone is presented on the interface table in the physical space. The vusers can converse with one another using the video-phone. The image on the video-phone screen is mapped onto a virtual object and becomes an avatar within the virtual space. This avatar registers the virtual proximity of the participants that are co-inhabiting the virtual environment. Each sees the virtual world from their own perspective. Each can make choices from the container-wheels constructing a collaborative experience of contextual generation. Again, emergent meaning production becomes a potential focus.

Nested within these choices from the container-wheels are high-level construction processes, where a single choice brings about the construction of an entire virtual world. I have coined the term Re-embodied intelligence to describe the encoding of particular sensibilities where the system can function as an extension of these (the artist's) sensibilities generating new virtual worlds based on the aesthetic parameters encoded in the system. The vuser can select these functions then alter the world to their liking or at any time erase an entire world and begin again.

Recombinant Poetics explores the generation of mutable poetic contexts. The emergent nature of the computer-based virtual environment is concomitant on human interaction with the media-elements and processes that are made operative through differing potential techno-poetic mechanisms. One could say that a number of artists are exploring this Recombinant Poetic strategy, employing different aesthetic and conceptual content to related poetic construction and navigation mechanisms. It is here registered that emergent content exploring complex human/machine relations is central to contemporary poetic experience. This interactive combinatorial poetic construction becomes the defining feature of this new techno-poetic field of exploration – Recombinant Poetics.

## Notes

1. See MATURANA, H. 1978. Biology of Language: The Epistomology of Reality. *In:* G.A. MILLER and E. LENNEBERG, eds. *Psychology and Biology of Language and Thought: Essays in Honour of Eric Lenneberg.* New York: Academic Press, pp.27–64. "When two or more organisms interact recursively as structurally plastic systems...the result is mutual ontogenic structural coupling... For an observer, the domain of interactions specified through such ontogenic structural coupling appears as a network of sequences of mutually triggered interlocked conducts... The various conducts or behaviours are arbitrary because they can have any form as long as they operate as triggering perturbations in the interactions; they are contextual because their participation in the interlocked interactions of the domain is defined only with respect to the interactions that constitute the domain... I shall call the domain of interlocked conducts...a consensual domain." (Maturana, 1978, p.47) See also WINOGRAD, T. and FLORES, F. 1986. *Understanding Computers and Cognition: A New Foundation for Design.* Norwood: Ablex Publishing. In *Understanding Computers and Cognition*, Winograd and Flores adopt Maturana's definition of "linguistic behaviour". They suggest the following: "Maturana refers to behavior in a consensual domain as 'linguistic behavior'. Indeed, human language is a clear example of a consensual domain and the properties of being arbitrary and contextual have at times been taken as its defining features. But Maturana extends the term 'linguistic' to include any mutually generated domain of interactions. Language acts, like any other acts of an organism, can be described in the domain of structure and in the domain of cognition as well. But their existence *as language* is in the consensual domain generated by mutual interaction. A language exists among a community of individuals and is continually regenerated through their linguistic activity and the structural coupling generated by that activity." (Winograd and Flores, 1986, p.49)
2. See SEAMAN, W. (1999) Recombinant Poetics: Emergent Meaning as Examined and Explored within a Specific Generative Virtual Environment. University of Wales College Newport Ph.D. Thesis
3. "Vuser" was coined by Seaman 2/5/98. It conflates the terms viewer and user. The related term (V)user was adopted by M. Rogalla after the initial coining of the term vuser by Seaman.
4. See VARELA, F., THOMPSON, E. and ROSCH, E. 1991. *The Embodied Mind, Cognitive Science and Human Experience.* Cambridge/London: MIT Press. Varela, Thompson, and Rosch in *The Embodied Mind*, speaking about Buddhist mindfulness/awareness suggest: "Its purpose is to become mindful, to experience what one's mind is doing as it does it, to be present with one's mind. What relevance does this have to cognitive science? We believe that if cognitive science is to include human experience, it must have some method of exploring and knowing what human experience is." (Varela, Thompson, and Rosch, 1996, p.23)
5. See *Websters New World Dictionary*
6. See HAYLES, N. K. (1999) *How We Became Post Human.* Chicago and London: University of Chicago Press.
7. *The World Generator/The Engine of Desire* has been shown internationally in Germany, Brussels, England, France, Hungary, and Tokyo.

8. In SEAMAN, W. (1999) Recombinant Poetics: Emergent Meaning as Examined and Explored within a Specific Generative Virtual Environment. I specifically examine the notion of meaning force. See also DERRIDA, J. 1978. *Writing and Difference*. Translation: A. BASS. Chicago: University of Chicago Press, p.25; Eco ECO, U. 1989. *The Open Work*. Translation: A. CANCOGNI. Cambridge: Harvard University Press. p. 14. And USHENKO, A. 1958. *The Field Theory of Meaning*. Michigan: University of Michigan Press. p. 79.
9. See DELEUZE, G. and GUATTARI, F. 1987. *A Thousand Plateaus: Capitalism and Schizophrenia*, vol.2. Trans. by Brian Massumi. Minneapolis: University of Minnesota Press. "Let us summarise the principal characteristics of a rhizome: unlike trees or their roots, the rhizome connects any point to any other point and its traits are not necessarily linked to traits of the same nature; it brings into play very different regimes of signs and even nonsign states. The rhizome is reducible to neither the One or the multiple. It is not the One that becomes Two or even directly three, four, five etc. It is not a multiple derived from the one, or to which one is added (n+1). It is comprised not of units but of dimensions, or rather directions in motion. It has neither beginning nor end, but always a middle (milieu) from which it grows and which it overspills. It constitutes linear multiplicities with n dimensions having neither subject nor object, which can be laid out on a plane of consistency and from which the one is always subtracted (n-1). When a multiplicity of this kind changes dimension, it necessarily changes in nature as well, undergoes a metamorphosis. Unlike a structure, which is defined by a set of points and positions, the rhizome is made only of lines; lines of segmentarity and stratification as its dimensions and the line of flight or deterritorialization as the maximum dimension after which the multiplicity undergoes metamorphosis, changes in nature. These lines, or ligaments, should not be confused with lineages of the aborescent type, which are merely localizable linkages between points and positions... Unlike the graphic arts, drawing or photography, unlike tracings, the rhizome pertains to a map that must be produced, constructed, a map that is always detachable, connectable, reversible, modifiable and has multiple entranceways and exits and its own lines of flight." (Deleuze and Guattari, 1987, p.21)
10. See EISENSTEIN, S. 1974. *The Film Sense*. Translation: J. LEYDA. New York: Harcourt Brace Jovanovich, Inc.; EISENSTEIN, S. 1949. *Film Form*. New York: Harcourt, Brace and Company; EISENSTEIN, S. 1970. *Notes of a Film Director*. New York: Dover Publications, Inc.
11. Conversation with Krueger for a series of differing papers presenting his concepts related architecture, media, perception and the environment.

# VIDEOPOETRY

## E. M. de Melo e Castro

Poetry is always on the limit of things. On the limit of what can be said, of what can be written, of what can be seen, even of what can be thought, felt, and understood. To be on the limit means often for the poet to be beyond the frontier of what we are prepared to accept as being possible.

The task of breaking these frontiers has been mostly in the hands of scientists but the appropriation of scientific concepts and of technological products is certainly the most exciting challenge the poet can set for himself or herself both as an inventor and a producer of things of beauty. I refer to a beauty of a different kind, one that necessarily goes beyond the established canons and sensibilities. But the use of new technologies to produce art is not only the appropriation of a new sort of tools. It is much more the breaking through of a different poetic perception.

The idea of the poem as a verbal galaxy of signs, first proposed in modern times by the French symbolist poet Stéphane Mallarmé, haunted the creative writing of the first half of the twentieth century. This galaxy includes the idea of the white page as a musical score standing as a challenge before the poet. This white page belongs to an ideal book the poet must write as his or her ultimate goal. But in the second half of the twentieth century things gradually changed under the pressure of scientific discovery, technological sophistication and the democratic diffusion of their effects on our perception of the world. The poet is no longer facing a white page. He or she faces a complex set of electronic apparatuses and their multiple possibilities to generate text and images in colour and in movement. The poet is confronted with his or her own skills to operate technological equipment.

The page is no longer there, not even as a metaphor. Space is now equivalent to time and writing is not a score but a dimensional virtual reality. Thus the idea of the book is coming to a crisis as it is gradually replaced by other means of external memory as the videotape, the floppy disk and even more by the CD-ROM. These media bring new possibilities for writing and reading as simultaneous space-time sequences, metamorphoses of signs and colours, and the

Figure. 1: Ernesto de Melo e Castro, Storyboard for "Roda Lume" (Wheel of Fire), videopoem, 2' 43", 1968. Broadcast in Portugal in 1969.

navigation on the highways of global communication. Videopoetry is thus a new possibility in the domain of the virtual.

When I began using video technology to produce my first videopoem, *Roda Lume* (Wheel of Fire), in 1968, I did not know where the limits were and where my experiments would take me. I was really experimenting on the most elementary meaning of the word experience. A sense of fascination and adventure told me that the letters and the signs standing still on the page could gain actual movement of their own. The words and the letters could at last be free, creating their own space.

The poetic function of language as defined by Jakobson emphasizes the message and its materials and structure. Thus the importance of phonetic values in oral poetry, of scriptural values in written poetry, of visual values in visual poetry, and of technological values when it is the case of the use of the computer and of video for the production of poetry and not only for simple repetitive and non-creative tasks. Videopoetry is then inevitable as a concept, responding to the challenge of the new technological means for producing text and image. Videopoetry is also an investigation of the specific characteristics of the electronic text, as opposed to those of the motion picture and also to the massification of TV broadcasting. But what are the specific characteristics that make video an adequate medium for poetic production?

Figure. 2: Ernesto de Melo e Castro, Storyboard for "Roda Lume" (Wheel of Fire), videopoem, 2' 43", 1968. Broadcast in Portugal in 1969.

We know that a new medium is at first seen and judged against the medium that came before it, until it is possible to establish a new set of aesthetic values belonging specifically to each new medium. Photography was judged against painting; cinema against theater; video against cinema. As for videopoetry the immediate references will be the experimental poetry of the 60s as iconized text. But the ultimate goal is to investigate video as a medium capable of developing by itself a new kind of reading pleasure. At first sight the aesthetic values present in video are the intimate relation of space and time, the rhythm of movement and the changing colours, all pointing to a poetics of transformation and to a grammar of integration of verbal and non-verbal signs. All these features contribute to a different and perhaps new meaning of reading.

One important point that needs careful consideration is certainly time because it is precisely a complex kind of time that the videopoem will give us. On the static written page the characters, the syllables and the words are still. The movement of reading belongs to our eyes following the sequence of signs commonly organized as horizontal lines from the top to the bottom of the page. In some forms of print-based visual poetry this may not be so and it is the reader who with his or her eyes must find the starting point and the possibilities of the reading sequences, if there are any. But in both cases the movement belongs to the eyes and to our imagination as reading goes on. During the watching of a videopoem on the TV monitor, the text (verbal and non-verbal) is not still. Letters, syllables and words all move in different and sometimes unexpected directions and ways. The scale of the signs can also be variable and so their definition against the ground if there is one. Colour is also a variable sign in itself.

Figure. 3: Ernesto de Melo e Castro, Storyboard for "Roda Lume" (Wheel of Fire), videopoem, 2' 43", 1968. Broadcast in Portugal in 1969.

Reading a videopoem is a complex experience as different temporal modalities of perception will coincide with moving and changing images. Thus we are confronted with different times and rhythms: a) the time belonging to the videopoem as one of its variables; b) the movement of our own eyes trying to find a way to read the signs; c) the time of our own decoding and understanding of what we are actually seeing.

A new poetics of reading is thus on the way.

Then we have also to consider the different possibilities of editing the images, creating either slow or quick sequences that will give different perception values. A quick time results in instantaneous visual apprehension tending to the limit of the subliminal. On the other hand, a slow time of editing will tend to the internalized reading opening a subjective enjoyment.

A concept of "visual time" is thus very important for a grammar of videopoetry as it defines the appropriate time of reading of each poem. Editing becomes for videopoetry a kind of musical tempo for visual images.

Colour is also a fundamental grammar element being as it is an orientation element of the movement of verbal and non-verbal elements. It is also a driver of the reader's eye movement acting as a semantic and emotion generator.

Figure. 4: Ernesto de Melo e Castro, Storyboard for "Roda Lume" (Wheel of Fire), videopoem, 2' 43", 1968. Broadcast in Portugal in 1969.

Sound, as music or human voice or even noise, is also part of the videopoem. It is used to make a counterpoint to the visual images and to create an atmosphere that facilitates the reading. But silence as a musical element is also important.

On the whole, a verbi-voco-sound-visual-colour-movement complex and animated image is created calling for a total kinesthetic perception.

It is interesting to note that the motion picture image is mainly a natural one captured by the camera and that what we actually see on the screen are images representing only a part of the total reality of the scene. However, the images of the videopoem are completely generated or transformed by electronic devices or digital functions. These images do not exist outside the apparatus that produces them and have no outside reference. They can also be stored in magnetic or optical supports.

Videopoetry is therefore made of virtual images organized in metonymic sequences. We are thus forced to recognize that, contrary to traditional and verbal poetry, it is not the metaphor that prevails in videopoetry. Also the images are more of an iconic character rather than a symbolic one.

Nevertheless, video as a medium and as an organizing principle of virtual images is a metaphor of reality. It constitutes a metalanguage. It is a multiple generator of visual discourse and poetic perception.

## A Personal Trajectory

As for my personal experience, I began experimenting with words within the frame of verbal poetry in the 1950s, searching for an economy of language that very soon brought me to the transgression of grammar, experimenting with combinatory algorithms applied to verbal materials, words and letters. I went from the hypotaxis to the parataxis abolishing the difference between verbal and non-verbal and reaching a totally visual concept of invention. The next step was starting to experiment with the means of making poetry. Concrete poetry in 1960 was for me not an arriving point but rather a launching platform.

At first I wrote experimental poems by handwriting them or using old typographic fonts. Later came letter-press techniques making the work easier. Soon it became evident to me that experimenting with letters and with different materials was the appropriate way to produce visual poetry. So I made poems with paper, wood, textiles, stone, and plastics, using very often collage techniques. Now I use light to produce infopoems and videopoems on the computer. My first videopoem – *Roda Lume* – is from 1968 and since then I realized that heavy materials are coming to an end as a support for communication. The dematerialized virtual image is in itself a poetic image and therefore the poem should also be dematerialized.

## Videopoemography

My own production of videopoems can be seen as a development of experiences in three different tempos:

I – An impulse towards the use of new technological means resulting in the production of my first videopoem – *Roda Lume* – in black and white consisting of animated geometric shapes and letters previously hand drawn. The animation was made by direct on-camera editing, registering image after image with a time-based corrector. A storyboard was first made with image sequence and its respective time. Sound was added afterwards as an improvised phonetic reading of the visual images. I produced the sound myself.

This videopoem was shown on a literary magazine on Portuguese TV in the beginning of 1969 and it produced a scandal amongst the spectators. It was then destroyed by the official TV station as it was considered to be without any interest. Now I am told that it is probably the first videopoem made as such, and that it is different from the techniques and aesthetics of the so-called videoart. I kept the storyboard drawings and was able to make a new version of it in 1986. Only the soundtrack is different as I did not keep a recording of the original improvisation and had to make a new one by memory. The duration of this version is two hours and fifty-eight minutes.

II – In 1985, as a result of an opportunity given to me by the Portuguese Institute for Distance Learning (IPED) and later by the Open University of Lisbon, I was able to use TV studios and to explore the creative possibilities offered by the new electronic and digital equipment recently installed. As a result I devised the project *Signagens* (Signings) that I developed up to 1989.

This project intended first of all to investigate video possibilities as a new medium for reading poetry. It was meant to be used in classes of literature and of Portuguese language. Very soon I realized that intersemiotic translation of print-based visual and experimental poems was

obvious, as video seemed to me a perfect medium for animation of letters and words. Then I produced a set of videopoems based almost exclusively on pre-existing poems from the 60s. I used mostly poems of my own from that time. The following videopoems were produced in this context:

- *As Fontes do Texto* (The Fountains of the Text) - 8'30"
- *Sete Setas* (Seven Arrows) - 1'29"
- *Sede Fuga* (Thirst Escape) - 1'23"
- *Rede Teia Labirinto* (Net Web Labyrinth) - 2'12"
- *Vibrações* (Vibrations) - 4'13"
- *Um Furo no Universo* (A Hole in the Universe) - 2'
- *Come Fome* (Eat Hunger) - 1'44"
- *Hipnotismo* (Hypnosis) - 33"
- *Ponto Sinal* (Period Sign) - 3'55"
- *Poligono Pessoal* (Personal Polygon) - 8'15"
- *O Soneto, Oh!* (The Sonnet, Oh!) - 5'34"
- *Objectotem* (Objectotem) - 5'37"
- *Escrita da Memória* (Memory's Writing) - 2'14"
- *Concretas Abstrações* (Concrete Abstractions) - 1'30"
- *Dialuzando* (Daylighting) - 5'

Having made these videopoems I realized that video has its own identity and that it is a suitable medium for the production of images of its own having no existence outside the system. A new period was started: I explored the specific virtual possibilities of video for poetic creation without having to use a poem created outside the medium. It can be said that the true videopoetry was beginning. My production of this period used exclusively computer generated images transformed by digital effects. The camera was practically of no use at that time. The titles of the poems then produced are:

- *Poética dos Meios* (Poetics of the Media) - 9'50"
- *Infografitos* (Infograffiti) - 5'24"
- *Ideovideo* (Ideovideo) - 7'50"
- *Metade de Nada* (Half of Nothing) - 5'55"
- *Do Outro Lado* (On the Other Side) - 5'
- *Vibrações Digitais Dum Protocubo* (Digital Vibrations of a Protocube) - 5'20"

III – When the *Signagens* project came to an end in 1989 I was confronted with the difficulty of finding a suitable studio to carry on my experiments. After various frustrated attempts I decided to install at home my own studio and started buying old and discontinued equipment still in good working condition though of very small commercial value, together with VHS videos and personal computers. I believe that more important than very sophisticated hardware is the creative mind that uses it. Thus in 1990 I began to produce a different kind of videopoetry using all types of virtual images and, contrary to the expectations, the results were much more interesting and aesthetically sophisticated than the ones obtained at the Open University studio. They are much more intense and give a disturbing experience to the eyes. They are a more advanced step in poetic experimentation. Up to now I have produced in my studio the following videopoems:

Figure. 5: Ernesto de Melo e Castro, "Ideovídeo", single-channel video, 1987, 8 min, color/sound (four frames).

Figure. 6: Ernesto de Melo e Castro, "Ideovídeo", single-channel video, 1987, 8 min, color/sound (four frames))

- *Ian Palach* (Ian Palach) - 5'40''
- *Lixo Super Lixo* (Junk Super Junk) - 6'
- *Sonhos de Geometria* (Dreams of Geometry) - 30'

*Sonhos de Geometria* is a visual meditation about transformation of shapes in space and time, developed in five videopoems. The first is *Sonho dos Bisontes Geómetras de Lascaux* (Dream of the Geometer Bisons of Lascaux) and is an evocation of the enigmatic pre-historic drawings and pictures stressing the importance of the contrast between light and dark in the production of those images. The second is *Sonho de Pitágoras* (Pitagoras' Dream). It is about the birth of the numerical symbols up to the organization of the decade and the Tetraktys as a symbolic form of all numerical relations. From there we go to the invention of the famous theorem. The third one *Sonho de Euclides* (Euclide's Dream) gives us the Euclidean geometry in two dimensions hoping for the third one: the laws of perspective. The fourth poem *Sonho de Mandelbrot* (Mandelbrot's Dream) shows the forms of nature, clouds, and trees as the original source of Fractal geometry, rendering interactions between these shapes and the Mandelbrot set. Finally the fifth one is *Sonho de Melo e Castro* (Melo e Castro's Dream). In this poem I use my own first video poem *Roda Lume* in an intertextual relationship together with other poems of mine, all being a proposition of a new way of reading and poetic fruition using feedback effects and a very accelerated rhythm.

In the large majority of my videopoems I use electronic music specially composed by the Portuguese duo TELECTU (Jorge Lima Barreto and Vitor Rua), mostly of a minimal repetitive character that I find perfectly adjusted to the nature of videopoetry. I want to emphasize particularly the original music for *Sonhos de Geometria* for its high quality and perfect aesthetic coordination with each poem. *Sonhos de Geometria* was published in Cuenca, Spain, in 1993, as a VHS videocassette by the literary magazine *Menú* under the direction of Juan Carlos Valera.

To complete this videographic reference it is necessary to include the videopoem *Vogais, As Cores Radiantes* (Vowels, The Radiant Colors – having as a starting point the sonnet by Rimbaud) that I made in 1986 on the RTP (Portuguese Radio and Television) studio after an invitation to participate in the series *Memória Audiovisual* (Audiovisual Memory) by Vasco Pinto Leite. Its duration is three minutes and seven seconds and the original music is by TELECTU.

# Language-based Videotapes & Audiovideotapes

## Richard Kostelanetz

In industrial society, the decorative crafts have been converted into mass media. Only the pressure of new creations against art as it has been defined keep art from merging with the media and allows works to survive for an interval as art. To maintain the pressure of de-definition has been the task of the avant-garde. – Harold Rosenberg, "Inquest into Modernism" (1978)

In an earlier memoir about my writing for/with videotape, I spoke of the standard small television screen as resembling the page of a book, in contrast to the larger, more enveloping visual field of the movie house and suggested that the imagery most appropriate for such a small screen would be intimate and devoid of excessive detail. For my earliest video creations, collected as *Three Prose Pieces*, I favoured simple screen-filling images similar to the essential page-filling images in the visual fictions I was also writing around that time (some of which were collected in *More Short Fictions* [1980]). In *Epiphanies* (1981) and *Partitions* (1986), I put on the screen only sequences of static arrays of words, fully realizing the resemblance to book pages. Two negative assumptions favoured from the beginning were that the television box must be good at presenting images other than the solo talking heads that predominate in public transmissions and structures other than the collages favoured by most "video artists". There was no need to duplicate what others were doing, no matter how opportunistic such aesthetic butt-kissing might be.

The next development began with a series of almost annual residencies at the Experimental TV Center in Owego, New York. Here, working with Hank Rudolph and Peer Bode, I had access first to slightly more sophisticated character-generators, or electronic letter-making machines. Instead of only one machine, I now had access to two, with different typefaces, each able (unlike before) to do smaller letters as well as full capitals; and these character-generators also had memories that allowed me to put a series of successive images, or pages, that could then be played back while the recording tape was running. Attached to this system was a tape drive

that can store on a single "data-cartridge" cassette as much as 300 separate pages of text, any or all of which can be random-accessed. In addition, the ETC studio offered processing equipment that facilitated such kinetic moves as dividing the screen between two sets of images or adding colour backgrounds that could be electronically changed as we recorded the images onto video tape. Thanks to rescanning, or the process of reshooting an image off a television screen, we could do yet more radical image-modification. I also used the so-called text programs of an Amiga 500 computer to "generate" letters that make words that move. As is my custom in guest residencies, I tried to exploit artistic possibilities within technological limitations, rather than entering a studio with detailed schemes designed to be realized at any cost.

With these technologies, I made a series of short pieces whose only content is language, some only a few seconds long, others perhaps a minute, and thought of these as *Kinetic Writings* (1988), to quote the title of a 22-minute tape collecting the best of them. But I also realized that the bulk of them could be divided into two categories – "Video Poems," which realize a conciseness of image and effect; and "Video Fictions," which imply movement from one place to another, which is to say narrative, even if abstract. However, since ETC's machines offer only synthesis, not editing, I must go elsewhere to produce a finished tape. That pair of hour-long tapes, when done, would represent, as far as I can tell, the first of their literary kinds.

Thanks to the data-cartridge technology, along with the character-generator's capacity to make letters "crawl" in an evenly paced horizontal line across the screen, I could cast on tape the "strings" I had written several years before. These lines of continuous letters contain overlapping words, each of which includes at least two or usually three letters from its predecessor (depending upon the rule made for each text). Most were in English, one was in German. Thus, *Stringtwo*, which has a two-letter overlap, opens with the following:

    Stringtwomenteroticystitisolatenderotogeniceapplesbiannultimaterminuse...

Once these extended strings of letters were entered into the data-cartridge, they could be continuously recorded in several ways: with just a single stream of letters running across the screen, at one of three available speeds, at times with colours changing in either the letters or the background; with an enlargement of the middle letters running as a counterpoint either above or below; with on-screen windows that contain changing fragments of the continuous imagery. Some of the shorter strings were incorporated into a 30-minute tape titled *Videostrings* (1989). The entire German text became *Stringsieben* (1989, 12:00), while *Stringtwo* (1990) alone runs well over 35 minutes. For the first, I added the music of Gordon Jillson, who had previously composed the soundtrack for *Partitions*; *Stringsieben* has harp music played by Nina Kellman. For the last I hope to add a kind of continuous pseudo-speech composed by Joseph V. DiMeo.

I also used the character-generator and data-cartridge to put on screen the text of my second most difficult audio composition. The text of *Turfs Arenas Fields Pitches* (1983) opens with those four words arrayed in the four corners of a single page and contains 60 more poems similarly structured. While in residence at Davis & Elkins College, I recruited four people to speak the words of each page in unison, as a kind of verbal chord, whose parts, I thought,

Figure. 1: Richard Kostelanetz, sequence of stills from *Kinetic Writings* (1988), video, no sound.

should be individually comprehensible, much as the notes of a musical chord can be individually identified. Attractive though that perceptual purpose was in theory, it was more problematic in practice, especially on first hearing, and what was difficult with four-word poems became even less feasible with eight-word poems composed to a similar spatial principle (Grounds Gridiron Scrubs Vocabularies Tracks Proscenia Lists Theaters). So it seemed appropriate to put the words of all these poems on screen not in their original geometric forms, but as horizontal lines, for durations roughly corresponding to their appearance on tape. (The videotape concludes with silent arrays of sixteen-word poems, likewise similar in structure, because they have not yet been aurally recorded. Since this videotape has three sections, I decided to title it with an opening word from each section: *Turfs/Grounds/Lawns* (1989, 23:00). As the soundtrack was processed at the Electronic Music Studio in Stockholm, where I have several times been artist-in-residence, it was transferred in stereo to the ³/₄-inch master videotape (and copied onto the hi-fi tracks of VHS tape); its sound, apart from its picture, is thus best played back not through the single small speaker of a standard television monitor but a stereo system customarily used for records and compact discs. Because the audio track of such videotapes is as important as the pictures, I classify them, unlike the others, as audiovideotapes. (I later used a more complicted video lettering to make visible the text of my audio *Onomatopoeia* [1988].)

Figure. 2: Richard Kostelanetz, still from *Kinetic Writings* (1988), video, no sound.

Previously exploring the principle of composing videotapes to my audio compositions, I started with *Seductions* (1981) and *Relationships* (1983), two extended electronically enhanced readings of texts that resemble each other with erotic content. For imagery I turned to the Amiga computer, which has an extraordinary capability for continuously generating richly coloured kinetic imagery. Since my texts were already comprehensible, it seemed unnecessary to show what was said (as was done with *Turfs*); instead, we found in the Amiga an endless flow of lush abstract kinetic shapes that had their own sensuous quality. Indeed, in many respects, the audiovideotapes *Seductions* (1988) and *Relationships* (1988) resemble the light show that I enjoyed at the best rock concerts two decades ago.

I realized that similar video syntheses might be effective with other audio compositions of mine. *Invocations* (1981, 1984), of and about the language of prayer, differs from Seductions and Relationships in having distinct sections, rather than continuous sound, and so it seemed appropriate to make for each section a video synthesis as long as its sound. Thus, each section has its own visual "setting", to use a word that is customarily used to identify sound made to enhance language. Again, it seemed appropriate to use not representational pictures, remembering the commandment against graven images, but continuous kinetic abstractions. I extended this last principle to *The Gospels* (1982), a two-hour fugue of the initial four books of the New Testament; but rather than letting the audiovideotape go with only one video synthesis, we literally put a new one on top of an old one, making the tape denser and, as the emphasis between the new and the old shifted, more various. As four ministers are simultaneously reciting complementary biblical texts, shapes flash across the screen. Some of them are circular, others rectangular, yet others strips, their colours changing in stochastic ways,

enhancing the acoustic experience without distracting from it (much like the light show at a rock concert).

Once I had these syntheses, I discovered what was not obvious at the beginning – that they were seen best not on standard small screens but on two-piece projection televisions that resemble film in having images that are looked at (not through, without fear of cathode ray tube damage), but differ from film in having a blurred surface and rougher edges. Indeed, there is every reason to regard projection television as a reproduction medium quite different from the book-like small screen television on one hand and film on the other.

For another audiocomposition, *Praying to the Lord* (1981), I made several Amiga syntheses that are similar in style but different in detail, hoping someday to broadcast them on several monitors, which is another medium for publishing background video, so that the images accompany not only the single soundtrack but one another.

In 1988, I finished an hour-long audiotape composition of and about the sound of baseball, *Americas' Game*, and wondered how to video it, so to speak. I did not want live-action footage or other kinds of familiar illustrations. Preferring an image with its own power, I chose a single baseball, well illuminated, that remains on screen, motionless, for the entire duration, 60 minutes, as a kind of Buddha that is worshipped, to be sure, as devoutly as other images of Buddha.

Only in this last piece do I deviate from my original assumption that my video art would be based on language or literature, for that assumption was the principle, as well as the signature, of my video art. I had noted before that few, if any, of my literary colleagues produced their own videotapes, as distinct from appearing as talking heads in videotapes made by others; and even though I have been making language-based videotapes for a quarter century now, none of them of talking heads (though some of talking lips), my interest remains unique. There is more work to be done, by others as well as me, in discovering not only video possibilities for language but video contents different from the common run.

# BIOPOETRY

**Eduardo Kac**

Since the 1980s poetry has effectively moved away from the printed page. From the early days of the minitel to the personal computer as a writing and reading environment, we have witnessed the development of new poetic languages. Video, holography, programming and the Web have further expanded the possibilities and the reach of this new poetry. Now, in a world of clones, chimeras, and transgenic creatures, it is time to consider new directions for poetry in vivo. Below I propose the use of biotechnology and living organisms in poetry as a new realm of verbal, paraverbal, and non-verbal creation.

1. Microbot performance: Write and perform with a microrobot in the language of the bees, for a bee audience, in a semi-functional, semi-fictional dance.
2. Atomic writing: position atoms precisely and create molecules to spell words. Give these molecular words expression in plants and let them grow new words through mutation. Observe and smell the molecular grammatology of the resulting flowers.
3. Marine mammal dialogical interaction: compose sound text by manipulating recorded parameters of pitch and frequency of dolphin communication, for a dolphin audience. Observe how a whale audience responds and vice versa.
4. Transgenic poetry: synthesize DNA according to invented codes to write words and sentences using combinations of nucleotides. Incorporate these DNA words and sentences into the genome of living organisms, which then pass them on to their offspring, combining with words of other organisms. Through mutation, natural loss and exchange of DNA material new words and sentences will emerge. Read the transpoem back via DNA sequencing.
5. Telephant Infrasonics: Elephants can sustain powerful infrasound conversations at distances as far as eight miles. These can be perceived by attuned humans as air pressure variations. Create infrasound compositions that function as long-distance elephant calls and transmit them from afar to a population of forest elephants.
6. Amoebal scripting: Hand write in a medium such as agar using amoebal colonies as the inscription substance and observe their growth, movement, and interaction until the text changes or disappears. Observe amoebal scripting at the microscopic and the macroscopic scales simultaneously.

Figure. 1: Eduardo Kac, "Microbot performance (Biopoetry proposal #1)", 2002. The "robeet" (robotic bee) would allow a poet to write a performative dance-text that has no reference in the physical world (that is, does not send bees in search of food). Instead, the new choreography (kinotation) would be (bee) its own reference.

7. Luciferase signaling: create bard fireflies by manipulating the genes that code for bioluminescence, enabling them to use their light for whimsical (creative) displays, in addition to the standard natural uses (e.g., scaring off predators and attracting mates or smaller creatures to devour).
8. Dynamic biochromatic composition: use the chromatic language of the squid to create fantastic colourful displays that communicate ideas drawn from the squid Umwelt but suggesting other possible experiences.
9. Avian literature: teach an African grey parrot not simply to read and speak and manipulate concepts and symbols but to compose and perform literary pieces.
10. Bacterial poetics: two identical colonies of bacteria share a Petri dish. One colony has encoded in a plasmid a poem X, while the other has a poem Y. As they compete for the same resources, or share genetic material, perhaps one colony will outlive the other; perhaps new bacteria will emerge through horizontal poetic gene transfer.
11. Xenographics: Transplant a living text from one organism to another, and vice versa, so as to create an in vivo tattoo.
12. Tissuetext: Culture tissue in the shape of word-structures. Grow the tissue slowly until the word-structures form an overall film and erase themselves.
13. Proteopoetics: create a code that converts words into amino acids and produce with it a three-dimensional proteinpoem, thus completely bypassing the need to use a gene to encode the protein. Write the protein directly. Synthesize the proteinpoem. Model it in digital and non-digital media. Express it in living organisms.
14. Agroverbalia: Use an electron beam to write different words on the surface of seeds. Grow the plants and observe what words yield robust plants. Plant seeds in different meaningful arrays. Explore hybridization of meanings.

𝖯𝖱𝖮𝖯𝖧𝖤𝖢𝖸

𝖠

𝖳𝖠𝖦𝖦𝖤𝖣  𝖢𝖠𝖳

𝖶𝖨𝖫𝖫 𝖠𝖳𝖳𝖠𝖢𝖪

𝖦𝖠

Figure. 4: Eduardo Kac, "Proteopoetics (Biopoetry proposal #13)", 2002 By assigning specific semantic values to aminoacids, a poet can write a protein. The "Genesis" protein, above, critically encodes the biblical statement: "Let man have dominion over the fish of the sea, and over the fowl of the air, and over every living thing that moves upon the earth."

15. Nanopoetry: Assign meaning to quantum dots and nanospheres of different colours. Express them in living cells. Observe what dots and spheres move in what direction, and read the quantum and nanowords as they move through the internal three-dimensional structure of the cell. Reading is observation of vectorial trajectories within the cell. Meaning continuously changes, as certain quantum and nanowords are in the proximity of others, or move close or far away from others. The entire cell is the writing substrate, as a field of potential meaning.
16. Molecular semantics: Create molecular words by assigning phonetic meaning to individual atoms. With dip-pen nanolithography deliver molecules to an atomically flat gold surface to write a new text. The text is made of molecules which are themselves words.
17. Asyntactical carbogram: Create suggestive verbal nanoarchitectures only a few billionths of a meter in diameter.
18. Metabolic metaphors: Control the metabolism of some microorganisms within a large population in thick media so that ephemeral words can be produced by their reaction to specific environmental conditions, such as exposure to light. Allow these living words to

Figure. 5: Eduardo Kac, "Asyntactical carbogram (Biopoetry proposal #17)", 2002. The beginning of a new alphabet. Letters can be created with carbon nanotubes, tiny cylinders only a few billionths of a meter in diameter, as exemplified by this letter "T". Words created at this nanoscale can be made stable under the laws of quantum molecular dynamics. The first letter of the word "Tomorrow".

dissipate themselves naturally. The temporal duration of this process of dissipation should be controlled so as to be an intrinsic element of the meaning of the poem.
19. Haptic listening: Implant a self-powered microchip that emits a sound poem upon contact (via pressure). The sound is not amplified enough to be heard though the skin. The listener must make physical contact with the poet in order for the sound to travel from the microchip inside the poet's body into the listener's body. The listener becomes the medium through which the sound is transmitted. The poem enters the listener's body not through the ears, but from inside, through the body itself
20. Scriptogenesis: Create an entirely new living organism, which has never existed before, by first assembling atoms into molecules through "Atomic writing" or "Molecular semantics". Then, organize these molecules into a minimal but functional chromosome. Either synthesize a nucleus to contain this chromosome or introduce it into an existent nucleus. Do the same for the entire cell. Reading occurs through observation of the cytopoetological transformations of the scriptogenic chromosome throughout the processes of growth and reproduction of the unicellular organism.

196 | MEDIA POETRY: AN INTERNATIONAL ANTHOLOGY

Figure. 6: Eduardo Kac, "Metabolic metaphors (Biopoetry proposal #18)", 2002 (realized in 2006). Approximately 5,000 different microorganisms (prokaryotic bacteria and archaea) make up the biopoem population. Make a mask with the text to be read. Expose to light everything but the text. In about 4 weeks the text will be dark enough to be clearly read. Expose the whole surface to environmental light and allow the words to dissipate. The population within the sealed chamber will recycle nutrients and will support itself with no additional aid.

# Part III – Historical and Critical Perspectives

## PART III – Municipal and Central Reservoirs

# Media Poetry – Theory and Strategies

## Eric Vos

Media poetry is innovative poetry created within the environment of new communication and information technologies. This observation is, of course, all right and all wrong. It is all right in describing the new media as environments for the creation of poetry, as offering technological possibilities for experiments in writing poetic texts. That is what is documented in this anthology. But it is all wrong in suggesting that the basis for media poetry is merely to adopt these technologies as writing, publishing, and reading tools. Computers, word processors, modems, communication software, and the Internet all take part in the writing and reading of poems published in numerous online literary periodicals – but they do not necessarily partake in their poetics. Many poems scattered over the Internet appear to ignore their electronic environment as much as they possibly can, aspiring to the conditions of print poetry. And that is evidently not what media poetry seeks to achieve.

So we must expand our definition. Media poetry is innovative poetry created and experienced within the environment of new communication and information technologies – and it could not have been created nor cannot be experienced in other environments. It is a poetry based on the integration of characteristic features of these technologies in the strategies that underlie the writing and reading of poetic texts. In terms of the labels often attached to the new media, we are dealing with a virtual, dynamic, interactive, immaterial poetry. This appears to be a much more valid description of media poetry – but what does it mean?

Well, one answer could be: That is precisely what the various poets represented in this anthology attempt to find out in and through their explorations of the poetic domains offered by the new media. But we will attempt to go a little further than begging the question in this way. We shall try to develop an account of the basis of media poetry, or at least to sketch the contours thereof. We call this basis 'theoretical' rather than 'poetical' because it expands the habitual domain of poetics to include considerations on communication and information theory, semiotics, and interart relationships. Also, we will discuss some characteristic writing strategies of media poetry. But in all this, we are well aware that we must leave many important questions unanswered.

We shall focus on what is new in media poetry – but what about the links with the tradition of (experimental) poetry? Surely media poetry did not come to us unprecedented. What has given rise to its present development? What is the reason that in our times many poets from completely different backgrounds, often – at least initially – unaware of each others existence and works, in such remote parts of the world as Brazil, France, Argentina, the United Kingdom, Germany, the United States, Portugal, the Netherlands (the list could, of course, be expanded), envisaged a future for poetry in the context of the new media? What is the relationship between their poetic work and their literary, socio-cultural, ideological, and historical environments? We shall focus on the common traits of their poetry – but what about the differences between their poet*ries*; what about the variety of forms to which media poetry has already given rise and which will surely increase in the years to come? We can only hope that such questions will be taken up soon and that our thoughts may be of some use in answering them.

In what follows, we shall often use the term 'communication'. We believe that communication is the focal point of both the new media and the new poetry that make up media poetry. Since we do not advocate a particular model of communication, the reader is free to supplement our views with his/her opinions on the structure of the communication process. But there is one proviso: 'Communication' must *not* be read as denoting a process the success or failure of which depends on whether or not the intentional objectives of a 'sender' are 'understood' by a 'receiver'. It should *not* be envisaged as a unilateral relationship, in which the 'sender' bears sole responsibility for his 'message' – or claims full control over it – and the 'receiver' is nothing but a decoding agent. As we hope to make clear, such a view would contradict the very basis of media poetry. Or, reversely, the innovative explorations undertaken in this poetry are invariably aimed at generating a very different communicative space.

### New Media, New Poetry – The Theoretical Basis

We may take that notion of 'space' quite literally. Writing, J. David Bolter reminds us,[1] always is and always has been a topical affair – i.e. an affair determined by the space of writing. Writing on paper pages, codex format, or writing with a printed book in mind differs from writing on clay tablets or papyrus scrolls not just in employing other tools. It means that the writer is engaged in an activity that takes place in a different environment, organized by a different set of rules and conventions. These environments are crucially important: status, nature, structure, and use of the written work are determined by them.

In the process of being established as such a 'writing space' a new medium like hypertext affects all these "concerns", to use William Dickey's term,[2] which, as he sums up,

> include multiplicity of perspective, variability of the structures and vocabulary of language, including the extension of the idea of language to non-linguistic elements ..., rejection of a single rhetorical authority and of linear causative organizations as providing the appropriate pattern for a work of literary art, admission of aleatory organizations and relationships as more accurate representations of experience, and at least an effective illusion of the simultaneity of experience.

In their concern with the interplay between text and space, hypertexts are therefore "tentative, fluid, changeable".[3]

Dickey's triad may serve to mark the generically important distinction between poetry that 'merely' addresses and poetry that 'genuinely' adopts the new media as a writing space. This distinction becomes obvious when we very briefly compare the kind of poetry represented in this anthology with the kind of poetry discussed, for instance, by Marjorie Perloff in her *Radical Artifice. Writing Poetry in the Age of Media*.[4] Perloff's is an eminent analysis of the ways in which contemporary experimental poetry addresses new media and communication technology and confronts itself with the semiotics of (electronic) mass media. But the poetry discussed is invariably print poetry. The writing is done on the page. Concepts like tentativeness, fluidity, and change may very well become relevant for both the reading processes and the reconsiderations of habitual thoughts on language, poetry, and verbal communication to which this writing gives rise – but the poetic inscription itself is given, static, and fixed. That is what print tends to do to writing.

Surely, the L=A=N=G=U=A=G=E poetry, John Cage's mesostic writings, Steve McCaffery's typewriter experiments, Oulipian devices, and other works presented by Perloff all question the concept of the poetic text as a conduit, aesthetically valuable because of its construction, through which some pre-encoded message is transmitted from author to reader. And surely that view on poetry as an aesthetic process of encrypting and decoding messages had already been challenged by many experimental poets of the past. In this respect, such poetic works share an interest with media poetry. But in all these former instances – from the Dada sound poem and the Futurist *parole in libertà* to the hybrid works of Visual Poetry, even to the texts produced by the programs of the first computer poets – the poetic text itself is 'already there'; it is presented to the reader in a fixed and final format. In media poetry, the reader is offered the opportunity, the means, and the required information (e.g. in the form of digital data) to bring a text into – virtual – existence. In media poetry, the poetic text is never 'already there'; it is not a package for but a parameter of the poetic communication process.

This, of course, is not to say that there are no messages, no meanings, no aesthetic values in media poetry at all. The point is that they cannot be thought of as being contained in the text and being delivered to the reader through this text, for there is no text independent of the reader's search for it.[5] Messages, meanings, and values are created alongside with the text.

Nor is this to say that bringing a text into being is the only objective of media poetry. It is, rather, a point of convergence between the various activities of poet and reader that, in their mutual dependence, constitute the poetic communication space. What really counts in media poetry is the way in which the ramifications of these activities transform the entire field of poetic communication. In the remainder of this section, we shall discuss four aspects that we consider particularly important: first, the exploration of *interrelationships between* constitutive factors of that field; second, the role of *unique features* of the new media in this respect; third, the *reconsiderations of conventions* that inevitably arise from such explorations; fourth, the *shared responsibility* of author and reader in all this. Together, these aspects constitute the theoretical basis for media poetry.

Given the nature of the communication channels employed in media poetry – e.g. computer, video, hologram – the signs out of which the poetic text is (to be) constituted are immaterial. The virtual domain of this poetry "exceeds all the more or less established techniques of

channeling poetic messages, because it breaks in a definitive way with the first support that produces and maintains them: real physical space", Argentinian poet Ladislao Pablo Györi writes.[6] This break is really a dramatic one; it opens up a world of new possibilities for the composition and combination of signs and for their electronic manipulation. (For brevity's sake, we refer to other essays in this anthology for examples.)

As media poetry centers on the exploration of these possibilities, it may appear that the employed channels are its constitutive source all by themselves. But in fact, they are only part of the story. What is really at stake here, in Bolter's words, is that "[t]here is a *dynamic* relationship between the materials and the techniques of writing, and a less obvious but no less important [and no less dynamic] relationship between materials and techniques on the one hand and the genres and uses of writing on the other."[7] Particularly the second of these relationships is crucial for media poetry. But one should keep in mind that Bolter's dynamics are no automatisms!

We referred earlier to the many poems drifting in cyberspace that would work just as well in a print environment. The poetic conventions and writing strategies that underlie their composition have nothing to do with the medium through which they are transmitted. Similarly, a Shakespeare sonnet does not become a hyperpoem merely by including it on a hypertextually organized CD-ROM. Even Tennyson's "proto-hypertextual" *In Memoriam*, a poem that "anticipates electronic hypertextuality", had to be "adapted" in order to work in its new environment of the Intermedia Web created by George Landow and his students at Brown University – the quoted terms are all Landow's.[8] The inclusion of links required decisions on what parts of the text should be linked with what other parts and with what other texts, and this, in turn, required reflections on context, poetic codes and conventions, literary history, and the reading process. A holopoem, in Eduardo Kac's conception, is typically *not* a holographic rendering of an ink-and-paper-based text; a videopoem is typically *not* a videotaped reading or video scanning of printed poetry.

The most significant lesson to be learned from these and similar observations is that the channel and other constitutive factors of the process of poetic communication should not be conceived of as independent units.[9] On the contrary, the relevance of innovations with regard to the channel of literary communication depends on the influence of such innovations on other factors. These factors go from the employed codes (including generic codes) and the syntax of poetic texts, via the newly generated possibilities of semantic valuation thereof, to the pragmatics of poetic communication and the experiences integrated therein. In fact, *exploring the very interrelationships of all these aspects* could well be considered an overall objective of media poetry.

It is in this respect that the immateriality of media poems truly transforms the field of poetic communication. There are two main reasons for this. First, the conditions for such exploration prevalent in virtual writing spaces are unavailable in a print environment, or only available to a very limited extent. Their employment triggers a revaluation of potentially every convention on the level of sign construction. Consequently, *new* interrelationships between the aforementioned aspects of poetic communication arise. Second, in responding to the media poem, the reader therefore cannot but engage in a similar revaluation. In their immateriality,

the explorations of media poetry may thus offer a new perspective on language itself and, ultimately, on our verbal behaviour. Let us now consider each of these points in a little more detail.

It follows from the above that in media poetry the poetic texts will be endowed with features that are *unique* to the virtual environments in which they are written and read. Surely one of the most important of these features is variability. Jim Rosenberg's hyperpoems, Eduardo Kac's holopoems, Melo e Castro's videopoems, and other works represented in this anthology are all characterized by a fluctuation and change that cancels the self-contained invariability of printed texts.

In Rosenberg's poems, as in all hypertexts, the reader has to find his/her own textual path by 'navigating' through a web of linked lexia.[10] In theory, this already questions the validity of the concept of '*the* literary message' as a syntagm of textual units presented in fixed and permanent linear sequence, transmitted in a process of literary communication from author to reader. But in practice, at least according to Rosenberg,[11] "hypertext does not go nearly far enough". The reference is to those hypertexts whose individual 'statements' or lexia comply with the syntagmatic rules of the natural language in which they are written. As Rosenberg continues, the non-linear discontinuity (or discontinuous non-linearity) that characterizes hypertext as an organizational principle "should be extended all the way down into the fine structure of language. Syntax itself can operate through the same kinds of operations as the hypertext link." For example, in his *Diffractions Through*[12] Rosenberg includes both 'polylinear' lexia, characterized by "the stringing of word skeins in a graphical space where normal print conventions establish no clear ordering among the skeins", and "relational syntax diagrams" as "planes" of the poem's hypertextual 'simultaneity', i.e. "the literal layering on top of one another of language elements". Verbal strings, scattered text chunks, diagrammatic schemes, and spatial layers all work together to shape the poetic writing space in which the reader has to find his/her route. Needless to say, this route will vary from reader to reader, and from reading to reading.

Variation and change take place in time; the introduction of time as a feature *of* the written text is another innovation uniquely realizable in the new media writing spaces. Time and time manipulation are explored in various ways throughout media poetry, particularly in Melo e Castro's video poems, in Kac's holopoems, and in the animated poetry of authors like Jean-Marie Dutey, Patrick-Henri Burgaud, Tibor Papp, Philippe Bootz.[13] It must be stressed that this time is genuine – albeit virtual – text-time, not real time, as in poetry performance, nor read-time. In fact, text-time and read-time need not coincide at all – for instance, in looped videos, or in works with reversible time vectors – and precisely that will then be one of the operative factors of the poems at stake. But then again, read-time may determine text-time: in all of Kac's holopoems, the duration of momentary configurations of the texts and the tempo of their transition depend on the (eye-) movements of the reader through time as well as space.

The employment of such features as variability, fluctuation, and temporality will result in a *reconsideration* of communicative habits, with more or less dramatic results. This concerns not just conventions of poetic writing, for instance, with regard to prosody or poetic closure – it particularly concerns conventions of verbal communication and its organizational infrastructure in general, for instance, on the levels of graphematics, morphology, and (text-) syntax.

Figure. 1: Jim Rosenberg, "Diffractions through" # 2 (1995), layer 1 (top), layer 4 (center), and simultaneity (bottom).

MEDIA POETRY – THEORY AND STRATEGIES | 205

For Rosenberg[14] and many others involved with hypertext literature and poetry, phrase structure is the bottom line when it comes to hypertextual organization of language. But evidently, other orientations are feasible. Eduardo Kac's *Storms* is a poem that *does* take hypertextual organization to the level of morphologic and graphematic structure, with links that 'blend' one word into another: "scene" into "scent", "face" into "trace". Kac's orientation is towards "motion, displacement, and metamorphosis".[15] This is particularly clear in holopoems such as *Adhuc*, in which the constituent letters of a fairly limited number of "basic words" float through holographic space, generating a realm of morphologic possibilities.[16] Now, as one word turns into another on the computer screen or within the holographic space, the most intriguing question is: what happens in between? Merely to state this question, to suggest that this notion of 'in between' could be imported into the framework of linguistic organization means to reconsider much of what we thought we knew about the language we are accustomed to use.

Commenting on the text generators developed by members of the French group L.A.I.R.E. and other authors, Philippe Bootz suggests that we can no longer uphold the concept of a 'text written to be read'.[17] Rather, it dissolves into a 'text-written' ("texte-écrit") and a 'text-to-read' ("texte-à-lire") or, alternatively, a 'text-to-see' ("texte-à-voir"). The 'text-written' is not to be confused, as Bootz emphasizes,[18] with the storyboard or the computer program for the generator. Rather, it is an "abstract structure compiled of a logic applied to the functional rules

Figure. 2: Eduardo Kac, "Adhuc", digital hologram, 30 X 40 cm, 1991.

of conceptual material", usually language. Although 'text-written' and 'text-to-read' are closely entwined, their syntactic status thus differs completely, at least according to Bootz's conceptualization. Grammar, in particular, only applies to the latter, for "grammar is an element of the material and not of the logic of functioning", Bootz writes. But obviously, that 'logic' determines the syntactic structure of the 'text-to-read'. What, then, is the status of that syntax? It is an aspect of a 'modality of realization' ("modalité de réalisation").[19] Couldn't we read 'modality' here in the logical, grammatical, as well as procedural sense of the word? In any case, Bootz's comments on text generators point to the interdependence of these three levels. The consequences thereof need to be considered in a revaluation of our views on 'the' structure of language and of poetic texts.

Poetry/text generators such as Pedro Barbosa's and Abílio Cavalheiro's *Sintext*[20] – offered to the reader as a computer application that combines a choice of fifteen source texts with permutational procedures, some parameters of which can be set by the reader – evoke fundamental questions with regard to the identification of 'the' text, as a syntagmatic construction. Is every generated text a self-sufficient unit? Or, are they, rather, samples of 'the' text, which should be regarded as an indefinite or even infinite continuum of possibilities? Is the source text or vocabulary part of 'the' text? Whoever is inclined to answer the latter question with a straightforward "no" should be reminded that the selection of that source is of crucial importance for the outcome of the generative process. Quite possibly, there are no straightforward answers to these questions – all answers depend on perspective, and recognizing that may be an important part of the generated text's 'meaning'. Again, all this has far-reaching consequences for what we believe to be 'texts' and for what we believe we can do with them.

Finally, as the contemplation of the interrelationships, features, and evoked transformations of conventional views sketched in the above are part and parcel of the process of poetic communication, the realization of this process becomes a *shared responsibility* of poet and reader. At first sight, this may appear to be nothing new. In a sense, the reader has indeed always been the one to decide whether or not a poem or any other text can 'fulfill its communicative function', for instance, in the very elementary sense that he or she must decide whether to read a text or leave it *unread*.[21] But that comes uncomfortably close to the view on communication that media poetry (and experimental literature in general) challenges; the view that holds that communication is the transmission of a 'meaningful content' through some message that the 'receiver' has to accept for the communication to succeed. In media poetry, as we see it, an entirely different *rapport* between author and reader prevails.

In media poetry communication becomes negotiation. It is not the text that 'fulfills its communicative function' or 'fails' to do so. Rather, the merging activities of poet and reader 'fulfill' poetic communication, and in that process a poetic text is created. The previously indicated characteristics of media poetry, from the navigation through hypertext webs to the modalities of computer-generated poems, all point to the same conclusion that Eduardo Kac draws from Baudrillard's philosophy of the media:

> If something is totally predetermined there's no communication. It is nothing but unilateral transmission. Communication must imply openness. ... When Baudrillard talks about restoring

responsibility to the media, ... it refers to the social responsibility that the media have, but it also opens up the idea for the artist to restore the responsibility of the media, in the sense that the media must allow people to respond, ... to interact, to share, to discover together, rather than be at the end as consumers.[22]

## Media Poetry – Some Writing Strategies

By way of example, and thus far from pretending to develop an exhaustive typology of forms of media poetry, let us now briefly consider some writing strategies developed in this poetry. We shall discuss cases in which the poetical focus is on syntax, on the procedures involved in the production of signs, and on the employed sign continuum, respectively. Of course these are abstractions from tendencies – in practice, poets will amalgamate and vary such writing strategies. But their momentary distinction may be useful in order to show some of the fundamental means and methods used in media poetry.

Media poetry often relies on the CONFRONTATION AND INTEGRATION OF VARIOUS SYNTACTIC SYSTEMS – not so much in the sense of combining various natural languages (although that may well be case, too), but of integrating altogether different types of syntactic organization. This, in turn, undermines these organizational structures. In fact, it would not be too far off to envisage media poetry as a collective attempt to CHALLENGE THE NOTION OF THE SYNTAGM AS SOMETHING GIVEN, particularly as something determined by the conventionality of a single, unequivocal syntactic system, and also as something *not* determined by choices of the reader.

We have already hinted at this when we discussed hypertext poetry and poetry generators. Other examples are ready at hand. Many media poems involve the JUXTAPOSITION of verbal – and other – elements, whether in two dimensions, or three (for instance, in some of André Vallias's multimedia digital works), or four (the latter in most of Kac's holopoems). When regarded as the complete absence of any syntactic structure, a "structural zero" in Jim Rosenberg's terms,[23] juxtaposition is disjunctively opposed to syntagmatics. But the new media writing spaces allow for other combinational procedures than verbal syntactic structure only, e.g. hypertext links, (virtual) diagrams, holographic metamorphosis, video transformations. As unresolved, or not-yet-resolved, structural relationships, these enable an *interplay between* rather than a diffusion of various possibilities of text construction. Thus conventional verbal syntax "becomes an option but not an obstacle," Rosenberg continues; "poetry is given the openness that has been taken for granted in the other arts for decades, without giving up the richness that syntax provides as a vocabulary of structural descriptions."

A complex example of the combination of various syntactic possibilities can be found in Eduardo Kac's *Insect.Desperto*.[24] In a very rapid succession of flashes, that revert direction halfway through the poem, English words and brief phrases appear, disappear and re-appear, scattered over the computer screen, while a spoken, synthesized Portuguese text is heard. The confrontations here are simultaneously between visual and aural language, between spatial and temporal development, between various natural languages (taking linguistic capacities and incapacities of the reader/viewer/listener into account), and between linear and non-linear verbal processes. While, as Kac writes in the 'ReadMe' file accompanying this poem, "the elusive movement of the words on the screen can be read in many ways", for instance, as

"unresolved hesitation concerning the construction of syntagms" but also as "reflecting the fleeting behavior of flying insects", its combination with the temporo-linear Portuguese text doubles the "evoke[d] inconsistencies and undecided aspects of life", verbal and otherwise.

Media poetry often involves a confrontation of CONTINUOUS AND DISCONTINUOUS SYSTEMACIES. The 'ordinary' verbal syntagm, grounded in the alphabet, is always a combination of discrete units (letters, lexemes, phrases, etc.), whereas, for instance, the video image covers the whole range from radical fragmentation, e.g. in montage, to total density, e.g. in colour transformations. Every attempt to reconcile or negotiate these systemacies implies that our semiotic habits need to be reconsidered. As Melo e Castro writes with regard to his series of 'infopoems' *The Cryptic Eye*: "A counter-semiotics will be required to establish new and unexpected relations between the tools and the means we use to communicate: the words and the colors."[25] The juxtaposition of words in English and Portuguese as part of the colour spectrum in the computer-video image "address[es] the question of readability and, ultimately, our capacity to read by using our eyes" .

Media poetry finds one of its pillars in the INTERACTIVE PRODUCTION OF TEXT/SIGN UNITS. An extreme example of the interactive poem (or narrative text, for that matter) is the one that, literally, does not exist *as* a readable text without a reader's act.[26] In their 'simultaneity', Rosenberg's poems are almost completely illegible – they require the reader to reconstruct legibility through selecting text planes. In Kac's holopoetry, the reception process required for the production of a readable text involves a range of physical and sensorial activities. What text the reader/viewer sees depends entirely on his/her physical position relative to the hologram and, especially, on his/her body and eye movement:

> When the viewer starts to look for words and their links, the texts will transform themselves, move in three-dimensional space, change in color and meaning, coalesce and disappear. This viewer-activated choreography is as much a part of the signifying process as the transforming verbal and visual elements themselves.[27]

Undermining the concept of the text or even the verbal sign as something given, something preordained, such works exemplify the reader's part in bringing the poem, its text, and its meaning into existence.

One might be inclined to object that this latter observation overlooks the fact that the reader's activities are always limited by parameters set by the poet. The choice of words or letters, their number, their relative position within the holographic or screen space, the size of that space – all these determine the 'choreographic' playground of the reader at least to some extent. But first of all, this only points to the *shared* responsibilities of poet and reader in developing a process of poetic communication. And, furthermore, expansions of that playground can be conceived quite easily.

One already often explored possibility is to subdue the mentioned parameters to chance, through ALEATORIC DEVICES. Of course, aleatorics have been employed in poetry before the new media were available, but the computer, for instance, opens up many new vistas in this respect. An example thereof can be found in the collaborations between Kenneth Sherwood

and Richard Kostelanetz on their *Monopoem Workings*.[28] First, Kostelanetz's 'monopoems' – single-word texts that serve as a source vocabulary – were "sent through a series of near-random cut-paste and alphabetization procedures" offered by an ordinary word processor. Then, the resulting texts were "amplified ... in accord with the computer's ear", expanding them "by addition of words that a standard word processor designates as phonetic matches." But what word processor – and in which language? Just suppose that not only the source and result texts of these 'workings' but also its program were downloadable (and what could the technological impediments thereof be?) Suppose that the 'workings' would continue on our personal computers. Then the resulting texts would differ from computer to computer, as the poem makes use of, or at least could make use of word processor's dictionaries compiled by their individual users, the readers of the poem, all in their own language. Telecommunications and telepresence installations could be added. It would even be conceivable to let a poem lead a 'virtual life' of its own on the Internet, through procedures similar to the ones employed in 'artificial life' projects. The ongoing development of the work, i.e. the continuous change of the parameters once set by its author, would then depend on such factors as the number of readers who care to connect to this poem and the size of the disk space they wish to provide it with. Language acquires yet another form of being!

These and quite a few of the aforementioned examples point to yet another writing strategy of media poetry that we want to mention here: the EFFECTUATION OF SIGN BEHAVIOUR, particularly motion. The Dutch-French poet Patrick-Henri Burgaud employs computer ANIMATION on the most fundamental of all writing levels, GRAPHEMATICS, in his poem *La Mer*. The noun phrase "Les vagues de la mer" is performed (that seems to be the right word) in what one could call animated calligraphy, and its complying verb phrase "dansent au chant des pierres" in a print-like screen font.[29] Burgaud is well aware that implementing motion on this basic level is not so much a goal in itself but a means to achieve new expressive possibilities on all levels of poetic communication:

> Animated poetry allows the exploration of all sign virtualities. The letter is no longer a zero space, non significant, absent. It is an image, a form that may be charged with meaning and values. This provides a range of opportunities to amalgamate word and image, from stylized pictograms to highly realistic representations. Motion, spatio-temporal development allows the introduction of a novel informative element, a narrative or discursive dimension that in turn orients and enriches the reading process.[30]

Others, for example, Philippe Bootz in *A bribes abbatues*,[31] use ANIMATION as a MORPHOLOGIC and SYNTACTIC device: word parts and phrases move over the computer screen to combine into new words and phrases, to change from nouns to adjectives or verbs, and so on. William Dickey's tripartite description of the condition of electronic writing as tentative, fluid, changeable can, arguably, be exemplified no more literally than through this poetry.

All in all, it appears that many of the media poetries, as they go all the way down into the fine structure of language as Rosenberg would say, at least in part aim at REPLETION OF THE VERBAL SIGN. They stress that there is, indeed, a sign *continuum*, out of which our verbal signs are distilled. This proto-semiotic environment is fully replete; it does not discriminate between

Figure. 3: Patrick-Henri Burgaud (in collaboration with Jean-Marie Dutey), "La Mer" (1993). These five images show frames of the looped animated visual poem "La Mer".

sign features that are and those that are not charged with a semiotic function. But verbal practice is different. Considerations of shape, colour, permutation, position in and movement through time and space, and other such qualities of the written sign are perhaps not entirely neglected in the institutionalized writing spaces of printed texts, but they are certainly codified into patterns that seem to reward us for *not* paying attention to these non-alphabetic aspects of our languages. Nonetheless, these are the aspects that directly link our languages to the sensorial

procedures through which we achieve understanding of the environments in which we live. The reward, allegedly, comes in transparence, clarity, unequivocality, rapid understanding, stability, vindication, authority. But there is also a loss of potentialities, of a potential understanding of both language and the world in which it is used as spaces in which we need *all* our sensorial capacities in order to find our way, or rather: in our never ending attempts to find our way.[32] The signs of Rosenberg's simultaneities, Kac's holopoems, Melo e Castro's videopoems, Burgaud's computer calligraphics, Bootz's animated texts, Cayley's generators, Vallias's digital and diagrammatic works, and a rapidly growing number of other media-poetic innovations restore a part of that loss, all in their own way, through their own channels. As Kac writes: "Language plays a fundamental role in the constitution of our experiential world. To question the structure of language" – through the means offered by the new media – "is to investigate how realities are constructed."[33]

## Notes

1. J. David Bolter, 1991, "Topographic Writing: Hypertext and the Electronic Writing Space", in Paul Delany & George P. Landow, eds, 1991, *Hypermedia and Literary Studies*, Cambridge: MIT Press, 106. See also: J. David Bolter, 1991, *Writing Space. The Computer, Hypertext & the History of Writing*, Hillsdale: Lawrence Erlbaum & Associates, passim.
2. William Dickey, 1991, "Poem Descending a Staircase: Hypertext and the Simultaneity of Experience", Delany & Landow, eds, *Hypermedia and Literary Studies*, 144.
3. Dickey, "Poem Descending a Staircase", 145.
4. Marjorie Perloff, 1991, *Radical Artifice. Writing Poetry in the Age of Media*, Chicago: University of Chicago Press.
5. Perhaps we should have said: there is no text-*sequence* without the reader constructing one. But then again, what definition of 'text' in the ordinary, verbal sense of the word does *not* implicitly or explicitly rely on some notion of sequentiality?
6. Ladislao Pablo Györi, 1995, *Criteria for a Virtual Poetry*, Buenos Aires [self-published broadsheet].
7. Bolter, *Writing Space*, 37, our italics.
8. George Landow, 1992, *Hypertext, The Convergence of Contemporary Critical Theory and Technology*, Baltimore & London: Johns Hopkins University Press, 37-40.
9. Another lesson is that to adopt new media is not necessarily to adopt them as a writing space in Bolter's sense of the word. The second, not the first, is what counts in media poetry.
10. The complexity of that web and the possibilities of navigation differ substantially from hypertext to hypertext, depending on such factors as the number of lexia and links, on whether or not there is a fixed 'beginning,' on whether it is a 'read-only' text or allows the reader to construct links and change lexia, and particularly on the way in which the hypertext is organized: with fixed links, or random links, or conditional links.
11. Jim Rosenberg, 1991, "Openings: The Connection Direct. Personal Notes on Poetics", online via http://www.well.com/user/jer/openings.html.
12. See <http://www.well.com/user/jer/>. Rosenberg's characterizations of the hypertextual principles involved in this work are quoted from "Navigating Nowhere / Hypertext Infrawhere"; cf. <http://www.well.com/user/jer/NNHI.html>.
13. See especially the electronic journal *Alire* (Paris: L.A.I.R.E.) for samples of this animated poetry.
14. As he writes in "Non-Linear Prosody": "Even I would balk at taking hypertext inside the word. The words are given to us, by and large; it does not seem reasonable to me to intervene in that natural process with an external administration of hypertext structure."
15. Eduardo Kac, 1995, *Holopoetry. Essays, manifestoes, critical and theoretical writings*, Lexington: New Media Editions, 64.

16. Kac. *Holopoetry*, 49, 'Still' images from this and other holopoems are included on Kac's WWW site <http://www.ekac.org/allholopoems.html>.
17. Philippe Bootz, 1994, "Poésies en machinations", in *Littérature*, vol. 96, 65. See also his contribution to this anthology.
18. Bootz, "Poésies", 68.
19. Bootz, "Poésies", 69.
20. Pedro Barbosa & Abílio Cavalheiro, 1994, "Sintext. Gerador de Textos" [1993/94], *Alire* 8, Paris: L.A.I.R.E.
21. Less elementary, the reader always has an interpretive task, in print as well as media poetry. The difference between the two lies in what is offered for interpretation.
22. Kac, *Holopoetry*, 113.
23. Rosenberg, "Openings".
24. For reasons that shall become clear shortly, it is impossible to reproduce even an aspect of this work accurately in print. Kac's web site gives access to the poem. See <http://www.ekac.org/multimedia.html>
25. E. M. de Melo e Castro, 1996, "The Cryptic Eye", in K. David Jackson, Eric Vos & Johanna Drucker, eds, *Experimental, Visual, Concrete. Avant Garde Poetry Since 1960*, Amsterdam/Atlanta: Rodopi, 'Infopoetry' is defined by Melo e Castro as "poetry made with the use of the computer"; it "thus adds the virtual reality of the poetic images to the virtual, dematerialized substance of the synthetic imagery and writing produced by the computer." In doing so, *The Cryptic Eye* relies on the computer's capability to create a video image.
26. It does of course exist *as* – digital – information stored on a computer disk or other storage medium.
27. Kac, *Holopoetry*, 85.
28. See http://wings.buffalo.eud/epc/rift/rift01/kost0101.html; Sherwood's following comments on "Monopoem Workings" are quoted from this source.
29. "The waves of the sea/dance to the song of stones." The 'floating' letters of the first phrase, especially the bird-shaped 'v' and the surf-like 'm,' and the print-like blocks of the second phrase are clearly linked with semantic values. Realized in collaboration with Jean-Marie Dutey, this poem is included in *Alire* 8.
30. Patrick-Henri Burgaud, 1995, "Multimediapoëzie/La poésie multimedia", Lecture presented at the Hogeschool voor de Kunsten at Arnhem, the Netherlands, our translation.
31. *Alire* 9, 1995, Paris: L.A.I.R.E.
32. This should *not* be read as a disqualification of print literature; we do not believe that print has exhausted its potential, as quite a few advocates of the new media claim. Still, new media environments allow and in fact invoke the use of sign features that are very hary hard to employ, if at all, in a print environment.
33. Kac, *Holopoetry*, 85.

# POETIC MACHINATIONS

**Philippe Bootz**

I had originally promised myself to keep quiet, to nicely put my pen back under the hood and consequently to withdraw from it the tiger that never comes to a rest. But I won't, after all. Up to the neck in an adventure that I feel to be mine, I have not been able to bring myself to play the part of the sterilized observer. Here I will offer an interpretation of the decade in which poetry lost its near virginity of the machine. I will rely on a brief history of the main facts before comparing the viewpoints and the ideologies developed by the two principal groups of writers in France that left their marks on this maturing process: the A.L.A.M.O. (a workshop of mathematics and computer-assisted literature) and L.A.I.R.E. (Lecture, Art, Innovation, Recherche, Écriture). It is not my intent to describe here what these teams produced. The reader who feels an interest will, throughout the article, find all the necessary references to gain access to their production.

## 1 – A brief history of time[1]
*1.1 – From the birth of groups...*
Today there is a general agreement on considering that the first programs of computer texts were developed in 1959 in Stuttgart by Theo Lutz and Brion Gysin.[2] These programs were text generators. In France, the situation was to develop along two parallel paths. The organization and dynamic of this development was unique in Europe. As a matter of fact, it relies on a few elements that are specific to France, some of them being linked to a literary momentum, others to conditions that made the emergence of distribution and trading tools easier. Let us make a brief review of these elements.

The first element is the strong literary tradition in France. One of its essential components, as far as computer poetry is concerned, is the adventure of the "Oulipo". The latter gave birth in 1982 to the A.L.A.M.O., a group made up of writers and computer scientists[3] "brought together around the project of using, in all possible ways, and without any preliminary bar, the computer in the service of literature"[4]. The A.L.A.M.O. headed towards automatic generation of texts and explored several of its aspects, among which poetic forms.[5] Many of its productions were presented at the exhibition *Les Immatériaux* at the Pompidou Center in 1985. The second

component, which is more diffuse and yet very real in France, is made up of sound, visual or spatialist poetry, post "Dada" movements whose authors more or less gravitated around the review *DOC(K)S*[6] which was for a long time edited and produced by Julien Blaine and now by AKENATON. A whole generation[7] reached the end of the 1970s and the beginning of the 1980s adhering to some of their elders' ideas but at the same time missing the central approach, which at that time was only visible in a few exhibitions.[8] This generation was then trying to develop techniques to write texts that took into account time and the presence of the reader (location-poems, network texts). This anticipated the techniques of video texts or of certain categories of computer interactive texts.[9] A large number of these authors, as a matter of fact, have turned to producing their work with the assistance of electronic media (video, computer). It is only recently that these new forms have been drawing more attention with the breakthrough of someone like Patrick Burgaud or of Philippe Castellin.

The second element to be taken into account is the impact of the Minitel. The latter was to give birth to an essential though ephemeral structure: the first telematic art review, *Art Access*, published by Orlan and Frédéric Develay. It had two issues which could be accessed in 1985 and 1986, the first issue having been written for the *Les Immatériaux* exhibition. This review thoroughly examined all the art fields while giving writers the possibility to write works specially adapted to the Minitel and accompanied by a critic's text. The review brought together such diverse artists as Ben, Fred Forest, Roy Ascott and Pierre Garnier, to mention but a few. Overall, 80 artists had realized 1500 screen pages. It is to be noted that *Les Immatériaux* appeared as a climax for the A.L.A.M.O. and as a starting point for the dynamic poetry which was to develop in the following years. The second issue of *Art Access*, published in 1986, contained works by Frédéric Develay (who was also in the first issue), Tibor Papp, and myself. Frédéric Develay facilitated my meeting with Tibor Papp at the beginning of 1988. It turned out that the texts that we were developing were so much in agreement in their aims and techniques that it appeared obvious that this was to go on. Thus, the idea of a team was born. A "federating" event was necessary: it was the gathering heralding the opening of the Maison de la Poésie of the Nord Pas de Calais, the local poetry festival which took place in Beuvry-les-Béthune in the Pas de Calais from 21 to 23 October 1988. During this event we presented an installation of computer-animated texts. The L.A.I.R.E. team, with Claude Maillard, Tibor Papp, Frédéric Develay, Jean-Marie Dutey, and myself, had just come into existence. It is important to point out that each member of the team had already produced work on computers, and that this meeting was the coming together of experiences which had already been evolving for several years. My first approach of generated texts dates back to 1977,[10] even though the most meaningful works (animated poetry) will only begin in 1985. It consisted of the realization on a PC of the "mange-texte" designed by Jean Marie Dutey[11] for the 1986 *Images et Mots* exhibition in Villeneuve d'Ascq and with the designing (and the realization on the T08 PC) of "Metamorphose", my first animated text, not yet published. During the 1980s, Jean-Marie Dutey and myself were already working as a team. Since 1984, Tibor Papp had been realizing on an Amstrad PC texts which he had the opportunity to present at the Pompidou Center and at diverse places as early as 1985; and, Claude Maillard was the first to publish, in 1986, a book including a work with a synthetic voice presented on the double medium book/floppy disk.[12] L.A.I.R.E. explored different paths, mostly at the beginning, from those explored by A.L.A.M.O.: animated poetry and computer sound poetry. But, contrary to the A.L.A.M.O., nobody at the time in L.A.I.R.E. contemplated the idea of distributing the texts produced on

computers other than on a disk medium, even though Frédéric Develay, who proposed the inclusion of the word Art in the team's acronym, insisted on a possible opening towards other forms of writing, such as video.

As a matter of fact, at the same time that computer-animated poetry was making a start, other authors were exploring text animation whether on computer or not, but meant to be read on a video medium. It would be arbitrary and questionable today to separate the evolution of these video approaches from that of computer poetry for it is obvious that they were forming at the moment a continuum which can be described by the same pattern,[13] a continuity that was well shown in an exhibition organized by ART 3000 at the Donguy gallery.[14] As early as 1982, Roger Laufer produced at the University of Paris VIII, in collaboration with Michel Bret, a little animated text, *Deux Mots*. At the same time, Paul Nagy was exploring the possibilities of video with a first text, *Sécuritexte* (1980), notably *Métro-police*, a video text (1985) which contained, in a video approach, all the animation grammar which is to be found in computer-animated poetry. It was also in 1985 that Frédéric Develay realized the videogram "Lieu provisoire état du texte" in which the picture track did not include text and which, for the moment, has not been followed by other attempts.

The year of 1985 appears as a transition period, marked by the end of experimentation and the beginning of maturity. It was then that we produced the first big event in which these approaches expressed themselves. The first symposium took place in Cerisy, organized by Jean-Pierre Balpe and Bernard Magné. All the events that were to take place in the following years (i.e., the birth of L.A.I.R.E., the emergence of electronic reviews, institutional recognition and the evolution of processes) were there in an embryonic stage. Everything was almost in place as early as 1985.

*1.2 ......... to that of electronic reviews*
L.A.I.R.E. was first concerned with the production of a review on disks, the first of its kind, *alire*, whose first issue was presented in January 1989 at the *Revue parlée* of the Pompidou Center. Since then the review has been published with a periodicity of one or two issues a year. The review was of vital interest for several reasons. The first and most obvious one, which undoubtedly was unanimously approved, was the need for a periodical with which to express and circulate our productions and ideas. But it was, mostly for me, perhaps, a necessary tool to give a prospect of private and intimist reading to the visual production which was to follow, making it independent of a duration of time, independent of a before-after of a public reading. For it is obvious that an animated and visual literature could very well be tempted by the spectacular and take the direction of a production which would be readable in a public context, during evening performances. The review is an essential element. It enabled the rise of interactivity and the invention of the concept of the *unique-reading poem*, which unfolds during several readings. These types of texts could certainly not have come into being without the existence of the review. Which publishing forms exist today for these productions, besides these two reviews? I say two, because in January 1991, Jean-Pierre Balpe (and not the A.L.A.M.O.) published the first issue of the review on disks, *Kaos*, with the help of the firm KAOS.[15] The recent workshops on literature and the computer[16] seem to confirm that no other enterprise of this kind exists in other countries. These reviews were the first to circulate literary works on disks and it is interesting to compare the first issues.

Figure. 1: *Alire*, initially published in 1989, was the first periodical on disk dedicated to the publication of digital poetry.

It may be noted that they do not compete with nor really complement each other but rather are parallel. Thus, in the first issue of *Kaos* there can be found animated texts by Tibor Papp and by myself. In issues 6 and 7 of *alire* one sees generators by Christophe Petchanatz and by Tibor Papp, respectively. The two reviews' viewpoints differ in several ways and yet it is impossible to say at the present time if those differences are meaningful or not. They are

- *Kaos* is free and offered as a new year's gift by the company while *alire* has to be paid for.
- *Kaos* is composed of one disk (either PC or Mac) inserted into an envelope whereas *alire* is composed of a paper sheet and several disks per issue with, generally, a mixture of PC and Mac disks. There even was some Atari but no Thomson or Amstrad formats, because of the small number of these machines in use. *alire* can also include an audio cassette for the sound texts which would require too specific a material. It is to be noted that the animated texts realized on Amiga computers and which cannot be entirely "played" by any other machine are not published in the review.
- *Kaos* makes sure its disks are as readable as possible. For instance, the first issue, on PC, only contains CGA texts, the most universal but least rich video norm, whereas *alire* accepts from the start the idea that a reader might have difficulties getting acquainted with some of the review's texts, the PC disks not being "translated" into Mac or the reverse. The present connection between the two standards, which should shortly do away with

this difficulty, does not make this acceptance any different, an attitude which is certainly new and a priori shocking for a review. We shall resume this point later.
- The last point to be noted is that the last issue of *Kaos* (94) does not contain any disk but is made up of a pack of cards.

It is also suitable to mention that other reviews have shown an interest in the development of these computer approaches, notably *Action Poétique* which published an issue devoted to the Oulipo (number 85), another on the A.L.A.M.O.(number 95), and a common issue with *Kaos* (number 129/130).[17] Furthermore, video poetry was able to express itself with the literary and artistic review on video cassettes *p'Art* started in 1987 by Paul Nagy. This review is no longer circulated.

We refer the reader interested in further details to works on the topic[18] and we shall merely point out the present fad for video text processing. Some, such as Michael Gaumnitz or Christophe Couillin, work with already written texts. Others, such as Benoît Carré, carry on a personal writing approach by means of the video.

## 2 – From the A.L.A.M.O. to L.A.I.R.E.: altering perceptions
*2.1 – shifting words*
Let's consider the interrogation about ideologies that have raised a significant turmoil among readers clinging to uses felt as ancestral.

The way the use of the computer is seen in relation to the literary object has evolved from the first experiments of the 1980s to the present productions. Many signs act as evidence. The first is visible when one compares the A.L.A.M.O. and L.A.I.R.E. acronyms. One can note the presence of the word "assisted" in the first and the absence of the word "computer" in the second. One can also note the presence of the word "literature" in the first but with its development by the words reading-art-writing in the second. The way approaches are positioned in the cultural microcosm has obviously evolved.

*2.2 – The text and its medium*
First of all, the computer is considered as outside the literary object, a necessary tool to the act of writing, the text being the object generated by the latter. So it is readable on paper. In this way, the prelude to issue number 95 of *Action Poétique* speaks of "computer assisted writing programs", of "texts obtained by means of diverse computer programs". Guillaume Baudin spoke at the Cerisy symposium about "text generating machines"[19]; generators were only analyzed under their algorithmic aspect, though Balpe quickly announced a series of issues around the notions of text, author, and reader. These issues were presented in his article "L'ange ou le diable en boîte", published in *Action Poétique*, number 95.

This position of the text as "generated" and of literature as "assisted" completely disappears with L.A.I.R.E. This position is not linked to the "low generating" nature of most of the L.A.I.R.E. team's productions. Indeed the only "classic automatic generator", insofar as it reproduces the procedure set up by Balpe, is Tibor Papp's "disztichon alfa" published in *alire7*,[20] whereas a generator of Raymond Queneau's "hundred thousand billion poems", also programmed by Tibor Papp is present in *alire1*. This text by Queneau was programmed because the display on

paper did not make it possible for the uncertain, statistical, and "to be read" nature of this text to be wholly expressed. The uncertain nature was not respected because the book often opened at the same page, destroying the equal probability of the combinations. The statistical nature was not verified since the immanence of the other "pages" in the book's bulk gave a "simultaneous presence" aspect to the possible combinations. The result of a throw of the dice is a decision, a produced and not potential event, the only one to exist, making the other elements of the mathematical series of results permanently swing from a throw of a potential nature to pure and simple non-existence. On screen, nothing exists except the realized combination. There are no other alternatives to this reading, even if other readings of the same generator remain possible. It is exactly there that the swinging over in the conception of the text occurs: apprehending the "generator" in its specificity of generator and not the generated product as "the" text, which would besides be "one among an infinite".[21] This apprehending, this understanding, is not reading yet, but a necessary condition to its starting. It requires, in any case, the physical presence of the generator, the only one able to produce the real time inherent in this transformation which, from endless possibilities, produced a unique and exclusive object that we shall no more call the text but the "text-to-be-seen", to remain in accordance with the developments that are to follow. A generator can only be given to be read on a computer and any display of a "generated text" outside its generation context is as significant an abbreviation and a deviation as the display of a poster or a photograph instead of a film. And this is true of all the texts that possess a generating nature linked to the intervention of chance, of calculation or of the factual (interactivity) during the production of the text-to-be-seen. So the computer, a writing tool for the author, is turned into a reading tool and there is no longer any point in mentioning "assistance".

The nature of the text's medium was worked upon in *alire* thanks to the presence of the paper leaf, whose role became clearer with the newer issues. If the first issues mixed graphic or written poems (produced by a computer tool) and theoretical texts, the decision was made from number 5 (December 1991) on to no longer publish on the leaf poems which would only use the computer as a particularly efficient production tool for texts with no generated nature. It is for those poems, that we do not refuse, that literature is computer assisted. The leaf was then to become the exclusive medium for theoretical texts until number 7 when a new phenomenon appears: a dialogue, *within the same text*, between a generated (or animated) part and a non-generated part. This dialogue is to be found in Jean Marie Dutey's work as well as in mine, though with different procedures. Computer poetry may require a computer medium in connection with other media. Conversely, there is no non-generated screen-page on *alire* or *Kaos* disks. It is a very clear no to the multimedia approach that presents itself as a big "mixing" of genres. We shall not follow McLuhan on the unifying, reducing and totalitarian path of the "global village". We shall besides consider this position a little further on, a position that demonstrates the permanence of the traditional private and intimist nature of literature. There is a very clear-cut separation between genres and in *alire* we would not accept to publish "screen versions" of static, non-generated texts designed to be shown on paper.

More generally and most certainly today, no one would contemplate showing "program-produced texts" without offering the generator itself to be read on an electronic medium. This evolution is obvious. For instance, the joint issue *Kaos 92/Action Poétique* 129/130 includes this aspect: "This issue of *Action Poétique* includes a computer disk, thus we wanted, in line with

the rest of our work, to engage in writing at the same time as in reflecting about writing".[22] In the same way, we have the varied symposia, in which non-academic authors are beginning to appear, either physically or by means of their works shown on the appropriate electronic medium (video or computer). Thus, during the "Nord Poésie et Ordinateur" conference organized by MOTS-VOIR at the University of Lille3 in May 1993 with the collaboration of the research center GERICO-CIRCAV and of the Maison de la Poésie of the Nord-Pas-de-Calais, half of the time was devoted to the projection of works and the other half to papers and theoretical debates. At the last Jussieu workshop, the authors asked for projections and displays and Paris VII's technical department was able to meet their demand. Proceedings themselves do not escape the rule: the proceedings of the Lille conference, A:\LITTÉRATURE, include two disks (one for PC, the other for Mac), which show examples of the different "styles" that can be seen today in computer poetry in France. There is also an electronic edition of the proceedings of the Jussieu workshop.

2.3 – *No longer a written text to be read but a written text, a text to be read*
Computer authors place themselves within a literary continuum and not in opposition to the poetic forms, whether traditional or not. On the contrary, they push them to the end of their logic, in a very modernist perspective. As a matter of fact, this leads to the reconsidering of their productions according to criteria which are not necessarily new, but which are sharpened and outside past fashions. Indeed the Lille conference brought into light an approach to the computer by visual poets, essentially Americans,[23] as well as points of convergence between approaches derived from post-Dada trends and approaches felt as more traditional. One easily understands then the public's opposition to this type of approach, which no longer relies on criteria instituted by the acceptance or the refusal of Dadaism and the epic which followed. This approach relies on a feeling that the computer is coming at the right time and in a more definite way than the other forms to propose a new approach to the triad author-text-reader, and that this approach is perfidiously part of a continuous process, in order to open new doors. Thus, Jean-Pierre Balpe announces in the presentation of *l'Imaginaire Informatique de la Littérature* (1991, p.27): "Since, however, they (the computer authors) do not question at all the notion of literature, as they on the contrary claim they belong to it and feed on it, the fact that they bring us to reconsider its nature and consequently its evolution seems unquestionable from now." I, for my part in *alire2* (1989), noted the continuity between computer approaches and visual poetry approaches: "thus may be dawning this poetry free from the paper language that twentieth century poets seek." And yet the approaches are different in the two texts. Jean-Pierre Balpe goes on in the same page: "Writing is no longer producing a given text but establishing abstract text models. The originality no longer lies in the product but in the production procedures". This very clearly sets out a hierarchy between a "program" and its product, only awarding the status of text to the latter.  But more than the organization of texts into a hierarchy, it is the importance of the structures (the production procedures) that is put forward. Whether the latter be removed from the product apprehended by the reader to the structure designed by the author seems to me of minor significance, even though this has been the first stumbling block with readers, a point often debated. The sequel of the *alire2* text states that

> being obliged to build the tools and the rules at the same time, to take the text as a pretext and as an object to be programmed, writing (......) organizes itself as an object and, for the first time perhaps, as outside itself. It is the first time indeed that the results of a text, its 'to be

Figure. 2: Jean-Pierre Balpe, "Hommage à Jean Tardieu" (Homage to Jean Tardieu), poem generator (Macintosh Hypercard), 1993.

read' aspect is not written in the same language as its 'written materiality'. This also is likely to disrupt the relationship between literature and its language...I am not trying to inform nor even to make it readable. The text is an organism that one makes one's own and that one destroys to read it. Let us note that this textual organism is not the metastructure set up by the author but only a product of the latter.

Here a separation of the text into two sides is taken up. The "production procedures" and the "to-be-read" aspect (an entity that makes up the text in almost all paper literature) are the complementary aspects of the same object, but which are not to be perceived in the same space, with the same relationship to the text. One belongs to the author's private sphere, the other to the reader's. In this vision, it is the relationship between the topic and the text which is given more value, with reading prevailing over writing. The latter is felt as cannibal, destroying

the text that it is reading but without any effect on the object made up by the author. The independence between text/author and reader/text relationships naturally leads to the text's perception splitting up. It is to be noted that this cannibal aspect given to reading will have strong repercussions on the way the texts themselves function, until it makes the notion of "unique-reading poem",[24] whose "to-be-read" aspect evolves in an irreversible way with the different readings.

## 3 – From the text designed as an object subject to a functioning process to the text designed as a medium to initiate reading

*3.1 – A structural approach; a functional approach to the text*
The A.L.A.M.O. authors have been trained in the Oulipo ideology according to which the text is first and foremost a linguistic structure. Jean Ricardou says so very clearly: "From now on, I, for my part, wish to define the text as a written work carrying further structures",[25] a sentence which describes the different types of possible structures. These authors, then, essentially manufacture structures and are not saving technical explanations on the way they function, whether on the products of generators or on the generators themselves whose structure is not to be mistaken with that of generated texts-to-be-seen. These informational mathematical structures, the "describers",[26] are essential at the generator's level, whereas this notion is completely absent from generated "texts". Priority, which has, willy-nilly, to be qualified as ideological, was being nevertheless given to the generated text, the generator being only presented as a "program", that is to say a means of production. This approach to the text is part of a literary tradition that hastened to evade Dadaism and the various poetic upheavals of this century.

L.A.I.R.E. substitutes two actions, reading and writing, for a textual object, favouring the notion of text according to two relationships: the author/text and the reader/text relationships. The text is no longer an independent object as much as the space in which two relationships are applied. The difference is significant. Its connection with the author, on the one hand, and with the reader, on the other, should therefore be taken into account in any discourse on the text and it should be very accurately specified *in which of the two relationships the characteristics stated about the text are applied*. For it turns out that, as we have already noticed, the notion of text does not apply to the same object in the two relationships, and this happens independently from the presence or absence of the computer, as we shall describe in detail soon. This approach means substituting a relational or functional analysis for a structural analysis of the text. The important issue actually is no longer to "give a purer meaning to the words of the tribe" but to "postpone the reading process during the writing". That is to say that the writer's role (and not the text's) is to *make read* in a particular way. This is what he or she is aiming at. Action has priority over the object and, within the former, reading has priority over writing. The text becomes the operational space for a reading function, the necessary medium for its realization. Before looking at the way this functions, we have to notice two things.

The first is that this approach places the text in relation to non-literary fields, a positioning that we shall analyze more in detail a little further on. The second is that the two structural and functional aspects are complementary and do not exclude one another, as any realization of a reading function can only be carried out through particular structures. Each structure generates its reading mode. The writing of most A.L.A.M.O. generators supposes for instance

Figure. 3: Jacques Donguy, "Tag-Surfusion", digital poem, 1994. First published in the digital magazine *Alire*, n. 8, 1994.

that it is the aesthete or the scholar who will read them. The reader is asked to participate in the playful experience of discovering the structures that they propose. These structures are not necessarily given since this is what they are about; their presence is clearly announced, however. [27] In *alire*, on the other hand, the presence of the structure is only given when the reader's action modifies the generator's possibilities in an irreversible way.[28] The reader is informed of the existence of a structure which reacts to his action. Apart from this extreme case, the reader does not even always realize that chance or calculations intervene in the poems published in *alire*. He therefore does not feel like reading them again with a "look for the differences" spirit. Consequently, it seems reasonable to deliver hidden structures, texts of which only a part is offered for reading without the reader being able in any way to realize this is so. If one considers structures that can in no way be read so as to exhaust them, one realizes that. The notion of text apprehended in the relationship author/text does not correspond to the notion apprehended in the relationship reader/text.

*3.2 – A functional model for the text*
A model for the functional approach to the text is beginning to take shape.[29] This model goes beyond computer poetry and has been applied, among others, to location-poems, to certain forms of visual poetry, to certain readings and performances.

This model specifies that the author produces a *texte-écrit* (written-text), an abstract structure made up of a logic applied to the rules governing the functioning of a conceptual material. This logic may be sequential or factual. This "*texte-écrit*" is a project not to be mistaken for the material form it takes up in the author's work (storyboard, program, card stacks, etc.). The material aspect *describes* with technical words, appropriate for a reading medium, the logical structure, the shape taken by the concepts as well as actions that can be performed on them. At this level, language does not exist as such. Grammar, notably, is an element of the material and not of the logic of functioning.

Whatever the material form its description may take up, this "*texte-écrit*" is a generator. It is going to produce *textes-à-voir* (texts-to-be-seen) on a particular medium that makes up the readable part of the text. These *textes-à-voir* may be classified concerning computer poetry, in a few genres: automatic generators, animated poems, sound poems, unique-reading poems... The characteristics of these various types of texts have been widely described in the already mentioned works and we shall not recall them here.

The *texte-à-voir* is essentially located in time, if only that of reading. It is found in a reading context made up of all the physical components present during the reading and not managed by the *texte-écrit*. It is therefore not the latter which will be read but the entity resulting from its association with the reading context. Eventually it is this entity, the only "objective" one in the relationship of the reader to the text that the reader apprehends through interpretative filters and reading grids to produce a *texte-lu* (read-text) located in his or her memory.

The author will translate his or her functional ideas by a particular bias of the *texte-écrit*'s logic. The specificity of the "reading process", of the method according to which the *texte-lu* is constituted by the reader, is an essential component of his or her style. One cannot really speak of the reader being manipulated by the author since it is the *realisation procedures* of the *texte-lu* that he or she is concerned with, and not its contents. The reader is not required to build a "fair" *texte-lu* or, in other words, to discover "what the author said" or to apprehend the "formal subtleties" of a *texte-à-voir*. The notion of misunderstanding, notably, does not belong to the *texte-écrit* nor consequently to the *texte-lu* (unless it is reintroduced by the very reader).

*3.3 – poetry in the information society*
The functional vision relies on an ideological response to society's functioning, or at least on a part of it. The functional approach seems to me typical of the generation that is thirty to forty years old today, and is visible in all genres (whether on computer or not) and all groups. It is not restricted to computer writing. Thus Benoît Carré in 1986 noted, concerning the location-poem he had realized for the Images et Mots exhibition in Villeneuve d'Ascq: "Because the text derives its meaning from the situation (which its presence gives birth to), it is not possible to propose through it a possible message, a vision of the world, however fragmentary: the reading act reveals nothing but particular relationships (material and semantic) between a text,

an environment and a reader".[30] As early as 1984, still about the reading of location-poems, I wrote "that poetry then does not transmit a discourse on lived experience, but a lived experience on lived experience".[31] After all, reading is a reader's performance, to take up the vocabulary used in the 1970s. Of course, no approach is totally structural nor totally functional. No approach excludes the other side. Jean Pierre Balpe's developments concerning the alterations of the concept of author are closer to a functional than to a structural approach.

An example of the difference in viewpoints between the structural and functional approaches is given within L.A.I.R.E. itself by the debate around the impact of the computers' reading speed, as presented in *alire*'s leaf (1990). In those notes I develop the idea that the machine plays an active part during the reading, close to the "performance" that can be found in music, and that the author must know and accept this fact which is part of the concept of reading developed in the theoretical model (...):

> This translation of the work by the machine is a true treatment of the semantic signal of the text-to-be-seen prior to any reading. It cannot be avoided. This is not a deterioration of the signal or an added background signal as happens with audio... In a way, the text-to-be-seen, the real poem, which will be read, is not stored even in the floppy disk plus machine set.
>
> This dematerialization, a sign of individualism, but also of a free reading, may be what fascinates me the most in computer literature as I see it.

To which Tibor Papp answers in the article "Littérature sur ordinateur - Enregistrement restitution" in the same issue: no, the situation is the same as that of sound poetry when tape recorders appeared, the situation will become stable and the problem will disappear :

> The essential difference between electronic works and those of the previous period lies in the way they are set on a final medium; this setting is not simply substituting writings; it uses a large number of relevant literary effects that cannot be separated from the electronic world; as in sound technology where "cutting up" and "editing" are an integral part of the literary works thus conceived.
>
> In this type of setting, the question is most of all to extend the senses or rather to go beyond them... It goes without saying that when one speaks of electronic playback on a cathode screen or with an amplifier, one supposes optimal retrieval, as worked upon and wanted by the author... Considering that the normalization of computers remains a problem, there may be incompatibility between the recorded work and the retrieved material. This type of incompatibility is very familiar; it already existed for sound works in the pioneering times of tape recorders.

One feels on the one hand the functional approach, which puts the stress on reading "at any cost", and the structural approach on the other which puts the stress on an object, the text, as an extension of the author. In this approach, the text is to be preserved considering the existence of a literary nature, even if this is specific to an electronic mode. It is to be noted that the functional approach does not deny the existence of a literary nature, but that it makes it subordinate to the reading. What should be aimed at before all is the existence of a specific reading procedure. One may

also note that the structural approach establishes a specificity of genres by the specificity of the medium (McLuhan's "the medium is the message"), whereas the functional approach establishes a specificity of genres by the specificity of the reading concepts. If the functional vision had to be summed up in a maxim, it might be "the poem only exists in the memory of who read it", thus favouring the reader/text relationship. For instance, the same animated text, read on computer or video screen, will not have the same results because of very different reading contexts. It will then be possible to speak of two different texts in regard to an object which, however, offers two identical texts-to-be-seen. In the same way, one will be able to talk about two different texts concerning the same program running on two very different computers implying very different reading contexts. The striking example is Jean Marie Dutey's *mange texte*, programmed in 1986. The version published in 1989 in *alire1* gives very different reading results whether it is run on a 8086 with 4 MHz or a 80386 with 25 MHz. The text is subordinate to the medium in the structural approach and to the reading context in the functional approach. Of course, taking into account the reading context generated by the machine's specificity must not be an alibi to accept anything, the author generally wanting his or her text to remain readable in a certain field of possible "contexts". As soon as these contexts prevent any reading, a remedy has to be found. This is what is now happening with the rise in speed of computers, a rise which was unforeseeable just a few years ago, and which requires some alteration in the programs of animated texts so as to master the speed of the animations and guarantee their readability. This will be done when a new edition of *alire* is published by MOTS-VOIR.

One may consider the functional approach as a response to an individualistic information (and, as a consequence, manipulation) society. It is a subject to subject response, with a private, even intimist nature, non informative in the sense that the written-text produces limited information compared to the actions performed by the reader (compared with, for example, educational software or other common products requiring the same amount of interactivity).

This is mostly true of automatically generated texts (seen as generators and not as "text manufacturing" machines, as was explained before) or of interactive unique-reading poems, but "classic" animated texts include a symbolic or ironic declension of this. This personalization of reading relationships may lead to two conclusions. The text-to-be-seen being unique, it may be perceived as being meant for nobody or on the contrary for everybody. This ambiguity is raised for that matter in the case of unique-reading texts where the generator, for each reading, answers the reader according to an interpretation grid for the reader's actions which is the author's. Then, after "art for all", we are entering the era of "art for everyone", thus confirming a fact. What is conveyed to the reader, outside any semanticism, is a consideration of his or her reading as a founding element of the text; it means giving its significance back to reading, apprehending the reader in his or her human dimension of actor and not consumer, acknowledging his faculty for building meanings, a source of freedom, rather than his ability to reproduce Pavlov's formal games. And this takes place during the creation of the text by the author. Then it means that creators are meeting, a meeting postponed in time in the same way as with telephone and answering machines. It entails that any reading is "work" before being enjoyment. It requires efforts and will, a will which is required as soon as the medium is approached, for the "handling" of the floppy disk to become a "hands-on reading experience" of the texts it contains. This effort may even become a matter of perseverance for the reader who does not own the standard machine on which the text is written.

Similar approaches exist in electronic art, as in the aesthetics of communication of Fred Forest and Mario Costa. Compared to electronic art designed to function in public performances, the new kind of poetry discussed here is original in its own right, as it proposes a "private" experience which asserts itself in duration.

## Notes

1. Here I raise my hat, even though this is not the subject, to Stephen Hawking.
2. Jean Baudot, *la Machine à écrire*, Les Editions du Jour, Montréal, 1964.
3. The A.L.A.M.O. was started by Simone Balazard, Jean-Pierre Balpe, Marcel Bénabou, Mario Borillo, Michel Bottin, Paul Braffort, Paul Fournel, Pierre Luson et Jacques Roubaud.
4. Preface to issue number 95 of the Action Poétique review devoted to the A.L.A.M.O., Avon, 1984.
5. It is essentially Jean-Pierre Balpe who, within the A.L.A.M.O., developed poem generators, for instance the Renga and Haiku programs presented at the exhibition *Les Immatériaux* in 1985 or AMOUR, a love poem generator which must be dating back to 1980. All these generators, and many others, are presented in detail in the book *Initiation à la génération de textes en langue maternelle*, Jean Pierre Balpe, Eyrolles, Paris, 1986.
6. Review *Docks*, Akenaton, Ajaccio.
7. One might quote, among others, the names of Brigitte Dorez, Benoit Carré, Jean-Michel Henniquez, Martial Lengellé, Jean-Marie Dutey, Frédéric de Vellay and Philippe Bootz.
8. Among others, the introduction of the EUTOPIE group in the *revue parlée* of the Pompidou Center on 22 March 1984, together with a small one week exhibition; the *Texte autre* exhibition at the Roubaix resource center from 1 to 29 December 1984 ; the *Satellisation, dessins en utopie* exhibition, which took place at the cultural center in Amiens from 18 May to 13 July 1985 and the *laser ? texte* installation in the J. J. Donguy gallery in Paris from 7 to 27 September 1985.
9. The relationship between these actions and dynamic poetry on video or electronic media was discussed at the international workshop *Litterature et Informatique* which took place in the Paris VII University in April 1994. A paper on this theme entitled *"Gestion du temps et du lecteur dans les poésies dynamiques"*, by Philippe Bootz, was published in the proceedings of the workshop (Littérature et informatique: La littérature générée par ordinateur, AUPELF-UREF, Paris, 1995).
10. Matrix poems, some of which were actually put on computer by a student, Jean-Michel Helincks, in 1979-1980 in the Lille School of Engineers (E.U.D.I.L.) on the University of Lille1 campus. This action is presented in alire7, MOTS-VOIR, Villeneuve d'Ascq, FRANCE, 1994.
11. Jean-Marie Dutey, the "Mange-texte ", *alire1*, L.A.I.R.E., Villeneuve d'Ascq 1989.
12. Claude Maillard, *le Théatre de l'écriture*, book 2: *le tome Son*, Les Editions Traversières, Paris, 1986.
13. Philippe Bootz, Video poetry and unique-reading poetry: two complementary approaches in A:\LITTÉRATURE, MOTS-VOIR and the GERICO-CIRCAV, Villeneuve d'Ascq, 1994. Other articles on the topic can be found in Nov'Art (January 1995) and the video event "video lue contée dansée" organized by the video team *Heure Exquise!* in the fort of Mons-en-Baroeul (September 1994).
14. (Pre) texte à voir, J. J. Donguy gallery, 1993.
15. French institutions and organizations remaining suspicious of this type of review, I think it is useful to give here their addresses. For *alire*: MOTS-VOIR, 27 allée des coquelicots, 59650 Villeneuve d'Ascq. For *Kaos*: KAOS, 113, rue Anatole France, 92300 Levallois.
16. Organized in Paris VII on 20, 21 and 22 April 1994 by Alain Vuillemin from the University of Artois and Michel Lenoble from the University of Montreal with the collaboration of Item-sup and the Ingénierie didactique laboratory of the University of Paris VII.
17. *Action Poétique*, Avon, number 85 dates back to 1984 and number 129/130 to 1992.
18. Among others: A:\LITTÉRATURE, already mentioned, which contains several articles on the history of computer literature; and, the Ph.D. thesis of Orlando Carreno, *Nuevas tecnologias de la informacion y creacion literaria*, Complutense University, Madrid, 1991, which should shortly be translated into French.

19. Guillaume Baudin, "a pretext for idleness " in J. P. Balpe and B. Magné (eds), *l'Imaginaire informatique de la littérature*, PUV, Presses universitaires de Vincennes, St Denis,1991 p.152.
20. Tibor Papp, "disztichon alfa", *alire7*, MOTS-VOIR, Villeneuve d'Ascq, 1994.
21. All these reasons specify the position of the text and of the reader and assert the book's limits with regard to these positions. One may consider the programming of the *cent mille milliards de poèmes* as L.A.I.R.E.'s manifesto and *alire1*'s other texts, whose aggressive nature can be noticed, as an alternative to automatic generators which transfer the focalization from the text's author to the reader.
22. *Action Poétique*, nr 129/130, Avon, 1992, p.4.
23. See the articles written by Orlando Carreño or Jacques Donguy in A:\LITTÉRATURE.
24. An example and a comprehensive presentation is to be found in A:\LITTÉRATURE. In a few words, a unique-reading poem can be presented as a hypertext generating an animated text in an irreversible way. Indeed interactivity brings about a navigation of an intertextual nature in the generator without the reader's knowing. The latter does not see this navigation nature at all nor even, for that matter, the generating nature of the structure since he can never come back to the same sequence. These aspects can only appear during exchanges between readers. The irreversibility is due to the fact that any act initiated by the reader is memorized for good and has an influence on the reading in process and those to come. This type of text can only function with a substantial number of interactive readings (ten or so). All things considered, the text-to-be-seen generated beyond that number of readings is no longer interactive but has a history for the one reader who generated it. It is to be noted that the concepts of that type have been proposed in Philippe Bootz's article, "The unique-reading poem", les cahiers du CIRCAV nr 3, GERICO-CIRCAV, Villeneuve d'Ascq, 1993.
25. Jean Ricardou, a discussion following Bernard Magné's article, "L'Imagination informatique de la littérature" p.204.
26. See, for instance, the most comprehensive work to this day, which describes in detail the way several generators from the pioneering days function: Jean-Pierre Balpe, *Initiation à la génération de textes en langue naturelle*, Eyrolles, Paris, 1986 or still, by the same author, *Hyperdocuments, Hypertextes, Hypermedias*, Eyrolles, 1990.
27. A typical passage from this announcement is as follows: "Reading the text once does not guarantee that you have used up the possibilities. You have to read and read again... " in *Action poétique*, number 129/130, p.6.
28. This information was given directly on the disk as an introduction to the extract from the unique-reading poem "Passage" by Philippe Bootz in A:\LITTÉRATURE.
29. Through the three articles already quoted from the Cahiers du CIRCAV nr. 3, from A:\LITTÉRATURE and the acts of the Jussieu workshop.
30. Benoit Carré, the catalogue of the *Lecture* installation within the *Images et Mots* exhibition, Villeneuve d'Ascq, 1986.
31. "Un modèle du monde vécu", Philippe Bootz in the catalogue of the *Texte Autre* exhibition, MOTS-VOIR, Villeneuve d'Ascq, 1984.

# DIGITAL POETICS OR ON THE EVOLUTION OF EXPERIMENTAL MEDIA POETRY

Friedrich W. Block

**1. Introduction or From technological leveling off to poetological positioning**
The academic and literary critical discussion regarding media poetry or digital texts[1] swings to and fro in method and conception between two poles: on one end is the 'work immanent' approach of structure description and classification, on the other, the deduction of abstract media esthetics. At a tangent to this since the 1990s, the general discussion on media, culture and media art has emphasized technological reasoning.

The concern with technology remains a dilemma: Technology has to be taken into account when dealing with structure analyses of works of digital poetry, but some traps lie in wait. Is the knowledge accounted for here really sufficient? I would say that few of those taking part in the discussion who do not actually work in the specific area artistically are capable of programming digital texts (the same may be said of some artists). Another problem is something I have casually termed a new techno-ontology: a 'cold fascination' for technological being (also of texts), which flares up briefly with each innovation pressing for the market in the respective field. This includes the far-reaching absence of any ideological criticism of things technical – mainly in the 1990s, where the area of media art as well as digital poetry expanded. In fact the opposite was the case: A 'new' avant-garde consciousness, ignited with current technical achievements and the connected artistic experiments, is undeniable in the digital poetry discussion: along with the new media, newness according to modern progress and as a value of economic exchange returns with a vengeance. If, however, you take 'technical' to mean more than the purely instrumental (the tools of hard and software independent of their cognitive, physical, or communicative use); that is, if 'technical' is interpreted dynamically as a process and symbolically according to the ancient world's notion of 'techne' (techne as creative workings or as art), then it is clear that the explanation of literature, digital literature, indeed, cannot be reduced to technology. In addition, questions of perception, communication, social and cultural orders arise. In this case, literature must be a multi-dimensional system to which belong the works themselves, the technical procedures and their corresponding media, and the protagonists with respective cognitive areas, action roles, groupings, institutions,

communications, and symbolic orders (such as genre knowledge or program of poetics). Each dimension is subject to certain coordinated dynamics and historical development.

Bearing this in mind, this chapter focuses on the "program" area.[2] Programs consist of certain strategies, principles, values, work attitudes, questions, and objectives which single artistic events and manifestations orient and control with pre or post interventions according to poetics. Programs occur in various planes of complexity that may cross each other. They develop intrinsic values and the specifics of these must be indicated – usually with type or genre titles or, if required, with group or movement names.

Some examples of programs and partial programs in order of abstraction include: Futurism, Zaum, language of stars/Viennese group, literary cabaret, dialect poem/digital poetry, Media Poetry, L.A.I.R.E. and unique-reading poem.[3] Of course, it is not necessarily the norm to integrate more comprehensive programs with partial programs or realizations. Since the 1970s, poetry has, if at all, favoured smaller programs: Strategies of individual artists without a clear 'superstructure'. In this respect labels such as 'digital poetry', 'net literature' or "New Media Poetry" may be the cause for surprise these days.

The arbitrarily chosen series (Futurism to digital literature) has been developed here in such a way as to allow for a further generic program term, a term admittedly not so reliable as, say, experimental literature.[4] From this viewpoint, we must ask how digital poetry should be assessed as a program: idiosyncratic and unique or more as a partial program. The avant-garde consciousness mentioned previously seems to speak for uniqueness, as does the tendency within the discourse to make a clear break from, say, all literature of book and print as well as the cultural history thereof.

The assessment as a partial program, however, is supported by the observation that standing definitions of digital poetry have a large proximity to strategies of existing and historically grown programs – including the mentioned avant-garde consciousness. At the least we can say they overlap. If this is so, and I assume it is, there are a number of advantages for the description of digital poetry: Certain strategies and abstract concepts for digital poetry can be enriched semantically and questioned at an 'added value'. This applies to declarations about the performance and function of digital poetry, as well as to the assessment of the quality of single works. Finally, it becomes possible to regard programmatic parallels as well as more general developments in a slightly different light.

As a test of this generic objective, let us dwell on the concept of experimental literature. Since the 1950s and increasingly so since the late 60s, the developments have produced a variety of polished procedures and strategies thanks to a strong bias on theory. These procedures are well thought out according to poetics as in no other area of literature. There is not another literary field in which the concern with new media technologies and things technical has been so intensive – not simply thematically, regarding content, but primarily in the formal structures themselves. Briefly, once again, before I outline this program with some key strategies, here is a compilation of all those qualities the current critical discourse ascribes to digital poetry.

## 2. Slogans or Popular definitions of digital media poetry[5]

Within the current critical discourse, digital poetry is ascribed an identity so long as it specifically deals with the conditions which computer, Internet (computer networks), and certain software programs and programming languages have to offer. This means that digital poetry is defined by the fact that it may be produced, disseminated, saved, and received only under these conditions, and not in any other way. In the main, the following possibilities have been derived from this or are named repeatedly as criteria:

- The mechanical, algorithmic generation of texts (supporting or complete)
- Electronic linkage (in the computer, on Intranet or Internet) of fragments and files of the same or also different media types
- Multi- or non-linearity of both text structure and individual reading matter derived from the electronic linkage
- Multimediality and animation of texts in the broadest sense if required
- Interactivity as a 'dialog' between machine (hard and software) and user as a (dependent on the programming) reversible or irreversible intervention into the display or database text, as a telematic communication between different protagonists on the computer network
- The shift or even de-differentiation of traditional action roles such as author, reader, editor derived from the aforementioned 'dialog'

These criteria are specific enough to delimit digital literature from other literature. They have but one flaw: they say nothing about the esthetic or artistic state of digital texts. Online shops, route planners, library catalogs, multimedia encyclopedia, scientific mailing lists or news forums, erotic chats, search machines or even the homepage of one John Smith or Lieschen Müller might just as well be included here. Once again, when technological conceptualization levels off, the old question of poeticism rears its head. At first the answers that were given here were informatively and esthetically aimed at predictability; later on they were aimed both cognitively and communicatively at semantic framing (convention of esthetics, coding of the art system). But with this the various criteria could only receive some prefix or other (e.g. *artistic* or *literary* interactivity) and little else was gained. Only when we proceed semantically according to art-specific conditions do we move forward. This can be tried via single work analysis, or with contextualization in reference to existing, more specific programs. If, in addition to technological criteria others such as 'reflection', 'production', 'presentation', or 'exemplification' of, or 'experimentation' with the technological and media possibilities are considered – then we have already reached the program of experimental poetry.

## 3. Affiliation or The birth of digital poetry in the spirit of poetic experimentation

Though the idea of the poetic experiment has a far more ancient history, it has circulated internationally amongst literary figures and academic observers since the 1950s.[6] This marked an historical break, following the global catastrophe of world war and the Holocaust, when a new generation, 20 to 30 years old at the time, started to seek out up-to-date and more advanced possibilities of poetry writing. Following the experience of a total abuse of language, media and art, the demand was for a more radical approach than simply supporting a 'realistic' representational function of language. The long-forgotten approaches of the avant-garde in the first decades of the century were rediscovered, and similar interests in approximately the same

age group where discovered in various regions of the world. Artists from Europe (including Eastern Europe), North and South America and Asia were soon communicating with each other. Often they cooperated in groups and soon started to meet up at international exhibitions, and collaborate in books, magazines, and other publication projects. By the end of the 1960s, concrete poetry was found to be too restricted, prompting numerous partial programs such as visual or performance poetry to appear on the scene. These partial programs increasingly overlapped with general genre programs such as Fluxus, pop art, conceptual art, mail art or copy art (the latter also called electrostatic art or Xerox art). Sound poetry had been under development in France since the 1950s and saw renewed growth in this larger experimental context.

Around 1967 and 1968 an intellectual climate emerged – at least in Europe – within the context of social, political, and cultural movements, which set the stage for the contemporary discourse on digital poetry and media art. Along with this transitional period, the likeness between experimental poetics developed since the 1950s and the philosophical reflection on language (e.g. Derrida's "Grammatology, 1967), the media revolution (e.g. McLuhan's "The Gutenberg Galaxy" 1962, in German 1968), and science (Heinz von Foerster's and John von Neumann's Cybernetics) stand out.[7]

From the beginning, the "experiment" as a program concept was intended not so much to aid the classification of certain texts, but rather to help orient a certain poetic context repeatedly said to have the following common criteria:

- The interest in a work being *with* rather than *in* the language (i.e. the concentration on its semantics and material aspects as well as its use in connection with other sign systems),
- To experiment with new perception and communication media
- To make the processes of producing and understanding esthetic forms a central theme
- To link and integrate and therefore also extend media and procedures used in more traditional forms of art
- To connect literature with other arts – particularly with contemporary developments in the fine arts and music – and with science and politics
- To reflect on the limits of literature
- The very rational and cognitively oriented attitude of the producers, their cooperation in groups and their international integration

The opening out and diffusion of post-war experimental and visual poetry into a variety of different programs – dependent to a large extent on individual artist personalities – was accompanied by the volatile development in the field of technical media. Language artists experimented as early as the 1960s with photography (Jochen Gerz), film and TV (Gerhard Rühm, Timm Ulrichs, and Klaus Peter Dencker), video (Ernesto de Melo e Castro), and later with neon writings (Mauricio Nannuci, Timm Ulrichs), photocopy (Jürgen Olbrich, Emmett Williams) and holography (Eduardo Kac, Richard Kostelanetz). In sound poetry the voice is reinforced and distorted using the electronic possibilities of new sound recording systems (François Dufrêne, Henri Chopin). The new radio play established experiences with stereophonic sound systems, including cut and original soundtrack (Friederike Mayröcker, Bill Fontana). Also, the typewriter possibilities were played out: This was a leading medium of

experimental poetry mainly because of its flexible typography that could be treated independently from the typesetter. Complementarily there were experiments with handwriting – psychograms for the 'technology of self' (Gerhard Rühm, Carlfriedrich Claus, Valeri Scherstjanoi). Of course, the book – the absolute criterion of differentiation according to the digital poetry discourse – was tested for possibilities of extension and deconstruction, for example, via kinetic transformation (Raymond Queneau), collage transformation (Jiri Kolar, Franz Mon), or sculptural and architectural transformation (Juan Brossa, Ian Hamilton Finlay, Timm Ulrichs).

The beginnings of computer-based literature did not happen in a vacuum, nor – as is often believed – do they lie in American hyperfiction in the late 1980s. They originated much earlier within the area of experimental and visual poetry, and can be described with a far greater

Figure. 1: Theo Lutz, original stochastic text, teleprinter output, 1959.

```
NICHT JEDER BLICK IST NAH. KEIN DORF IST SPAET. NOT EVERY LOOK IS NEAR. NO VILLAGE IS LATE.
EIN SCHLOSS IST FREI UND JEDER BAUER IST FERN. A CASNOT EVERY LOOK IS NEAR. NO VILLAGE IS LATE.
JEDER FREMDE IST FERN. EIN TAG IST SPAET. A CASTLE IS FREE AND EVERY FARMER IS FAR.
JEDES HAUS IST DUNKEL. EIN AUGE IST TIEF. EVERY STRANGER IS FAR. A DAY IS LATE.
NICHT JEDES SCHLOSS IST ALT. JEDER TAG IST ALT. EVERY HOUSE IS DARK. AN EYE IS DEEP.
NICHT JEDER GAST IST WUETEND. EINE KIRCHE IST SCHMAL. NOT EVERY CASTLE IS OLD. EVERY DAY IS OLD.
KEIN HAUS IST OFFEN UND NICHT JEDE KIRCHE IST STILL. NOT EVERY GUEST IS ANGRY: A CHURCH IS NARROW.
NICHT JEDES AUGE IST WUETEND. KEIN BLICK IST NEU. NO HOUSE IS OPEN AND NOT EVERY CHURCH IS SILENT.
JEDER WEG IST NAH. NICHT JEDES SCHLOSS IST LEISE. NOT EVERY EYE IS ANGRY. NO LOOK IS NEW.
KEIN TISCH IST SCHMAL UND JEDER TURM IST NEU. EVERY WAY IS NEAR.NOT EVERY CASTLE IS QUIET.
JEDER BAUER IST FREI. JEDER BAUER IST NAH. NO TABLE IS NARROW AND EVERY TOWER IS NEW.
KEIN WEG IST GUT ODER NICHT. JEDER GRAF IST OFFEN. EVERY FARMER IS FREE. EVERY FARMER IS NEAR.
NICHT JEDER TAG IST GROSS. JEDES HAUS IST STILL. NO WAY IS GOOD OR NOT EVERY COUNT IS OPEN.
EIN WEG IST GUT. NICHT JEDER GRAF IST DUNKEL. NOT EVERY DAY IS LARGE. EVERY HOUSE IS SILENT.
JEDER FREMDE IST FREI. JEDES DORF IST NEU. A WAY IS GOOD. NOT EVERY COUNT IS DARK.
JEDES SCHLOSS IST FREI. NICHT JEDER BAUER IST GROSS. EVERY STRANGER IS FREE. EVERY VILLAGE IS NEW.
NICHT JEDER TURM IST GROSS ODER NICHT JEDER BLICK IST FREI. EVERY CASTLE IS FREE. NOT EVERY FARMER IS LARGE.
EINE KIRCHE IST STARK ODER NICHT JEDES DORF IST FERN. NOT EVERY TOWER IS LARGE OR NOT EVERY LOOK IS FREE.
JEDER FREMDE IST NAH, SO GILT KEIN FREMDER IST ALT. A CHURCH IS STRONG OR NOT EVERY VILLAGE IS FAR.
EIN HAUS IST OFFEN. KEIN WEG IST OFFEN. EVERY STRANGER IS NEAR THEREFORE NO STRANGER IS OLD
EIN TURM IST WUETEND. JEDER TISCH IST FREI. A HOUSE IS OPEN. NO WAY IS OPEN.
EIN FREMDER IST LEISE UND NICHT JEDES SCHLOSS IST FREI. A TOWER IS ANGRY. EVERY TABLE IS FREE.
EIN TISCH IST STARK UND EIN KNECHT IST STILL. A STRANGER IS QUIET AND EVERY CASTLE IS FREE.
NICHT JEDES AUGE IST ALT. JEDER TAG IST GROSS. A TABLE IS STRONG AND A LABOURER IS SILENT.
KEIN AUGE IST OFFEN. EIN BAUER IST LEISE. NOT EVERY EYE IS OLD. EVERY DAY IS LARGE.
NICHT JEDER BLICK IST STILL. NICHT JEDER TURM IST STILL. NO EYE IS OPEN. A FARMER IS QUIET.
KEIN DORF IST SPÄT ODER JEDER KNECHT IST GUT. NOT EVERY LOOK IS SILENT. NOT EVERY TOWER IS SILENT.
NICHT JEDER BLICK IST STILL. EIN HAUS IST DUNKEL. NO VILLAGE IS LATE OR EVERY LABOURER IS GOOD.
KEIN GRAF IST LEISE, SO GILT NICHT JEDE KIRCHE IST WUETEND. NOT EVERY LOOK IS SILENT. A HOUSE IS DARK.
EIN BILD IST FREI ODER EIN FREMDER IST TIEF. NO COUNT IS QUIET THEREFORE NOT EVERY CHURCH IS ANGRY.
EIN GAST IST TIEF UND KEIN TURM IST FERN. A PICTURE IS FREE OR A STRANGER IS DEEP.
EIN GAST IST LEISE. JEDES BILD IST FERN. A GUEST IS DEEP AND NO TOWER IS FAR.
EIN TISCH IST OFFEN. JEDER KNECHT IST FREI. A GUEST IS QUIET. EVERY PICTURE IS FAR.
JEDER TURM IST NEU UND EIN BILD IST ALT. A TABLE IS OPEN. EVERY LABOURER IS FREE.
NICHT JEDER TISCH IST GROSS ODER JEDES DORF IST ALT EVERY TOWER IS NEW AND A PICTURE IS OLD.
 NOT EVERY TABLE IS LARGE OR EVERY VILLAGE IS OLD.
```

Figure. 2: Theo Lutz, stochastic text, 1959. Translation by Helen MacCormack (2005).

continuity than the digital revolution propaganda with its historical break would have us believe. First 'stochastic' or 'artificial' texts were produced in 1959 by Theo Lutz within the Stuttgart group surrounding Max Bense, with the help of a program run on the large computer Zuse Z 22.[8] Parallel to this experiment the first exhibitions with pictures created digitally were taking place. Jean Baudot (1964 in Montreal) and Gerhard Stickel (1966 in Darmstadt) produced 'automatic texts'. During these experiments it was not so important to interpret the results, nor even the actual processes in the machine. The main question was how the machine should be interpreted with regard to its esthetic function, e.g., in relation to the creativity of the human author. These early approaches were accompanied in particular by a subtly differentiated poetology that received its impetus from cybernetics, information theory and semiotics. As early as 1950 – the year of Allan Turing's pioneering essay "Can a machine think?" – the synthesis of human and machine was explained with an ontological bent by Max Bense in "Literaturmetaphysik".[9] The essays of Oswald Wiener, a member and mentor of the Viennese group, were particularly relevant from a poetics point of view. In them, the "Turing Machine" was propagated as a model of understanding and of esthetic processes. In the 1969 book *Die verbesserung von mitteleuropa, roman* (The improvement of Central Europe, novel, 1969) his "bio-adapter" concept ironically anticipated the move into cyberspace.

In the USA, Aaron Marcus had been exploring virtual and interactive text space in his "Cybernetic Landscapes" since the end of the 1960s, and had developed a poetics program of interactivity, simulation, and movement.[10] In France, too, the poetic analysis of computers has been continuous since the early 1970s. The background for this were the statements of the "workshop for potential literature" (OULIPO) whose members Paul Fournel, Italo Calvino, and Jacques Roubaud were concerned with different procedures of "computer-aided creation processes".[11] The roots of net literature in the specific sense of literature within computer network systems (minitel (a.k.a. videotext) projects such as "A.C.S.O.O." or " L'Objet Perdu"), can also be traced back to the early 1980s in France.[12]

Of course there were also individual artists whose experiments gradually led them to work with hypermedia: This can be said of the French mentioned above and Stuttgart Group member Reinhard Döhl, among others. It was also the case of pioneers like Ernesto de Melo e Castro or Richard Kostelanetz, and of one of the leading hypertext poets, Jim Rosenberg, and it is also true of younger representatives such as André Vallias who started out in visual poetry.

Following from this affiliation of digital poetry, it seems obvious to ask whether certain key strategies of experimental poetry can be used to esthetically enrich technological criteria such as 'programming and source codes', 'animation and processuality', 'interactivity', or 'hypermedia'.

## 4. Retroperspective or Digital poetics with strategies of the experimental program

When poetological examples are listed here, this is not to assert the continued existence of a certain school or even to assert the assumption that digital poetry is epigonal. It is precisely this development of post-war experimental poetry as form or movement which must be considered to have been complete since the late 1960s. The selected examples do, however, stand for the experimental program since the 1950s as a whole, as well as for the 'intellectual climate' mentioned earlier. They are only intended to illustrate the importance of poetological ideas and strategies for the development of contemporary media poetry in addition to their realization in individual artworks.

*4.1. 'Material' and digital medium*
Avant-garde poets in the post-war period started to treat language as "material". With the notion of 'material' a fundamental change of reference and function in literary language usage was called for within the program of experimental poetry. The esthetic interest focused primarily on the language as a sign system, as a cognition and communication medium, and as the artistic means of creation. It was language itself which was valid in all its qualities – the visual qualities in particular as the material upon which it is necessary to reflect and to form – similar to the material of colours, lines, areas in art ("Concrete Art", Theo van Doesburg, 1930) or the material of tones and sounds in music ("Concrete Music", Pierre Schaeffer, 1948).

As a complement to form, the concept 'material' replaced the old pre-modernist definition of substance (German: "Stoff" – which aimed at spirit, meaning, theme, contents, fable) – initially with a tendency to emphasize strongly the 'material', i.e. perceivable side of the signs. Most recently with conceptual art (and experimental as conceptual poetry) it has become clear that intellectuality, ideas, semantics, and codes can also function as material in art.

In the meantime, a more neutral idea put forth is the esthetically current concept of 'medium', this being the transformation of 'material' in terms of a logic of difference – an abstract and highly integrative media concept as Niklas Luhmann has suggested.[13] With this, experimental poetry would have always been media poetry.

From a semiotic point of view, the program outlined in the 1950s and 1960s poetry manifestos was concerned with the following: that all esthetic word processing be subject to the priority of 'self reference' or 'exemplification' by language or sign complexes. Or, following system-theory: one always orientated on a level of second-order observation which potentially treated all

Figure. 3: Aaron Marcus, A sequence from "Cybernetic Landscape I", 1971–1973.

structure and use possibilities of language – as observation *medium* – according to *form* aspects.

The poetological statements repeatedly mentioned the text being 'reduced' to the language material that was clear from a design point of view – often only a word or word fragment on the page, focusing on perceptible graphic or phonetic forms – but which, on the contrary, must be seen theoretically as an increase in complexity in possible meanings. Above all else, 'reductions' like 'material' should be seen as an indicator of the move to a higher self-referential observation level. In practice this indicates a calculated or method-conducted intervention into the language or non-language codes, e.g. by procedures of isolation, contamination, fusion, and permutation.

Digital poetry gains the following from these principles: If digital poetry requires a corresponding type or genre name according to poetics, then this should exemplify its specific

digital or hypermedia structures and processes, its specific type of media. This means it creates events and situations to observe language-usage within the hypermedia. Of course the material is no longer only the word, nor is it, generally speaking, the medium, the character, the media-codes and notations but their specific manifestations in computers and computer networks. According to 'material' thought, the procedures which stage source codes, programming, and interfaces self-referentially are the most important here. Such exemplification is present, and clearly visible, for example, when the difference between HTML code and browser interpretation is produced, as in the Japanese group Exonemo's "Discoder" (the "Jodi" group is another classic), or when different symbol formats are contaminated as in the ASCII-Art-Ensemble, which experiments with the "American Standard Code for Information Interchange" or when Perl scripts are used to compose, as in the case of Alan Sondheim (each poem a small program – also demonstrated with historical affiliation on Florian Cramer's "Permutations" website). Of course all other demonstrations of computer-based features need to be included here, such as hypermedia, networking, animation, interactivity – this will be looked at in more detail – or simply the discrepancy between hard and software, e.g. in Frank Fietzek's "Bodybuilding" installation which uses a prime mover as interface for text production and reception.[14]

*4.2. "movens": animation and information process*
Another concern apparent in the 1950s and 1960s, which can be applied to the present development of digital poetry as far as the question of movement is concerned, is the distinction between movement as a perception event on the screen (animation), on the one hand, and as a structural movement of the calculations or symbolizing processes and action processes (information processing), on the other. The current trend shows a tendency towards the second phase.

One stage important for the establishment of the movement strategy within the program of experimental art and literature is a volume which appeared in 1960 containing "documents and analyses for literature, fine arts, music, architecture", entitled "movens" and published by Franz Mon in cooperation with Walter Höllerer and Manfred de la Motte. The literary perspective of this enterprise was aimed at formulating experimental poetics in such a way as to embrace the complete arts with the main theme of movement. Essentially it was all about the esthetic production and processing of sign processes. Umberto Eco's book *The Open Work* (Opera aperta, 1962) appeared two years later with a corresponding opinion: The open artwork is produced most consistently when the activity of awareness and interpretation of those who produce and receive the work can be conceptually expected, and it becomes an "artwork in movement".

Procedurally, "movens" is a 'retro perspective' (a concept termed by Cathérine David for the "Documenta X", 1997) when artists like Hans Arp, Alberto Giacometti, Kurt Schwitters, or Gertrude Stein are integrated with the past – from the immediate to the avant-garde. These important figures stand for the processual character of art. The same is true for the contemporary examples that among others originate from experimental poetry, light and kinetic sculpture, dynamic theater, electronic music, or a 'labyrinthian' architecture. The attention is directed towards the dynamic 'material' (once again!) in the broadest sense of language or symbolic processes.

So you see, "movens", too, makes the connection of kinetics and process orientation within the idea of movement and thereby supports the poetics base for digitally poetic criteria of animation and information processing. Interesting approaches in the area of digital poetry build entirely on this connection – supported technologically. The French, for example, concerned themselves early on with time in digital texts. Since the 1980s, groups such as ALAMO and LAIRE explored, on the one hand, the temporal relationship of movement on the screen or text animations and, on the other, visual possibilities as well as interactivity within this course of motion. The concern is also to explore the tension between the time units of programmed text, perceived text, and read text (e.g. Philippe Bootz). Following from this understanding of time and movement one is today particularly interested in the staging of information processes (in the computer, e.g. the

Figure. 4: ASCII Art Ensemble (Walter van der Cruijsen, Luka Frelih, Vuk Cosic), "Deep ASCII", 55 min (no sound), 1998. The film "Deep Throat" was converted to ASCII and displayed on a Pong Arcade.

conversion of text into pictures as in the previously mentioned "Verbarium" by Sommerer & Mignonneau, on the Net, e.g. "23:40" by Guido Grigat or "mi-ga's" spam mail art, or, as in the recent works of Eduardo Kac, also in the tension between artificial and 'natural' data processing).[15]

*4.3. Audience activity and interactivity*
The interest in the process has brought about the fact that not only the activity of producers is conceptualized, but also that of the audience. This has also led to interactivity.

In the 1950s the concept of art was extended to include open structures and processes. This has led generally to an esthetic attention to symbolic, cognitive, and communicative processes and, also, particularly to the direct incorporation of audience or recipient. This applies to intermedia art, action art, happening art, Fluxus and conceptual art, and it also applies to experimental poetry developing in close contact with these approaches. The concern here is with the psychophysical conditions in the formulation process – with a rare concentration and differentiation (as in Carlfriedrich Claus' "Exerzitien"). And at the same time, while the author functions are relativized, they are also projected onto a 'new' active recipient who comprehends and completes the creation process. The 'new reader' has become an ideal figure for open and self-reflexive perception, interpretation, and comprehension processes. The program of experimental poetry can no longer do without this personal projection.

The interactivity of digital poetry refines this program in the respect that now the ideal becomes technically clear or is made empirical. The activity of the user is often programmed – self-referential in the best cases (as a switch, form or input function, e.g., in Philippe Bootz' "unique-reading poem" or in "Assoziationsblaster" by Alvar Freude and Dragan Espenschied).[16] The user's activity may also be symbolized or staged in the work itself (e.g. the hyper-textual role play in Luc Courchesne's "Portrait One"). On the other hand, the user appears embodied in the game with the machine or already as its part – e.g. when producing text by means of a bicycle (Shaw's famous "Legible City") or a prime mover (Fietzek's "Bodybuilding"). At all events interactivity lives off the analogy and the dialogue between user and computer, which conceives both as data processing systems with hard and software components which are made to intersect. Even the first text generators were inspired by this analogy – more or less de-constructively.

*4.4. Intermediality and hypermediality*
A further strategy in the discourse of digital poetry is hypermediality.[17] This is regarded as an extension of hypertext, in which not only text files, but also audio files, picture files, and video files are inter-switched with each other and issued as a "Gesamtdatenwerk" (a 'complete data work', an expression coined by Roy Ascott).[18] According to Roberto Simanowski, here we are dealing with "the at present [i.e.:1999] perhaps most relevant type of digital literature",[19] which takes the hypertextual inheritance of its predecessor into multimedia. This understanding of hypermediality is, however, reduced to the multimedia surface of the output devices, and insufficiently fulfills the specific requirements of the computer and corresponding artistic works. The digital media hype here is not what is produced with effective publicity at more or less cunning 'verbiaudiovisions', but rather the fact that each perception medium is coded digitally, i.e. alphanumerically (ultimately with '1' and '0'). The interesting poetic works build upon this

Figure. 5: André Vallias, "Oratorio", interactive poem, 2003.

in accordance with the experimental program and the conceptualization of 'material' (see IV.1). Moving pictures, indeed whole films are published as a writing process in ASCII (ASCII Art Ensemble); text input is converted into pictures ("Verbarium"); with user interventions in the HTML source code, texts and pictures displayed by the browser are deconstructed and rearranged ("Discoder").

With these procedures, concepts like 'multimedia' or 'Gesamtdatenwerk' lead the wrong way (in the direction of mass-media spectacle and back to Richard Wagner's totalitarian 'Gesamtkunstwerk'). The strategies of visual and sound poetry are fundamentally more informative when they have not simply concentrated on linking disparate media but rather on the intermedial exemplification thereof.

The conceptualization of intermediality according to poetics is helpful here as carried out by Dick Higgins in the mid 1960s in the intertwining area of intermedia art and experimental poetry.[20] For Higgins it was all about a 'conceptual fusion' of medial conditioned horizons (i.e. media concepts realized culturally and individually). "Conceptual fusion" refers to the fact that we are not dealing with a mixture of media (this is why the counter-concept 'mixed media' is

used in analogy to today's multimedia) but rather with an artificial artistic production of the gap or the break between traditional forms (or coding) of media. This means that accessed media (writing, pictures, sound) are presented self-referentially as symbolic forms. Conceptually they therefore dissolve themselves – a second order observation – in an imaginary 'metamedium'.

The extension of visual or sound or intermedia poetry into digital or hypermedia literature as in the examples mentioned above consists in the following: The conceptual or ideational semantics of "fusion" (also described as strategy of a diffuse 'metamedium') is conveyed through technical or syntactic manipulation of computer programming languages. Or to use spatial imagery: the horizontal axis of perceptible intermedia (e.g. a "Schriftzeichnung" [written drawing] by Gerhard Rühm) is extended by a vertical axis of programming (e.g. via self-referential interventions in the HTML or Perl script code). This also corresponds to the 'empirisation' of existing strategies of experimental poetry, as illustrated above in regards to interactivity.

## 4.5. Summary or "Texts in the spaces in between"

In my reflection on digital media from the perspective of poetry, I have attempted to avoid a viewpoint that relies on the wordings of the 'consciousness industry' (only today does Ardorno's invective seem charged correctly). My attempt leads to an intermediary discourse that interweaves evolved conceptualizations of poetics and technology.

I hereby avoid an additional accessing of the old dualism of two worlds (C. P. Snow) in which one might simply switch more or usually less competently to the technical side. Opposed to this, literature appears within the program of experimentation as a part of the technically and medially shaped world that is at the same time recursively observed from a literary angle. This procedure has been the only way to locate the site of digital literature within the net of literatures, i.e. in the system of literary communication. The first reference point of technically oriented or digital poetry is the specific context of art and literature: its protagonists, works, discourses, programs!

With the allocation of digital poetry to the program of experimental media poetry, its performance and function also brighten (at the same time both externally as a scientific observation and internally as a demand of poetics): If poetry is an art of symbols (an art of manipulation of symbols – words) and if 'digital' means the technology of universal symbolization, then we are here dealing with the perception and experience of 'symbolic symbolization' – at the end a 'dia-bolical' venture which literally throws aside the mechanics or the conditions and possibilities of symbolizing. If poetry is art or literature in the etymological sense of 'creating and producing' (poiesis) and if 'digital' denotes 'technical' in the same sense, then things technical – dynamic material and material process at the same time – also appear to be self-referential here. Digital poetry reveals the possibilities of present media cultural practice, i.e. current ways of worldmaking.

In other words: here we are dealing with the one place in literature in which, as nowhere else, the function of literature in the technical age is made clear, but with a thoroughly critical (diabolical) look into the interior dynamics of technical thought and action. This also implies a continuous ideological criticism of things technical which has yet to be formulated with clarity

elsewhere. From this angle, digital poetry intensifies and illuminates the function that the experimental program has generally fulfilled excellently since the 1950s – excellently in so far as the question of technology is treated not only thematically but mainly 'technically' here with all available means. It is this function of the poetic experiment in general which becomes clear through digital poetry.

Digital texts as experimental poetry always lie somewhere 'in between' these poetological contexts: program strategy, (inter-) medium or material, movement, and activity. Literally, they are 'media poetry', open texts aimed at complex mediated, communicative and cognitive processes. In keeping with Franz Mon (1961), these are "Texte in den Zwischenräumen" – texts in the spaces in between.

**Notes**
1. Also see http://www.uni-erfurt.de/kommunikationswissenschaft/p0es1s/start.htm.
2. In another essay I questioned the conditions of the receiver changed by interactivity: "Diabolische Vermittlung. Zur Konzeption von Bewußtsein und Körperlichkeit in interaktiver Medienpoesie", in: Oliver Jahraus, Nina Ort (ed.): "Beobachtungen des Unbeobachtbaren. Konzepte radikaler Theoriebildung in den Geisteswissenschaften". Weilerswist 2000, p. 148-168.
3. "L.A.I.R.E" (acronym for Lecture, Art, Innovation, Recherche, Écriture as program points), is the name of a group of French authors initially surrounding Philippe Bootz and Jean Pierre Balpe. The "poème à lecture unique" (unique-reading poem) is a specific poetry form developed by Bootz which is programmed so that every single reading of the text changes it irreversibly in a way the recipient can hardly conceive.
4. Although not every protagonist in this field will identify himself or herself with this conceptuality (the rejection of any labels would be an extra item on the program agenda) and even though there are perhaps more appropriate terms, the term 'experimental literature' seems to this day to be the one most capable of keeping up internationally. For this program cf: Friedrich W. Block: "Erfahrung als Experiment. Poetik im Zeitalter naturwissenschaftlicher Erkenntnistheorien", in: Heinz Ludwig Arnold (ed.): "Lyrik des 20. Jahrhunderts", Text und Kritik, Sonderheft XI/99, p. 248-264.
5. Until now, the concept "Media Poetry" has not gained acceptance in Europe. Since I will concentrate, in the following, on literature with computer and networks, I use the term 'digital poetry' as a shortened form for "digital media poetry". Under the perspective developed here, 'media poetry' seems to me to be the most meaningful umbrella term that largely coincides with the historically evolved term "experimental poetry".
6. The German poet Novalis already made an analogy between physical experiment and poetry in his fragments.
7. In 1967 Alan Turing's "Computing Machinery and Intelligence" appears in German for the first time alongside essays by John von Neumann and Claude Levy-Srauss in the influential German culture magazine *Kursbuch* (nr. 8).
8. Cf. Reinhard Döhl: "von der ZUSE Z 22 zum www". 1998, URL: http://www.netzliteratur.net/zuse_www1.htm, as well as Siegfried J. Schmidt: "Computerlyrik – eine verlorene Chance?", in Manfred S. Fischer (ed.): "Mensch und Technik: literarische Phantasie und Textmaschine". Aachen 1989, p. 139-152.
9. Max Bense: "Literatur Metaphysik. Der Schriftsteller in der technischen Welt". Stuttgart 1950.
10. The "Cybernetic Landscapes" simulated a three-dimensional landscape on the screen with writing and text elements through which the user could navigate by joystick – an early prelude to the "Legible City" created as of 1988 by Jeffrey Shaw and Dirk Groeneveld. Cf.: Aaron Marcus: "Aaron Marcus", in Ruth Leavitt (ed.:) "Artist and Computer", New York 1976, p. 13-18.

11. According to the lecture "Computer and Writers" given by Fournel in the Centre Georges Pompidou during the "Writers-Computer-Conference" in 1977. At the time Fournel and Roubaud were founding members of the ALAMO group that exclusively devoted itself to digital literature. In turn the LAIRE group, which is still active today, emerged from the ALAMO group. Cf. note 3 or for more detail on this genealogy and its poetics: Philippe Bootz: "Poetic Machinations", in this book.
12. "A.C.S.O.O" stands for "Abandon Commande Sur Ordre Operateur", realized in 1983/84 by Camille Philibert and Jacques E. Chabert. At the same time Roy Ascott initiated "La Plissure du Texte" which is a comparable project of distributed authorship. During the *Immatériaux* exhibition in 1985 the minitel system was used for a large-scale collective writing project. See for the telematic cohesion of "poésie expérimentale et ordinateur": Jacques Donguy, "Poésie et Ordinateur", in: Alain Vuillemin/Michel Lenoble (eds): *Littérature et informatique: la littérature générée par ordinateur* (Arras, France: Artois Presses Université, 1995, p. 212-232. The "art com" project realized by Eugen Loeffler in San Francisco in 1984 is another root of net poetry.
13. Friedrich W. Block, "The Form of The Media. The Intermediality of Visual Poetry", in Winfried Nöth (ed.): *Semiotics of The Media. State of the Art, Projects, and Perspectives* (Berlin, New York: 1997), p. 713-730.
14. URLs: "Discoder": http://www.exonemo.com/DISCODER/indexE.html
    "ASCII Art": http://www.desk.org/a/a/e
    "Verbarium": http://www.interface.ufg.ac.at/~christa-laurent/verbarium/
    "Permutations": http://userpage.fu-berlin.de/~cantsin/permutations/index.cgi.
15. URLs: "23:40": http://www.dreiundzwanzigvierzig.de, mi_ga; http://www.o-o.lt; Eduardo Kac: http://www.ekac.org.
16. Re Bootz cf. note 3, "Assoziationsblaster": http://www.assoziations-blaster.de/.
17. Exemplary of this understanding of hypermediality is Jakob Nielsen, *Hypertext and Hypermedia* (Boston: Academic Press, 1990).
18. Cf.: Roy Ascott, "Gesamtdatenwerk. Konnektivität, Transformation und Transparenz", in *Kunstforum international* 103 (1989), p. 100-109.
19. Roberto Simanowski, "Digitale Literatur. Begriffsbestimmung und Typologisierung", www.dichtung-digital.com/Simanowski/28-Mai-99-1/typologie.htm.
20. Dick Higgins, *Horizons, the Poetics and Theory of the Intermedia* (Carbondale, IL: Southern Illinois Univ. Press, 1984).
21. Franz Mon: "Texte in den Zwischenräumen", in Franz Mon, *Texte über Texte*, Neuwied, Berlin: Luchterhand, 1970, p. 40-43.

# Reflections on the Perception of Generative and Interactive Hypermedia Works

## Jean-Pierre Balpe

Today a large number of artworks are regularly produced with computers and digital tools. This has different consequences, one of which being that these works are multimedia. Everybody knows now that this means that different modes of perception are solicited at the same time: seeing, listening, touching and even sometimes smelling or, maybe, tasting, depending on the possibilities of the interface.

This situation is not really new. But more interesting is that today all these perceptive differences are only appearances and that, in fact, in a hypermedia work they all belong to the same system of digital codification. That really means that there is no theoretical differences at all between one sound, one picture, one movement, one taste or one smell. They can all be described by the same set of codes and semantic unification that allow the artist to create real correspondence between them. For instance, what is perceived as a sound may, in fact, appear as a picture or, to the contrary, a picture may appear as a sound – as shown by all the digital tools used to create electronic sounds. In many cases, what appears as a picture may, really, be a text. Indeed, if we use the correct tool we can read a text out of what seems to be a picture. Another important consequence is that if the perceptible appearances of objects are different from their semantic deep structures, some changes in these structures will also produce changes at the level of the appearance. This is an example of interactivity in which somebody acting on the structure produces perceptible changes.

Then the question is what kind of relations are there between interventions at the level of the structure and the representations at the perception level? This puts the participant in a situation of experimentation. He or she no longer contemplates but acts on the work of art to discover, through experimentation, the relations between his or her acts and the appearances which the work of art adopts, what kind of action provokes a reaction and what kind of reaction. Through this situation of question-answer, the participant has the possibility of understanding

Figure. 4: Jean-Pierre Balpe, Miguel Chevalier and Jacopo Baboni-Schilingi, "MeTapolis", 2000. Still from the installation, an immersive VR environment that merged a mythical city architecture, music, and poetry generators in English, Spanish, or French. "MeTapolis" was presented at the Museo de Arte Contemporáneo de Monterrey, Mexico, in 2000.

what kind of relation sets are there, and so to consider what lies behind the appearences of the work of art.

This has many consequences... For instance, is it possible or not to perceive a relation between the action and the representation, and what does it mean? What happens in somebody's mind when he doesn't perceive these relations or, on the contrary, when he perceives them? A big part of digital art today plays on these questions: If I move into a space and if my displacement produces a change in a musical piece that I am listening to, what kind of relations are there between my action and my listening and what is the meaning of such relations between the movement produced and such and such sounds? Such a set of questions is central to the use of interactivity in art: What does it mean, indeed, to be interactive and why should it be better to be interactive than not to be?

This question is at the heart of one installation named 'Labylogue' that Maurice Benayoun created in 2000 with the composer Jean-Baptiste Barrière and me as creator of the model of text. The installation worked simultaneously in Brussels, Belgium; Lyon, France; and Dakar, Senegal. In it a spectator moves in a virtual 3-D labyrinth of walls on which texts appear. A

'player' from Lyon tries to virtually meet a player from Dakar or from Brussels or with both of them. To do that, this spectator can speak and, when he speaks, depending on what he says, the music and the texts of the installation will change. So, when a participant from Bruxelles speaks to the one in Dakar that he has virtually met inside the labyrinth—that means when the video picture of one of them meets the video picture of another one—their conversation is taken into account by the installation itself, creating a complex interactivity between the present spectators, the sound of the installation, its speech and its text. The questions for him are then 'how and why?'.

To participate in the installation, I use a microphone and a joystick. I see a labyrinth on the blue walls of which I can read texts that appear and disappear. Some of them – in light blue – seem to be the material of the walls themselves, something like an old memory of what happened before. Some others in white seem to appear just now. But, at the beginning, I don't know if there is a reason for their apparition: Does their apparition depend on the time, the place, the duration of the installation or on something that I have done? Or on something else, for instance, the weather outside of the installation place or the temperature of the room or the number of people who are at a given moment inside the building where the installation is situated? To try to answer all these questions I have to try different things. What happens when I speak or when I don't? What happens when I virtually meet somebody in the labyrinth? An so on... An infinite number of hypotheses are originally possible and it is only by testing, by trying to do such and such things that I begin, after a while, to understand the relations between me, the people I meet, our actions, our speeches and the events produced on the screen. For the most part, I forget what I perceive in order to concentrate on what I understand. Perception is no longer solicited for itself but appears to be used as a simple pretext. I have to question myself on my own perceptions and the importance I give to them.

In such a situation, what is perceived at such and such moment is not interesting by itself but essentially because it opens up different possibilities and perspectives. Digital media, being neither fixed nor definitive, are always changing: What you see now, what you hear now, will not be the same in a few minutes and maybe never. This is also a question: Is it possible or not to have at another time – when and why – the same contextual appearances of the work of art? And if the answer is 'no', what then is the work of art?

Generativity is another of the structural possibilities of digital coding. Seeing that there is a gap between the deep representation of the media and the perceptible appearances that the medium itself will set up, it is possible to conceive the deep representation not only as an instruction but as a model and to let that model produce itself the changing perceptible representations. This really means that the creator himself or herself has no longer the possibility to foresee, at such and such moment, what will be the forms presented to some spectators. This creates a new set of relations between the deep structure and perception. For instance, with the composer Jacopo Baboni-Schilingi, I created in 1997 a show for the IRCAM (Institut de Recherche et Coordination Acoustique/Musique: Music and Acoustics Research Institute) entitled 'Trois mythologies et un poète aveugle' ('Three Mythologies and a Blind Poet'), which used rather complex relations of interactivity and generativity. This show was principally based on two generation algorithms: one algorithm of French text generation and one algorithm of music generation. They worked together: When a text was created, in real time, an original

248 | MEDIA POETRY: AN INTERNATIONAL ANTHOLOGY

Figure. 5: Jean-Pierre Balpe, Jean-Baptiste Barriere, and Maurice Benayoun, "Labylogue", 2000. Still from an interactive piece connecting three francophone cities (Brussels, Lyon, and Dakar) through the Internet. Remote participants navigate with a joystick in the environment. While they communicate with their voices, the text generator interprets what they say and leaves a trace of what they say as text on the virtual blue walls in real time. When the participants find each other in the textual labyrinth, their faces appear on the computer screen. "Labylogue" was presented in 2000 at Espace Méridien (Brussels), Maison de la Culture Douta Seck (Dakar), and Musée d'Art Contemporain, Lyon.

musical composition was created based on that original text so that a spectator of the show could believe that text and music were previously created. And that was indeed one of the questions of the show: What is perceived? The show itself or the theoretical show that lies behind it? The capacity to create different shows or the participation at something like an original performance? In that show there were three poets: Henri Deluy, Joseph Guglielmi and me. The text generator wrote texts in the style of each of us, but none of them were written before the show. When one text was created, the spectator could see the creation of the text, then the text itself, and then listen to the reading by the poet in question – Henri Deluy read a given text signed by himself but that he never wrote and never saw before. There were always differences between the text on the screen and the reading of the poet, because the poet was reading in public a text he had never seen before and made 'mistakes'. But his mistakes were generally significant because they always showed the deep differences between the model of text and the conception of this peculiar text by the poet himself. So the spectator was always navigating into different modes of perception – reading and hearing essentially – and that hesitation allowed him to understand more of the show itself. Another example: In the same show there was a pianist, a percussionist and a soprano. All of them had fragments of partitions that the computer managing such peculiar performance of the show asked them to play. But the piano and the percussions were MIDI instruments and the small differences of performance were acting on the virtual piano or the virtual percussion instrument playing *with* them. So when the spectator believed to hear something as a concert, in fact, he was listening to a competition between the performers and the computer, between the performers and the composer. Last example: When the soprano was singing such and such phrases, the text generator wrote sentences around these peculiar phrases. But most of the spectators thought that the soprano was led by the computer and not the contrary.

The entire show was built on questions about perception, appearances and deep structures – and tried to lead the spectator to simultaneously perceive all these levels, thus, creating another level of meaning. The perceiver is here in the centre of the apparatus; he is not contemplating a painting or looking at a show, but is inside of it as a part of it. At the same time, outside and inside, acting on it and trying to understand how he acts on it. He is certainly not the creator of the work of art because he can act only within the possibilities of actions and choices that the artist delegates to him. He is at the same time free and captive; and one of the interests of such a situation is that he has to manage such a contradiction in a kind of struggle between the artist's mind and his own mind. He plays and is played... He plays, as never before in the history of art, at the same time as a spectator and the director of the show. He discovers not only the work of art but also the way the artist is playing with concepts, perceptions and representations.

I continue to create works that explore these questions through shows and installations. Still, in 2000, for example, I collaborated with Miguel Chevalier and Jacopo Baboni-Schilingi in the creation of 'MeTapolis', an immersive VR environment that merged a mythical city architecture, music and poetry generators in English, Spanish or French. 'MeTapolis' was presented at the Museo de Arte Contemporáneo de Monterrey, Mexico, in 2000.

Digital art and poetry raise important questions that are central to both fields. They renew traditional problems with new modes of perceptual stimulation.

# SCREENING A DIGITAL VISUAL POETICS

**Brian Lennon**

Book was there, it was there.

Gertrude Stein

"O sole mio." The contemporary elegy, Peter M. Sacks has observed, mourns not only the deceased but also the ceremony or medium of grief itself.[1] Recent trends in digital media theory signal the absorption of initial, utopian claims made for electronic hypertextuality and for the transformation of both quotidian and literary discourse via the radical enfranchisement of active readers. Born in 1993, the democratizing, decentralizing World Wide Web – at first, the "almost embarrassingly literal embodiment" (George P. Landow) of poststructuralist literary theory, a global Storyspace – has in a mere six years been appropriated, consolidated, and "videated" as a forum for commerce and advertising.[2] Meanwhile, with the public recantation of hypertext's virtues becoming a kind of expiation ritual,[3] the initially minimized *warnings* of new-media theorists such as Landow, Jay David Bolter, Michael Joyce, Stuart Moulthrop, and others are being echoed with increasing frequency. These thinkers have seen from the start that electronic *hypertextuality*, or the computerized proliferation of symbolic writing, was only a step on the way to general electronic *hypermediation* dominated by iconic visual, rather than symbolic textual, forms. Bolter's recent thinking in particular emphasizes the continuing marginalization of (hyper)text as the "videating" media of television and film adapt and encroach on previously textual environments of the Web.[4]

As if in response to this (as though, in the accelerating vistas of electronic writing, there were time enough for anything like "response"), Web-based or distributed electronic writing has evolved from its first alphabetic-(hyper)textual forms toward diverse incorporations of, and hybridizations with, the static or kinetic image. At the same time, poets and visual artists working from a tradition of typographic experimentation that reaches back to futurism and Dada, and includes twentieth-century visual and Concrete poetry, are using networked, heterogenetic writing spaces to create and distribute a new electronic visual poetry. This growth of visual writing may be seen as a response to the technological acceleration that permits more and more complex forms of information – from simple text, to static images, to animated and then

to user-interactive text-image clusters or constellations, what might be called "lex/icons" – to coexist in one "medium" or information-delivery system. It might also be seen as evidence that commoditizing the videation of the Web invites subversive uses of that videation – just as, say, the video art of Bill Viola is dependent on (and talks back to) the same technology that extends the commodity value of a blockbuster (and then Blockbuster) film.[5] As Bolter suggests, "True electronic writing is not limited to verbal text: the writeable elements may be words, images, sounds, or even actions that the computer is directed to perform."[6]

Out of habit, we identify the "modernist" poetic text as "materialized", and the "postmodernist" poetic text as "dematerialized", ephemeral, a "simulacrum". The extent, however, to which "materiality" (taken as sensous, extraverbal reality, something more than the functional-instrumental, "transparent" use-value of a word) is integral to much postmodernist poetry, poetics, and art practice might be seen as reason to interrogate this habit of thought.[7] Theories of postmodernism – those, for example, of Jean Baudrillard, Jean-François Lyotard, or Fredric Jameson – that replay a "break" or "divide" tend, overtly or covertly, to become entangled in the problem of the "McLuhanesque": that is, they are built around the notion of a *revolution* in the rise of media, an event that must dramatically and irrevocably have changed the essential fabric of daily life in the developed West. That these theories describe at least the *perception* of some significant cultural and historical complex called "postmodernism" is unworthy of dispute. What a synthetic and structuralizing theoretic overview may neglect (especially when it goes seeking diagnostic or prophetic authority) is the hybridity of practice by which even self-identified avant-gardes, such as the American L=A=N=G=U=A=G=E writers, tend to locate themselves historically. Postmodernist poets continued use of the self-consciously "material" print media of high modernism, in tactical response to life in a postmodern, technologically mass-mediated society (even while they embrace new electronic media as well), is a literally "literary" form of resistance to both the dematerializing, utilitarian ends of technology – what artist Simon Penny terms the "engineering world view"[8] – and the pure theoretic mode that, in its estrangement from or resistance to art practice, reverts to apocalyptic (or, less often, utopian) prophecy.[9]

Taking their cue from Bruno Latour's *We Have Never Been Modern*, Bolter and Richard A. Grusin have recently argued for the notion of a "genealogy of media" that situates new digital media in the long history of mediated and "remediated" representation in western art and literature.[10] While they do not deny that the "digital revolution" is a significant addition to this genealogy (Bolter, in particular, could hardly be accused of minimizing the impacts of digital technology), they take pains to oppose Jameson's lapsarian insistence "that there is something special about the mediatization of our current culture" placing unprecedented pressure on the reality of the subject.[11] Another line of argument runs from the "cyborg" socialist-feminism of Donna J. Haraway through N. Katherine Hayles's recent writing on virtual reality and the "posthuman".[12] Both thinkers envision a hybrid subjectivity in continual oscillation between human materiality, or bodily agency, and technologically assisted paramateriality or para-agency. The cyborg or posthuman neither dystopically rejects the automaton, nor transcendentally dissolves itself in it, but instead moves continually between nature and culture, organic and synthetic, individual and collective, partaking of both (and enjoying the advantages of each).

Perhaps more concretely, recent work such as Johanna Drucker's *The Visible Word* and Adalaide Morris's *Sound States* anthology are efforts to bring this technologically *enhanced* rather than *erased* subjectivity back into the postdeconstruction field of literary and culture studies.[13] Drucker's post-Derridean "hybrid theoretical model" for the "materiality of the typographic signifier" in futurist and Dada writings, and the efforts of Morris, Hayles, Garrett Stewart, Marjorie Perloff, and other *Sound States* contributors to revisit the "secondary orality" of Walter Ong,[14] return our attention to the implications of art practice for "ephemeralist" theories of the postmodern. It is significant, I think, that Drucker is a hybrid practitioner herself, producing challenging artworks as well as works of scholarship and criticism in the field; and also that so much of the work assessed in Perloff's invaluable criticism is that of the European historical avant-garde, then the line of American modernist, "radical modernist", and postmodernist art/theory running from Gertrude Stein to the objectivists, Charles Olson, and L=A=N=G=U=A=G=E, all of whom insisted on the essential reciprocity of theory and practice, articulation and demonstration, ephemerality and concrete agency. "Materiality", as Drucker envisions it, is constituted broadly by "interpretation" – the reader-viewer's interaction with the work – even if that interpretation involves, in Haraway's or Hayles's sense, a kind of mixing of oneself into the medium.

And even if the work and its medium, I will suggest here, are wholly digital: bits of data stored on a disk, or the electronic event of transfer by which those bits are reproduced and moved from one location to another – re-created, that is, by the interface with which the reader summons them. The putative demise of textuality, inevitable or no, on the electronic network known as the World Wide Web is presently accompanied by a flourishing of poetry and text-based or alphabetic art that takes for granted not only its own dynamic, kinetic, virtual, and interactive visuality, but also – contrary to alarmists' fears – a real, material, bodily human "interactor". In what follows I propose to offer an essay, a tentative gesture, at a digital visual poetics: a poetics that draws by necessity on an entire century's worth of language art and visual poetry, while at the same time formulating ways to read and to look at, to "screen", the new and seemingly newly ephemeral artefact of the electronic visual poem. Having incorporated electronic hypertextuality, this new poem is now appearing as visually "kinetic" (literally, in electronic motion) and "virtual" ("moved through" by an electronic simulacrum of the reader).

### 1. Virtual Reality, Trip Masters, and "Machinic Heterogenesis"
Of Robert Carlton ("Bob") Brown's invented "reading machine", Jerome McGann notes, "Brown's *jouissance* of the word anticipates the Derridean moment by forty years, and prophesies as well the practical emergence of computerized word-processing and hypertextual fields."[15] Now that we see with machine eyes, protocybernetic moments abound; and one of the prime difficulties in formulating a poetics of the moment is the risk that what seems blindingly new may, at a turn in thought, reveal itself to be no more than a version of what one already knows. This is the paradox built into Steve McCaffery's and bpNichol's notion of the "book machine", another prototechnology whose hybrid formula is appealingly blunt, and, more importantly, familiar. In speaking of a digital visual poetics, I want also to avail myself of McCaffery's and Nichol's "unacknowledged present", itself an adaptation of Gertrude Stein's "continuous present", and in many ways a more suitable trope for the new media than "avant-garde".[16] As a theory of coterminous theory and practice, as a formalism of intermediate

genres, and as a progressive politics of "partial, real connection" (Haraway), a digital visual poetics may operate on the fringes and in the interstices of many other discourses. Rather than breaking new ground, it may write within the *zona inexplorada* of a never wholly discovered, validated, or otherwise bounded network field. Rather than staking a claim to replace (and then be replaced), it may form a temporary node or rhizome (Gilles Deleuze and Félix Guattari) within a constellation of temporarily related nodes.

Because virtual reality (VR) simulation technologies offer the most radically manipulable operations on visual experience, they will be central to a digital visual poetics. With these operations come problematizations of subjectivity and agency that literally enact the "postmodern problem," offering users a practical experience of Nietzschean "eternal recurrence," of Heidegger's destruction of metaphysics, of the Foucauldian and Barthesian deaths of the subject, or of the arational consciousness of the religious mystic or narcotic-hallucinogenic drug user.[17] Virtual reality is *the* material problem of the postmodern, the machine that came along to test not only our prophesied disappearance into the Great Simulacrum, or the endless play of *différance*, but also the conditions under which theorists may plausibly claim authority for such prophecy. What does it mean to proclaim, with Baudrillard, that "we have all become ready-mades ... dedicated ... to mediatic stupefaction, just as the ready-made is dedicated to aesthetic stupefaction"?[18] Landow, Bolter, and others have noted the nihilism in Baudrillard's insistence that "we" can no longer perceive the differences between "junk" and "art", surface and depth, the simulated and the real.[19] Like the parents and educators of the 1980s "Dungeons and Dragons" scare, the prophets of technoapocalypse do not trust "us" to know informatic constructions from our own bodies; such things are "known to happen".[20] The extent to which this relies on a notion of "the public" as irrational – a notion often used to excoriate high modernism, but perhaps as useful to describe the neutrality of pop art and other self-consciously elite infatuations with "low culture" – has yet to be acknowledged at a time when we are still struggling with the paternalism of theories that have tried in good conscience, but without complete success, to deconstruct their *own* grounds. What is most puzzling in the alarmism of VR opponents (or VR advocates, for that matter) is the conviction that an average "cybercitizen" will inevitably utilize a mimetic technology mimetically – that is, in further flight from "real", not virtual, reality, in further flight into something that is, however convincing, still an illusion.

This disjunction between perceptions of design and perceptions of usage illuminates some of the ways in which cultural theory and cultural practice misunderstand each other. "Theorists", whose professional specialization is as much an economy as any other, imagine all sorts of figural ghosts and simulacra where there are still real human bodies sitting in front of the televisions and computer screens, or strapped into the VR apparatus. For their part, "practitioners" – poets and artists – grow estranged from an abstraction that they may come to see as irrelevant to their material labor or craft-based interaction with machines, and correspondingly they neglect the possibility that we may not only be bodies, in just the sense hinted at so powerfully by VR. It *should* go without saying that as nineteenth-century realism furnished the flashpoint for modernist irrealism in the same principal media, a "Victorian" birth of mimetically biased virtual reality implicitly and automatically signals some form of self-revision. It seems less likely that "all the hard-won vision of the twentieth century is to be surrendered to wire-frame realism in the twenty-first" than that it will be carried into further

permutations both cyclical and diachronic.[21] The crucial fact is that, as William Dickey puts it, the computer is a tool "placed in our hands so that we can create with it something it was not intended for."[22] This hybrid and noninstrumental engagement of the technology is a locus of poetical-aesthetic and political response, and I want briefly to trace its manifestation in three relevant topics of cultural discourse.

*a. Hybrid Theoretical Models: "The Materiality of the Typographic Signifier"*
"The experimental typography which proliferated in the early decades of the twentieth century," writes Johanna Drucker, "was as much a theoretical practice as were the manifestos, treatises and critical texts it was often used to produce."[23] Boundaries separating literary from art practice, practice from theory and criticism, and one literary or visual genre/medium from another were notably porous at the flourishing of the historical avant-garde (Russian and Italian futurism, Dadaism, cubism, etc.). Drucker's book *The Visible Word: Experimental Typography and Modern Art, 1909–1923*, while restricted to a defined historical period, offers a model for the "materiality" of visual-linguistic signs that looks forward through what she calls the "nearly proto-electronic and cybernetic" sensibility of F. T. Marinetti[24] – its kinetic adumbration of a "dematerialized", "wireless", or "electronic" medium.[25]

Drucker's model emerges from a critique of two opposed ideologies: that of phonic presence in structuralist linguistics, and that of the self-absenting play of inscribed *différance* in deconstructive critique. Derridean critique, and poststructuralist theory more generally, have encouraged an unproblematized definition of "information", and "information art", as *les immatériaux*.[26] For Drucker, Derrida's critique of Saussure, and of a metaphysics of presence more generally, "cancels the possibility of ever apprehending *substance*" in the ambiguous, simultaneous, or oscillating visual materiality of type, which combines "the arbitrary (or at least, conventional) character of the linguistic sign with the more complex features of the visual sign."[27] In response, she offers a counterformulation, a purposefully heterogeneous discourse for visible language that hints at contemporary implications for what Richard Lanham has called "the complete renegotiation of the alphabet/icon ratio" inherent in desktop publishing[28] – and that extends itself to the same questions of subjectivity that are problematized by VR:

> The concept of materiality, then, cannot simply be grounded in a Derridian deconstruction. Nor can it, after Derrida's critique, return to a placid and unquestioning acceptance of the concept of substance as self-evident presence or being. The question of whether it is possible to posit the existence of material as substance without a metaphysics of presence lurking inevitably behind it remains to be resolved.[29]

Insofar as it brings "visual presence" to meet "literary absence", this notion of materiality is supported by a "hybrid theoretical model which contains certain internal and irresolvable contradictions."[30] Derridean "relational, insubstantial and nontranscendent difference" and "phenomenological, apprehendable, immanent substance" are held together at risk to the authority of both; they are bound (or not) in a postdeconstructive hermeneutics that, like Deleuze and Guattari's figure of the rhizome, writes fluid lines of alterity and travel rather than "arborescent" points of contention and stasis:[31]

The basic conflict here – of granting to an object both immanence and nontranscendence – disappears if the concept of materiality is understood as a process of interpretation rather than a positing of the characteristics of an object. The object, as such, exists only in relation to the activity of interpretation and is therefore granted its characteristic forms only as part of that activity, not assumed a priori or asserted as a truth.[32]

The typographically rendered page is an image, and it is also language; the reader is also a voyeur, viewer, or "screener". Representation is at once *in* and *of*. These simultaneities operate within the production of both visual pattern and semantics; both are integral to signification, and both inform Drucker's "materiality of interpretation". It is a potent model for a digital visual poetics, whose object is never merely "text" even in the most generous poststructuralist sense – and especially when, as in Eduardo Kac's virtual reality poems, the "text" is a representation of three-dimensional typographical objects in the "quadri-dimensional" hermeneutic space of an electronic visual simulation.

*b. Hybrid Bodies: Politics, Poetics, and the Posthuman*
Another model of hermeneutic materiality appears in the writings of Donna J. Haraway and N. Katherine Hayles. Haraway's socialist-feminist "cyborg" is a political-aesthetic persona comprised of constantly shifting, "partial, contradictory, permanently unclosed constructions of personal and collective selves," a hybrid of mind and body, animal and human, organism and machine, public and private, nature and culture, man and woman.[33] Haraway writes against a tradition of Marxian humanism that offers, in her view, only boundary-maintaining divisions (base/superstructure, public/private, material/ideal) and secular Edens of natural innocence; her own call for a postdeconstruction theater of "partial, real connection," or material practice, reveals a commitment to continual inquiry via desire divorced from any final or totalizing resolution: "Some differences are playful; some are poles of world historical systems of domination. 'Epistemology' is about knowing the difference."[34] A contemporary socialist feminism, Haraway suggests, will utilize the resources of "high-tech facilitated social relations"[35] toward the elimination of fixture in racial, sexual, and class identities, without losing sight of the ways in which the same technologies embody patriarchal-capitalist "informatics of domination"[36] and repression.

As an aesthetic and political persona, the cyborg resists the repressive structures inbuilt in electronic technologies of military-industrial origin, and at the same time refuses "an anti-science metaphysics, a demonology of technology."[37] The body, and "embodiment," exist politically not as an original "state of nature" divorced from and threatened by technology, but in partial fusion with it: "Intense pleasure in skill, machine skill, ceases to be a sin, but an aspect of embodiment. The machine is not an *it* to be animated, worshipped, and dominated. The machine is us, our processes, an aspect of our embodiment."[38] In aesthetic-political terms, such an engagement will reject Marxian-humanist and avant-gardist notions of "revolution" for something closer to Gertrude Stein's sense of a "continuous present".[39] An "organic" or "holistic" politics exhibits excessive dependence on the "reproductive metaphors" of Edenic innocence or pre-Babel unity. Regeneration, not reproduction, Haraway suggests, is the cyborg moment – and it is enacted through the technology of writing:

> Writing is pre-eminently the technology of cyborgs, etched surfaces of the late twentieth century. Cyborg politics is the struggle for language and the struggle against perfect

communication, against the one code that translates all meaning perfectly.... That is why cyborg politics insist on noise and advocate pollution, rejoicing in the illegitimate fusions of animal and machine.[40]

Politics and poetics are united: "This is a dream not of a common language, but of a powerful infidel heteroglossia."[41]

The postmodern ideology of dematerialization that drives Baudrillard's nihilism depends, for Haraway, on the origin story of a presimulacrum, or intact, nonsimulated, real reality (presumably antedating the rise of media).[42] For Hayles, it is an ideology with its own highly determined material and "embodied" historical context in the so-called information revolution – though its most dangerous tendency, as ideology, is to obscure just that material context. "How much of what we call postmodernism," Hayles asks, "is a response to the separation of text from context that information technology makes possible?"[43] The *fluidity* of text (information), accelerated by global network technologies, makes the control of material context for information ("spin") the potential nexus for both technocratic repression and its resistance:

> Whether in biotechnology, disinformation campaigns or hightech weapons, the ability to separate text from context and to determine how the new context will be reconstituted is literally the power of life and death. In this context, what Niklas Luhmann calls "context control" is crucial to understanding how relations between power and knowledge are constituted in postmodern society.[44]

"Informatics" – the "technological, economic, and social structures that make the information age possible" – comprise material conditions for the production of decontextualized and dematerialized information.[45] The scientific-humanistic discourse of informatics, engaging the humanistic discourses of postmodern theory, is necessarily hybridized: "Excavating these connections requires a way of talking about the body that is responsive to its postmodern construction as discourse/information and yet is not trapped within it."[46]

Hayles's "embodied" body is, like Haraway's cyborg, an aesthetic-political persona – not a body as such, or an identity, or an essentialized Self, but a position "enmeshed within the specifics of place, time, physiology, and culture, which together compose enactment."[47] Insofar as "bodily practices have a physical reality which can never be fully assimilated into discourse,"[48] information, or technology, the body entering the immersive or absorptive VR environment of dematerialized simulacra does not thereby automatically undergo identical dematerialization. What *does* occur, Hayles argues, is the constitution of a new subjectivity in and through this technologically provided experience: a subjectivity capable to hold the simulated and nonsimulated together in a hybrid or cyborg simultaneity. It is not that the body disappears into the simulation, nor that the simulation invades the organic domain of the body. They simply coexist. Uneasily, perhaps – but the unease itself, and an aesthetic-political willingness to tolerate such unease, even to *cultivate* it, is a potent form of resistance to the global "technocratic context" of a deterministic information society. Embodiment – the resistant subject position, the body's organic intervention in the machine – is "generated from the noise of difference."[49]

Self-organization from noise, a concept central to information theory, is at the heart of Haraway's "regeneration" and of Félix Guattari's formulation of "machinic heterogenesis".[50] In place of hierarchical and patriarchal reproductive legitimation, the socialist-feminist cyborg or hybrid – what Hayles terms the "posthuman"[51] – substitutes regenerative illegitimacy as a strategy for resisting the militarism and capitalism of technology, *through* technology:

> The drive for control that was a founding impulse for cybernetics . . . is evident in the simulations of virtual reality, where human senses are projected into a computer domain whose underlying binary/logical structure defines the parameters within which action evolves. At the same time, by denaturalizing assumptions about physicality and embodiment, cybernetic technologies also contribute to liberatory projects that seek to bring traditional dichotomies and hierarchies into question.[52]

A machine politics is also a machine poetics. "Hacking" is one of its prime forms: to write is also to write illegitimate code, to "write over" the instrumental (technocratic) functions of a user interface, disrupting the controlled delivery of information. A resistant subjectivity of temporal, spatial, physiological, and cultural specificity is thereby reinserted into the context-erasing simulation, assuming the status of a "para-site."[53]

*c. Hybrid Practices: The "Aesthetics of Information"*
In his own gestures toward a digital poetics, Matthew G. Kirschenbaum has advanced the notion of a "radical aestheticization of information" as a strategy of broadly humanistic response to new research in computer science. He suggests that the instrumentally designed operations of computer technologies may yield results of unintended (and unattended) aesthetic interest – one of his examples is Antonio Gonzalez-Walker's "Language Visualization and Multilayer Text Analysis" project, at the Cornell Theory Center – and argues unapologetically for attention to "beauty" in the "visual materiality of information."[54] As hybrid practice, Kirschenbaum's advocacy combines attention to the "phenomenological materiality of electronic media" – a materiality constituted, like Drucker's, not ontologically but in the event of human interaction with the machine – with the injunction, derived from the theories of Russian formalism, to "defamiliarize" the objects of attention – in this case, information.[55] New electronic artworks, he suggests,

> are concerned with demonstrating the materiality of their environments. . . . this concern extends itself into the supposedly immaterial electronic writing spaces which some of these objects inhabit. . . . although created and authored by human beings, [they] are at all points engaged in the construction of artificial subject positions – artificial intelligences if you will, though perhaps artifices of intelligence is more accurate and less (or more) glib.[56]

Contemporary graphic design and electronic typography, Kirschenbaum suggests, are establishing the aesthetic paradigms to which poets and artists of the moment will respond – just as futurist and Dadaist poet-artists are seen, in Drucker's account, responding to the technologically determined print aesthetics of the early twentieth century. Kirschenbaum's "artificial subject position" or "artifice of intelligence" is, like the hybrid, cyborg and posthuman, an aesthetic-political formation useful to a digital visual poetics. From the European historical avant-garde to Anglophone L=A=N=G=U=A=G=E writers of the 1970s and 1980s, twentieth-

century poetic and visual innovators have shared the project of "materializing" language and the technological media that modify it. Now, as the new writing technology of the computer nears ubiquity in the developed West, the task of an electronic poetics will be to operate on, to alter, the computer's instrumental teleology – its design for informational transparency and functionality – as other poetics have resisted the transparencies of discourse and media in their times. Hybridization (of theory as of practice, of bodies as of machines), hacking, para-sitism, and other nontotalizing, nontechnocratic forms of resistant engagement will inform a poetics of the new visual/textual media and the new opportunities for communication and critique (as distinguished from command and control), *through forms of writing*, that they make possible. In the simultaneously material and ephemeral fields of such practice, the notion of "avant-garde" may seem finally provincial, absorbed into the sensibilities of an art that positions itself at once here and (whether virtually or no) elsewhere.

## 2. Eduardo Kac's "Secret"

"What happens as we go?" asks Michael Joyce.[57] What happens as we "screen" – bring up on screen, examine, evaluate – "Secret", an interactive virtual reality poem created in 1996 by artist and poet Eduardo Kac, which he claims is the "first of its kind"[58]. The poem references a small body of electronic visual and "kinetic" poetry based on network standards developed since 1993 (HTML, VRML, JavaScript, etc.),[59] some of which can be found at virtual gallery and exhibition websites such as Kenneth Goldsmith's UbuWeb (http://www.ubu.com) and

Figure. 1: Eduardo Kac, "Secret", VRML poem, 1996.

260 | MEDIA POETRY: AN INTERNATIONAL ANTHOLOGY

Figure. 2: Eduardo Kac, "Secret", VRML poem, 1996.

SUNY-Buffalo's Electronic Poetry Center Gallery (http://wings.buffalo.edu/epc/gallery/).[60] At the same time, "Secret" adapts the mimetically biased technology of VR to represent the material typographic sign, the symbolic letter, the word, and other units of writing as three-dimensional objects in space, and in this it enters the company of work such as Jeffrey Shaw's "The Legible City", the Virtual Shakespeare Project at MIT's Media Lab, and Kirschenbaum's electronic dissertation.[61]

So: what happens as we go? The file loads; the viewer rests at the center of an "alpha-architectural space"[62] – "whitespace" turned "blackhole"[63] – in which the word "wind" floats some distance ahead and slightly to the right. The word's four letters are constructed from cylinder and sphere shapes of heterogeneous size, visual density, texture, and apparent level of light reflection. A representation of a control panel (not part of the poem, but a configuration of the Web browser used to view it) presents us with a number of options. We may approach the word/object "wind" on a "gravity" (grounded) or a "floating" plane; we may zoom in on the word/object from our represented position in space; we may "slide" vertically or horizontally through the space, or "tilt" from one represented position; we may "pan" from one position; we may "manually" rotate the word/object.

Exploration of the space reveals an ideogrammatic word constellation, "readable" from top to bottom and from right to left:

Figure. 3: Eduardo Kac, "Secret", VRML poem, 1996.

wind
that blows

within

sail away
like
tranquil thunder

The constellation is visible in toto only at a distance and an angle that render each word/object and subconstellation nearly illegible; as one reverses, slides up or down, and pans from the entry point, each word/object and subconstellation appears, achieves legibility, and recedes toward illegibility as the next approaches.

This is only "entry" reading. It is up to the viewer to travel toward and away from and around, under, and over each word/object and subconstellation, and toward and away from and around, under, and over the entire visual-textual constellation. "Reading" here is a polymodal activity, which may include:

1. "Reading" the words in the conventional sense.
2. Examining the words as representations of three-dimensional objects – an operation that may involve rotating them, traveling "above," "below," "behind," "past," or even "through" them – literally, "subversion".
3. Reflecting on the nature of this simulated interaction with the simulated materiality of the words (reading one's reading).
4. Reflecting on the simulation interface itself – reading the virtual-reality software itself as a work of writing or code.

Kac's practice is prolific and diverse, having included graffiti poetry, book art, and body-poetry (using his body in performance to shape letters); electronic signboard and videotext poetry; holographic and hypertext poetry; digitally animated and interactive cinematic visual poetry; installation art; telepresence, telematic, and biological art; digital painting; and, most recently, robotic art. In his theoretical writings, he has developed a wide-ranging and radically engaged machine poetics, one part of which (chiefly from the essays on "holopoetry") I can present only briefly and superficially here.[64]

"I felt on the one hand", Kac writes in "Key Concepts of Holopoetry", "that the printed page imprisoned the word within its two-dimensional surface, thus creating specific limits to poetic expression. On the other hand, I realized that the construction of solid three-dimensional objects

Figure. 4: Eduardo Kac, "Secret", VRML poem, 1996.

Figure. 5: Eduardo Kac, "Secret", VRML poem, 1996.

gave the word a permanence and a physical presence that contradicted the dynamics of language."[65]

The goal of a hologram or (in a slightly different way) a VR poem is *simulated* linguistic materiality – the real materiality of real objects being inherently too static or inert for Kac's purpose. Furthermore: it is not the simulation of a linguistic materiality that might be construed in real three-dimensional space (say, by carving letters out of blocks of wood), but rather that which is displaced onto the viewer, or interactor, in the confrontation with the radical *immateriality* of word/image in the holographic or electronic medium. Holographic poems are "quadri-dimensional because they integrate dynamically the three dimensions of space with the added dimension of time. This is not the subjective time of the reader found in traditional texts, but a perceived time expressed in the holopoem itself."[66] As the space of the poem dematerializes into an "oscillatory field of diffracting light," its temporality becomes a dynamic function of "viewer-activated choreography"[67] – a viewer's interaction with, and alteration of, the poem. Central to this effect is Kac's theory of the "fluid sign",

> essentially a verbal sign that changes its overall visual configuration in time, therefore escaping the constancy of meaning a printed sign would have. . . . Fluid signs are time-reversible, which means that the transformations can flow from pole to pole as the beholder wishes, and they can also become smaller compositional units in much larger texts, where

Figure. 6: Eduardo Kac, "Secret", VRML poem, 1996.

each fluid sign will be connected to other fluid signs through discontinuous syntaxes. Fluid signs create a new kind of verbal unit, in which a sign is not either one thing or another thing. A fluid sign is perceptually relative. For two or more viewers reading together from distinct perspectives it can be different things at one time; for a non-stationary reader it can reverse itself and change uninterruptedly between as many poles as featured in the text. . . . Fluid signs can also operate metamorphoses between a word and an abstract shape, or between a word and a scene or object. When this happens, both poles reciprocally alter each others' meanings.[68]

In "Secret", this occurs at the level of the subconstellation that "reads":

[string of quasi-alphabetic letters/symbols]
within
[or cross/crucifix shape]

The ideogram/sentence "wind that blows . . ." has, upon the viewer's arrival at a position near this subconstellation, disintegrated into strings of quasi-typographic objects that approach and withdraw from alphabetic signification, and that change their individual and collective configurations according to the viewer's position in space. "After" that – temporality being, not the determined "subjective time" of print literature, but a broadly variable function of the

viewer's intervention – it simply disintegrates into isolated, ambiguously lexical and iconic particles (the crucifix that is also a t, the cylinder and sphere that are also an l and an o).

Far from "disintegration," though, the operation of this very small poem, as I read it, is to write the polymorphic convergence of the lexical-visual in electronic writing, the paradox of material representation in an immaterial medium, and the invitation to a participatory poetics that travels well beyond the naïve claims for reader empowerment that are advanced, and as quickly dismissed, by the techno-aesthetic utopians and their opponents. Michael Joyce puts it well: "this is theater as much as virtuality. . . . as theater, virtuality and interactivity enact nothing less than reading embodied."[69] It is not mere user participation in an electronic work of art, some valorously "active" clicking at a mouse, that is being sought here; what is sought, rather, is a reflection of the vital ambiguities of life lived through technologies that change us, and our ways of living and thinking, even as we change them in responding to perceived evolutions in our knowledge: a feedback loop linking contemporary cultural forces and instrumental technologies into reciprocal and recombinant relations.[70]

The title of Kac's poem indulges the transcendent-revelatory metaphysics of passive reading even as it interrogates and challenges that reading. As Charles Bernstein has put it, apropos of Gertrude Stein: "Faced with the sound, the materiality, or the presence (present) of language as music of sense in our ears, we project a secret: a hidden language."[71] Here, though, the secret is not simply *illusion* or simulacrum, to be collapsed into the truth of the real, but a figure for the hybrid unattainability – or simultaneity – of "pure" presence/absence, materiality/immateriality, reality/virtuality, and so on. The "secret" is to hold two contradictions in suspension, withholding their resolution in an endless play of difference *within the* body. "Secret" is not, I venture, "avant-garde" – however far it may appear to reach forth into a manifestly alien, self-organized aesthetics. Its effect as a poem, as a piece of art, depends on "polluted" reading: reading against metaphysics as against positivism; against apocalypse as against utopia; against revolution as against tradition.

## 3. "Hacking a Private Site": Some Concluding Thoughts

"Our encounter with the future text," Michael Joyce suggests, "carries with it what might be called the melancholy of history."[72] Already, the theory and practice of electronic poetics are almost unmanageably diverse. Cyberpoetry, hyperpoetry, infopoetry, virtual poetry, digital videopoetry, computer *Lettrisme*, experimental electronic typography, and intersign poetry flourish in thriving movements and submovements (some constituted solely by their inventors). OuLiPo has been succeeded by InfoLiPo.[73] What Alberto Moreiras calls "hacking a private site"[74] stands not for the effort to consolidate these proliferating poetries, or to find one's safe place among them, but for the politics they collectively enact in breaking codes that limit the *uses* of a technology to its *functions*. In this spirit, I would like to close with a speculation on the role that digital media may play in the continual revising of tradition that is a poetics.

In our time, "information" is displacing traditional capital, including the unpatentable intellectual and aesthetic capital by which artists, writers, and humanities scholars earn their livelihood.[75] As an alternative to "end of culture" scenarios, new formulations of a postmillennialist "experimental humanism"[76] are being offered by scholars and writers who are pressured to defend the legitimacy of their own cultural activity as well as to resist the automation of literacy

Figure. 7: Infolipo, screen capture from the website of the Infolipo group, representing their exhibition "Expoésie" (Expoetry, with four installations by Ambroise Barras, Cécile Bucher, Lorenzo Menoud and Delphine Riss, presented at the Palais de Rumine, Lausanne, 2005.

that is "deskilling" them as teachers (along with their students). Such an experimental humanism, Richard Lanham suggests, will "think systemically"[77] – both in the specifically technocratic sense of the term, and in a wider sense that sees the "information revolution" and its technologies as part of the cultural-historical context of the late twentieth century. In other words, it will be resolutely "interdisciplinary", and technologically hybridized without being technologically cannibalized.

The discourse of information theory may be the most potent new appropriation for a digital poetics. Now that an academic critical literature has established the importance of poetic strategies once (often still) derided as productive of "unpoetical" nonsense, randomness, and opacity, the informational concepts of noise, pattern, and recombination may (through no intention of their originators) provide new ways to read and to write about the poetries of the past, as well as informing those of the continuous or unacknowledged present. Perhaps some of our most challenging poetries have courted randomness, courted nonsense, in protocybernetic anticipation, or perhaps they remain challenging merely because new languages seem glad to engage them. The task in any case is, as Moreiras suggests, to "define a task of thinking that would refuse to believe itself above and beyond technique."[78] As "the humanities" are increasingly charged with the task of responding to the informatic engineering world view, the leisure of a theory divorced from experimental practice may prove to be more unsustainable than ever.

**Notes**
1. Peter M. Sacks, *The English Elegy: Studies in the Genre from Spenser to Yeats* (Baltimore: Johns Hopkins University Press, 1985), p. 299: "Sociologists and psychologists, as well as literary and cultural historians, consistently demonstrate the ways in which death has tended to become obscene, meaningless, impersonal – an event either stupefyingly colossal in cases of large-scale war or genocide, or clinically concealed somewhere behind the technology of the hospital and the techniques of the funeral home." It is the technology, of course, that is key: and this applies not just to the technologically *obscured* death of human bodies, but to the technologically *assisted* figural "death," first of the author (Barthes, Foucault), then of the printed book (Birkerts et al.), and now of the techno-socialistic "network" (with military antecedents) that the Internet once was.

2. See George P. Landow, *Hypertext: The Convergence of Contemporary Critical Theory and Technology* (Baltimore: Johns Hopkins University Press, 1992), p. 34. "Storyspace" is the hypertext authoring tool developed by Jay David Bolter and Michael Joyce in 1985-86; for an account of their collaboration, see Michael Joyce, *Of Two Minds: Hypertext Pedagogy and Poetics* (Ann Arbor: University of Michigan Press, 1995). The term "videation" is Marjorie Perloff's; see *Radical Artifice: Writing Poetry in the Age of Media* (Chicago: University of Chicago Press, 1991), p. 74.
3. See, for example, Laura Miller, "www.claptrap.com," *New York Times Book Review*, March 15, 1998, p. 43 – a likably pugnacious, if typically defensive, riposte to enthusiasts.
4. See Jay David Bolter and Richard A. Grusin, *Remediation: Understanding New Media* (Cambridge, Mass.: MIT Press, 1999).
5. See Marjorie Perloff, "The Morphology of the Amorphous: Bill Viola's Videoscapes," in *Poetry On & Off the Page: Essays for Emergent Occasions* (Evanston: Northwestern University Press, 1998), pp. 309-321.
6. Jay David Bolter, *Writing Space: The Computer, Hypertext, and the History of Writing* (Hillsdale, N.J.: Erlbaum, 1991), p. 26.
7. For accounts of the importance of a materialized writing practice to the "Language" writers, see, e.g., Marjorie Perloff, *Radical Artifice* (above, n. 2); Bruce Andrews and Charles Bernstein, eds, *The L=A=N=G=U=A=G=E Book* (Carbondale: Southern Illinois University Press, 1984); Charles Bernstein, *A Poetics* (Cambridge, Mass.: Harvard University Press, 1992).
8. Simon Penny, "The Virtualisation of Art Practice: Body Knowledge and the Engineering World View", *Art Journal* 56 (fall 1997): 30-38; available on the Web at http://www-art.cfa.cmu.edu/www-penny/texts/Virtualisation.html.
9. Critical-theoretic estrangement from practice is a by-product of the professionalized economy of the university. One remedy is for writers to work also as critics, editors, and publishers. By all indications, the "small press revolution" of the 1960s and 1970s continues unabated today – not only in a profusion of printed chapbooks and magazines, but also in the networked environments of electronic publishing. It is interesting to note, however, that many young writer-editor-publishers – who make extensive use of telecommunications for the personal networking that is integral to what is virtually a "gift economy" – still prefer the more costly print medium for publication. This is not, I think, mere anachronism, and it raises more interesting questions about community, activism, and the "future of the book" than the diffuse cultural debate conducted in the popular media.
10. Bolter and Grusin, *Remediation* (above, n. 4).
11. Ibid., p. 57.
12. See Donna Haraway, "A Cyborg Manifesto: Science, Technology, and Socialist-Feminism in the Late Twentieth Century," in idem, *Simians, Cyborgs, and Women: The Reinvention of Nature* (New York: Routledge, 1991), pp. 149-181; N. Katherine Hayles, "The Seductions of Cyberspace," in *Rethinking Technologies*, ed. Verena Andermatt Conley (Minneapolis: University of Minnesota Press, 1993), pp. 173-190; idem, "Text Out of Context: Situating Postmodernism within an Information Society," Discourse 9 (spring/summer 1997): 25-36; idem, *How We Became Posthuman: Virtual Bodies in Cybernetics, Literature, and Informatics* (Chicago: University of Chicago Press, 1999).
13. Johanna Drucker, *The Visible Word: Experimental Typography and Modern Art, 1909-1923* (Chicago: University of Chicago Press, 1994); Adalaide Morris, ed., *Sound States: Innovative Poetics and Acoustical Technologies* (Chapel Hill: University of North Carolina Press, 1997).
14. Walter J. Ong, *Orality and Literacy: The Technologizing of the Word* (London/New York: Methuen, 1982).
15. Jerome McGann, *Black Riders: The Visible Language of Modernism* (Princeton: Princeton University Press, 1993), p. 88.
16. Steve McCaffery and bpNichol, *Rational Geomancy: The Kids of the Book-Machine; The Collected Research Reports of the Toronto Research Group, 1973-1982* (Vancouver: Talonbooks, 1992).
17. For an interesting discussion of simulation technologies and contemporary "drug culture", see Avital Ronell, "Our Narcotic Modernity", in Conley, *Rethinking Technologies* (above, n. 12), pp. 59-73.

18. Jean Baudrillard, "Aesthetic Illusion and Virtual Reality", in *Jean Baudrillard: Art and Artefact*, ed. Nicholas Zurbrugg (London: SAGE, 1997), pp. 19-27, p. 22.
19. See Landow, *Hypertext* (above, n. 2), pp. 20-22; Bolter and Grusin, *Remediation* (above, n. 4), p. 194.
20. In the early 1980s, the popularity of information-based role-playing games such as "Dungeons and Dragons" led to hysteria when a handful of juvenile crimes (which would otherwise have been attributed to Satanism or heavy-metal music) were taken for proof of damaging immersion in the games' fantasy.
21. Joyce, *Of Two Minds* (above, n. 2), p. 206.
22. William Dickey, "Poem Descending a Staircase: Hypertext and the Simultaneity of Experience", in *Hypermedia and Literary Studies*, ed. Paul Delany and George P. Landow (Cambridge, Mass.: MIT Press, 1991), p. 145.
23. Drucker, *Visible Word* (above, n. 13), p. 9.
24. Ibid., p. 109.
25. Ibid., p. 138.
26. In a brief history of computer poetry in Europe since 1959, Philippe Bootz highlights the 1985 *Les Immatériaux* exhibition at the Pompidou Center as "a climax for A.L.A.M.O. [a computerized offspring of OuLiPo] and . . . a starting point for the dynamic poetry which was to develop in the following years" in *France and elsewhere* (Philippe Bootz, "Poetic Machinations", *Visible Language* 30:2 [1996]: 118-137).
27. Drucker, *Visible Word* (above, n. 13), pp. 34-39, pp. 39 and 34.
28. Richard A. Lanham, *The Electronic Word: Democracy, Technology, and the Arts* (Chicago: University of Chicago Press, 1993), p. 34.
29. Drucker, *Visible Word*, p. 39.
30. Ibid., p. 43.
31. Gilles Deleuze and Félix Guattari, *A Thousand Plateaus: Capitalism and Schizophrenia* (London: Athlone Press, 1988), pp. 6ff, p. 21.
32. Drucker, *Visible Word*, p. 43.
33. Haraway, *Simians, Cyborgs* (above, n. 12), p. 157.
34. Ibid., pp. 160-161.
35. Ibid., p. 165.
36. Ibid., p. 181.
37. Ibid.
38. Ibid., p. 180.
39. See Gertrude Stein, "Composition as Explanation", in *The Selected Writings of Gertrude Stein* (New York: Random House, 1962), pp. 514-518: "No one is ahead of his time, it is only that the particular variety of creating his time is the one that his contemporaries who also are creating their own time refuse to accept. . . . Continuous present is one thing and beginning again and again is another thing. These are both things. And then there is using everything."
40. Haraway, *Simians, Cyborgs* (above, n. 12), p. 176.
41. Ibid., p. 181.
42. For an analysis of postmodernism as "disappointed rationalism" (which has inspired the digital media theory of Bolter and Grusin, among others), see Bruno Latour, *We Have Never Been Modern*, trans. Catherine Porter (Cambridge, Mass.: Harvard University Press, 1993). Cyborgs and other hybrids are, in Latour's account, "nonmodern" or "amodern" (but *not* antimodern) in their refusal to perpetuate the linear and binary structures that define ideologies for both the modern *and* the postmodern.
43. Hayles, "Text Out of Context" (above, n. 12), p. 27.
44. Ibid., p. 30.
45. Hayles, *How We Became Posthuman* (above, n. 12), p. 29.

46. Ibid., p. 193.
47. Ibid., p. 196. This conception of agency or subjectivity is remarkably congruent with that developed in the poetics of the so-called L=A=N=G=U=A=G=E writers, many of whom advanced cogent theoretical justifications for a poetic practice that radically altered, or entirely discarded, the Romantic lyric subject, while retaining other options for aesthetic-political agency. See, e.g., the essays and manifestos collected in Andrews and Bernstein, L=A=N=G=U=A=G=E Book (above, n. 7; particularly Ron Silliman's "Disappearance of the Word, Appearance of the World"); Bernstein, Poetics (above, n. 7); Ron Silliman et al., "Aesthetic Tendency and the Politics of Poetry: A Manifesto", Social Text 19/20 (1988): 261–275.
48. Hayles, How We Became Posthuman (above, n. 12), p. 195.
49. Ibid., p. 196. For another picture of this resistance (via a reading of J. G. Ballard's Crash), see Scott Durham, "The Technology of Death and Its Limits: The Problem of the Simulation Model", in Conley, Rethinking Technologies (above, n. 12), pp. 156-170.
50. Félix Guattari, "Machinic Heterogenesis", in Conley, Rethinking Technologies, pp. 13-27. For an extended discussion of "self-organization from noise" and its relation to literature and aesthetics, see William R. Paulson, The Noise of Culture: Literary Texts in a World of Information (Ithaca, N.Y.: Cornell University Press, 1988).
51. See Hayles, How We Became Posthuman (above, n. 12), pp. 2-3.
52. Hayles, "Seductions of Cyberspace" (above, n. 12), p. 174.
53. See Johannes Birringer, "Makrolab: A Heterotopia", PAJ: A Journal of Performance and Art 60 (September 1998): 66-75.
54. Matthew G. Kirschenbaum, "Truth, Beauty, and the User Interface: Notes on the Aesthetics of Information", paper presented at the conference "Mixed Messages: Image, Text, Technology", University of North Carolina, Charlotte, 13 October 1997; available on the Web at http://www.engl.virginia.edu/~mgk3k/papers/beauty/index.html.
55. Here, again, a congruence with L=A=N=G=U=A=G=E and related poetics may be noted.
56. Matthew G. Kirschenbaum, "Machine Visions: Towards a Poetics of Artificial Intelligence", electronic book review 6 (November 1997): http://www.altx.com/ebr/ebr6/ 6kirschenbaum/6kirsch.htm, section I.
57. Joyce, Of Two Minds (above, n. 2), pp. 199-218.
58. See KacWeb, the artist's personal website/gallery (http://www.ekac.org), which, in addition to "Secret", archives other work and selected theoretical writings.
59. HTML: Hyper Text Markup Language; VRML: Virtual Reality Modeling Language. Javascript is one of a number of "script" languages (Dynamic HTML is another) designed to facilitate graphic animation and interactive functions.
60. The work collected on these sites, by Tan Lin, Juliet Ann Martin, Janet Zweig, Charles Bernstein, Brian Kim Stefans, Loss Peque-o Glazier, and others, brings to the network-architectures first explored by hypertext prose writers the polymorphous influence of typographic and hypergraphic experimentation – from futurism, Dada, and surrealism through the international Concrete movement of the 1950s and countless other schools and subschools of "visual poetry," in both electronic and traditional media, up to the present day. For an excellent introduction to Concrete poetry, see Mary Ellen Solt, "A World Look at Concrete Poetry", in Concrete Poetry: A World View, ed. idem (Bloomington: Indiana University Press, 1970), pp. 7-66. Other sources worth consulting are Richard Kostelanetz, ed., Visual Literature Criticism: A New Collection (Carbondale/Edwardsville: Southern Illinois University Press, 1979); Theo D'haen, ed., Verbal/Visual Crossings 1880-1980 (Amsterdam: Rodolpi, 1990). For discussions of digital visual poetry, see David K. Jackson, Eric Vos, and Johanna Drucker, eds, Experimental – Visual – Concrete: Avant-Garde Poetry Since the 1960s (Amsterdam: Rodolpi, 1996); Visible Language 30.2, issue entitled "New Media Poetry: Poetic Innovation and New Technologies" (1996).
61. Michael Joyce discusses "The Legible City" at some length in Of Two Minds (above, n. 2), pp. 199-218. For a discussion of the Virtual Shakespeare Project, see D. Small, "Navigating Large

Bodies of Text," *IBM Systems Journal* 35:3-4 (1996): http://www.almaden.ibm.com/journal/sj/mit/sectiond/small.html; Kirschenbaum, "Truth, Beauty" (above, n. 54). Kirschenbaum provides information about his dissertation, as well as a smaller project composed in VRML, at http://www.engl.virginia.edu/~mgk3k/.

62. Joyce, *Of Two Minds*, p. 203.
63. Katie Salen and Sharyn O'Mara, "Dis[appearances]: Representational Strategies and Operational Needs in Codexspace and Screenspace", *Visible Language* 31:3 (1997): 278.
64. See, e.g., Eduardo Kac, "Holopoetry", Visible Language 30:2 (1996): 184-213; *idem*, "Key Concepts of Holopoetry," in Jackson, Vos, and Drucker, *Experimental – Visual – Concrete* (above, n. 60), pp. 247–257; *idem*, "Beyond the Spatial Paradigm: Time and Cinematic Form in Holographic Art", "Holopoetry, Hypertext, Hyperpoetry", and "Recent Experiments in Holopoetry and Computer Holopoetry", all available from http://www.ekac.org.
65. Kac, "Key Concepts", p. 247.
66. Kac, "Holopoetry", p. 187.
67. Ibid., pp. 193, 190. For an extended discussion of time in "information art," see Perloff, "Morphology" (above, n. 5).
68. Kac, "Holopoetry" (above, n. 64), p. 194.
69. Joyce, *Of Two Minds* (above, n. 2), p. 204.
70. Hayles, *How We Became Posthuman* (above, n. 12), p. 14.
71. Bernstein, *Poetics* (above, n. 7), p. 146.
72. Joyce, *Of Two Minds* (above, n. 2), p. 234.
73. See the InfoLiPo website at http://www.unige.ch/infolipo/.
74. Alberto Moreiras, "The Leap and the Lapse: Hacking a Private Site in Cyberspace", in Conley, *Rethinking Technologies* (above, n. 12), pp. 191–203.
75. Hayles, "Text Out of Context" (above, n. 12), p. 28.
76. Lanham, *Electronic Word* (above, n. 28), p. 11.
77. Ibid., p. 26.
78. Moreiras, "Leap" (above, n. 74), p. 194.

# PART IV – APPENDICES

# MEDIA POETRY – A CHRONOLOGY FROM 1921 TO 1996

Far from exhaustive, this timeline is meant as a preliminary list of relevant moments in the history (and pre-history) of media poetry.

**1921** – The Russian poet Velimir Khlebnikov writes "The Radio of the Future" in which he foresees the impact of telecommunications on literature in particular and culture in general.

**1923** – The poet E. E. Cummings incorporates the mechanical system of his portable Smith-Corona typewriter into the visual syntax of many of his poems. In 1923 he publishes *Tulips and Chimneys*, his first book of poetry.

**1933** – Filippo Marinetti and Pino Masnata publish the "Manifesto della radio", or "La radia". Five poetic/conceptual radio works are signed by Marinetti and Masnata, although quite possibly they were created by Masnata alone. On 24 November 1933, Fortunato Depero and Marinetti made the first Futurist transmissions over Radio Milano.

**1947** – Antonin Artaud records "Pour en finir avec le jugement de Dieu" (To Have Done With the Judgment of God). The work, specially commissioned for radio broadcast, was censored just before its scheduled premiere and only broadcast 20 years later.

**1958** – French poet Maurice Lemaître releases the LP record "Maurice Lemaître présente le lettrisme" (Columbia, Paris), with one poem by Isidore Isou and three by Lemaître.

**1959** – Théo Lutz creates "Stochastische Texte", texts/poems generated through a computer, in Stuttgart.

**1959** – Bernard Heidsieck and Henri Chopin found "poésie sonore" (sound poetry), through which they (and others) will use recorders and microphones "not simply as reproductive tools but as transformative mixing devices".

**1960** – Brazilian poet Albertus Marques creates his first Electric Poem. In a published article he wrote: "The printed word is of no use to me. Only light can make things appear and disappear, and, therefore, transmit the real idea and the desired poetic charge."

**1960** – Raymond Queneau and François Le Lionnais found Oulipo (Ouvroir de Littérature Potentielle, or Workshop of Potential Literature) in France, a group of writers and mathematicians that includes as members Claude Berge, Georges Perec, and Italo Calvino, among others.

**1960** – Brion Gysin's "Pistol-Poem".

**1961** – The Italian poet Nanni Balestrini creates his first computer poem, "Tape Mark I".

**1961** – Audio broadcast on the BBC: "The Permutated Poems of Brion Gysin" (I am that I am, Pistol Poem, and other works).

**1962** – In May, 1962, *Horizon* magazine published a selection of poems by the "Auto-Beatnik": a computer program created by R. M. Worthy (USA) and others at the Laboratory for Automata Research of the Librascope Division of General Precision, Inc., a company which manufactured computers and other electronic equipment.

**1962** – Gerd Stern creates "Over", a kinetic poem with programmed lights, now in the collection of the Oakland Art Museum. This was the first in a series of programmed kinetic poems.

**1963** – Rul Gunzenhäuser publishes his first automatic poems ("Weinachtgedicht") in Germany.

**1963** – Balestrini creates "Tape Mark II".

**1963** – Clair Philippy (USA) uses an RCA 301 computer to create "blank verse at the rate of 150 words a minute". He publishes the poems no. 027, 929, 078, 105 and 140 in *Electronic Age*.

**1963** – Austrian visual artist Marc Adrian creates de 35mm film poem "Text I". The poem is black and white, has sound, and runs for 3 min 40 sec. With white letters against a black background, the poem presents a permutation of the words "hammer", "butter", and "wind" in variable sequences, superpositions, alternations, and different screen positions.

**1964** – In Montréal, Jean Baudot (Canada) publishes "La machine à écrire mise en marche et programmée par Jean A. Baudot".

**1964** – Henri Chopin begins in France publication of his sound and multimedia magazine *"OU"*, which will be published until 1974.

**1964** – L. Couffignal and A. Ducrocq create the poem "Un doute agréable couleur de lotus endormi" (France).

**1964** – Austrian visual artist Marc Adrian creates de 35mm film poem "Text II". The poem is black and white, has sound, and runs for 2 min 34 sec. With white lower case letters against a black background, the poem presents a sequence of two letters at a time on the screen. Each letter has the height of the screen, so that each letter pair essentially occupies the entire screen area.

**1965** – Brion Gysin's permutational poem "I am that I am" (1959) is digitized by Ian Sommerville.

**1965–69** – Austrian visual artist Marc Adrian creates "Konkrete Kombination", an interactive kinetic poem in the form of a light box measuring approximately 1.5 x 1.5 meters. The light box has a grid of letters. Every time the viewer steps on a pedal, different letters light up, forming different associations. "Konkrete Kombination" is in the collection of the Museum Moderner Kunst Stiftung Ludwig Wien.

**1966** – Gerhard Stickel creates stochastic poems on an IBM-7090: "Autopoeme" and "Monte-Carlo Texte".

**1967** – The publishing house Drosde Verlag (Düsseldorf) releases a collection of poems programmed by M. Krause and G. F. Schaudt on a Zuse Z 23.

**1968** – Margaret Masterman and Robin McKinnon-Wood create computer haiku.

**1968** – The exhibition "Cybernetic Serendipity", realized at the Institute of Contemporary Art, London, includes computer poems and texts by Marc Adrian, Margaret Masterman/Robin McKinnon-Wood, Cambridge Language Research Unit, Nanni Balestrini Alison Knowles/James Tenney, Edwin Morgan, Jean A. Baudot, and E. Mendoza.

**1968** – E. M. de Melo e Castro (Portugal) creates the videopoem Roda Lume (Wheel of Fire), which is broadcast in Portugal by RTP in 1969.

**1969** – Jackson Mac Low (USA) creates "PFR-3 Poems" in the context of the Art and Technology Program, Los Angeles County Museum of Art.

**1969** – John Giorno's "Dial-A-Poem System", based at the Architectural League of New York, uses ten telephone lines and for five months enables callers to listen to pre-recorded pieces by Allen Ginsberg, Giorno, William Burroughs, and others. The project ran for several years.

**1970** – Carl Fernbach-Flarsheim presents "The Bolean Image/Conceptual Typewriter" at the exhibition "Software – information technology: its new meaning for art", Jewish Museum, New York.

**1971** – Klaus Peter Dencker creates "textfilms": "Raush" 8'11", "Starfighter" 4'27", and "Astronaut" 4'02", all dated 1970-71.

**1971** – Marie Borroff creates computer poems "experiments in computer-generated poetic imagery".

**1972** – Klaus Peter Dencker publishes "Textfilme" in: Mitteilungen des Instituts für moderne Kunst, Nürnberg.

**1972** – Brazilian poet Erthos Albino de Souza begins to develop a body of work in computer poetry, creating and publishing the poem "Le Tombeau de Mallarme" (Mallarmé's Tomb), based on "a problem of physics that deals with the distribution of temperature in pipes within other pipes."

**1973** – Greta Monach publishes "Compoëzie" in Brussels, with her *automatergon* texts.

**1973** – R. W. Bailey publishes the anthology of *Computer Poems* with 16 authors.

**1973** – Aaron Marcus creates "Cybernetic Landscape I" (1971–1973), an interactive navigational three-dimensional digital environment, at the Computer Graphics Laboratory, Princeton University. Marcus: "Instead of the white field and black letterforms of traditional written symbols, the field is the deep, black space of night, and the symbols have been transformed into glowing filaments of light – a direct extension of the desire for 'constellations' which Mallarmé, Gomringer and others cherished. The 'objects' are diagrams for objects, as the letterforms are diagrams for sound/ideas. All are in a dematerialized form."

**1973** – Arthur Layzer's film "Morning Elevator" is shown at the International Computer Arts Festival, The Kitchen, New York.

**1974** – Robert J. Sigmund publishes "Energy crisis poems: poetry by program" (Cleveland: Ground Zero, 1974).

**1975** - Richard Kostelanetz (USA) creates "Three Prose Pieces" on video, the first of a long series of "literary video" works.

**1975** – Computer poems by several authors are shown in "Europalia", an event realized in Brussels.

**1976** – In Barcelona Ángel Carmona publishes the book "Poemas V2. Poesía compuesta por una computadora."

**1978** – Richard Kostelanetz creates the hologram "On Holography", a revolving cylinder containing five syntactically circular statements about holography itself.

**1980** – French Jean-Pierre Balpe creates the poetry generator "Poèmes d'Amour" (Love Poems).

**1981** – Portuguese Sylvestre Pestana creates a series of animated poems on a Sinclair ZX-81 computer.

**1981** – Charles Hartman (USA) conducts his first computer poetry experiments on a Sinclair ZX-81 computer: a BASIC program called RanLines that stored twenty lines in an internal array and then retrieved one randomly each time the user pressed a key. Hartman would continue his research and create poetry programs such as 'Scansion Machine' and 'Autopoet', among others.

**1981** – French Paul Braffort and Jacques Roubaud create the literary group ALAMO: "Atelier de Littérature assistée par la Mathématique et les Ordinateurs" (Literature Workshop aided by Mathematics and Computers).

**1982** – Eduardo Kac creates a series of ASCII poems.

**1982** – Michel Bret produces the 16mm film "Deux Mot", 6 min., based on a text by Roger Laufer.

**1983** – Eduardo Kac creates the holographic poem, or holopoem, entitled "Holo/Olho", the first in a series of 24 holopoems created by Kac until 1993.

**1984** – London-based Anglo-Canadian poet John Cayley creates "wine flying: non-linear explorations of a classical Chinese quatrain", first programmed on a BBC microcomputer in 1983 and 84. In 1988, it was ported to the Macintosh and HyperCard.

**1984** – Eduardo Kac presents the electronic poem "Não!" (No!), on an LED display at the Centro Cultural Cândido Mendes, Rio de Janeiro.

**1984** – William Chamberlain publishes the book "The Policeman's Beard is Half Constructed". The authorship is attributed to RACTER, "written in compiled BASIC on a Z80 with 64k of RAM." Racter (the program) was co-authored by Chamberlain and Thomas Etter.

**1984** – Hugh Kenner and Joseph O'Rourke created a computer program called 'Travesty' which modulated any piece of language fed into in it by reproducing patterns of letters or words which the program found in a text at different user-definable levels or 'orders'.

**1984** – Canadian poet bp Nichol publishes "First Screening", animated poems programmed in Basic on an Apple II computer. In 1993 these poems were translated to Hypercard by J. B. Hohm [Nichol, bp. First Screening. J. B. Hohm, ed. (Red Deer College Press, 1993).

**1985** – Brazilian João Coelho creates a suite of animated computer poems in Basic.

**1985** – Eduardo Kac creates the minitel poem "Reabracadabra", and presents it on the minitel network through the Nobel Art Gallery, São Paulo. This was the first of a suite of minitel poems created and presented online in 1985 and 1986 by Kac.

**1985** – First electronic art magazine in France accessed via Minitel: "Art-Accès Revue". It was created for the exhibition "Les Immatériaux", Pompidou Center, Paris.

**1985** – Eduardo Kac realizes the first exhibition of holopoems (Museu da Imagem e do Som, São Paulo, and Escola de Artes Visuais do Parque Lage, Rio de Janeiro).

**1985** – In 1985 during the festival "Polynix 5" at the Pompidou Center the French Hungarian poet Tibor Papp presented the animated programmed poem "Les très riches heures de l'ordinateur", created on Atari.

**1985** – Eduardo Kac translates his lost holopoem "OCO" (1985) to a three-dimensional digital poem.

**1985** – Richard Kostelanetz creates the hologram "Antitheses." Other "literary holography" works would follow in the late 1980s.

**1987** – Poet David Antin created skypoems over Los Angeles and San Diego in 1987 and 1988 through a technique called Skywriting, which consists in writing or drawing in the sky through smoke or another gaseous element released from an airplane, usually at approximately 10,000 feet.

**1988** – Eduardo Kac presents the first digital holopoem, "Quando?" (When?), 1987/88, at Fundação Nacional de Arte-Funarte, Rio de Janeiro.

**1988** – Jim Rosenberg (USA) creates "Intergrams".

**1988** – Judith Kerman publishes "Colloquy", an interactive poetry authoring system, implemented by Robert Chiles.

**1989** – Philipe Bootz and members of the Mots-Voir group publish the first poetry magazine on diskettes: alire.

**1989** – Rod Willmot of Sherbrooke, Québec, writes "Everglade", a long poem in hypertext. It was written in Willmot's own DOS-based hypertext environment, "Orpheus".

**1989** – Jeffrey Shaw creates "The Legible City", which allows the visitor to ride a stationary bicycle through a simulated representation of a city that is constituted by computer-generated, three-dimensional letters that form words and sentences along the sides of the streets.

**1990** – Brazilian André Vallias creates the digital poem "Nous n'avons pas compris Descartes", the first in an ongoing series of digital poems.

**1990** – Eduardo Kac presents a solo exhibition of holopoems at the Museum of Holography, New York. The exhibition includes a catalogue with Kac's limited-edition holopoem "Amalgam" (1990). This is the first "print" publication of an actual holopoem.

**1990** – Robert Kendall (USA) creates in DOS the kinetic poems "The CLue: A MiniMystery" and "It All Comes Down to _____".

**1990** – Eduardo Kac creates "IO", a three-dimensional navigational poem. "IO" is translated to VRML in 1995.

**1991** – Sharon Hopkins publishes the paper "Camels and Needles: Computer Poetry Meets the Perl Programming Language", in which she describes the use of the PERL (practical extraction and report language) to create poems.

**1991** – Jean-Pierre Balpe and Bernard Magné publish the book *L'imagination informatique de la literature [The digital imagination in literature]* (Saint-Denis: Presses Universitaires de Vincennes).

**1991** – Jay David Bolter publishes the book *Writing Space: The Computer, Hypertext, and the History of Writing* (Mahwah, New Jersey: Lawrence Erlbaum Associates).

**1991** – Eduardo Kac creates the digital holopoems "Adhuc", "Zero", and "Adrift".

**1991** – John Cayley realizes his "first computer-assisted performance of 'Indra's Net", 'Poets in Action', Museum of Modern Art, Oxford.

**1991** – Jim Rosenberg publishes the article "Diagram Poems, Intergrams", in the journal *Leonardo*, N. 24, Vol. 1.

**1992** – Andre Vallias curates the exhibition "p0es1a-digitale dichtkunst" Germany, which includes works by Fritz Lichtenauer, Jim Rosenberg, Eduardo Kac, and others.

**1992** – Jean-Pierre Balpe publishes in France "Informatique" a special double issue of the journals , *Action poétique* and *KAOS*.

**1993** – Jim Rosenberg publishes his "Intergrams" on disk, *Eastgate Quarterly Review of Hypertext*, Vol. 1, No. 1.

**1993** – Patrick-Henri Burgaud creates the digital poem "Les Vagues de la Mer" (The Waves of the Sea), realized in collaboration with Jean-Marie Dutey. The poem is published in 1994 in *alire*, number 8.

**1993** – Chris Funkhouser creates MOO poems.

**1993** – Eduardo Kac creates the digital holopoem "Maybe Then, If Only As" and the hypertext poem "Storms".

**1994** – The Electronic Poetry Center is founded at State University of New York, Buffalo.

**1994** – Philippe Bootz edits and publishes A:\LITTÉRATURE, special issue of the journal Cahiers du CIRCAV, with diskettes.

**1994** – Jacques Donguy publishes his performance poem "Tag-Surfusion" in the magazine *alire* N. 8, France.

**1995** – John Cayley presents an installation and a position paper, 'Machine Modulated Poetry: Beyond Hypertext', at the Eighth Annual Conference on Writing and Computers, London. An excerpt of his talk is published as: "MaMoPo by PoLiOu: Machine Modulated Poetry by Potential Literary Outlaws", *Writing and Computers Newsletter*, No. 12, 1995.

**1995** – Jean-Pierre Balpe publishes his manifesto "Pour une littérature informatique: un manifeste..." [For a Digital Literature: A Manifesto...] in the book *Littérature et informatique: la littérature générée par ordinateur*, edited by Alain Vuillemin and Michel Lenoble (Arras: Artois Presses Université).

**1995** – John Cayley publishes "Book Unbound" on CD in an issue of the UK-based multi-media, multi-format magazine, ENGAGED.

**1995** – Jim Andrews creates his website "Vispo".

**1996** – Eduardo Kac publishes online his VRML poems "Secret" and "Letter".

**1996** – Jim Rosenberg publishes *The Barrier Frames* and *Diffractions Through* (Watertown, MA: Eastgate).

**1996** – John Cayley presents the essay "Hypertext/Cybertext/Poetext" at the "Assembling Alternatives: An International Poetry Conference/Festival" at the University of New Hampshire, Durham, NH.

**1996** – Eduardo Kac publishes the book *New Media Poetry: Poetic Innovation and New Technologies* (special issue of the journal Visible Language, Vol. 30, N. 2), RISDI, Providence, Rhode Island. The book includes essays by Jim Rosenberg, Philippe Bootz, E. M. de Melo e Castro, Andre Vallias, Ladislao Pablo Gyori, Eduardo Kac, John Cayley, and Eric Vos. Kac also publishes a limited edition CD-ROM, *International Anthology of Digital Poetry*, as an accompaniment to the book.

# Selected Webliography

**Compiled by Eduardo Kac**

### MEDIA POETS IN THIS ANTHOLOGY
Jim Rosenberg
http://www.well.com/user/jer/

Stephanie Strickland
http://www.stephaniestrickland.com.

Eduardo Kac
http://www.ekac.org

Philippe Bootz
http://transitoireobs.free.fr

Orit Kruglanski
http://www.iua.upf.es/~okruglan/

André Vallias
http://www.andrevallias.com

Ladislao Pablo Györi
http://www.postypographika.com.ar/menu-sp1/generos/vpoesia/menu-sp.htm

Giselle Beiguelman
www.desvirtual.com/giselle/

John Cayley
http://www.shadoof.net/in/

Bill Seaman
http://digitalmedia.risd.edu/billseaman/

E. M. de Melo e Castro
http://www.ociocriativo.com.br/guests/meloecastro/

Richard Kostelanetz
http://www.richardkostelanetz.com

## SELECTED MEDIA POETS / LANGUAGE ARTISTS

Jenny Weight
http://www.idaspoetics.com.au

Jacques Donguy
http://www.costis.org/x/donguy/index.asp

Fabio Doctorovich
http://www.postypographika.com.ar/menu-sp1/paralen2/paral1s/fd-biosp.htm

Arnaldo Antunes
http://www.arnaldoantunes.com.br

Loss Pequeño Glazier
http://epc.buffalo.edu/authors/glazier/

Jim Andrews
http://www.vispo.com

Jean-Pierre Balpe
http://poetiques.blogg.org

Aya Karpinska
http://www.technekai.com/

Jörg Piringer
http://joerg.piringer.net/index.html

Komninos Zervos
http://www.gu.edu.au/ppages/k_zervos/

Robert Kendall
http://www.wordcircuits.com/kendall/

Deena Larsen
www.chisp.net/~textra/

Enzo Minarelli
http://www.3vitre.it/index.html

Paul Braffort
http://www.paulbraffort.net

bpNichol
http://www.chbooks.com/projects/bp/

Patrick-Henri Burgaud
http://homepage.mac.com/philemon1/trameouest/patrickhenriburgaud4.htm

Chris Funkhouser
http://web.njit.edu/~funkhous/

Young-Hae Chang Heavy Industries
http://www.yhchang.com

Judd Morrissey
http://www.judisdaid.us/index.html

Mary-Anne Breeze
http://www.hotkey.net.au/~netwurker/

## MEDIA POETS BEFORE 1980
Theo Lutz
http://www.stuttgarter-schule.de/lutz_schule_en.htm

Brion Gysin
http://www.ubu.com/sound/gysin.html

Jackson Mc Low
http://epc.buffalo.edu/authors/maclow/

Nanni Balestrini
http://www.nannibalestrini.it

Henri Chopin
http://www.ubu.com/sound/chopin.html

Bernard Heidsieck
http://www.ubu.com/sound/heidsieck.html

Oulipo
http://www.oulipo.net

Raymond Queneau
http://www.bevrowe.info/Poems/QueneauRandom.htm

Pedro Barbosa
http://www.pedrobarbosa.net

Erthos Albino de Souza
http://www.ekac.org/erthos.html

Aaron Marcus
http://www.atariarchives.org/artist/sec4.php

Klaus Peter Dencker
http://www.thing.net/~grist/l&d/dencker/denckere.htm

## MEDIA POETRY, ELECTRONIC WRITING, AND CRITICISM
p0es1s
http://www.p0es1s.net/

Postypographika
http://www.postypographika.com.ar

DOC(K)S – Computer Poetry
http://www.sitec.fr/users/akenatondocks/DOCKS-datas_f/collect_f/generiqueanim.html

éc/arts
http://www.ecarts.org

The Electronic Poetry Center
http://epc.buffalo.edu/

E-Poetry: An International Digital Poetry Festival
http://epc.buffalo.edu/e-poetry

New Media Poetry (The University of Iowa's International Writing Program)
http://www.uiowa.edu/%7Eiwp/newmedia/gallery.html

Alire
http://motsvoir.free.fr

Eastgate
http://www.eastgate.com

The Hyperliterature Exchange
http://hyperex.co.uk

Electronic Literature Organization
http://www.eliterature.org

Dichtung-digital - journal für digitale ästhetik
http://www.dichtung-digital.com

Alt-X
http://www.altx.com

Atelier de Littérature Assistée par la Mathématique et les Ordinateurs (A.L.A.M.O):
http://alamo.mshparisnord.net/presentation/index.html

Infolipo Group
http://infolipo.unige.ch

Trace
http://trace.ntu.ac.uk

VideoBardo
http://www.videopoesia.com

Electronic Book Review
http://www.electronicbookreview.com

Netzliteratur
http://www.netzliteratur.net

L' Astrolabe: Recherche littéraire et informatique
http://www.uottawa.ca/academic/arts/astrolabe/index.html

# SOURCES

**The following chapters were published in the first edition of this anthology (Eduardo Kac, editor. *New Media Poetry: Poetic Innovation and New Technologies* (Visible Language, vol. 30, n. 2, 1996, RISD, Providence, Rhode Island):**

The Interactive Diagram Sentence: Hypertext as a Medium of Thought, Jim Rosenberg
Poetic Machinations, Philippe Bootz
Videopoetry, E. M. de Melo e Castro
We Have Not Understood Descartes, André Vallias
Virtual Poetry, Ladislao Pablo Gyori
Beyond Codexspace: Potentialities of Literary Cybertext, John Cayley
Holopoetry, Eduardo Kac
Media Poetry – Theories and Strategies, Eric Vos

**The following chapters were first published as follows:**
Language-Based Videotapes & Audiovideotapes, Richard Kostelanetz, in: ("Language-Based Videotapes", *Synaesthetic*, 2 (1994), pp. 85–87).
Biopoetry, Eduardo Kac, in: (*Cybertext Yearbook 2002-03*, edited by Markku Eskelinen & Raine Koskimaa, University of Jyvaskyla, Finland, 2003).
Screening a Digital Visual Poetics, Brian Lennon, in: (*Configurations*, volume 8, number 1, winter 2000, The Johns Hopkins University Press, 2000). Revised for this book.

**The following chapters were written specifically for this volume:**
Quantum Poetics: Six Thoughts, Stephanie Strickland
From ASCII to Cyberspace: a Trajectory in Digital Poetry, Eduardo Kac
Unique-reading poems: a multimedia generator, Philippe Bootz. Translated from the French by Christel Taine.
Interactive Poetry, Orit Kruglanski
Nomadic Poems, Giselle Beiguelman
Recombinant Poetics, Bill Seaman
Reflections on the Perception of Generative and Interactive Hypermedia Works, Jean-Pierre Balpe
Digital poetics or On the evolution of experimental media poetry, Friedrich W. Block

# Biographies

**Eduardo Kac** is an artist and writer who first created holographic poetry, or holopoetry, in 1983 and who started to create digital poetry in 1982. He created his first poem online in 1985 (with the French minitel network), and since the early 1980s has built a body of work in media poetry. Well known for his bio art, including 'GFP Bunny' (the green-glowing rabbit Alba, 2000), Kac has also created biopoems (poems written with or within living beings). His poetic works and theoretical poetry essays have been exhibited and published internationally.

**Jim Rosenberg** is a poet and hypertext theorist. His publications include *Intergrams, Diffractions through: Thirst weep ransack (frailty) veer tide elegy* and *The Barrier Frames: Finality crystal shunt curl chant quickening giveaway stare*, both published by Eastgate Systems, Cambridge, MA, USA.

**Stephanie Strickland** is a print and new media poet. Her fourth book, *V: WaveSon.nets/Losing L'una*, has a Web component, http://vniverse.com. Prize-winning works include *V, True North, The Red Virgin: A Poem of Simone Weil,* and *Ballad of Sand and Harry Soot*. She serves on the board of the Electronic Literature Organization.

**Philippe Bootz** is a French poet. He works as an assistant professor of multimedia at the University of Versailles-St. Quentin and as a researcher at the Paragraphe Laboratory (University Paris 8) and at the Laboratory of Digital Music of Marseille (MIM).

**Orit Kruglanski** is a Barcelona-based, Israeli-born interactive poet and writer. She creates literature in interactive media and develops alternative peripheral devices. She works at Institut Universitari de l'Audiovisual, Universitat Pompeu Fabra, Barcelona.

**André Vallias** is a Brazilian poet who lives in Rio de Janeiro. From 1987 to 1994 he studied in Germany and, influenced by the ideas of the philosopher Vilém Flusser, began to produce poems in digital and electronic media.

**Ladislao Pablo Györi** is a Buenos Aires poet who first proposed 'virtual poetry' in 1995. His publications include the book *Estiajes* (Buenos Aires: Ediciones La Guillotina, 1994), originally written in 1988.

**Giselle Beiguelman** is a new media artist and writer and multimedia essayist who teaches Digital Culture at the Graduate Program in Communication and Semiotics of PUC-SP (São Paulo, Brazil). Her books include *O Livro depois do Livro* [The Book after the Book] (São Paulo: Editora Peirópolis, 2003).

**John Cayley** is a London-based poet, literary translator and the founding editor of The Wellsweep Press, which, since 1988, has specialized in the publication of literary translation from Chinese.

**Bill Seaman**, artist, writer, Department Head, Digital+Media Department (Graduate Division), Rhode Island School of Design, Providence, RI, USA.

**E. M. de Melo e Castro** is a Portuguese poet. A retrospective of his work, entitled 'O caminho do leve' (The way of lightness), was realized in 2006 at the Museu de Serralves, Portugal, with an accompanying catalogue.

**Richard Kostelanetz**, a prolific author, has also produced literature in audio, video, holography, prints, book-art and computer-based installations, among other new media. His many books include *Wordsand, 1967-1978: art with words, numbers and lines, in several media: an unillustrated catalog with related documents* – Burnaby, B.C.: Simon Fraser Gallery, Simon Fraser University; New York: RK Editions, 1978.

**Eric Vos**, independent critic, Amsterdam. His publications include Jackson, K. David, Eric Vos, and Johanna Drucker. *Experimental, visual, concrete: avant-garde poetry since the 1960s*. Amsterdam; Atlanta GA: Rodopi, 1996.

**Friedrich W. Block**, curator at Literature Foundation Brückner-Kühner, Kassel, Germany, writer, works on experimental poetry. His books include Block, Friedrich W., Christiane Heibach, and Karen Wenz, eds. *p0es1s: The Aesthetics of Digital Poetry* (Ostfildern-Ruit, Germany: Hatje Cantz Verlag, 2004).

**Brian Lennon**, Assistant Professor, Penn State University, Department of English, University Park, PA, USA. His books include *City: An Essay*. The University of Georgia Press, 2002.

**Jean-Pierre Balpe**, formerly the head of the Hypermedia Department and of the Paragraphe laboratory at the University Paris 8, is a poet, researcher and theorist of the relations between the computer and literature. His books include *101 poèmes du poète aveugle* (Tours: ed. Farrago, 2000) and *Contextes de l'art numérique* (Paris: Hermes, 2000).

# **Acknowledgements**

I would like to thank the Cité Internationale des Arts, Paris, and the Biennale Internationale des Poètes en Val-de-Marne (the Val-de-Marne International Poetry Biennial), France, for two memorable residencies that provided me with the space and time to complete this book. I would also like to thank The Illinois Arts Council which provided essential support through its Governor's International Arts Exchange Program. Additional assistance was provided by a Faculty Enrichment Grant from The School of the Art Institute of Chicago. I am particularly indebted to Intellect Books Publishing Manager May Yao, whose patience and commitment enabled me to bring the project to completion.

# INDEX

Page locators in *italic* refer to illustrations. Numbers preceded by 'n' refer to notes.

1:1 (Jevbratt), 27
"2+2 = Crowd" (Beiguelman), 102, 103
6th Annual Digital Salon, 31

A bribes abbatues (Bootz), 209
Abracadabra (Kac), 137, 137, 145
"Accelerating Frame" (Waldrop), 28
"Accident" (Kac), 56, 57
Action Poétique, 217
"Actual possession of the world ..." (Cayley), 116
Adhuc (Kac), 147, 205, 205
Adrift (Kac), 145, 147, 147
A.L.A.M.O., 213-214, 215, 217, 221-222
Albeit (Kac), 142-143, 145
"Aleer" (Vallias), 90
alire, 216, 217, 218, 219-220, 222, 225
Amalgam (Kac), 144, 144-145
America's Game (Kostelanetz), 189
Andromeda Souvenir (Kac), 145, 146
animations, 54-62
"Antigone" (Sophocles), 90
Arp, Hans, 237
Art Access, 214
Arte On-Line exhibition, 48
Artecidadezonaleste project (Project Cityarteasternzone), 100
"As much as you love me" (Kruglanski), 82, 83
ASCII Art Ensemble, 237, 240
 "Deep ASCII", 238
ASCII poems (Kac), 46-47, 47, 48
Ascott, Roy, 214, 239
"Assoziationblaster" (Freude), 239
Astray in Deimos (Kac), 147-149, 149
"Asyntactical carbogram (Biopoetry proposal # 17)" (Kac), 195

Baboni-Schillingi, Jacopo
 "MeTapolis" (Balpe, Chevalier and Baboni-Schilingi), 246, 249
 "Trois mythologies et un poète aveugle" ("Three Mythologies and a Blind Poet")(Balpe and Baboni-Schilingi), 247, 249
Ballad of Sand and Harry Soot, The (Strickland, 1999), 29-31, 30
Balpe, Jean-Pierre, 215, 219, 249
 "Hommage à Jean Tardieu", 220
 "Labylogue" (Benayoun, Barrière and Balpe), 246-247, 248
 "MeTapolis" (Balpe, Chevalier and Baboni-Schilingi), 246, 249
 "Trois mythologies et un poète aveugle" ("Three Mythologies and a Blind Poet") (Balpe and Baboni-Schilingi), 247, 249
Barbosa, Pedro, Sintext (Barbosa and Cavalheiro), 206
Barreto, Jorge Lima, 184
Barrière, Jean-Baptiste, "Labylogue" (Benayoun, Barrière and Balpe), 246-247, 248
Baudin, Guillaume, 217
Baudot, Jean, 234
Baudrillard, Jean, 206-207, 252, 254, 257
Beiguelman, Giselle
 "2+2 = Crowd", 102, 103
 "I Love You", 101
 "Irene_Ri" ("Irene_Laughs"), 96
 "Os Vipes são Bípedes" ("VIPs are Bipeds"), 98
 "Streets", 99, 100
Ben, 214

Benayoun, Maurice, "Labylogue" (Benayoun, Barrière and Balpe), 246–247, 248
Bense, Max, 234
Bernstein, Charles, 265
biopoetry, 191–196
Blaine, Julian, 214
Bode, Peter, 185
"Bodybuilding" (Fietzek), 237, 239
Bolter, Jay David, 200, 201, 251, 252, 254
 Remediation (Bolter and Grusin), 31
Book of the Book, A (Rothenberg and Clay), 25
Book Unbound (Cayley), 117, 120
Bootz, Philippe, 203, 205–206, 214, 216, 224, 238, 239
 A bribes abbatues, 209
 passage, 67–73, 69, 70, 71
bpNichol, 253
Brasil High Tech exhibition, 48
Breeze, Mary-Anne (Mez), 27, 32
Bret, Michel, Deux Mots (Laufer and Bret), 215
Brigham, Tom, 39
Brossa, Juan, 233
Brown, Robert Carlton ("Bob"), 253
Burgaud, Patrick-Henri, 203
 La Mer (Burgaud with Dutey), 209, 210
Bush, Vannevar, 28, 29

Cage, John, 15, 201
Calvino, Italo, 234
Carré, Benôit, 217, 223
Carroll, Lewis, Sylvie and Bruno Concluded, 27
Cavalheiro, Abílio, Sintext (Barbosa and Cavalheiro), 206
Cayley, John, 11
 "Actual possession of the world ...", 116
 Book Unbound, 117, 120
 Collocations: Indra's Net II, 112–114
 "Critical Theory", 113–114, 114
 "An Essay on the Golden Lion", 117
 Golden Lion: Indra's Net IV, 114, 115, 117
 "Han Shan" (Cayley), 117
 Indra's Net series, 110–117
 Leaving the City, 114, 116
 "Moods & Conjunctions", 114
 Moods & Conjunctions: Indra's Net III, 111, 114–117
 Scoring the Spelt Air, 108
 The Speaking Clock, 118–119, 120
 "Under it All", 111, 112, 113, 113, 114
 wine flying, 108

Chaos (Kac), 138, 139
Chevalier, Miguel, "MeTapolis" (Balpe, Chevalier and Baboni-Schilingi), 246, 249
Chopin, Henri, 232
Christie, John, 120
Claus, Carlfriedrich, 233
 "Exerzitien", 239
Clay, Steven, A Book of the Book (Rothenberg and Clay), 25
Collocations: Indra's Net II (Cayley), 112–114
"Concrete Art" (von Doesburg), 235
"Concrete Music" (Schaeffer), 235
Costa, Mario, 226
Couillin, Christophe, 217
Courchesne, Luc, "Portrait One", 239
Coverley, M. D.
 To Be Here as Stone Is (Strickland and Coverley), 32
 Errand Upon Which We Came (Strickland and Coverley), 32–34, 33
"Critical Theory" (Cayley), 113–114, 114
Cryptic Eye, The (Melo e Castro), 208, 212n25
Cubitt, Sean, 40–42
"Cybernetic Landscape" (Marcus), 236

"d/eu/s" (Kac), 50, 52, 54
David, Cathérine, 237
de la Motte, Manfred, 237
"Deep ASCII" (ASCII Art Ensemble), 238
Deleuze, G., 254, 255
 A Thousand Plateaus (Deleuze and Guattari), 170, 174n9
Deluy, Henri, 249
Dencker, Klaus Peter, 232
Derrida, Jacques, 134, 155n1, 155n3, 156n4, 232, 255
Descartes, René, 87
Deux Mots (Laufer and Bret), 215
Develay, Frédéric, 214
 "Lieu provisoire état du texte", 215
diagram poems, 16–18, 20
Diagram Series 3 (Rosenberg), 16, 17
Dickey, William, 200–201, 209, 255
Dickinson, Emily, 32
Die verbesserung von mitteleuropa, roman (Wiener), 234
Diffractions Through (Rosenberg), 203
Diffractions Through # 2 (Rosenberg), 204
DiMeo, Joseph V., 186
Döhl, Reinhard, 235

Donguy, Jacques, "Tag-Surfusion", 222
"Don't forgive me" (Kruglanski), 82–83
Drucker, Johanna, The Visible Word: Experimental Typography and Modern Art, 253, 255–256, 258
Dufrêne, François, 232
Dutey, Jean-Marie, 203, 214, 218
    La Mer (Burgaud with Dutey), 209, 210
    mange text, 225

Eccentric (Kac), 142, 143–144, 145
Eco, Umberto, The Open Work, 237
Eisenstein, Sergie, 166, 168
Electronic Word, The, Lanham, Richard, 31
Epiphanies (Kostelanetz), 185
Errand Upon Which We Came (Strickland and Coverley), 32–34, 33
Escracho (Kac), 47
"Essay on the Golden Lion, An" (Cayley), 117
"Exerzitien" (Claus), 239
exhibitions
    Arte On-Line exhibition, 48
    Brasil High Tech exhibition, 48
    Expoesie exhibition, 266
    Images et Mots exhibition, 214, 223
    Les Immatériaux exhibition, 213, 214
Expoesie exhibition, 266

"Falésia" (Vallias), 89
Fazang, 117
Felstiner, John, The Way to Macchu Picchu, 40–41
Fietzek, Frank, "Bodybuilding", 237, 239
"five small poems" (Kruglanski), 79
Flusser, Vilém, 85, 90n1
Fontana, Bill, 232
Forest, Fred, 214, 226
Fournel, Paul, 234
Freude, Alvar, "Assoziationblaster", 239

Garnier, Pierre, 214
Gaumnitz, Michael, 217
generative and interactive works, 245–249
Gerz, Jochen, 232
Giacometti, Alberto, 237
Gibbs, Willard, 32, 35
Golden Lion: Indra's Net IV (Cayley), 114, 115, 117
Goldsmith, Kenneth, 258
Gonzalez-Walker, Antonio, 258

Gospels, The (Kostelanetz), 188–189
Grusin, Richard A., 252
    Remediation (Bolter and Grusin), 31
Gu Cheng, 117
Guattari, F., 254, 255, 258
    A Thousand Plateaus (Deleuze and Guattari), 170, 174n9
Guglielmi, Joseph, 249
Györi, Ladislao Pablo, 201
    "Vpoem 12", 91
    "Vpoem 13", 92
    "Vpoem 14", 94
Gysin, Brion, 213

Hamilton Finlay, Ian, 233
"Han Shan" (Cayley), 117
Haraway, Donna J., 252, 253, 254, 256–257, 258
Havoc (Kac), 149–151, 150
Hayles, N. Katherine, 31, 252, 253, 256, 257
Hébert, Jean-Pierre, Sisyphus, 29
Heilner, Alex, 31
Higgins, Dick, 240–241
Hofstadter, Douglas, 37
Höllerer, Walter, 237
Holo/Olho (Holo/Eye) (Kac), 136–137, 142
holograms, 110–112
holopoetry, 129–155, 203, 207, 208
"Hommage à Jean Tardieu" (Balpe), 220
Hopkins, Gerard Manley, 88
Hypercard, 21
hypertext systems, 20–21, 23n4, 107–108, 120

"I Love You" (Beiguelman), 101
"Ideovídeo" (Melo e Castro), 182, 183
l'Imagaire Informatique de la Littérature, 219
Images et Mots exhibition, 214, 223
Les Immatériaux exhibition, 213, 214
Impermanence Agent (Wardrip-Fruin), 39–40
In Memoriam (Tennyson), 202
Indra's Net series (Cayley), 110–117
Infolipo group, screen capture from website, 266
"(Words are) InnerSpace Invaders" (Kruglanski), 77, 78
"Insect.Desperto" (Kac), 57–58, 58, 207–208
interactive works, 77–84, 245–249
Intergrams (Rosenberg), 19, 20
Inversions (Kim), 37
Invocations (Kostelanetz), 188
"IO" (Kac), 52, 55

"IO" (Vallias), 89, 89-90
"Irene_Ri" ("Irene_Laughs") (Beiguelman), 96

Jameson, Fredric, 252
Jevbratt, Lisa, 1:1, 27
Jillson, Gordon, 186
Joyce, Michael, 251, 258, 265

Kac, Eduardo, 206-207, 232
    Abracadabra, 137, 137, 145
    "Accident", 56, 57
    Adhuc, 147, 205, 205
    Adrift, 145, 147, 147
    Albeit, 142-143, 145
    Amalgam, 144, 144-145
    ASCII poems, 46-47, 47, 48
    Astray in Deimos, 147-149, 149
    "Asyntactical carbogram (Biopoetry proposal # 17)", 195
    Chaos, 138, 139
    "d/eu/s", 50, 52, 54
    Eccentric, 142, 143-144, 145
    Escracho, 47
    Havoc, 149-151, 150
    Holo/Olho (Holo/Eye), 136-137, 142
    holopoetry, 203, 207, 208
    "Insect.Desperto", 57-58, 58, 207-208
    "IO", 52, 55
    "Key Concepts of Holopoetry", 262-263
    on language, 211
    "Letter", 58, 59, 62, 64n9
    Lilith (Kac with Kostelanetz), 141-142
    Maybe Then, If Only As, 153, 154
    "Metabolic metaphors (Biopoetry proposal # 18)", 196
    "Microbat performance (Biopoetry proposal # 1)", 192
    minitel works, 47-54
    Multiple, 145
    "Não!" ("Typewritings" series), 46-47, 48
    "Oco", 53, 54, 137-138
    Omen, 145
    "Perhaps", 62-63, 63
    Phoenix, 141, 143
    "'Prophecy' (Biopoetry proposal # 4)", 193
    "Proteopoetics (Biopoetry proposal # 13)", 194
    Quando, 139-141, 140
    "Reabracadabra", 48
    "Recaos" (Kac), 51, 52
    "Reversed Mirror", 61, 62
    "Secret", 62, 65n11, 259-264, 259-265
    Shema, 142, 143
    Andromeda Souvenir, 145, 146
    "Storms", 54, 55, 56-57, 205
    "Telephant Infrasonics (Biopoetry proposal # 5)", 193
    "Tesão", 49
    Time Capsule, 41-42
    "Typewritings" series, 46-47
    "Untitled" ("Typewritings" series), 47
    "UPC", 57
    "Wine", 60, 62
    Wordsl No. 1 (Kac), 139, 140
    Wordsl No. 2 (Kac), 139
    Zephyr, 151, 152, 154
    Zero, 147, 148
    Zyx, 137-138, 138
Kaos, 215-217, 218
Kaos/Action Poétique joint issue, 218-219
Kellman, Nina, 186
"Key Concepts of Holopoetry" (Kac), 262-263
Kidder, Tracy, The Soul of a New Machine, 38
Kim, Scott, Inversions, 37
Kinetic Writings (Kostelanetz), 186, 187, 188
Kirschenbaum, Matthew G., 258
Kolar, Jiri, 233
Kostelanetz, Richard, 141, 232, 235
    America's Game, 189
    Epiphanies, 185
    The Gospels, 188-189
    Invocations, 188
    Kinetic Writings, 186, 187, 188
    Lilith (Kac with Kostelanetz), 141-142
    Monopoem Workings (Sherwood and Kostelanetz), 208-209
    More Short Fictions, 185
    Partitions, 185
    Praying to the Lord, 189
    Relationships, 188
    Seductions, 188
    Stringsieben, 186
    Stringtwo, 186
    Three Prose Pieces, 185
    Turfs Arenas Fields Pitches, 186-187
    Videostrings, 186
Kruglanski, Orit
    "As much as you love me", 82, 83
    "Don't forgive me", 82-83
    "five small poems", 79

"(Words are) InnerSpace Invaders", 77, 78
"Please", 79, 80
"WhereAbouts", 81

La Mer (Burgaud with Dutey), 209, 210
"Labylogue" (Benayoun, Barrière and Balpe), 246–247, 248
L.A.I.R.E., 214–215, 217
Landow, George, 202, 251, 254
language-based videotapes and audiovideotapes, 185–189
L=A=N=G=U=A=G=E writers, 201, 252, 253, 258, 269n47
Lanham, Richard, 255
    The Electronic Word, 31
Latour, Bruno, We Have Never Been Modern, 252
Laufer, Roger, Deux Mots (Laufer and Bret), 215
Lawson, Cynthia, V: Vniverse (Strickland and Lawson), 34–35
Leaving the City (Cayley), 114, 116
"Legible City, The" (Shaw), 239, 260
Les Immatériaux exhibition, 213, 214
Leste o Leste? (Did You Read the East?) (2002), 97, 98, 98, 100, 100–101, 101
"Letter" (Kac), 58, 59, 62, 64n9
Lexia to Perplexia (Memmott), 29
"Lieu provisoire état du texte" (Develay), 215
Lilith (Kac with Kostelanetz), 141–142
Lima Barreto, Jorge, 184
l'Imagaire Informatique de la Littérature, 219
Luhmann, Niklas, 235, 257
Lutz, Theo, 213, 234
    stochastic text, 233, 234
Lyotard, Jean-François, 252

MacLow, Jackson, 110–111
Magné, Bernard, 215
Maillard, Claude, 214
Mallarmé, Stéphane, 175
    "Notes", 86, 87
mange text (Dutey), 225
Marcus, Aaron, 234
    "Cybernetic Landscape", 236
Marinetti, F.T., 255
Mathews, Harry, 114, 124n29
Maxwell, James Clerk, 35
May, Gideon, The World Generator/The Engine of Desire (Seaman and May), 157–163, 159–161, 164–168, 165, 167, 169, 171, 172

Maybe Then, If Only As (Kac), 153, 154
Mayröcker, Friederike, 232
McCaffery, Steve, 201, 253
McGann, Jerome, 253
McLuhan, Marshall, 103, 218, 225, 232, 252
media poetry
    audience interactivity, 240
    chronology, 273–278
    definitions of, 199–200, 231
    functional approach to text, 221–226
    generative and interactive works, 245–249
    history and development of, 213–221, 229–242
    strategies, 207–211, 235
    theoretical basis, 200–207
Melo e Castro, Ernesto de, 232, 235
    The Cryptic Eye, 208, 212n25
    "Ideovídeo", 182, 183
    Roda Lume (Wheel of Fire), 176, 176, 177, 178, 179, 180, 184
    Signagens (Signings) project, 180–181
    Sonhos de Geometria, 184
    video poetry, 203
    Vogais, As Cores Radiantes (Vowels, The Radiant Colors), 184
Memex, 28
Memmott, Talan, 27
    Lexia to Perplexia, 29
Memória Audiovisual (Audio Visual Memory) (Pinto Leite), 184
Mer, La (Burgaud with Dutey), 209, 210
"Metabolic metaphors (Biopoetry proposal # 18)" (Kac), 196
"MeTapolis" (Balpe, Chevalier and Baboni-Schilingi), 246, 249
Métro-police (Nagy), 215
Mez (Mary-Anne Breeze), 27, 32
"Microbat performance (Biopoetry proposal # 1)" (Kac), 192
minitel, 47–54, 64n4, 214
Mon, Franz, 233, 237, 242
Monopoem Workings (Sherwood and Kostelanetz), 208–209
Moods & Conjunctions: Indra's Net III (Cayley), 111, 114–117
More Short Fictions (Kostelanetz), 185
Moreiras, Alberto, 265
Morris, Adalaide, Sound States anthology, 253
Moulthrop, Stuart, 251
Multiple (Kac), 145

Nagy, Paul, 217
    Métro-police, 215
Nannuci, Mauricio, 232
"Não!" ("Typewritings" series: Kac), 46–47, 48
neuro-cognitive shifts, 36–40
Newton, Isaac, 35
Nezvanova, Netochka, 27
Nichol, B.P. (bpNichol), 253
nomadic poems, 97–103
non-linear poetics, 108, 122n8
"Nord Poésie et Ordinateur" conference, 219
"Notes" (Mallarmé), 86, 87
"Nous n'avons pas compris Descartes" (Vallias), 86

"Oco" (Kac), 53, 54, 137–138
Olbrich, Jürgen, 232
Olson, Charles, 253
Omen (Kac), 145
Open Work, The (Eco), 237
Orlan, 214
"Os Vipes são Bípedes" ("VIPs are Bipeds") (Beiguelman), 98
oscillation and resonance, 31–35

Papp, Tibor, 203, 214, 217, 224
p'Art, 217
Partitions (Kostelanetz), 185
passage (Bootz), 67–73, 69, 70, 71
Penny, Simon, 252
"Perhaps" (Kac), 62–63, 63
Perloff, Marjorie, 253
    Radical Artifice: Writing Poetry in the Age of Media (Perloff), 201
Phoenix (Kac), 141, 143
Pinto Leite, Vasco, Memória Audiovisual (Audio Visual Memory), 184
Plant, Sadie, Zeroes + Ones, 28
"Please" (Kruglanski), 79, 80
Poétrica (2003), 97, 98, 101–103, 102, 103
"Portrait One" (Courchesne), 239
Praying to the Lord (Kostelanetz), 189
"'Prophecy' (Biopoetry proposal # 4)" (Kac), 193
"Proteopoetics (Biopoetry proposal # 13)" (Kac), 194
"PRTHVÎ" (Vallias), 88

Quando (Kac), 139–141, 140
Queneau, Raymond, 217, 233

Radical Artifice: Writing Poetry in the Age of Media (Perloff), 201
"Reabracadabra" (Kac), 48
"Recaos" (Kac), 51, 52
recombinant poetics, 157–173
Relationships (Kostelanetz), 188
Remediation (Bolter and Grusin), 31
resonance and oscillation, 31–35
"Reversed Mirror" (Kac), 61, 62
Revue parlée, 215
Rimbaud, Arthur, 184
"Rio" (Vallias), 90
Roda Lume (Wheel of Fire) (Melo e Castro), 176, 180, 184
    Storyboard, 176, 177, 178, 179
Rosenberg, Harold, 185
Rosenberg, Jim, 32, 110, 207, 208, 209, 235
    Diagram Series 3, 16, 17
    Diffractions Through, 203
    Diffractions Through # 2, 204
    hyperpoetry, 203, 205
    Intergrams, 19, 20
Rothenberg, Jerome, Book of the Book, A (Rothenberg and Clay), 25
Roubard, Jacques, 234
Rua, Vitor, 184
Rudolph, Hank, 185
Rühm, Gerhard, 232, 233, 241
Rushdie, Salman, 41

Sacks, Peter M., 251
Schaeffer, Pierre, "Concrete Music", 235
Scherstjanoi, Valeri, 233
Schwitters, Kurt, 237
Scoring the Spelt Air (Cayley), 108
Seaman, Bill, The World Generator/The Engine of Desire (Seaman and May), 157–163, 159–161, 164–168, 165, 167, 169, 171, 172
"Secret" (Kac), 62, 65n11, 259–264, 259–265
Seductions (Kostelanetz), 188
Shaw, Jeffrey, "The Legible City", 239, 260
Shelley, Mary, 28
Shema (Kac), 142, 143
Sherwood, Kenneth, Monopoem Workings (Sherwood and Kostelanetz), 208–209
Siggraph 1999, 29
Signagens (Signings) project (Melo e Castro), 180–181
Simanowski, Roberto, 239
Sintext (Barbosa and Cavalheiro), 206

Sisyphus (Hébert), 29
Snow, C.P., 241
Sonhos de Geometria (Melo e Castro), 184
Sophocles, "Antigone", 90
Soul of a New Machine, The (Kidder), 38
Sound States anthology (Morris), 253
Speaking Clock, The (Cayley), 118–119, 120
Stein, Gertrude, 237, 251, 253, 256, 265
stenographic paradigm, 27–31
Stewart, Garrett, 253
Stickel, Gerhard, 234
"Storms" (Kac), 54, 55, 56–57, 205
"Streets" (Beiguelman), 99, 100
Strickland, Stephanie
    The Ballad of Sand and Harry Soot (1999), 29–31, 30
    To Be Here as Stone Is (Strickland and Coverley), 32
    Errand Upon Which We Came (Strickland and Coverley), 32–34, 33
    True North, 32
    V: Vniverse (Strickland and Lawson), 34–35
    V: WaveSon.nets/Losing L'una, 34
Stringsieben (Kostelanetz), 186
Stringtwo (Kostelanetz), 186
superposition, 35–36
"Surfaces" (Vallias), 89
Sylvie and Bruno Concluded (Carroll), 27

"Tag-Surfusion" (Donguy), 222
TELECTU (Jorge Lima Barreto and Vitor Rua), 184
"Telephant Infrasonics (Biopoetry proposal # 5)" (Kac), 193
Tennyson, Alfred, In Memoriam, 202
"Tesão" (Kac), 49
Thousand Plateaus, A (Deleuze and Guattari), 170, 174n9
Three Prose Pieces (Kostelanetz), 185
Time Capsule (Kac), 41–42
To Be Here as Stone Is (Strickland and Coverley), 32
Translating Neruda: The Way to Macchu Picchu (Felstiner), 40–41
"Trois mythologies et un poète aveugle" ("Three Mythologies and a Blind Poet") (Balpe and Baboni-Schilingi), 247, 249
True North (Strickland), 32
Turfs Arenas Fields Pitches (Kostelanetz), 186–187

Turing, Allan, 234
"Typewritings" series (Kac), 46–47

Ulrichs, Timm, 232, 233
"Under it All" (Cayley), 111, 112, 113, 113, 114
unique-reading poems, 67–73, 239
"Untitled" ("Typewritings" series: Kac), 47
"UPC" (Kac), 57

V: Vniverse (Strickland and Lawson), 34–35
V: WaveSon.nets/Losing L'una (Strickland), 34
Vallias, André, 235
    "Aleer", 90
    "Falésia", 89
    "IO", 89, 89–90
    multimedia digital works, 207
    "Nous n'avons pas compris Descartes", 86, 86–87
    "Oratorio", 240
    "PRTHVÎ", 88
    "RIO", 90
    "Surfaces", 89
    "The Verse", 87–88, 88
"Verse, The" (Vallias), 87–88, 88
Vianni, Bruno, 79
videopoetry, 175–184
Videostrings (Kostelanetz), 186
Viola, Bill, 252
virtual poetry, 91–96
Visible Word, The (Drucker), 253, 255–256, 258
Vogais, As Cores Radiantes (Vowels, The Radiant Colors) (Melo e Castro), 184
von Doesburg, Theo, "Concrete Art", 235
von Foerster, Heinz, 232
von Neumann, John, 232
VPD (virtual poetry domain), 93, 95
"Vpoem 12" (Györi), 91
"Vpoem 13" (Györi), 92
"Vpoem 14" (Györi), 94

Wagner, Richard, 240
Waldrop, Rosmarie, "Accelerating Frame", 28
Wardrip-Fruin, Noah, Impermanence Agent, 39–40
We Have Never Been Modern (Latour), 252
Weil, Simone, 35
"WhereAbouts" (Kruglanski), 81
Wiener, Oswald, Die verbesserung von mitteleuropa, roman, 234

Williams, Davey, 38
Williams, Emmett, 110-111, 120, 232
wine flying (Cayley), 108, 109
"Wine" (Kac), 60, 62
Wop Art (2001), 97, 98, 99, 100
"(Words are) InnerSpace Invaders" (Kruglanski), 77, 78
Wordsl No. 1 (Kac), 139, 140
Wordsl No. 2 (Kac), 139
World Generator/The Engine of Desire, The (Seaman and May), 157-163, 159-161, 164-168, 165, 167, 169, 171, 172

XFR, Experiments in the Future of Reading, 25
Xie Ye, 117

Zephyr (Kac), 151, 152, 154
Zero (Kac), 147, 148
Zeroes + Ones (Plant), 28
Zyx (Kac), 137-138, 138